ART
OF THE
THIRD
REICH

ART OF THE THE

THIRD REICH PETER ADAM

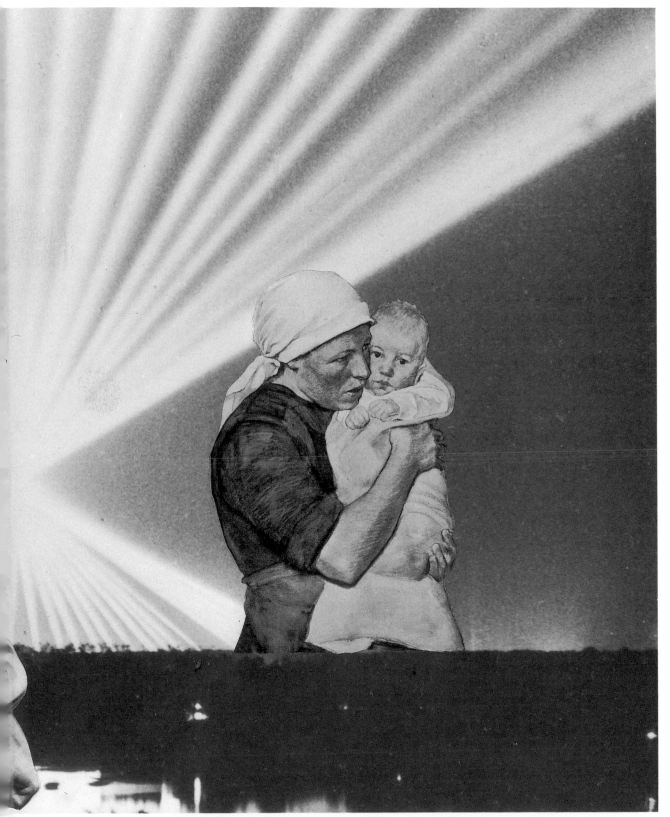

HARRY N. ABRAMS, INC., PUBLISHERS, NEW YORK

Editor: Phyllis Freeman

Designer: Bob McKee

Photo Editor: Uta Hoffmann

Library of Congress Cataloging-in-Publication Data

Adam, Peter.

Art of the Third Reich / Peter Adam.

pp. cm.

"Based on a television series Peter Adam made for the BBC in

1988"—

Includes bibliographical references and index.

ISBN 0–8109–1912–5 (cloth)

1. National socialism and art. 2. Art, German. 3. Art,

Modern—20th century—Germany. I. Title.

N6868.5.N37A34 1992

709'.43'09043—dc20 91–25563

Text copyright © 1992 Peter Adam

Illustrations copyright © 1992 Harry N. Abrams, Inc.

Published in 1992 by Harry N. Abrams, Incorporated, New York

A Times Mirror Company

Printed and bound in Japan

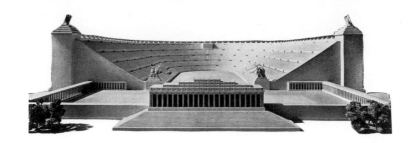

CONTENTS

INTR

ODUCTION

Not much is known about the art of the Third Reich, the period from 1933 to 1945 during which Adolf Hitler ruled over Germany in the name of National Socialism. Quite a number of books have been written about its political history, but very few about the art it produced. The passionate discussion that usually follows any attempt to display works from this period demonstrates that politicians, wide sections of the population, and even art historians are still ignorant about the nature and substance of the art produced in Germany under the National Socialists.

The general assumption is that all the art, however persuasive, was so bad that it does not deserve the attention of art historians. The exclusion of this period from the history of art is almost universal. Nikolaus Pevsner's verdict that "every word about it is too much" is echoed by many. Germany has pushed a whole chapter of its cultural history under the carpet. But the tide is turning. At a meeting of German art historians in Frankfurt in 1988, the subject of the official art under the National Socialist regime was debated for the first time in public.

Few people have actually seen the works: many were lost in the bombings, and during the last months of the war the National Socialists hid many of their artworks in bombproof shelters. When the Americans arrived in 1945, they discovered an immense hoard of

paintings, sculptures, even rugs and antique furniture. Most of the so-called official German art was shipped to the United States, where it was locked away by the Department of Defense. It was agreed by a committee of art historians and government officials that no work that depicts a swastika or any other Nazi insignia should be returned to Germany. The United States Government has kept about 325 of the most inflammatory works in a vault under the auspices of the army in Washington. In 1950, however, 1,659 works were sent back to Germany, and in 1986, a further 6,255.

The returned works, too, are hidden away in a storage space belonging to the customs office in Munich. Germany has no central Ministry of Culture—each state is in charge of its own cultural affairs—so the Ministry of Finance was put in charge of this art. National Socialist art is still a great embarrassment to the German government. Only art historians and people with a "genuine professional interest" are allowed to see it. Few have made use of the opportunity. It is convenient for many people to push this art out of the way by largely ignoring it.

So far no German museum has expressed the wish to show any of these works, although there are negotiations for the newly founded Museum of German History in Berlin to take the whole collection over. In the meantime, the paintings, still in their gilded frames, some bearing the label "Purchased by the Führer," await their future destiny. They sit on simple wooden shelves in no particular order among the remnants of carpets and furniture of the official National Socialist buildings. No art historian is in charge of them. There is a handwritten catalogue that could give some information about dates or ownership of the work, but it is carefully guarded and out of sight.

Washington also held on to a large collection of so-called war paintings, work done by soldiers during the war. Most of these, at least those without overt National Socialist subjects, were also shipped back to Germany. They are kept more appropriately at the Army Museum in Ingolstadt. But they cannot be seen either. An attempt by the director of the museum to exhibit the work was stopped by the Ministry of Finance. This awkward inheritance is better kept in the cellar out of view and consideration.

The embarrassment about the pictures and the way they are handled is widespread. No one seems to know what to do about them. The owners of the works or families of the painters also seem not very interested in regaining access to them. Periodicals and books published during the National Socialist period that dealt with the art of the Third Reich are scarcely available; most libraries were only too eager to destroy the damaging evidence.

Oversimplification about the art of this period has led to clichés. The secrecy has helped to create a legend; there are rumors of National Socialist treasures lying in museum vaults. The imagination runs wild. The general lack of knowledge means that painters or sculptors once widely popular are now unknown. One can scarcely find out which of their works were widely distributed through postcards, photographs, or posters. Or who bought their paintings. "Are they art or merely historical documents?" Some still believe that they have evil powers which could rekindle National Socialist thought. Others fear that paintings of this kind could actually appeal once more to a large public. The

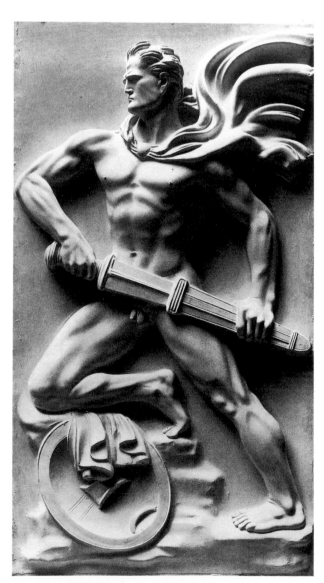

Arno Breker. The Guard

arguments are heated. People think that showing them is an insult to the artists banned by the Hitler regime. But the opinion is gaining ground that it is important to look at National Socialist art and evaluate it in its political context. It is recognized that this art cannot be studied solely from an aesthetic point of view.

The art of the Third Reich is difficult, complex, and controversial. Whether it be in the form of fine arts, architecture, film, literature, or music, it cannot be considered in the same way as the art of other periods. It must be seen as the artistic expression of a barbaric ideology. One can only look at the art of the Third Reich through the lens of Auschwitz.

Few political systems that lasted just twelve years have inflicted such enduring damage to the psychology of a country as the National Socialist regime. From 1933 to 1945 culture became the operative, key word of this regime.

"Adolf Hitler's state has made it its responsibility to embrace all art, in past and present forms," stated the magazine *Weltkunst* (World of Art), "and to absorb it into the great idea of the *Volk*."[1] *Volk* was one of the key words of National Socialist philosophy, meaning "folk and folkdom," the totality of the German people and the German race.

Art was considered one of the most important elements in building the new Reich and the new man. Political aims and artistic expression became one. "The modern state has taken on itself a cultural mission. It also insists on ruling over the arts. This means a commitment for the painter, sculptor, poet, and musician. Their work must serve the people," declared the writer Ludwig Eberlein.[2]

Culture assumed mystical significance. Hitler thundered: "Art is a noble mission. Those who have been chosen by destiny [*Vorsehung*] to reveal the soul of a people, to let it speak in stone or ring in sounds, live under a powerful, almighty, and all-pervading force. They will speak a language, regardless of whether others understand them. They will suffer hardship rather than become unfaithful to the star which guides them from within."[3]

The task of art in the Third Reich was to impose a National Socialist philosophy of life. It had to form people's minds and attitudes. Hitler said, "Art has at all times been the expression of an ideological and religious experience and at the same time the expression of a political will."[4]

On March 23, 1933, at the Reichstag in Berlin, shortly after taking over power, Hitler outlined the

Die Familie ist die kleinste, aber wertvollste Einheit im Aufbau des ganzen Staatsgefüges.
—Adolf Hitler

Georg Sluyterman von Langeweyde. The Family
"THE FAMILY IS THE SMALLEST BUT MOST PRECIOUS UNIT IN THE BUILDING OF A STATE."
—ADOLF HITLER

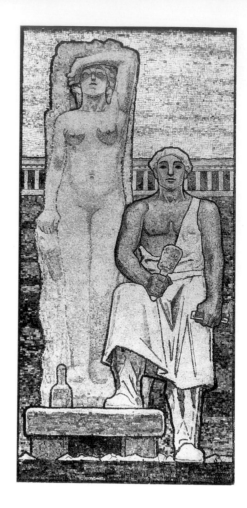

Fritz Erler. The Fine Arts.
Detail of a mural

aims and tasks of his new government to the assembled legislators. "Simultaneously with the purification of our public life," he said, "the government of the Reich will undertake a thorough moral purging. The entire educational system, the theater, the cinema, literature, press, and broadcasting will be used as a means to that end."

Hitler regularly delivered cultural speeches endlessly repeating the same ideas. At the Nuremberg Party Day of September 11, 1935, he again stressed, in a long speech, the link between the arts and politics. A special *Kulturtagung* (cultural conference) became a permanent feature of the annual Nuremberg rallies. The 1937 and 1938 rallies were both used for Hitler's major cultural speeches.[5] The openings of the annual "Great German Art Exhibitions" in Munich were also used by Hitler for flamboyant speeches on the cultural policies of the National Socialists. Only with the beginning of war did he hand the task of opening exhibitions over to his Minister of Propaganda, Joseph Goebbels.[6]

The National Socialists discovered that art not only could carry a political message but was also a perfect medium for creating and directing desires and dreams. It was able to program people's emotions and direct their behavior.

The National Socialists were masters at inventing and imposing stereotyped concepts and art forms which substituted for genuine artistic and personal experience. The result was the people's total submission to a state aesthetic: stifling to the eye and the sensibilities.

Hitler's ideas about art did not emerge overnight. In *Mein Kampf* (My Struggle), written in the twenties, long before he came to power, Hitler repeatedly underlined his belief that modern art was the product of diseased minds, themselves the product of a degenerate race. The opposite of the shining Aryan was the dark Jew. Uncreative, driven only by commercial thoughts, the Jew was the archenemy of culture, the parasite, bare of any idealism, without cultural roots.

. . . the Jewish people, with all its apparent intellectual qualities, is nevertheless without any true culture, especially without a culture of its own. For the sham culture which the Jew possesses today is the property of other peoples, and is mostly spoiled in his hands. When judging Jewry in its attitude towards the ques-

tion of human culture, one has to keep before one's eye as an essential characteristic that there never has been and consequently that today also there is no Jewish art; that above all the two queens of all arts, architecture and music, owe nothing original to Jewry. What he achieves in the field of art is either bowdlerization or intellectual theft.[7]

Hitler's obsession with the Jew never abated. The ideas expressed in his early writing all found their way into his later speeches, repeating again and again the same theme: "The Jews, infected through and through with capitalism and acting in that spirit, never possessed an art of their own and never will possess such an art."[8] In 1938 at the national Party meeting he proclaimed: "We know that if a Jew understands German-Aryan art, this is due to the fact that he has one drop of German blood, by mishap or accident. This drop begins to work against him. . . . The large mass of Jews is as a race culturally unproductive. That is why it is drawn more to Negro art than to the culturally higher works of the truly creative races."[9]

The German race had an educational mission, Hitler asserted. The Aryan became the custodian of culture. It was his task to fertilize the rest of humanity with new cultural ideas. "What we see before us of human culture today, the results of art, science, and tech-

niques, is almost exclusively the creative product of the Aryan,"[10] Hitler had written in *Mein Kampf.* He felt "the obligation in accordance with the Eternal Will that dominates this universe to promote the victory of the better and stronger, and to demand the submission of the worse and the weaker. . . . In this world human culture and civilization are inseparably bound up with the existence of the Aryan. His dying off or his decline would again lower upon this earth the dark veils of a time without culture."[11]

Hitler always stressed Antiquity as the real precursor of German art. "The struggle that rages today involves very great aims: a culture fights for its existence, which combines millenniums and embraces Hellenism and Germanity together."[12] "For if the time of Pericles appears incorporated in the Parthenon, so does the bolshevistic present in a cubistic grimace."[13] He took great care to link Jewishness with his other enemy, Marxism. "The bourgeois world is Marxist, . . . Marxism itself plans to transmit the world systematically into the hands of Jewry."[14]

Antitheses like bourgeois and artist, *Volk* and Führer, superman and underdog, virile and effeminate, Aryan and Jewish were constantly stressed to confirm his idea of the master race.

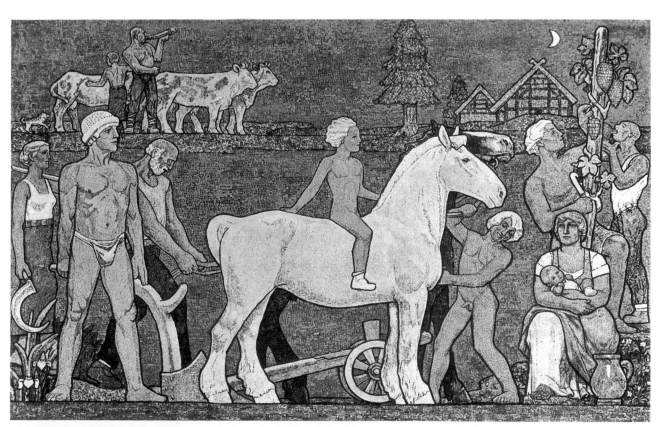

Fritz Erler. The Land. *Detail of a mural*

For that race, Hitler demanded from art an ideal model. He postulated an Aryan beauty able to heal the German body and soul. The function of art was "to create images which represent God's creatures, not miscarriages between man and monkey. . . . Art must be the Prophetess of Sublimity and Beauty and thus sustain that which is at once natural and healthy. The cult of the primitive is not the expression of a naïve unspoiled soul, but of utterly corrupt and diseased degeneracy."15

In 1937 the Ministry for Education and Science published a pamphlet in which Dr. Reinhold Krause, a leading educator, wrote that "Dadaism, Futurism, Cubism, and other isms are the poisonous flower of a Jewish parasitical plant, grown on German soil. . . . Examples of these will be the strongest proof for the

Page from the National Socialist children's book Trust No Fox and No Jew
"THE GERMAN IS A PROUD MAN/ WHO CAN WORK AND FIGHT./ HE IS BEAUTIFUL AND FULL OF COURAGE,/ THAT IS WHY THE JEW HATES HIM FOREVER."
"HERE IS THE JEW,/ YOU SEE IT RIGHT AWAY,/ THE GREATEST SCOUNDREL IN THE WHOLE NATION!/ HE THINKS HE IS VERY BEAUTIFUL/ BUT HE IS REALLY UGLY."

"We Farmers Are Cleaning Things Up. We Vote List 2—National Socialists." Election poster

Wir Bauern misten aus

Wir wählen Liste: 2 National-Sozialisten

Verfasser u. Herausgeber: Heinz Franke, München, Brienner Str. 45

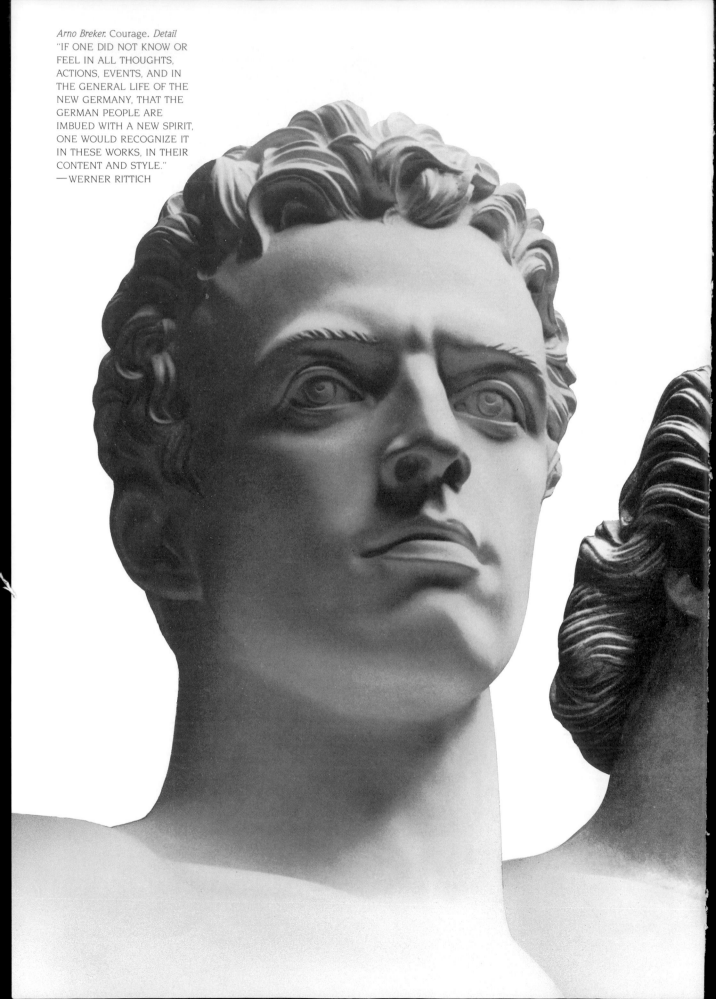

Arno Breker. Courage. *Detail*
"IF ONE DID NOT KNOW OR
FEEL IN ALL THOUGHTS,
ACTIONS, EVENTS, AND IN
THE GENERAL LIFE OF THE
NEW GERMANY, THAT THE
GERMAN PEOPLE ARE
IMBUED WITH A NEW SPIRIT,
ONE WOULD RECOGNIZE IT
IN THESE WORKS, IN THEIR
CONTENT AND STYLE."
—WERNER RITTICH

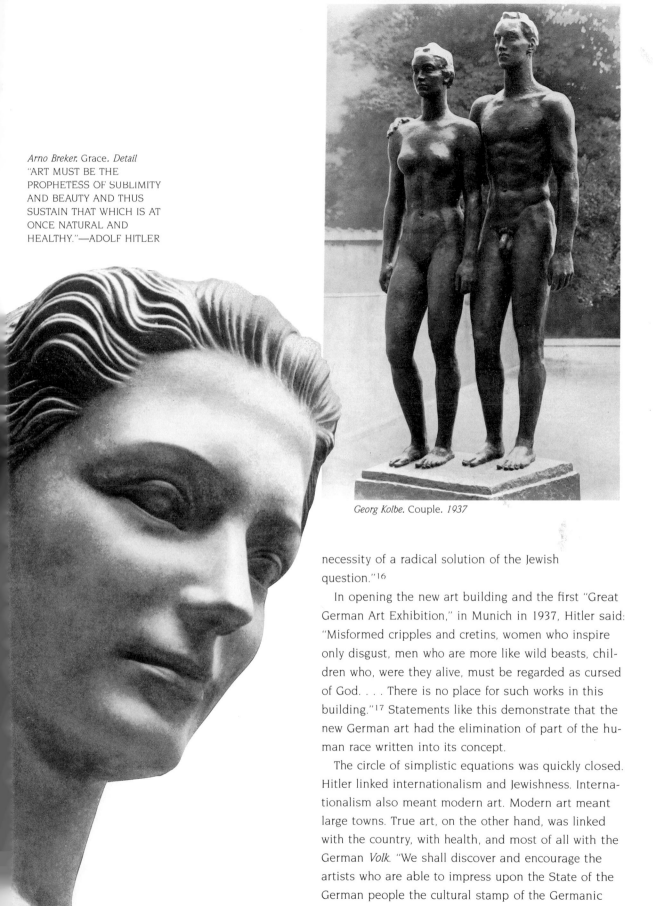

Arno Breker. Grace. *Detail*
"ART MUST BE THE
PROPHETESS OF SUBLIMITY
AND BEAUTY AND THUS
SUSTAIN THAT WHICH IS AT
ONCE NATURAL AND
HEALTHY."—ADOLF HITLER

Georg Kolbe. Couple. *1937*

necessity of a radical solution of the Jewish question."[16]

In opening the new art building and the first "Great German Art Exhibition," in Munich in 1937, Hitler said: "Misformed cripples and cretins, women who inspire only disgust, men who are more like wild beasts, children who, were they alive, must be regarded as cursed of God. . . . There is no place for such works in this building."[17] Statements like this demonstrate that the new German art had the elimination of part of the human race written into its concept.

The circle of simplistic equations was quickly closed. Hitler linked internationalism and Jewishness. Internationalism also meant modern art. Modern art meant large towns. True art, on the other hand, was linked with the country, with health, and most of all with the German *Volk.* "We shall discover and encourage the artists who are able to impress upon the State of the German people the cultural stamp of the Germanic race which will be valid for all time," Hitler said. "It is

this which in the end leads to an order of society in which the great eternal values of a people become visibly recognizable and which clearly suggests the care for the life of the community and consequently regard for the life of the individual. . . . All man's great cultural creations have arisen as creative achievements out of a community consciousness and therefore in

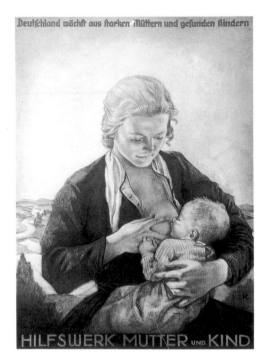

Poster of the Organization to Aid Mothers and Children. ca. 1935 "GERMANY GROWS THROUGH STRONG MOTHERS AND HEALTHY CHILDREN."

their origin and in the picture which they present they are the expression of the soul and the ideals of the community."[18]

The art of this racially pure culture was to overcome differences of class and forge the nation into an organic community of people following the same ideas. It was used to bind every individual to the nation. The collective aim was the only reason for art, just as architecture and mass meetings were to absorb people in a communal experience. It removed the individual's desire to probe, to experiment, to search. Instead, it prescribed answers and ideologies dictated from above. The right thinking was propagated everywhere. "The right thinking is the base for the right action. . . . The National Socialist revolution is a revolution of thought! Its greatness lies in the fact that it has de-

throned individual thought, which governed us for centuries, and has replaced it by communal thought. This gives us a new base and new possibilities of expression," wrote the press spokesman for the Ministry of Information.[19]

Hitler's revolution was as much a cultural as a political one. He convinced people that art was of prime importance to the leadership. "No age can claim to free itself from its duty to foster art; it would lose, did it do so, not only the capacity for artistic creation, but also the capacity to understand, to experience art. . . . The creative artist educates and perfects through his work the nation's capacity for appreciation."[20]

Hitler never tired of appealing to the soul and to people's ideals—the word "Seele" (soul) loomed large in his speeches. It stood for feeling, inner qualities that only the Germans, according to the Nazis, possessed. Hitler rarely promised a better material world. It was not a higher living standard but a better way of life, a life filled with deeper meaning. New houses were built not to enrich the people but to bring them closer to the soil. New factories meant not higher wages but a healthier working life with stronger workers in the service of the nation. Group outings were not for amusement alone. Their primary aim was to

Poster
"THE NSDAP PROTECTS THE NATIONAL COMMUNITY. CITIZENS, IF YOU NEED COUNSEL AND HELP—TURN TO YOUR LOCAL ORGANIZATION."

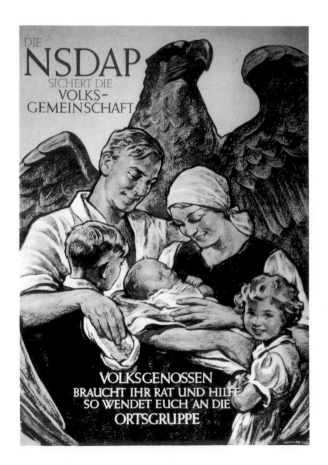

Commemorative stamps.
Top row, left and right:
Swastikas; center: Air Raid
Protection.
Center row: Führer Building
and House of German Art, Munich.
Bottom row: 100 Years of German
Railroads, 1835–1935

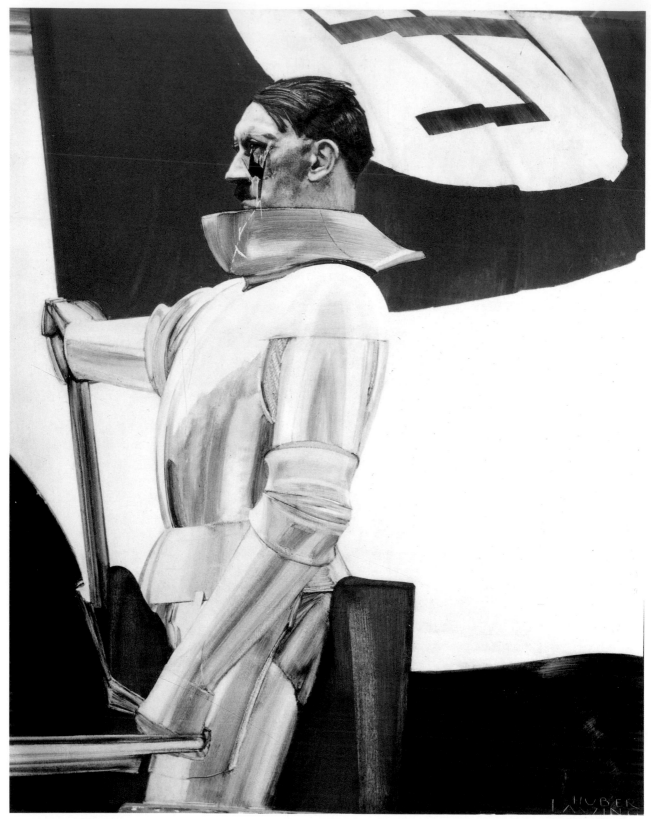

Hubert Lanzinger. The Flag Bearer

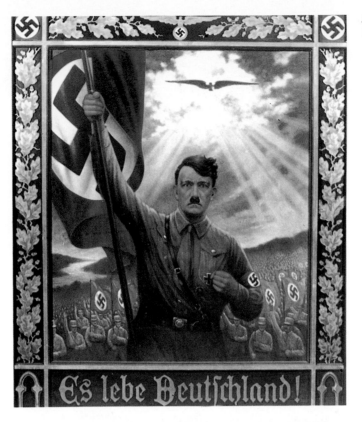

Es lebe Deutschland!

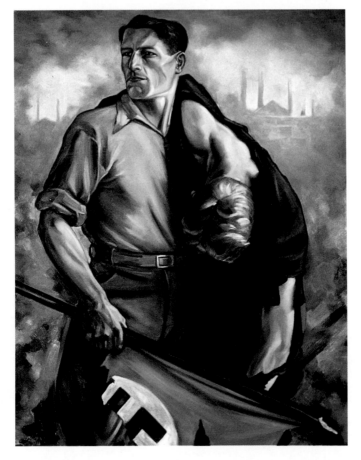

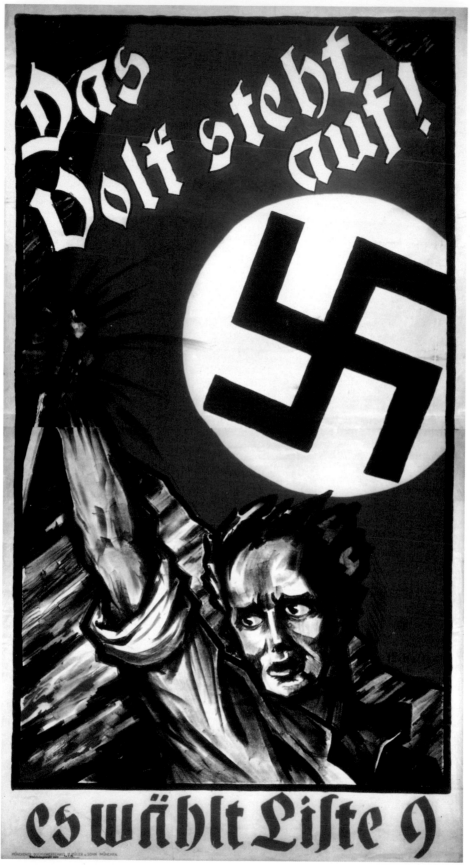

H. Schultes. "The Nation Rises! Vote for List 9." 1930. Poster

bind people together and educate them. It all looked so civilized!

The call to what is best in people in an increasingly materialistic world appealed to a nation that held culture and moral attitudes in high regard, and Hitler was the artist and the protector of the arts. He himself never ceased to propagate his image as the architect and the artist. After centuries of darkness the new German art was seen as a great Renaissance, and the man responsible for it was Adolf Hitler. "Now the whole nation walks again united and relentlessly into the light.

Soldiers. *Cover of a National Socialist coloring book for children*

Where did this light come from? It came from the depths of the German people, from the older generations, from the peasants, whose blood is still linked to the soil. . . . But most of all, the light came from one man, a man who kept his soul pure, who has not been corrupted by wrong education and culture, as millions among us have; the light came from Adolf Hitler," wrote Robert Böttcher, the president of the Art Teachers' Association.[21]

Through cultural changes Hitler wanted to create the new man. "The new age of today is at work on a new human type. Men and women are to be more healthy, stronger: there is a new feeling of life, a new joy in life. Never was humanity in its external appearance and in its frame of mind nearer to the ancient world than it is today."[22] Walter Benjamin wrote: "Fascism is the aestheticizing of politics." The central role of art in German politics made it attractive to many people. It gave it a false human face. People closed their eyes to the more horrendous side of the regime and wallowed in the artistic window dressing: a bloodless takeover of a nation's entire culture. "He who would win the great

masses must know the key which opens the door to their hearts," Hitler wrote in *Mein Kampf.* "Its name is not objectivity, that is, weakness, but will power and strength. One can only succeed in winning the soul of a people if, apart from positive fighting for one's own aims, one also destroys at the same time the supporter of the contrary."[23]

National Socialist doctrine lived in almost every painting, film, stamp, and public building, in the toys of the children, in people's houses, in tales and costumes, in the layout of villages, in the songs and poems taught in schools, even in household goods. The cultural infiltration of every sphere of life never ceased. Sometimes subtle, working on the subconscious, sometimes crude, working on fear. It never stopped until it brainwashed almost the whole nation. "The most striking success of the revolution of a view of life will always be won whenever the new view of life is, if possible, taught to all people, and, if necessary, is later forced upon them. . . . In every really great revolutionary movement propaganda will first have to spread the idea of this movement . . . the more quickly, the more intensively propaganda is carried out . . . the better, the stronger, and the more vigorous the organization is that stands behind it."[24]

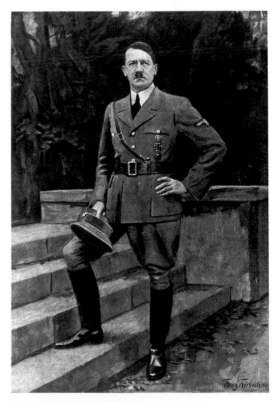

Franz Triebsch. The Führer. *1941*

CHAPTER 1 THE NORDIC NATIONAL IDEO

THE HIGH CULTURES OF THE INDIANS, PERSIANS, GREEKS, AND ROMANS WERE INDO-GERMANIC CREATIONS. THEY UNMISTAKABLY SHOW NORDIC CREATIVITY. . . . EVEN TODAY WE FEEL AN AFFINITY WITH THOSE CULTURES OF THE SAME RACIAL ORIGIN. PEOPLE OF OTHER RACES ALSO CREATED CULTURES, BUT WHEN WE APPROACH THE CULTURE OF ANCIENT CHINA, OF BABYLON, OF THE AZTECS AND THE INCAS, WE FEEL SOMETHING DIFFERENT. THEY TOO ARE HIGH CULTURES BUT THEY ARE ALIEN TO US. THEY ARE NOT OF OUR RACE; THEY TRANSMIT A DIFFERENT SPIRIT. THEY HAVE NEVER REACHED THE SAME HEIGHTS AS THOSE CREATED BY THE NORDIC SPIRIT.

—SS (Internal Security Force) Training Manual[1]

MYTH: SOCIALIST LOGY

"Nordic" became a key word in the National Socialist theory of art. But Nordic did not mean only northern Europe. The pyramids of Egypt, the temples of Greece, the German cathedrals were all appropriated. In the eyes of the Nazis, these monuments were the carriers of a spiritual content, determined by the same blood. "*Blut*" (blood) was another key word forever reiterated. This Germanic blood was supposed to be visible in all German works of art. "We have no doubt that cultural creative work, since it is the most sensitive expression of a talent conditioned by blood, cannot be understood, far less appreciated, by individuals or races who are not of the same or related blood."[2]

In an essay on Romain Rolland and the German intellect, a contemporary writer tried to define what is meant by the German "*Geist*" (spirit):

We can find the Germanic spirit everywhere that people of the same blood, Nordic blood, live. This kinship embraces not only the Edda and the Nordic sagas but also the profound wisdom of the ancient Indians, the Persians, as well as the works of classical Greece. . . . The gigantic works of a Luther, Kant, Fichte, Dürer, Goethe, Schiller, Beethoven, Mozart, of a Frederick II, Bismarck, and Hitler, to mention only a few names out of the large number

of great German intellectuals who have all lifted what is Germanic into what is German [Germanentum in Deutschtum]. . . .

> *What do we call "Germanic"? It is the emanation of the soul, the Nordic myth, the belief in the "starry sky above us and the eternal law within us" [quotation from* Fidelio—P. A.]. *"Germanic" means the highest moral values, the profound knowledge of a tragic destiny, and the cheerful affirmation of a renaissance. To be "Germanic" means plunging into one's soul, listening to the inner voice.[3]*

Germany's descent into Fascism had begun long before Hitler came to power. The belief in the Nordic myth and in the superiority of the German race was not new. There was a whole tradition of thought on which Hitler could base his anti-intellectual chauvinistic ideas. "What is German? It must be something wonderful, for it is more beautiful than anything else," wrote Richard Wagner in a letter to Friedrich Nietzsche.

Here too the ground for Hitler was well prepared. In 1912 the writer Hermann Burte, who would figure large in the Third Reich, published *Wiltfeber der Ewige Deutsche* (Wiltfeber, the Eternal German). The novel's hero went to search for his German roots and built a Utopian world based on peasant life, close to the German soil. The novel was a wide popular success.

Associations that fostered a Germanic Utopia flourished. In 1923 the publicist Willibald Hentschel proposed a racially pure Germanic colony named "Mitgart" after a legendary Aryan site. Mitgart was to become a breeding place where selected heroes would fertilize selected maidens in order to produce an elite race. Hentschel, born in 1858, lived long enough to see himself highly honored by the Nazis. An organization called Artemanen sought to revive the strength of the peasants and the idea of the nobility and purity of peasant blood.

The magazine *Die Sonne, Monatsschrift für Nordische Weltanschauung und Lebensgestaltung* (The Sun, Monthly of Nordic Philosophy and Way of Living), which was published in the twenties, regularly featured articles on art and race. For them, Michelangelo's figures, Nietzsche's superman, and Goethe's Faust were giants with Nordic souls, able to fight any Oriental or Roman influence.

The National Socialists thought that their art would transcend history. "True art is and remains eternal," Hitler claimed. "It does not follow the law of fashion; its effect is that of a revelation arising from the depths of the essential character of a people."[4]

Sepp Hilz. The Red Necklace

Opposite:
Still from Leni Riefenstahl's film Olympia—Feast of the Nations. *1936*
"THE NORDIC ARTIST WAS ALWAYS INSPIRED BY AN IDEAL OF BEAUTY. THIS IS NOWHERE MORE EVIDENT THAN IN HELLAS'S POWERFUL, NATURAL IDEAL OF BEAUTY."—ALFRED ROSENBERG

Hitler continually stressed the link with the past. "It is the mark of the really gifted artist that he can express new thoughts with words that have already been coined; in order that they have a lasting timeless significance, they must possess eternal values [*Ewigkeitswert*]." Everything that smacked of Germanic or Nordic values was dragged out and used in the rewriting of history. The wars of the Nibelungen, the Holy Wars, the Reformation, were all battles for the German spirit, and Hitler saw himself as the standard-bearer of the present crusade (see illustration page

EIN ACHTES KANN ICH/ACHTET DAS VOLK ES/ NÜTZT ES IHM IN DER NOT: WO HADER UND HASS DIE HELDEN ERREGT/SCHLICHTE ICH SICHER UND SCHNELL· EDDA

Ernst Dombrowski.
Henry the Lion
". . . IF THE PEOPLE RESPECT IT/ IT WILL BE VALUABLE IN TIME OF NEED: WHERE DISCORD AND HATRED INFLAME THE HEROES/ I RESOLVE IT SAFELY AND SWIFTLY."
—EDDA

Right:
Jürgen Wegener. German Youth. *Detail*

18). Dürer and Holbein, old folk dances and customs, were incorporated into their cultural vocabulary. The appropriation of the great names of the past played an important role in National Socialist doctrine. They guaranteed continuity and made the regime legitimate.

Everything was designed to lend authority to the new system and give it a spurious eternal value. Alfred Rosenberg, the most notorious Nazi theorist, had claimed that "from Aryan India came metaphysics, from classical Greece beauty, from Rome the discipline of statesmanship, and from Germania the world, the highest and most shining example of mankind."[5]

It did not end there. As ancient Greece was interpreted as a flowering of Aryan culture, so were the Romantics, for they too had looked to Greece and to the Middle Ages for inspiration and guidance. Some of the National Socialists, however, rejected the Gothic. Rosenberg and the painter and architect Paul Schultze-Naumburg considered it decadent, a Jewish-Christian culture. Hitler's architectural favorites were Friedrich Gilly and Karl Friedrich Schinkel, the nineteenth-century masters of Prussian classicism. They were seen as the noblest expression of German art, rooted in

roots was one of the favorite themes of the so-called national thinkers. The English-born political thinker Houston Stewart Chamberlain linked Rome with the Germans, and in a much-read novel by Felix Dahn, *Ein Kampf um Rom* (A Battle for Rome), written in 1867, the Germans were traced back to ancient Rome. Literature was widely used to spread the cult of the old Germans. In the beginning of this century the reading of the German sagas, the Nibelungen, and the Edda was constantly encouraged—a fashion which continued during the Third Reich. In 1934 a new College of Nor-

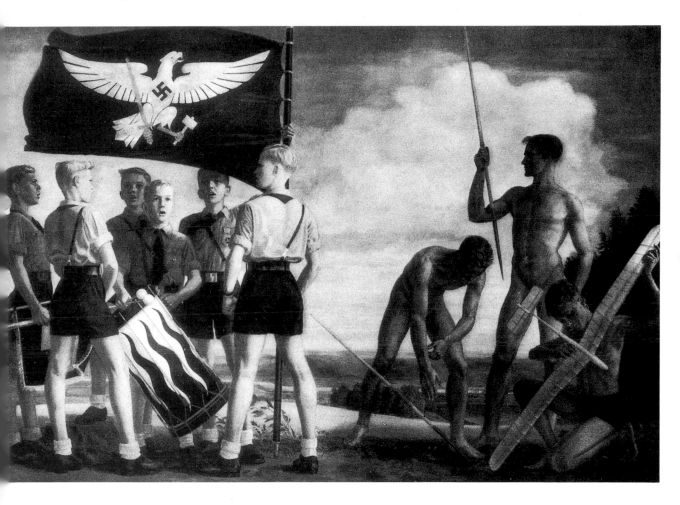

classical antiquity. In Hitler's mind, Schinkel's buildings, the Acropolis, and later Albert Speer's Reichskanzlei (Reich Chancellery) were to form a seamless tradition. But the National Socialists did not enthrone all of Schinkel's work; they chose only what suited them. As among the nineteenth-century paintings they had picked the genre scenes, they concentrated on Schinkel's Neoclassical work, ignoring his neo-Gothic designs.

The celebration of a glorious German past was one of the many ideas the National Socialists borrowed from the nineteenth century. The return to Germanic

dic Art (Nordische Kunsthochschule) was opened in Bremen.

The idea of the *Volk*, too, had long been a cherished notion. The enormous social, geographical, and political changes that had taken place in Europe in the preceding century had alienated individuals and made them feel increasingly isolated from each other. Industrialization had cut them off from nature. To bind people again in a volkish unity and to restore the link with nature had been a dream since the days of the Romantic movement. Bismarck's unification of Germany was seen by many as a mere political step.

Wilhelm Dohme. Bulwark
Against the East

Wilhelm Dohme. Peasants
Presenting Harvest Gifts of
Gratitude to Henry the Lion

Spiritually and culturally the Germans still felt dis-
united, ready to listen to any prophets promising
unity. The idea of a great German *Volk* found receptive
ears even among intellectuals, but especially among
the youth, who by tradition had radical leanings to the
left or right. By the beginning of this century the volk-
ish idea was well established in Germany; Hitler only
had to absorb it into his philosophy. But it was Hitler
who created the mythos of the German *Volk*, the
mythos able to embody the longing of all those who
had looked for consensus and unification. And the arts
played a major part in creating this mythos of the
dawn of a new German culture and civilization.

The struggle between modernists and traditionalists,
too, had begun long before it became one of the cen-
tral themes of Nazi art theory. "The Germans have a
mission for all nations on earth," wrote Paul de
Lagarde in 1866. Powerful organizations with several
hundred thousand members, like the Dürerbund (Dürer
League) on the left and the Alldeutsche Verband (Pan-
German League) on the right, fought bitter ideological
battles. "We belong to the master race. . . . Germany,
awake!" was the fighting call of the Pan-German
League in 1890.

The painter Fritz Erler, whose work would later fea-
ture heavily in National Socialist exhibitions, had in
1899 founded an artists' association, Die Scholle (The
Sod). A popular art magazine, *Der Kunstwart* (The
Guardian of Art), edited by Ferdinand Avenarius, ap-
peared in 1904. They shared the call for more idealized

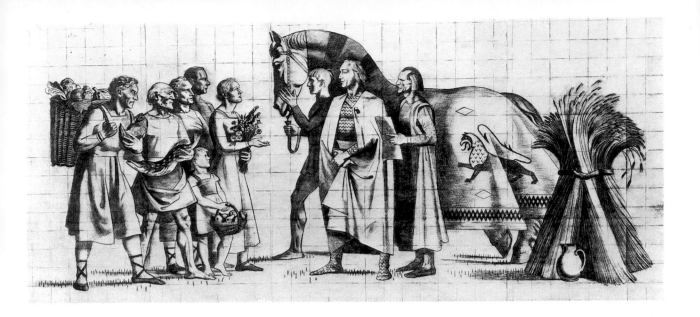

art forms in which beauty and noble feelings prevailed.

The first writer to use the word "degenerate" in connection with art was Max Nordau in 1893, in a novel called *Entartung* (Degeneration). Julius Langbehn, author of *Rembrandt als Erzieher* (Rembrandt as Educator; 1890) and, with M. Nissen, of *Dürer als Führer* (Dürer as Leader; 1928), and Houston Stewart Chamberlain based their writings on racial ideas.

The early 1900s had seen a great flowering of the arts. This was the beginning of what most people call modern art. Painting, writing, and music all followed a trend toward introspection and a search for truth rather than beauty in the traditional sense. Human suffering in an increasingly dehumanized world became a major theme. Many people were antagonized by an art growing out of what was often associated with German *Angst* (anxiety). In 1911 the painter Carl Vinnen published a manifesto protesting against the "Modernists." It was signed by 134 artists.

Of course the modernists fought back. Magazines like Herwarth Walden's *Der Sturm* (The Storm; 1910–32) spoke up for modern art. In 1919 the National Gallery in Berlin opened an extensive modern section which included not only the work of the painters of the Brücke (Bridge) and the Blaue Reiter (Blue Rider) groups but also works by Braque and Picasso.

Because of the national shame that resulted from the Treaty of Versailles at the end of the First World War, many people turned against anything foreign or liberal. With the arrival of the Impressionists, the history of art had been largely rewritten. Modern art came as a shock to most people—especially in the south of Germany, which still basked in a wholesome Biedermeier world and provincial coziness. The modern painters were not widely established and were really known only in the big cities. While the intellectuals embraced all sorts of artistic experiments, many others felt that art was getting further and further away from ordinary people. Art increasingly needed a commentary and it had to be explained, not just looked at and enjoyed. It had become elitist. To a nature-loving and, for the most part, provincial people who longed for the good old days, modern art, modern architecture, and the by-products of decadent big-city life were disturbing. The urban bourgeoisie was considered antisocial, in love with new machines, misled by foreign ideas, and obsessed with money. All this smacked of revolution and of the destruction of the old order. Society needed to defend old values against any kind of further revolution. Right-wing political groups exploited these widespread fears. The calls for a ruling hand to bring order became louder—and Hitler was ready (see illustration page 19).

Even before the First World War, Paul Schultze-Naumburg was critical of the decadent art produced in the cities, and pleaded for a pastoral style, such as that favored in southern Germany. In his writing, racially based art theories, anti-Semitism, and the Blood and Soil ideology were closely linked. It is hard to

Birthday Celebration,
Westerwald. *1924/28.*
Photograph August Sander

Wealthy Farmer. *ca. 1925.*
Photograph August Sander

Lawyer Dr. Quinke, Cologne.
1924. Photograph August Sander

imagine to what extent the obsession with race affected people. It led Schultze-Naumburg, in his zeal, to spot Oriental traits in Lucas Cranach: "Cranach is instructive; mongoloid traits are frequent. . . . We cannot determine Cranach's blood, but we can be certain that besides his Nordic elements, there must be some from the Asian race."[6]

Many of Hitler's theories on art, especially his habit of locating Aryan art in classical Greece and in the Middle Ages, came from Schultze-Naumburg, who saw in these precursors

high intelligence, inventiveness and civic virtues. . . . Art needs a different soil from the acre fertilized by the dung of international artistic research. The art of the nineteenth century, when people did not live under a unifying idea, lacked the cheerful affirmation of our present time. . . . This affirmation fills the whole population with a new, and universally felt, meaning. This has become the Myth of the Twentieth Century. . . . With the rebirth of a new volkish state grows the possibility of a new, truthful art, rooted in the German people.[7]

The failure of German art was seen as a failure of the German soul. "We must ask why did German art falter? Why did Germany break up? . . . There are a hundred things that precipitated the fall, but the ultimate reason for the poisoning lies in the rape of the German soul," wrote Robert Böttcher.[8]

Books, pamphlets, and associations promised to get rid of foreign influence and to bring forth a German culture with German standards based on the discipline and order of earlier centuries.

In 1920, in her apartment in Dresden, the painter Bettina Feistl-Rohmeder formed an art group called the Deutsche Kunstgesellschaft (German Art Society), patterned along the lines of Schultze-Naumburg's theories. Only artists of German blood were admitted. It published two magazines: *Deutsche Kunstbericht* (German Art Report) and *Deutsche Bildkunst* (German Sculpture). The German Romantics were their model, and they turned against what they saw as "the horrible deformed bodies found in modern art." Words like "Nordic," "German," "heroic," "rustic," "noble"—all qualities which National Socialist ideology claimed as particularly German—were widely used.

The works of Gauguin and Matisse were labeled nonart. Gallery and museum directors who favored modern artists were attacked, and the Weissenhof Siedlung (a model housing development erected in Stuttgart in 1927) with buildings by Ludwig Mies van der Rohe, Le Corbusier, and other modern architects provoked a barrage of protests. "Oriental flat roofs were replacing gabled homes," wrote Schultze-Naumburg, voicing an anxiety that found much sup-

Arab Village. *Spoof of the Weissenhof housing complex, Stuttgart, 1927*

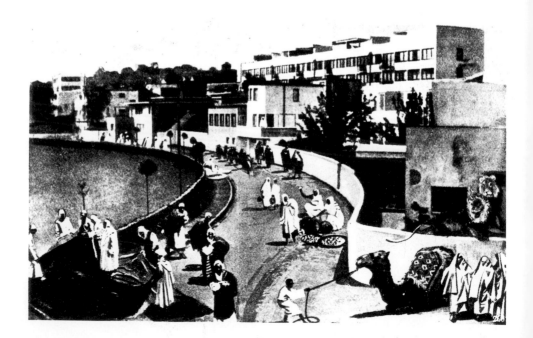

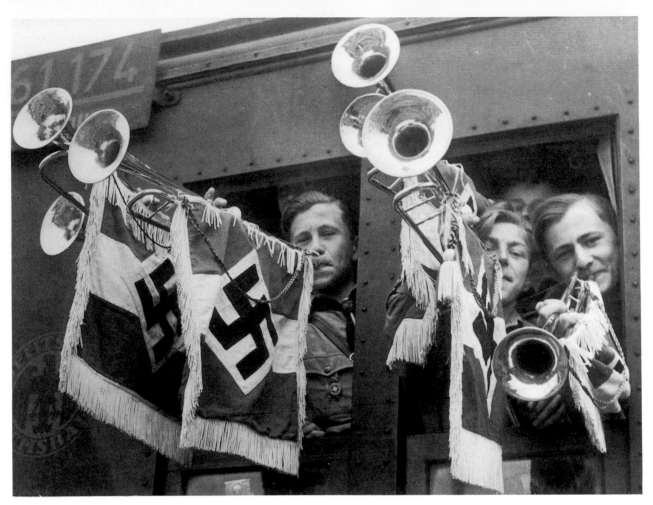

Hitler Youth

port also among architects. Feistl-Rohmeder continued her tirades of hatred throughout Hitler's regime. In 1938, she wrote a book called *Im Terror des Kunstbolschewismus* (In the Terror of Art Bolshevism).

Manifestos "Against Negro Culture, For a German Heritage" appeared as early as 1930. In the region of Thuringia, Erwin Piscator's famous Berlin Theater Group was not allowed to perform, and films by Sergei Eisenstein, as well as Georg Wilhelm Pabst's *Three-penny Opera* (1931), were banned.

Alfred Rosenberg, an architect by training, also formulated many of the ideas that served as the basis of National Socialist ideology. His book *Der Mythos des 20. Jahrhunderts* (Myth of the Twentieth Century), published in 1933, with its defense of the concept of blood and soil, made him the Party's ideological spokesman. "In order to create a contrast to the blond infanta, Veláz-

quez paints a midget next to her, one of those bastard types Spain is so full of. . . . Gauguin looked for his ideal of beauty in the South Seas . . . [in] girl friends of a black race. . . . He too is torn apart and rotting away, like all of those who searched the world for a lost beauty."[9]

In August 1927, Rosenberg founded his National Socialist Society for German Culture. It became in 1928–29 the Kampfbund für deutsche Kultur (League for the Defense of German Culture). The aim of this organization was to halt the corruption of art and to inform the people about the relationship between race and artistic values. The moral foundation of art had to be a heroic one. Rosenberg asserted that the destruction of art was begun by the Impressionists and continued by the Expressionists. "This alien Syrian-Jewish plant has to be pulled out by its roots," he wrote.

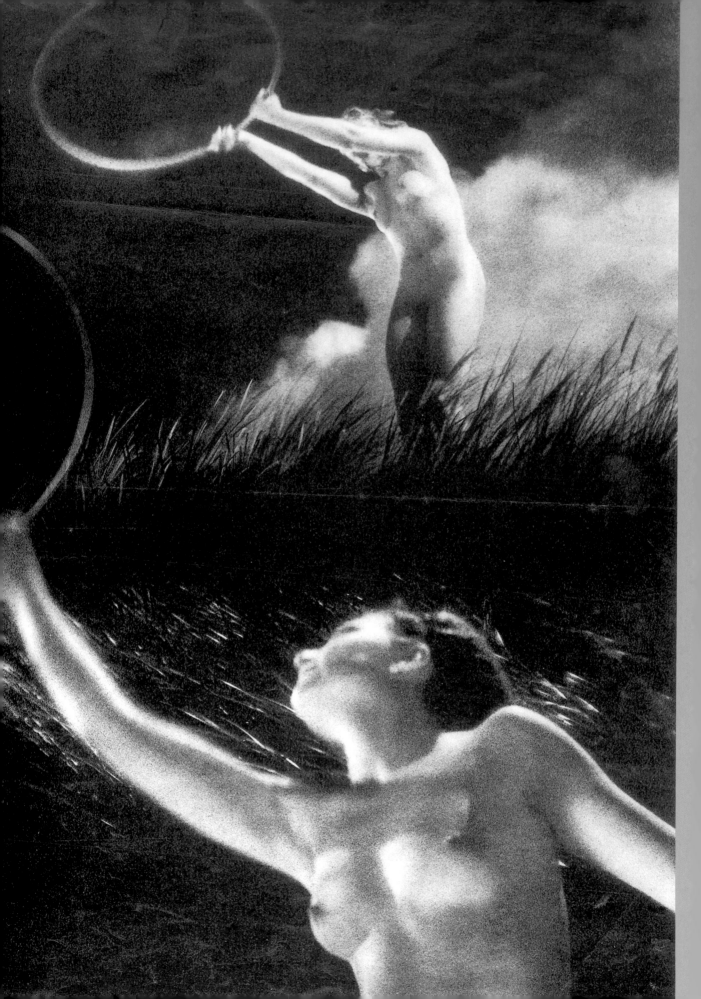

The National Socialists' constant call for a return to nature and to simpler forms and materials was also not new. An antiurban pastoral feeling had flowered long before Hitler made it one of the recurrent elements of his ideology. Hordes of young men hiked through the countryside singing German *Volkslieder* and being moved by German myths that embraced the good and the heroic. The German Jugendbewegung, the Wandervögel (the youth movement, the Wandering Birds—a poetic version of the Boy Scout movement), was immensely popular. No other country had such a widely organized youth movement. Formed in 1901 in Berlin by Karl Fischler, it spread quickly throughout the entire country. By 1911 it had 15,000 members. However varied in origins and aims, the loyalty to the concept of a *Volk*, to tradition, to the love of nature was a unifying factor. Not primarily a political movement, it was nevertheless the seed for Hitler's harvest of almost an entire generation. The ideological basis was the formation of the individual into a member of the group. The youth movement and what it stood for were celebrated in almost pseudo-religious hymns by poets like Walter Flex. His words and thoughts were later absorbed by the Reichsjugendführer (Reich Youth Leader), Baldur von Schirach, in his songs for the Nazi Youth Movement.

Terms like "Jewish," "degenerate," "Bolshevik" were widely used before 1933 to describe almost everything that was considered modern. This included not only politically motivated leftist artists like Käthe Kollwitz, Ernst Barlach, and George Grosz, but most of the artists who were at the center of the international art scene.

As it attacked modern painting, the Kampfbund für deutsche Kultur also attacked the work of the leading modern architects: Bruno Taut, Peter Behrens, Ludwig Mies van der Rohe, Walter Gropius, Heinrich Tessenow, Erich Mendelsohn, and others.

Opposite:
Still from Leni Riefenstahl's film
Olympia—Feast of the
Nations. *1936*

Still from Wilhelm Prager's film
Ways to Strength and Beauty.
1924–25

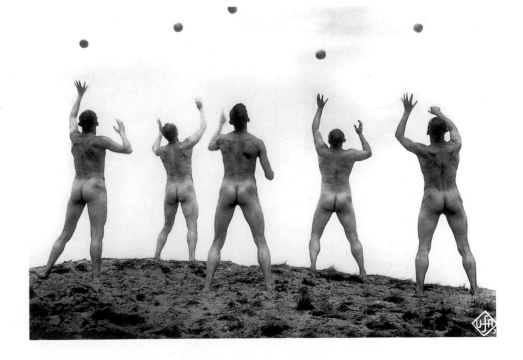

Hanns Bastanier. First
Snow Cloud
"THIS IS GERMANY, HAIL
GERMANY FROM THE
DEPTHS OF YOUR HEART."
—WILHELM WESTEKER

Dance as a messianic happening that embraced the cult of the naked body and rhythmic movements was very popular in the early part of this century. Nude bathing became one of the favorite pastimes, and *Freibäder* (nude bathing establishments) blossomed. The ideas of Turnvater Jahn (Gymnast-Father Jahn, Friedrich Ludwig Jahn), who at the beginning of the nineteenth century had founded the German Gymnastic Association, were widely propagated. The healthy Aryan body was seen as a bastion against Latin, Asian, or other foreign influx. Magazines like *Kraft und Schönheit* (Strength and Beauty) or *Die Schönheit* (Beauty) were full of a missionary belief in the renewal of spiritual values by divesting oneself of clothes and fusing one's naked body with nature. Paintings and photographs celebrated the naked body in ecstatic poses. Finally, in 1929 a mass congress under the title "Nacktheit und Erziehung" (Nakedness and Education) was organized. Its aim was to fuse all the various sects into one great mass movement.

A new feeling for the body emerged. Gymnastics, dance, fashion, the nudist movement all began to discover and to celebrate the body. The schools of Rudolf Steiner and Emile Jaques-Dalcroze propagated the collective dream of a healthy, natural human being. The productions of Max Reinhardt, the dances of Isadora Duncan and Mary Wigman were seen as a liberation of the body in a kind of ecstatic union with nature. At the turn of the century, painters like Fidus (*nom de plume* of Hugo Höppener) promoted an art that featured nudes reaching out to the sun, the sun being the giver of life. Just the kind of imagery the National Socialists would adopt.

Art has always been central to German life. To uphold traditional values, as represented by Goethe, Beethoven, and the other "greats" of Germany's past was of concern to the whole nation. Humanistic culture was a key concept for the very large and well-educated middle class. "Art is what elevates; it does not descend to the gutter," Kaiser Wilhelm II had said in words Hitler might have used. The idea of a healthy, broadly accepted culture, based on national, folk, and even racial ideas, corresponded to what many people felt. The call for a return to order sounded with almost hysterical intensity. Some of it matched the future tirades of the National Socialists.

Modern art had only a handful of defenders and many adversaries. The Weimar Republic was a melting pot that held many divergent ideas. The issues debated were diverse and often contradictory. There

seemed to be an impending crisis that must at all costs be avoided. In Hans Arp and El Lissitzky's book *Die Kunstismen / Les Ismes de l'Art / The Isms of Art*, published in 1925, no fewer than sixteen different movements are mentioned. A flood of new styles threatened the established view of art and of society. The constant artistic changes were anathema to bourgeois taste, which demanded permanence and reassurance from its art. It was on this desire that the National Socialists built their art theory. Modern art for them was the spiritual sellout of national values by decadent artists. In their cultural speeches Goebbels and Hitler stressed the fact that the increasing variety of movements and styles was the product of a greedy Jewish Bolshevik clique. Modern art was the villain; it stood for decadence, internationalism, Jewishness, homosexuality, Bolshevism, big-city capitalism. "So long as the characteristic features of the great cities of our day, the outstanding points that catch our eyes, are warehouses, bazaars, hotels, offices in the form of skyscrapers, etc., there can be no talk of art or any real culture," Hitler said.[10]

In total contrast to the permanence of true German art, modern art was short-lived because it was obsessed with fashion. Art was in the hands of international dealers. It was primarily commercial. So charged the National Socialists. And they took good care to tack labels like "capitalism" and "inflationary prices" onto modern art. For many Germans, having just overcome the most horrendous inflation in their history and with unemployment topping six million, this was precisely what they wanted to hear. Hardship in the cities was extraordinary. It was an easy task to represent the city as sterile and chaotic. The country seemed a wholesome and fertile paradise which appealed to those living in the dingy courtyards of the towns, who had no prospect of work and no hope.

Realistic painters working in the nineteenth-century tradition also felt they were losing out against the modernists, who were stealing the headlines and getting high prices in the international markets. Now their time had come. They jumped at the opportunity. "German art! What a wonderful world opens when I hear these words!" wrote the painter and sculptor Hanns Bastanier in 1935. "During the last fourteen years, most of what has been offered, collected, recognized, fostered as German art is not German art. It is international, like its creators, not German. While these works were the favorite children of museums . . . German art sat, in the clothes of a beggar, like a German

Cinderella on the side of the road. Mocked by international experts, it survived through the charity of the people."[11]

Many did not realize that the discussion about representational art and abstract art had become a political one. Some thought that it was merely an aesthetic debate. Some of the established but neglected artists saw themselves becoming the guardians of culture. And the National Socialists stirred up feelings of revenge. Anti-Semitic feelings were whipped up by constantly stressing that in the arts the Jews were in power. Existing conflicts within professional groups were exploited in the worlds of theater, film, music, and the visual arts. Here, too, Hitler cashed in on the atmosphere of jealousy and philistinism. It was an easy task to fuel antagonism. Racial prejudices were widespread. The eminent historian Werner Sombart linked capitalism with Jewishness in his influential book *Die Juden und das Wirtschaftsleben* (The Jews and the Economy), published in 1910. His ideas were quickly picked up by others. Literature too spoke of violation of the German race through the Jews. Artur Dinter's *Die Sünde wider das Blut* (The Sin Against Blood), published in 1918, was immensely popular and was brought out in large editions.

"The Jewish influence on the general public was disastrous," wrote the architect Julius Schulte-Frohlinde about the Weimar Republic, voicing the racial prejudices of many. "Newspapers, architectural books, and magazines were contaminated by this spirit. They confused even those who wanted good things. The phraseology of the Neue Sachlichkeit [New Realism] triumphed. The inventors of this soulless international fashion were Jews and Marxists, who could not and will never understand the German soul."[12]

The first inkling of the barbarism to come could be felt with the destruction of Oskar Schlemmer's frescoes in the stairwell of the Bauhaus in Dessau in October 1930. At the same time seventy works of modern art by Paul Klee, Emil Nolde, Oskar Kokoschka, Lyonel Feininger, and others were taken from the Schlossmuseum in Weimar. But many interpreted these actions as merely provincial philistinism. Few saw the writing on the wall.

The circles that supported Hitler, and they included much of the educated middle class, were totally mistaken when they thought that the new regime would bring back the good old days and restore the old feudal system by encouraging thatched roofs, folk dances, celebrations of winter solstices, and swastikas. Hitler's *Mein Kampf* had laid down the rules of what he considered degenerate, what was acceptable, and what was not. But few people had read it.

At the beginning of the Hitler regime there were no direct guidelines about the look of the new German art, only some vague ideas about volkishness and Teutonic values. What the policymakers did know, however, was what the new German art should not include.

CHAPTER 2 THE RING

A BOOK WAS WRITTEN, NOT POETRY IN A LOW
COMMON SENSE, AND YET A POEM, A VIEW OF
A NEW PEOPLE IN A NEW STATE! THE MAN WHO
WROTE IT IS CALLED ADOLF HITLER! . . . THE GREAT
STATESMAN OF THE GERMANS IS A KIND OF POET. . . .
A PROSE COMES INTO BEING WITH A SURGING
QUALITY UNIQUELY ITS OWN, A MARCH-LIKE STEP,
WITH TENSIONS AND PROJECTIONS OF THAT ATTITUDE
WHICH NIETZSCHE HAD IN MIND WHEN HE SAID: "I LOVE
HIM WHO HURLS FORTH THE GREAT WORD OF HIS DEED,
SINCE HE WILLS HIS FALL." . . . IF FREDERICK THE GREAT,
THE FAR-SIGHTED MONARCH, THE FRIEND AND PUPIL OF THE
RATIONALIST VOLTAIRE, COULD FRUCTIFY POETRY THROUGH
HIS DEEDS, ALL THE MORE SO CAN ADOLF HITLER, THE SON OF
THE PEOPLE, RISEN FROM ITS POWERFUL DEPTHS, STEELED BY SUFFERING
AND PRIVATION, FAMILIAR WITH ALL THAT IS HUMAN, A VOLUNTEER
SOLDIER IN THE WORLD WAR, . . . DESIGNATED BY THE NORNS AS ELECT.
—Hermann Burte in a speech to the poets of the Greater German Reich in 1940[1]

MASTERS

Although Adolf Hitler
always considered Linz, where he spent most of his
childhood, his hometown, he was born on April 20, 1889,
in Braunau in Austria. From an early age he had vowed
to dedicate his "life wholly to art." He had a talent for
painting and drawing and as a young man never tired of
sketching theater buildings, museums, even a bridge for
the town of Linz. Several of these plans were later realized

It has been noted that Hitler's anti-Semitism and his
suspicion of anything modern were well developed
from his early youth on. Many people have tried to ex-
plain Hitler's hatred of intellectuals and of modern art
by the fact that he failed to pass the entrance exam-
ination of the Vienna Academy in 1907. This failure
has often been exaggerated. The myth of the artist re-
jected by the decadent bourgeois art establishment
suited his image, and he never ceased to propagate it
himself. In fact 85 of his 113 fellow art students also
failed the entrance examination. But the verdict of the
academy—"Sample drawing: unsatisfactory"—was cer-
tainly a big blow to him. He later wrote it was "like a
glaring flash of lightning." He tried to study architec-
ture and was again told that he lacked the necessary
qualifications. He also failed in a painting class. As he
later wrote in *Mein Kampf*: "By all reasonable judg-

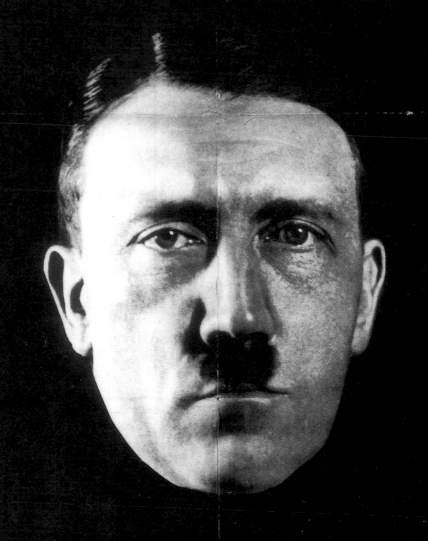

HİTLER

ment, the fulfillment of my dreams of being an artist was no longer possible."

Hitler was self-educated and his attitude toward art and his judgments about it had the hallmark of the self-taught. As a student in Vienna he developed the roots of what became the aesthetic principles of the Third Reich. From the start his approach to art was totally conventional and full of prejudice. He acquired attitudes he would never change. It was a catastrophic combination of political motives with very narrow, intensely felt aesthetic concepts. They would mark the arts policies of the Third Reich.

Hitler loved the nineteenth century, especially the works of the traditionalists Hans Makart, Anselm Feuerbach, and Ferdinand Waldmüller, but knew nothing of the innovators Egon Schiele and Gustav Klimt. Even as a young man eager to become an artist Hitler had no desire to explore anything new or unconventional. It was always the well-trodden path. He reveled in the Neoclassic facades of Vienna and endlessly sketched the Ringstrasse. He continually drew architectural subjects, but they show no influence from the new generation of Viennese architects, Josef Hoffmann, Otto Wagner, or Adolf Loos.

Hitler had always had a penchant for Munich, where he moved from Vienna. It is rather revealing of his conventional outlook that he chose provincial Munich rather than modern and sophisticated Berlin. But here too, as in Vienna, he ignored any new artistic trends. Wassily Kandinsky, Franz Marc, and Paul Klee all lived and worked in the bohemian Schwabing district at the same time as Hitler, but he joined those who branded their groups as exemplars of what would later be called "cultural Bolshevism," a label extensively used in National Socialist phraseology.

Hitler was very prolific in his artwork. According to his own account he made over 700 paintings in Vienna alone. The estimated number of his watercolors, oils, and drawings varies between 2,000 and 7,000.[2] Hitler himself liked particularly his early watercolors and oils, done from 1905 to 1908. He also attached some importance to the work done in the prison in Landsberg in 1923–24, while he was incarcerated for an abortive putsch. But except for his architectural drawings, he was never very proud of them. "My architectural sketches were my most prized possession, the fruit of my brain. I held onto them and never gave them away, as I did my pictures."

Hitler's artwork lacked originality but he was a competent copier and *pasticheur*. His early drawings were

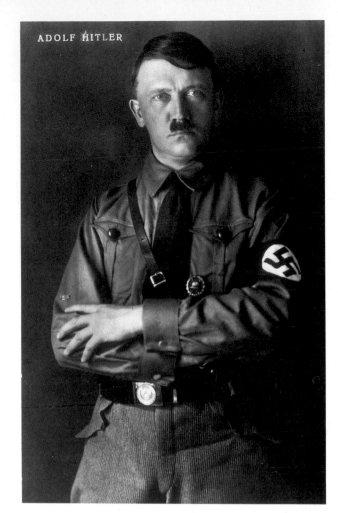

ADOLF HITLER

Adolf Hitler. *Postcard*

Opposite:
Hitler. *Poster*

already marked by his *folie de grandeur*. Among them were sketches for the triumphal arches and cupolas that his chosen architect, Albert Speer, later would attempt to build for him. His lifelong passion for architecture explains why he was more liberal in his attitudes toward that art form than toward any of the others. In contrast to the most extreme voices in the Party, who rattled on against the intellectualism of the Bauhaus School, Hitler did not share their total distaste for innovators like Walter Gropius and Le Corbusier, and he allowed modern trends to continue. As late as 1936, when the visual arts had already been cleaned up, one could still find articles featuring the work of Mies van der Rohe and Peter Behrens, who was named that year to head the architectural department of the Prussian Academy.

When Hitler was a student he frequently sold his work on the street, sometimes giving it to friends in return for favors. Their conventional style, their traditional themes, and their neat execution obviously appealed to many people who rejected anything modern. Later he managed to sell his work through some dealers in Vienna.

Hitler also made advertising prints and posters to keep himself going. His drawings included plans for tanks, battleships, and a stage set for *Tristan und Isolde*. He later designed the National Socialist flag, the SA (Storm Troopers) standard, and the masthead of the *Völkischer Beobachter* (The Volkish Observer), the official National Socialist newspaper. He also boasted that everything that made the Mercedes automobile beautiful was based on his ideals and that the Volkswagen Beetle was his design. Cutlery and furniture for the Reich Chancellery were also designed by him. From 1920 onward he replaced the word "artist" after his name with "writer." He read ferociously and tried his hand at writing a play.

The National Socialist Party (NSDAP) was the first to collect Hitler's work for its archive. Under Rudolf Hess, a "secret section" systematically recorded and authenticated and photographed all of Hitler's sketches, advertising designs, watercolors, and oil paintings. This archival activity was maintained until the beginning of the war.

In 1937 Hitler decreed that no one should write about his drawings and forbade any exhibitions. He probably realized that the quality of his art was incompatible with the vision he had of himself as the "artist-statesman." A few years later he banned the sale of his work abroad. It was eagerly sought after at home, how-

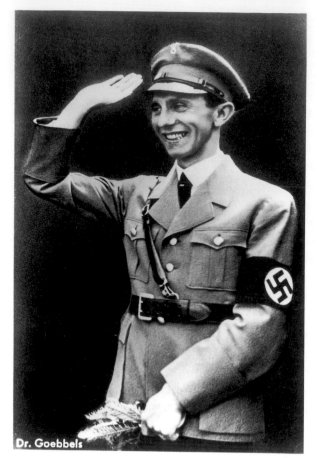

Dr. Goebbels

ever. There was a rumor that many of Hitler's paintings were destroyed on his order, but this has not been proved.

Considerable amounts of money were offered for a Hitler original; examples could be bought right through the war. One of the biggest collectors of Hitler's architectural drawings was Albert Speer.

Despite Hitler's order not to publish anything about his art work, there were some reproductions and reprints still in circulation. But on the whole, the general public knew little about them. Strangely enough, in 1936, the American magazine *Esquire* reproduced some of his work, and eight paintings were reproduced in *Collier's* magazine in 1938.

Hitler's drawings have been criticized for being totally amateurish, which is not true. But like his writing, they smacked of philistine neatness. Nevertheless, his knowledge of architecture and his skill in drawing deserve a certain respect. Of course, the praise they received during the National Socialist period was absurd:

This simple lance corporal and front fighter always worked also as an artist even between the bitter experiences of the bat-

tles. . . . His works are not a romantic rendering of the war, but a serious and moving monument. . . . He catches, with the eye of a German landscape painter, the foreign land, so that it becomes familiar. . . . In all the drawings one detects the born architect putting the Viennese Academy to shame. But most of all we recognize in all the details of his work honest, loving, and upright devotion to the whole.[3]

Hitler also had a great passion for music. He saw for himself a career which would combine the visual arts and music. He idolized Richard Wagner and Anton Bruckner, but totally ignored Gustav Mahler and Richard Strauss, and of course the modern Viennese School of Arnold Schoenberg, Anton Webern, and Alban Berg. As a young man, he went night after night to the opera and claimed to have seen *Tristan und Isolde* thirty-four times. His relationship with Wagner's music was of an almost psychotic nature. It is reported that he spoke about the "hysterical excitement" that overcame him when he recognized "the kinship with the great man." Wagner's ideas about blood brothership and his overt anti-Semitism found their way into Hitler's ideology.

"You artists live in great and happy times. Above you the most powerful and understanding patron. The Führer loves artists, because he is himself one. Under his blessed hand a Renaissance has begun. . . . Oh, century of artists! What a joy to be part of it!" proclaimed Dr. Joseph Goebbels,[4] the other ringmaster who dominated German art from 1933 to 1945.

Born in 1897, Joseph Paul Goebbels was the most cultured and intellectual of the National Socialist leaders. Goebbels had studied under the eminent Jewish professor of German literature Friedrich Gundolf. But he never belonged to the Gundolf circle, which included many followers of the poet Stefan George. Goebbels's association with Gundolf may have prompted his futile attempt to persuade George to return to Germany from Switzerland, where he had taken refuge in 1933.

Goebbels's ideas about race, about the godlike mission of the Führer, and his conviction that one must be ready to sacrifice one's life for one's country, were formulated long before he came to power. His early sentimental novel, *Michael: Ein deutsches Schicksal* (Michael: A German Destiny), published in 1928 by the National Socialist publisher Franz Eher, tells the story of the conversion of a young intellectual to National Socialism. It is full of jibes at "the Jews [who] are not like us, they have soiled the German race." In his essay "Thinker or Priest," Goebbels talks about the mission

of the German people: "We will be heroes and redeemers for a Reich that is to come." He cast the German people in the role of National Socialist Christians, with Hitler as the intermediary between man and God. The Jew was seen as the anti-Christ and Hitler therefore became the Christ figure. "Was he a man, half plebeian, half God? Is he Christ or only St. John?" Goebbels wrote in his diary.

Once Goebbels joined the National Socialists, he rose quickly in the hierarchy of the Party. He founded the daily newspaper *Der Angriff* (The Attack) in 1930. In his hands it became his first powerful tool of propaganda, attacking the liberal attitudes of the Weimar Republic. Two months after Hitler came to power, in March 1933, Goebbels was appointed Minister for People's Enlightenment and Propaganda. If Hitler saw himself as the architect of the nation, Goebbels saw himself as the writer. Like his Führer, he had come from a modest background and had failed to make a mark as a journalist or a writer. It was the Party that gave him the opportunity to work as a journalist.

Of course, there were many cliques trying to influence the arts policy of the Party, and the hierarchy abounded with intrigues. According to Albert Speer, Goebbels always looked down on the philistinism of his colleagues. Göring considered Goebbels a parvenu, and Heinrich Himmler, in his zeal for his SS (Internal Security Force), felt superior to them all. Of course, Hitler always had the last say.

Goebbels was totally under Hitler's control; even his speeches were edited and approved by Hitler. Goebbels had his own political and cultural ideas, but he modified them whenever Hitler intervened. He became more independent in propaganda and cultural matters once war was declared, Hitler being too preoccupied with his roles as the great commander and statesman.

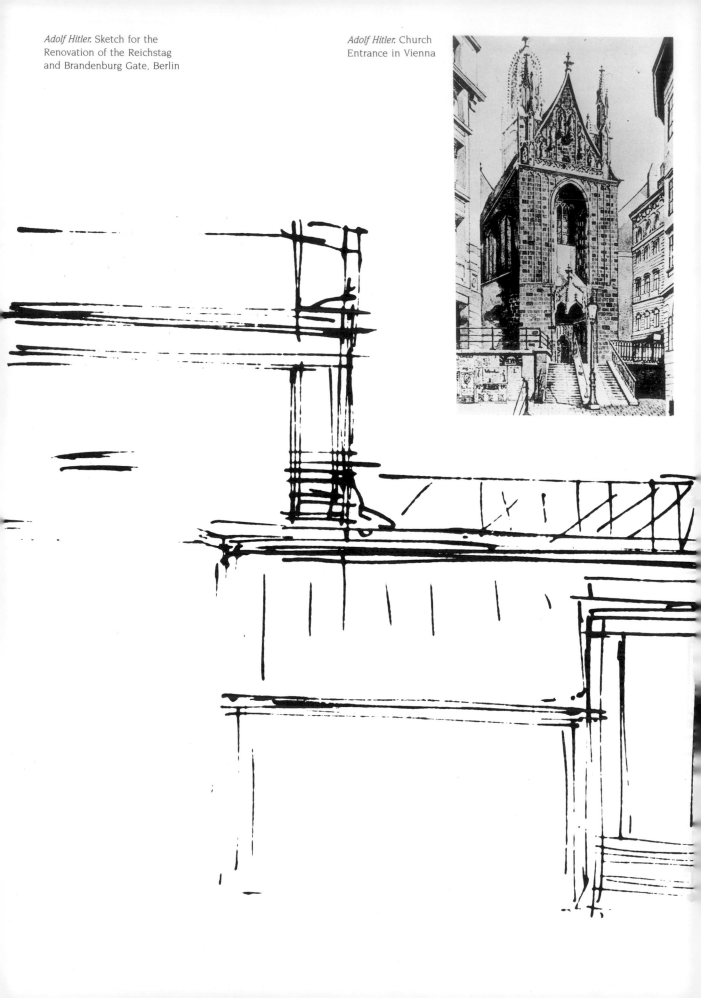

Adolf Hitler. Sketch for the
Renovation of the Reichstag
and Brandenburg Gate, Berlin

Adolf Hitler. Church
Entrance in Vienna

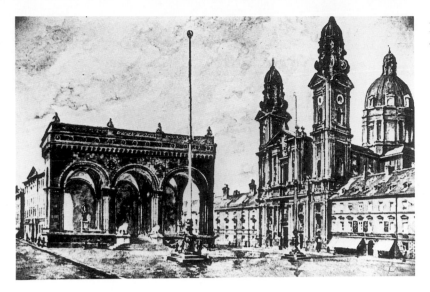

Adolf Hitler. Odeonsplatz with
the Feldherrenhalle and
Theatiner Church, Munich

THE NATIONALIZATION OF THE GREAT MASSES CAN NEVER TAKE PLACE BY WAY OF HALF MEASURES, BY A WEAK EMPHASIS UPON A SO-CALLED OBJECTIVE VIEWPOINT, BUT BY A RUTHLESS AND FANATICALLY ONE-SIDED ORIENTATION AS TO THE GOAL TO BE AIMED AT. . . . POISON IS ONLY CHECKED BY ANTIDOTE, AND ONLY THE INSIPIDITY OF A BOURGEOIS MIND CAN CONCEIVE THE MIDDLE LINE AS THE WAY TO HEAVEN. . . . THE NATIONALIZATION OF OUR MASSES WILL BE SUCCESSFUL IF, ALONG WITH ALL POSITIVE FIGHTING FOR THE SOUL OF OUR PEOPLE, ITS INTERNATIONAL POISONERS ARE EXTIRPATED. . . . IN THE BLOOD ALONE THERE RESTS THE STRENGTH AS WELL AS THE WEAKNESS OF MAN. AS LONG AS THE PEOPLE DO NOT RECOGNIZE AND PAY ATTENTION TO THE IMPORTANCE OF THEIR RACIAL FOUNDATION, THEY RESEMBLE PEOPLE WHO WOULD LIKE TO TEACH THE GREYHOUND'S QUALITIES TO POODLES, WITHOUT REALIZING THAT THE GREYHOUND'S SPEED AND THE POODLE'S DOCILITY ARE QUALITIES WHICH ARE NOT TAUGHT, BUT ARE PECULIAR TO THE RACE. PEOPLES WHO RENOUNCE THE PRESERVATION OF THEIR RACIAL PURITY RE-NOUNCE ALSO THE UNITY OF THEIR SOUL IN ALL ITS EXPRESSIONS. . . . THE RACE QUESTION NOT ONLY FURNISHES THE KEY TO WORLD HISTORY, BUT ALSO TO HUMAN CULTURE AS A WHOLE. —Adolf Hitler, Mein Kampf, 1925[1]

THOSE WHO ARE RESPONSIBLE FOR THE SHAPING OF PEOPLE'S ATTITUDES IN THE SPHERE OF POLITICS MUST ENDEAVOR TO DIRECT [THE PEOPLE'S] ARTISTIC FORCES—EVEN AT THE RISK OF RIGOROUS INTERVENTION. —Adolf Hitler, 1939[2]

CHAPTER 3 THE PRACTICE OF SOCIALIST

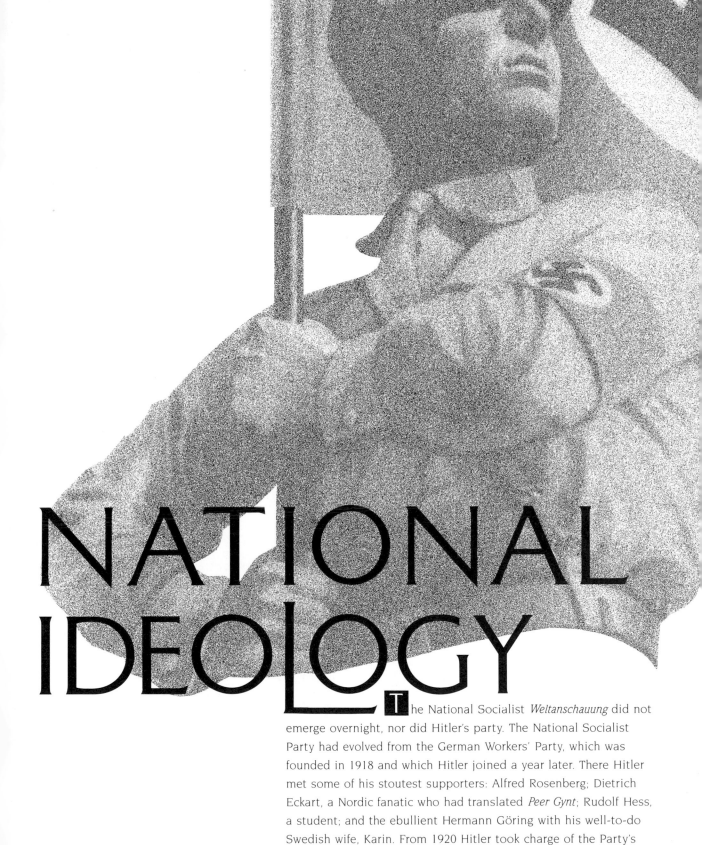

NATIONAL
IDEOLOGY

The National Socialist *Weltanschauung* did not
emerge overnight, nor did Hitler's party. The National Socialist
Party had evolved from the German Workers' Party, which was
founded in 1918 and which Hitler joined a year later. There Hitler
met some of his stoutest supporters: Alfred Rosenberg; Dietrich
Eckart, a Nordic fanatic who had translated *Peer Gynt*; Rudolf Hess,
a student; and the ebullient Hermann Göring with his well-to-do
Swedish wife, Karin. From 1920 Hitler took charge of the Party's
propaganda, promptly organizing mass meetings. From 1919 to 1933
he devoted all his time and energy to increasing the membership of

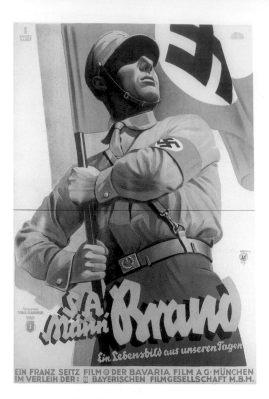

Julius U. Engelhardt. S.A. Man
Brand—A Biography of Our
Time. *1933. Film poster*

Richard Spitz. Nazi Vision
of Greatness

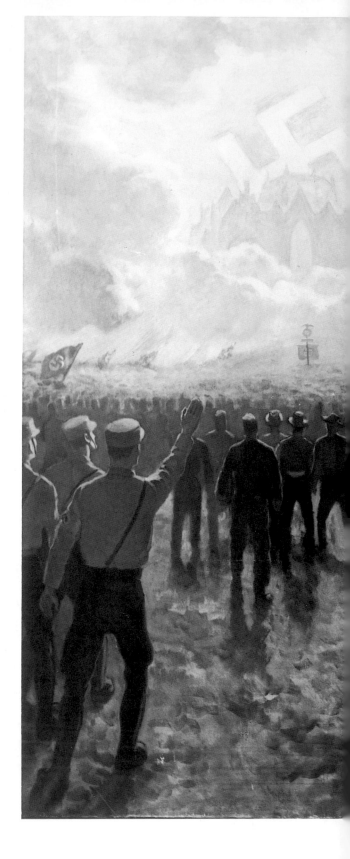

the Party and to taking over the entire country. In December 1924 he emerged from prison, where he had been sent after the November putsch of 1923. There he had written *Mein Kampf.* On his release he intensified the struggle. The Party membership rose from 25,000 in 1925 to 72,000 in 1927, when at the first Party rally in Nuremberg 30,000 Storm Troopers marched in front of him. By 1929 the Party had nearly 200,000 members (see illustrations pages 19 and 20).

World depression hit Germany harder than most countries. Hitler understood how to fire up the dissatisfied masses when unemployment reached the 6 million mark. A nation weighed down by anxiety and poverty, and filled with resentment against the countries that had, in the Treaty of Versailles, deprived it of all its colonies, was an easy target for a party that promised change and renewed pride. By 1931 the National Socialist Party had become the second most important party in the land and Adolf Hitler its most powerful political figure.

Hitler came to power on January 31, 1933. The National Socialists lost no time in putting their cultural politics into practice, as demonstrated in their posters.

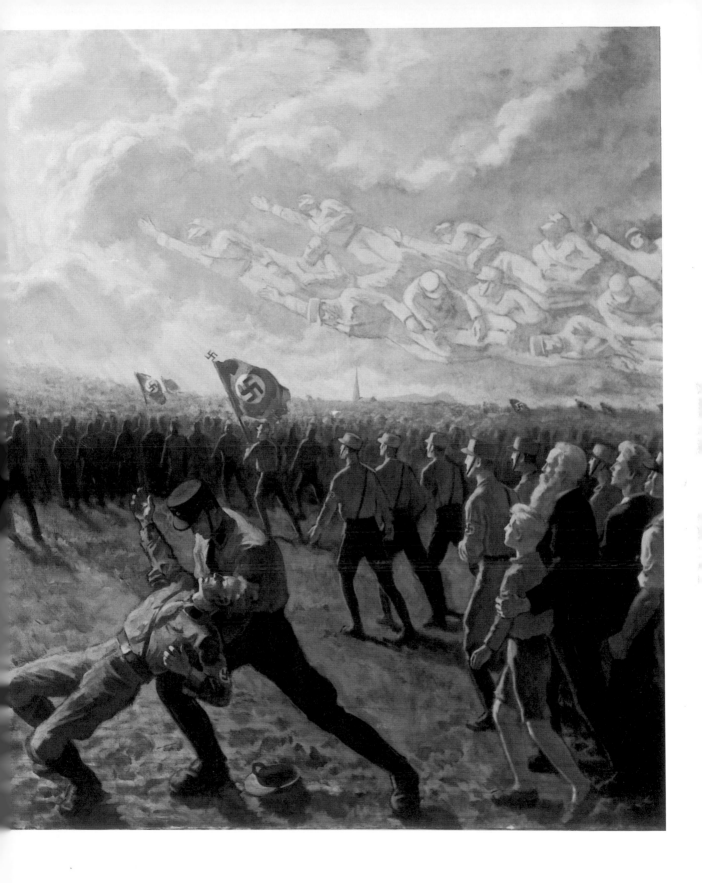

They began with a number of demonstrations of strength. They set about eliminating what they rejected in ceremonies like book burning, and celebrated what they admired by organizing spectacular mass meetings and by funding massive architectural schemes. The cultural landscape of Germany was reshaped, from the printed page to the autobahn network.

On May 10, 1933, at Goebbels's instigation, 2,000 books were collected, among them whole libraries like that of Magnus Hirschfeld's Institute for Sexual Research, and burned by the National Socialist Student Organization. This festival of vandalism began at ten in the morning and finished at midnight, with a speech by Goebbels. Under the eyes of newsreel cameras, he proclaimed that "the period of Jewish intellectual imperialism is over. From its ashes a new spirit will arise."

Among those whose works were burned were Heinrich Mann, Sigmund Freud, Karl Marx, Kurt Tucholsky, Carl von Ossietzky, Erich Kästner, Erich Maria Remarque, and Alfred Kerr. The first official book burning, held in Berlin and presided over by Goebbels, was followed by similar ceremonies in Munich and Dresden and most other university towns. Students, often led by their teachers, marched through town, shouting Nazi slogans. Fifty or more authors were blacklisted, among them Thomas Mann, Ricarda Huch, and Alfred Döblin. Scores of writers had already left the country and were soon to be followed by Stefan and Arnold Zweig, Franz Werfel, Jakob Wassermann, Hermann Kesten, Bertolt Brecht, and many more.

The National Socialists also lost no time in cleansing the German art scene of all foreign and modern influences. "*Gleichschaltung*," or synchronization, became a watchword. As soon as the National Socialists came to power, in the museums in Berlin, Essen, Mannheim, and Cologne that had shown avant-garde works, the liberal-minded curators were replaced by reliable Party men, brought up in the philosophy of a Rosenberg. The infamous Count Klaus Baudissin, doctor of philosophy and major in the SS, took over the Folkwang Museum in Essen and became one of the chief advisers in arts matters to the Führer.

To many of the followers of the Nazi regime the whole extraordinary cultural richness of the Weimar Republic was anathema. The list of people who were deprived of their jobs and had to leave would fill pages. A few names stand for many: the painters Willi Baumeister, Karl Hofer, Max Beckmann, Paul Klee, and Otto Dix were removed from their teaching posts. The

musicians Arnold Schoenberg, Hans Eissler, Kurt Weill, Bruno Walter, Otto Klemperer, Fritz Busch, and Artur Schnabel shared the same fate. The writers Carl von Ossietzky, Erich Mühsam, and Paul Metter were sent to concentration camps, never to leave them. The German theater lost Leopold Jessner, Max Reinhardt, Erwin Piscator, Fritz Kortner, Max Pallenberg, Elisabeth Bergner, Therese Giehse, and many others.

The impoverishment of German cultural life was staggering. Book production shrank by 30 percent. The number of German newspapers dropped from 4,700 in 1932 to 3,100 in 1934. Of 10,000 magazines, over half disappeared within five years of the National Socialists' coming to power.

In September 1933 the Reichskulturkammer (RKK; Reich Culture Chamber) was founded. It was the central organization responsible for the control of German arts, a powerful organization that embraced almost the entire artistic life of the country. A German periodical reported how Goebbels took charge: "The new Reich Culture Chamber was opened today with a festive ceremony. The extraordinary importance of this event in cultural history not only justified the ceremony in Philharmonic Hall in the presence of the best creative talents we have in Germany today, it demanded it. In his speech, Dr. Goebbels underlined the revolutionary character which is the basis for the fundamental restructuring of our entire cultural life."[3]

In the Culture Chamber were departments for film, the visual arts, architecture, literature, and music. With the exception of science and education, all cultural activities were now under Goebbels's control. At the age of thirty-six, Goebbels had become the second most important man in the land.

The *Gleichschaltung* of artists was relatively easy. For a long time the arts in Germany had been institutionalized. Privately sponsored art clubs and societies had been an important part of the German artistic scene. Artists of similar interests and style grouped themselves together in these associations. The Third Reich could also build on the attitudes and customs of many artists who worked in traditional art forms during the Weimar Republic.

The organization of all professionals spelled the political and personal streamlining of the arts and the total control of all artistic life. It guaranteed that the arts would follow and express the philosophy of the Party, and harnessed all artists to serve the ideology of the state. ". . . just as the leadership of the state claims for itself the political guidance of other areas of

the people's life, likewise does it make the same claim here. This does not mean that politics must interfere in the inner function of art. . . . It means only that the state regulates and orders its great beginning and total engagement," Goebbels said in 1937.[4]

In a state where the men in power became the sole executors of culture, the role of the artist had to change. Goebbels disguised the role of the Culture Chamber by claiming that it gave artists greater freedom and a true purpose:

Organization plays a decisive role in the lives of peoples. . . . every organization must demand that its members surrender certain individual private rights for the benefit of a greater and more comprehensive law of life, and thereby a goal-directed point of departure for energies which if isolated are powerless, but which if united have a striking, penetrating effect. . . . a host of old habits and prejudices, to which many people had become fondly attached, had to be overcome through the organization of the German creative artists in their Reich Culture Chamber. . . .[5]

The artist was no longer a private person; he became a public figure. "An art which must rely upon the support of small cliques is intolerable. The artist cannot stand aloof from his people. His art must reinforce the sure and healthy instinct of a people," Hitler announced in Nuremberg on German Cultural Day in 1937.[6]

Their new role as a political educator promoted artists to a higher place within the nation. Many were seduced by this. "Today the artist wants again to participate in the life of the people. He wants to be part of its fight, its pain and deprivation. [The] artist no longer wants to be 'free' but wants his art to serve an idea, a state, a church, a community. . . . This philosophy of the new German Reich gives art its commitment and its content," wrote the architect Winfried Wendland,[7] who was responsible for the Department of National Socialist Cultural Policies in the Ministry of Culture. Professor Wendland was also a curator at the Academy of Applied Arts. There were enough artists, teachers, and intellectuals like him to carry out these absurd ideas.

Of course, only the racially pure and the politically reliable were admitted to the various culture chambers for the individual arts. In November 1933 *Germania* reported that Goebbels had explained: "In future only those who are members of a chamber are allowed to be productive in our cultural life. Membership is open only to those who fulfill the entrance condition. In this way all unwanted and damaging elements have been excluded."[8]

As we see, artists in all fields united to solve the Jewish problem even before the Party did so. Right from the start the Reich Culture Chamber numbered 45,000 members. Of course there were many privileges offered to those who supported the regime. At the beginning artists were exempt from military service—a privilege not granted to scientists. And many enjoyed great financial gain. To abstain spelled the end of a professional career and a life in oblivion. It also led to the loss of social security and other benefits. In 1935, two years after its founding, the Reich Culture Chamber had 100,000 members, including 15,000 architects, 14,300 painters, 2,900 sculptors, 6,000 designers and graphic artists, 2,000 art publishers and art dealers, and thousands of filmmakers, actors, and musicians. This represented a formidable sellout by intellectuals to a political idea which had chased many of their colleagues across the German borders and imprisoned others at home.

There was not much large-scale public protest. In the beginning, patriotism led a number of artists to admire certain aspects of Hitler's arts program. Some prominent writers like Walter von Molo, Rudolf Binding, Josef Ponten, and Martin Heidegger even signed documents pledging loyalty to the Führer. Others, like Gerhart Hauptmann, applauded the new regime.

Thousands of artists and intellectuals did leave Germany, among them some of the best, but there were still plenty of people to fill the empty places in universities, on the stages, and in the orchestras. The persecution and the ensuing exodus continued right up to the annexation of Austria in 1938, which brought increased persecution of intellectuals. The cheering masses that greeted Hitler's arrival in Vienna did not notice that some of their most eminent thinkers, like Stefan Zweig, Carl Zuckmayer, and Sigmund Freud, had fled the country, while Egon Friedell threw himself out of a window. Orchestras were cleansed of their "Jewish elements," while Richard Strauss, Wilhelm Furtwängler, Eugen Jochum, Elisabeth Schwarzkopf, and many others lent their support. For many this action was a mixture of cowardice, opportunism, and political blindness. Some were simply sucked in by the regime, and when they woke up, for many it was too late.

It is still amazing that such an anti-intellectual regime, which based its ideology on the most shallow, banal, and trivial concepts, could attract so many intellectuals. Joachim Fest has pointed out that Hitler's arrival was seen by many intellectuals as "a healing process," a way out of their existential despair. It is

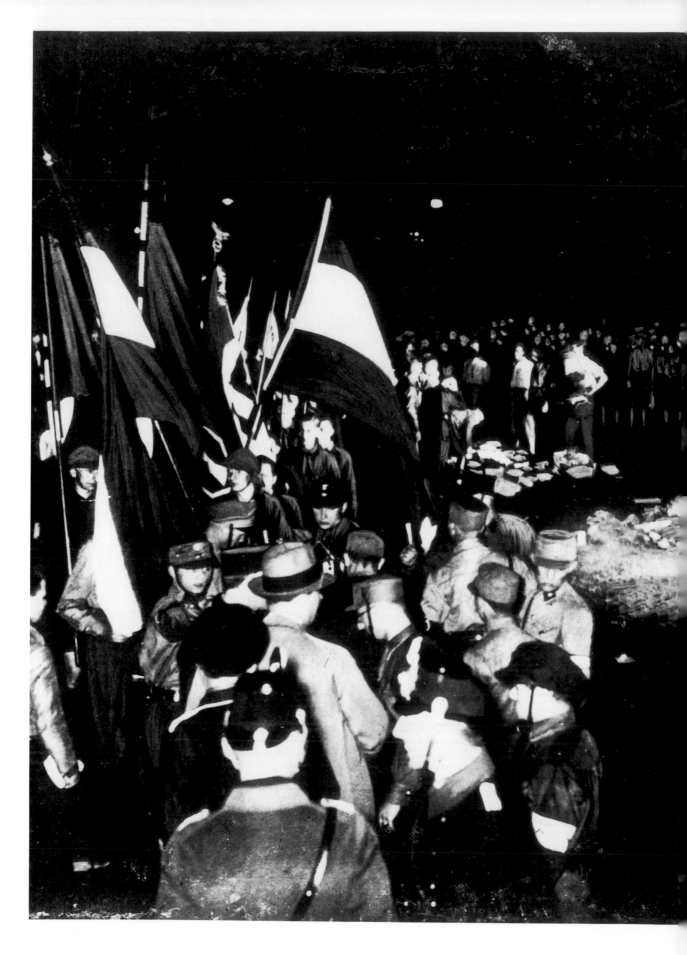

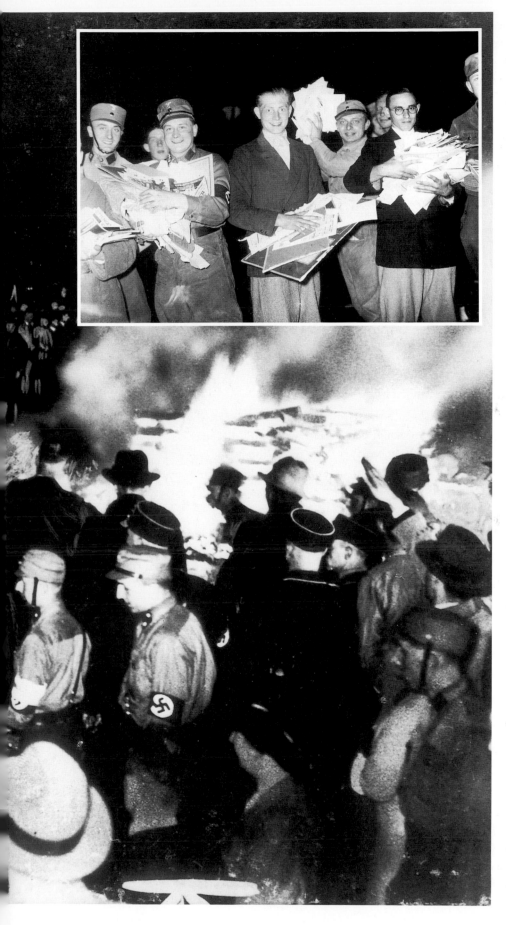

Burning of banned literature in front of the State Opera, Berlin, October 5, 1933

"THE CUSTODIANS OF ALL PUBLIC AND PRIVATE MUSEUMS ARE BUSILY REMOVING THE MOST ARTROCIOUS CREATIONS OF A DEGENERATE HUMANITY AND OF A PATHOLOGICAL GENERATION OF 'ARTISTS.' THIS PURGE OF ALL WORKS MARKED BY THE SAME WESTERN ASIATIC STAMP HAS BEEN SET IN MOTION IN LITERATURE AS WELL WITH THE SYMBOLIC BURNING OF THE MOST EVIL PRODUCTS OF JEWISH SCRIBBLERS."
—S.A. MANN

true that many artists working in the traditional vein were seduced, finding themselves able to communicate with the masses, thereby being released from the isolation of modern art. The poet Gottfried Benn wrote to Klaus Mann in exile:

I declare myself for the new state, because it is my people [Volk] that is making its way now. Who am I to exclude myself; do I know anything better? No! Within the limits of my powers I can try to guide the Volk to where I would like to see it; but if I should not succeed, still it would remain my Volk. Volk is a great deal! My intellectual and economic existence, my language, my life, my human relationships, the entire sum of my brain, I owe primarily to this Volk. My ancestors came from it; my children return to it. And since I grew up in the country, and among farm animals, I also still remember what native ground stands for. Big cities, industrialism, intellectualism—these are all shadows that the age has cast upon my thoughts, all powers of the century, which I have confronted in my writing. There are moments in which this whole tormented life falls away and nothing exists but the plains, expanses, seasons, soil, simple words: Volk. [9]

Goebbels, skeptical about the success of his organized book burning, tried to reassure artists that the Party would be generous and that not all art would be politicized. He considered the excesses that happened the birth pangs of a revolution. Trying to dispel the criticism that the art policies of the Third Reich were backward-looking, he said at the general meeting of the Reich Culture Chambers in June 1934: "We National Socialists are not unmodern; we are the carrier of a new modernity, not only in politics and in social matters, but also in art and intellectual matters. To be modern means to stand near the spirit of the present [*Zeitgeist*]. And for art, too, no other modernity is possible." [10]

There was a lot of talk about a liberating spirit which would bring forth a new German art. On Hitler's birthday in 1933 the director of the Academy of Fine Arts of Württemberg, the painter Arnold Waldschmidt, announced: "Never before in German history has there been an epoch which gave us greater tasks in all fields, and in complete freedom, than the Germany of today. The essence of freedom is the will to be free. The powerful rise of Germany is in contrast to the choking calmness of the liberal states. It is like a mighty storm, blowing through the whole of the German people. It awakens all spiritual and intellectual forces. Such total will to live means culture, culture in its highest sense, regardless of the style it expresses itself in." [11]

Despite these high claims, no new art form emerged. It is often assumed that in the year 1933 a new style was invented that could be classified as Fascist. Nothing could be further from the truth. The year 1933 was a political landmark and a clear break with the past, but the change in the arts did not happen all at once. Many artists initially took a waiting position; some hoped for something new to emerge. The early years of the Hitler regime were marked by fierce ideological infighting. While the organization of the arts into professional bodies was carried out without much protest, there were vehement discussions as to what form the new art should take and which artists should be allowed to practice it.

At the outset Goebbels showed a liberal attitude toward the arts. He wanted to stand above the conflict between modern and traditional art. He tried to make room for some of the modern artists. As he had wooed the writer Stefan George, he tried to persuade Thomas Mann to return. With some of the artists he was successful, as in the case of Richard Strauss, who became president of the Reich Culture Chamber for Music, with Wilhelm Furtwängler as vice-president. He tried in vain to get the half-Jewish Fritz Lang to take over the Culture Chamber for Film despite the fact that his *Doctor Mabuse* was banned. The cultural office sent invitations to the architects Mies van der Rohe and Peter Behrens, who both, for a while at least, were allowed to build.

Goebbels somehow also hoped to keep the Expressionist artists within the National Socialist fold. At the beginning some of them, like Emil Nolde, Erich Heckel, Ernst Barlach, and Karl Schmidt-Rottluff, were seen as "Nordic" artists whom the National Socialist movement could embrace. Letters were dispatched to them inviting them to join the Culture Chambers. In December 1933, Goebbels sent a telegram to Edvard Munch on his seventieth birthday describing him as "the spiritual heir of the Nordic nature."

In the beginning, many things were still possible, which blinded hordes of intellectuals to the true purpose of the new regime. Quite a few artists fell into the trap. Never sophisticated politically, they were lulled into believing that there was a future for their work in National Socialist Germany. The poet Gottfried Benn could still write his "Confession to Expressionism," and standing next to Filippo Tommaso Marinetti, Benn delivered the opening speech at the Italian Futurist Exhibition in Berlin—an event made more

palatable by the Futurists' embrace of war. That was in 1933. Things would soon change.

Some of the more sophisticated members of the National Socialist Student Union turned against the official art style now propagated. They too wanted to include a kind of Nordic Expressionism, a demand which also won Goebbels's approval. The students staged a mass demonstration in the main auditorium of the University of Berlin in a last effort to defend modern art groups such as the Blaue Reiter and the Brücke against the cultural politics of their right-wing counterpart, the German Cultural Union.

On September 1, 1933, in his first speech on art, Hitler castigated the continuation of liberalism in art, attacking the effort of the National Socialist Student Union: "We will not allow these charlatans and untalented artists to enter our arts scene even if they change their opinion," Hitler said. "Under no circumstances must the representatives of decadence become the voices of the future. This is our state, not theirs, we will not let it be soiled."[12]

The faint flickers of liberalism gave some courage to the dissenting art world. Shortly afterward, the Berlin dealer Ferdinand Möller held an exhibition of sixty watercolors by Nolde. In other cities too there were a few galleries that dared to show works by Feininger and Schmidt-Rottluff. In the summer and autumn of 1933 some modern art was still exhibited in factories.

Hitler, spurred on by Rosenberg, kept a watchful eye on any remaining liberalism and reprimanded Goebbels for his laxness. Despite this rebuke Goebbels continued to fight for a more modern art. He was eager to show that art had first of all to do with talent, and not with political content. Die Kunstkammer, the official arts magazine of the Reich Culture Chamber for the Visual Arts, sometimes spoke up for the avantgarde. As late as 1935 its editor, Otto Andreas Schreiber, wrote two articles attacking volkish art, and praising modern art for its prophetic nature. This would not have been possible without Goebbels's backing. Goebbels frequently defended the magazine against the attacks from Rosenberg. He also planned an exhibition of Berlin artists in Munich's Neue Pinakothek. The catalogue included works of German Expressionism. Beckmann, Barlach, Feininger, Hofer, Kollwitz, Marcks, Nolde, Pechstein, and Schmidt-Rottluff were all to be shown. "The people from Munich should see what good art is," Goebbels was reported to have said. Unfortunately the exhibition opened with only Kollwitz's pictures on show. The other moderns had disappeared.

The bitter battle with Rosenberg, whom Goebbels called a "stubborn dogmatist,"[13] had begun. Rosenberg wrote: "Men like Nolde and Barlach provoke violent discussion. Some National Socialist artists want to exclude them from our future art; others praise them to the sky. Let us therefore try to form a judgment free of subjective opinion about the appropriate style for National Socialist thought. We will see that in all centuries, and despite differences in fashion and political upheavals, the Nordic artist has always been marked by a special ideal of beauty. This is nowhere more evident than in Hellas, where we see the powerful, natural ideal of beauty. This also dominated Titian, Palma Vecchio, Giorgione, and Botticelli, who painted Gretchen-like figures. This ideal lives in Holbein, in the Nibelungen, and in Goethe's Dorothea. It dominates the face of Pericles and the Rider of Bamberg."[14]

Hitler had to intervene. In a speech at the Reichsparteitag (Party Day) in Nuremberg in September 1934, Hitler once more attacked "Cubists, Futurists, and Dadaists," but intervening in the debate between the fanatical Rosenberg and the more liberal Goebbels, he also castigated the "volkish apostles" as too backward to belong to the new German revolution.

CHAPTER 4 THE TUR

THE SUMMIT IN GERMANY'S ARTISTIC LIFE HAS ALWAYS BEEN REACHED IN PERIODS DURING WHICH THE DEEP LONGING OF THE PEOPLE FOUND ITS ARTISTIC EXPRESSION. IN THE EARLY PERIOD, IN THE SONGS OF HEROES AND GODS; IN THE MIDDLE AGES, IN THE BUILDING OF OUR CATHEDRALS; AND THEN IN THE MUSIC AND THE POETRY. THE GERMAN SPIRIT ROSE LIKE A GIANT FLAME ONCE MORE DURING THE LAST ONE HUNDRED FIFTY YEARS IN ALL FIELDS, TO BE ALMOST COMPLETELY EXTINGUISHED AT THE TURN OF THIS CENTURY. . . . SINCE THEN THE OFFICIALLY RECOGNIZED ART HAS BECOME A MATTER OF PLAYING WITH EMPTY FORMS OR REPRESENTING A DISTORTED WORLD POPULATED BY MISCARRIAGES AND CRETINS. THE ART PROPAGATED BY ACADEMIES AND MUSEUMS EXISTED ARROGANTLY ABOVE THE HEAD OF THE LAY PEOPLE, WHO DID NOT UNDERSTAND IT. IT WAS FOR A SELECT FEW—THE ART INTELLECTUAL AND THE ART MARKET. ART HAD NO VALUE, ONLY A PRICE. IT WAS NO LONGER THE FRIENDLY GODDESS HEALING AND BLESSING. IT WAS ONLY A WHORE.

—Professor Hans Adolf Bühler, 1934[1]

NING POINT

While the ideological battles raged, the National Socialists were busy implementing their own ideas. Art museums were an easy target. "No other museum in Germany has as many works of 'Jewish' artists as the Folkwang Museum in Essen. In the meantime German artists remain outside . . . lose their livelihoods, queue up at the labor exchange, starve. . . . There are no Leibls, from Menzel only a small preliminary drawing, no Caspar David Friedrich, no Blechen. But the French are represented! The museum is full of Emile Bernard, Pierre Bonnard, Georges Braque, Cézanne, Corot, Denis, Gauguin, Matisse, Renoir, Signac, Vlaminck, etc., and this in a town which bled to death under the French!" thundered the *Deutsche Kultur-Wacht* (The Guardian of German Culture).[2]

The Nazis began their purging process by removing dissenting elements in academies and art institutes. The venerable Prussian Academy in Berlin, the most important and distinguished art institute in Germany, was one of Goebbels's main targets. The correspondence with some of its most prominent members says much about the infighting and the general attitude. In May 1933, shortly after Hitler came to power, the eminent Jewish painter Max Liebermann resigned as the president of the academy. He declared: "During my

long life I have attempted, with all my strength, to serve German art. It is my conviction that art has nothing to do with politics or origin. Since this belief is no longer valid, I can no longer belong to the Prussian Academy, of which I was a member for over thirty years, and which I served as president for twelve years."[3]

The reaction of one newspaper was typical: "Liebermann's idea about the isolated artist, alienated from the *Volkstum*, has lost its validity today and in the future."[4]

Liebermann remained in Germany and died in 1935, lonely and officially forgotten. At his funeral at the Jewish Cemetery, of the so-called Aryan artists only three came to pay their respects: Käthe Kollwitz, Konrad von Kardorff, and Hans Purrmann. Liebermann's wife took her life in 1943, the moment the Nazis arrived at her home with a stretcher to fetch the eighty-five-year-old widow of the great German painter.[5]

Nowadays it is hard to conceive how much political events altered the lives of many of the leading artists. In the first year of Hitler's reign two other eminent members of the cultural establishment, Kollwitz and the writer Heinrich Mann, were forced to resign from the Prussian Academy because they had signed a manifesto supporting the banned workers' movement. In a letter dated May 15, 1933, several other distinguished members were asked to resign and to present themselves for re-election. The sculptor Ernst Barlach resigned in protest. He remained in Germany but his work was banned. Karl Schmidt-Rottluff shared the same fate. The architect Erich Mendelsohn also resigned and immigrated in 1933 to England. Mies van der Rohe resigned but remained in Germany until 1938.

But not everybody made such clear-cut decisions. Emil Nolde wrote a letter refusing to resign. "When I was elected to the academy, I was told this was done with the recommendation of the minister's commission. I see no reason now for a re-election. . . . This is a friendly answer to your letter." Emil Nolde, who had joined the National Socialist Party as early as 1920, never understood why his work was banned. Karl Hofer cowardly pointed out in a letter to Hitler that there was only a small proportion of Jews among painters, but he was nevertheless expelled from the Prussian Academy. Ernst Ludwig Kirchner was equally unwary. His letter says much about the attitudes of many: "I never tried to get into the academy. . . . I have no personal advantage from my membership. . . . For thirty

Max Liebermann. Self-Portrait. *1908*

Georg Günther. Rest During the Harvest

"IT IS THE TASK OF THE CONTEMPORARY ARTIST TO CREATE A LINK TO THE OLD MASTERS AND AT THE SAME TIME NOT TO CONSIDER THEMSELVES TOO GRAND TO LOOK AT SIMPLE PEASANT ART, WHICH IS THE EXPRESSION OF THE DIVINE THROUGH THE BLOOD."
—ADOLF BABEL

Julius Paul Junghanns. Plowing

"GREAT AND SIMPLE IN ITS UNDERSTANDING OF MAN AND ANIMAL IN THEIR COMMON WORKING AND RESTING."—ROBERT SCHOLZ

Poster for Veit Harlan's film
Jud Süss. *ca. 1940*
"THE LARGE MASS OF JEWS
IS AS A RACE CULTURALLY
UNPRODUCTIVE. THAT IS
WHY THEY ARE MORE
DRAWN TO THE NEGRO
THAN TO THE CULTURALLY
HIGHER WORKS OF THE
TRULY CREATIVE RACES."
—ADOLF HITLER

Opposite:
Poster for the exhibition "The
Eternal Jew," Vienna, 1938

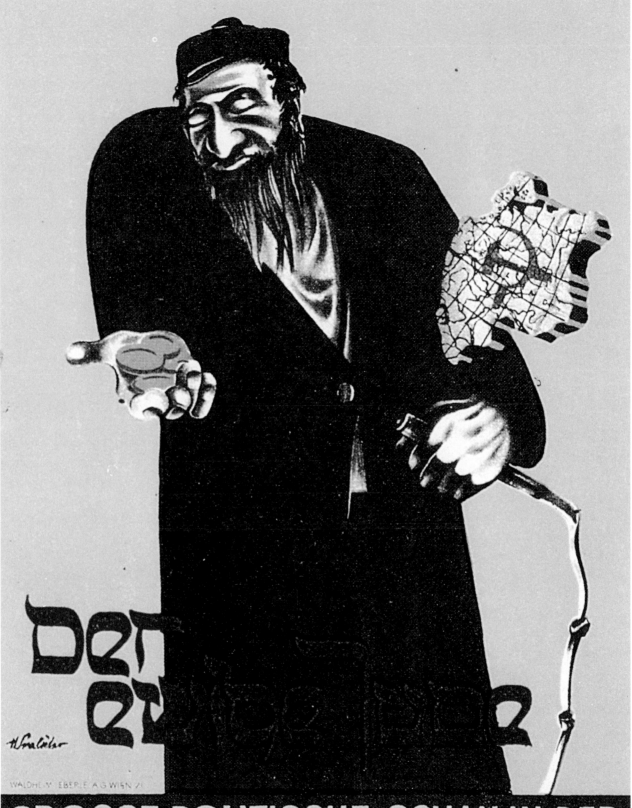

DER EWIGE JUDE

WALDHEIM EBERLE A.G. WIEN 21

GROSSE POLITISCHE SCHAU IN DER NORDWESTBAHNHALLE IN WIEN. AB 2.AUG.1938. TÄGLICH GEÖFFNET VON 10-20 UHR

Ernst Liebermann. By the Water

Below:
Albert Janesch. Water Sports. *1936*
"REPRESENTATION OF THE PERFECT BEAUTY OF A RACE STEELED IN BATTLE AND SPORT, INSPIRED NOT BY ANTIQUITY OR CLASSICISM BUT BY THE PULSING LIFE OF OUR PRESENT-DAY EVENTS."
—HUBERT WILM

years I have fought for a strong new real German art and will continue to do so until I die. I am not a Jew, a Social Democrat, or otherwise politically active and have a clear conscience. I therefore will patiently await what the new government decides to do with the academy and put the fate of my membership faithfully into your hands."[6]

Kirchner, not realizing that his kind of art was soon to be persecuted too, supported the SS state. When the National Socialists attacked him in 1935 he thought it was a mistake. Even Kandinsky was naïve enough to hope that the Rosenberg clique could be infiltrated by more modern elements, and Oskar Schlemmer thought for two years that it was all a passing phase. Like many others, they believed that the horror would soon be over.

By the end of 1933 the Prussian Academy of Art, the most influential arts institution in Germany, had been cleansed of the avant-garde. Fifty-three new men were appointed who toed the Party line, among them Hitler's favorites: the architects Roderich Fick, Hermann Giesler, and Albert Speer; the sculptors Arno Breker, Josef Thorak, and Richard Scheibe; and the painter Werner Peiner.

The sculptor August Kraus, vice president of the academy and dean of the visual arts division, together with the composer Georg Schumann, dean of the department of music, wrote a letter to Adolf Hitler assuring him of the devotion of the artists of the Prussian Academy: "As representatives of the visual arts and music departments, we are aware of the responsibility that we have to the people and the state, and we await the day when all Germans will stand in unison behind their Führer."[7]

Other prominent artists had to leave their posts. In April 1933, Otto Dix was thrown out of the Dresden Academy, and his work was confiscated. He was arrested in 1939 but continued to live in Germany after his release. Edwin Scharff was expelled from the Prussian Academy. Paul Klee and Oskar Moll were forced to leave their posts as professors at the Düsseldorf Academy.

Goebbels signed a decree providing that all modern art should be removed from German museums, and so even the artists who had at first embraced the new regime, like Nolde and Munch, were taken off the walls.

The fact that Paul Klee and Edwin Scharff have been dismissed from the academies in Berlin and Düsseldorf by our Minister of Culture is an important step on the road to liberation from fourteen years of the enslavement of German art by alien elements

[wrote Robert Scholz, one of the leading art critics of the Nazi establishment, in the ominous Deutsche Kultur-Wacht*]. Who were these false gods? How could they exert such an influence on the artistic life of Germany? They were renegades, who found their artistic blessings and their "higher" culture in the cafés of Montmartre. There they turned into ruthless dictators in matters of taste. . . . They were in Paris, in the morbid atmosphere of an artistic Bohemia which pretends to be the cream of spiritual humanity. . . . The Hofers, Molls, and all the others have imported the poison of artistic nihilism to Germany. . . . They were incapable of creating real art, the Hofers, Klees, and Molls, so they turned the criteria around and made Expressionism and Cubism, and when the French were not sufficiently receptive, they bor-*

Georg Sluyterman von Langeweyde. Two SA Men. *From the series* The Führer Speaks

rowed from the wild art of the Negro. And the fact that one once considered Paul Klee a great artist will be seen by future generations as a sign of a complete spiritual sellout. . . . And these speculators were allowed to teach our artistic students in lucrative jobs in the infamous Bauhaus of Weimar, in the art schools of Düsseldorf and Breslau, where Moll imported from Paris the sugary playfulness of a Matisse, while German creative artists were ignored and suffered material hardship. They could not pass on any talent because they had none. . . . We do not reject the modernists because they are modern but because they are spiritually destructive.[8]

The attack of these right-wing national forces bore fruit: an exhibition of "100 Years of Belgian Art," planned for the Prussian Academy, was canceled. An exhibition of Norwegian art, for the National Gallery in Berlin, shared the same fate.

Government interference in the policies of German museums was not new. Here too Hitler learned from his predecessors. In 1906, the Kaiser, known for his philistine and traditional outlook, forbade the National Gallery to buy modern art. He accused the director of failing in his patriotic duties. A gift to the museum of three Van Gogh paintings led to a ban on all Impressionist and Post-Impressionist work.

The so-called "museum war" about the independence of the museum from government interference continued right into the twenties, when the museum connived with an Association of Friends of the National Gallery to purchase works by Picasso, Braque, and Gris. A conservative national newspaper was quick to denounce this and branded the museums "temples of decadence."

In 1933 the National Gallery still showed some of its modern works in the Kronprinzen-Palais. It managed to purchase some works by Schmidt-Rottluff, Nolde, and Kirchner. But with Hitler in power, the attacks intensified. A show of paintings by the Brücke and the Blaue Reiter groups led to the closing of the entire modern section. The fight over modern art, which had lasted for thirty years, was finally won by the state.

In the meantime, as a preparation for the new style, a celebration of a healthy Germanic art began. In April 1933 a traveling exhibition of "German Art" was organized by the National Socialists in Braunschweig. Other such exhibitions followed. The cultural bosses everywhere organized exhibitions of "pure German art," which demonstrated to the public the kind of paintings they would favor. Similar viewpoints came to the fore in movies of the time. Alfred Rosenberg led in 1934 with an exhibition in Berlin of two hundred traditional paintings and sculptures full of National Socialist content, demonstrating the continuity of volkish themes. In Munich there was the exhibition of "Blut und Boden" (Blood and Soil). Another show, "German Land—German Man," traveled around the country. Berlin followed with a similar show, under the title "German Peasant—German Land." In September 1934 a "Great Anti-Bolshevist Exhibition" opened in Nuremberg, followed by the exhibition "The Eternal Jew" in November (see illustration page 67).

Between 1933 and 1937 the Neue Pinakothek in Munich regularly showed "art worthy of the new state." This included country scenes by nineteenth-century painters such as Wilhelm Leibl and Hans Thoma, as well as mythological scenes and pictures of animals. Other approved themes were the Judgment of Paris, Leda with or without the Swan, beautiful peasant girls half-dressed or in Bavarian costume, the breastfeeding mother, fields ripening with corn—the whole

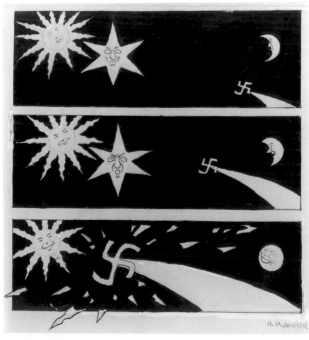

A. Roeseler. The New Comet

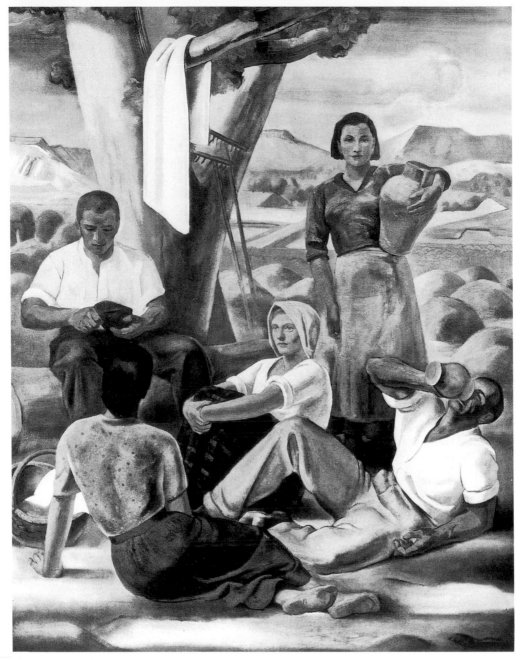

Karl Schlageter. End of the Day. *Detail from a mural*

gamut of a healthy traditional life of which the southern part of Germany was so fond, and which appealed to many others.

"Art must not be isolated from blood and soil," wrote the art historian Kurt Karl Eberlein in 1933. "Either one speaks German and then the soul speaks or one speaks a foreign language, a cosmopolitan, fashionable Esperanto language, and then the soul is mute."[9]

The Nazis prepared their ground well, advertising their new aesthetic. Art magazines like *Die Völkische Kunst* (Volkish Art) and later *Kunst und Volk* (Art and

People), spelled out the new art policy, while Goebbels's *Völkischer Beobachter* continued its tirades of hatred against Jewish/Bolshevist art.

Newspapers and magazines picked up the subject of a German art as opposed to an international one. "The philosophy of National Socialism grew from the nature and culture of our *Volk*. It is the proper soil for art and culture, which will grow livelier and more natural here than in the asphalt culture of the intellectuals of past centuries. Our museums too will have to be restructured. It is not enough to remove a few 'dangerous' pictures. We must change the old principle of cool dis-

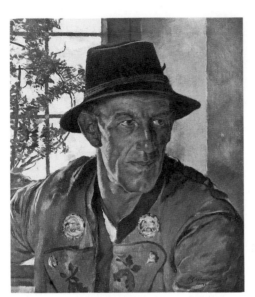

Constantin Gerhardinger. Peasant
from Samerberg. *1941*
"THE IMAGE OF THE FACE OF
A PEASANT OF GERMAN
RACE, MARKED BY WORK,
DESTINY, AND CHARACTER,
POINTS TO THE SOURCE OF
STRENGTH OF THIS ETERNAL
PEOPLE."—ROBERT SCHOLZ

tance and bring true popular art to the people. . . .
Our museums must once more become museums for
the people. Places of national and racial conscious-
ness, not just places to study commercial values.
Never again places for the virus of decadence," wrote
Otto Klein in 1934.[10]

The attacks on modern art were fanned by the frus-
tration that no new German art had developed. "We
know that the road to a National Socialist art, i.e., a
German style of the twentieth century, is still long. . . .
The transformation of the soul of a people or more ac-
curately the reawakening of a communal *Volk* soul
takes decades or centuries."[11]

Despite the fact that large groups of the population
were led toward the arts, new art was not forthcoming.
In 1936 Goebbels admitted that new artistic talents
had not emerged, "but they will come, let us not get
impatient," and Hitler pointed to architecture as the
real renewal in art. But even he spoke in private about
the mediocrity of contemporary German art. He would
buy works in order to encourage artists, but he would
not hang them in his private apartments. Some of the
more serious of the Party's artists even expressed dis-
satisfaction with the routine work and artistic
opportunism that produced pictures suitable for travel
agencies. It was Hitler's mistrust of Prussian intellec-
tualism that was responsible for the south German
provincialism that dominated the scene (see illustra-
tions page 65). Some of the art magazines, too,

Ferdinand Andri. Mother
and Child
"THE HAPPY WAY OF
PAINTING BY THE ALPINE
ARTIST ANDRI,
STRENGTHENED THROUGH
WEATHER AND SOLIDLY
ANCHORED IN HIS NATIVE
SOIL."—ERNST WURM

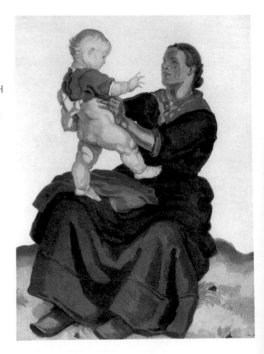

expressed doubts about what was being done. So Goebbels decided to silence the last dissenting voices.

Because this year has not brought an improvement in art criticism, I forbid, once and for all, art criticism in its past form [declared Goebbels in 1936]. From now on art reporting will take the place of art criticism. Criticism has set itself up as a judge of art—a complete perversion of the concept of "criticism." This dates from the time of Jewish domination of art. . . . Art reporting should not be concerned with values, but should confine itself to description. Such reporting should give the public a chance to make up its own mind. Only those publicists who follow the ideas of the National Socialists and speak with the honesty of their hearts will be allowed to undertake such a task.12

Hitler wholeheartedly endorsed the decision of his cultural minister. "The artist creates for the people and we will see that henceforth the people will be called in to judge its art. Great artists and architects have the right to withdraw from the critical attention of their petty contemporaries."13

Not all art institutes immediately followed the official policies. But by 1936 modern art was totally banned. Even Goebbels's relatively liberal attitudes were stifled by the tirades of Rosenberg and by Hitler's distaste for anything modern. Pictures by Nolde that hung in Goebbels's home were taken down without protest. A sculpture by Barlach was also removed.

In 1936 the Berlin Academy had the last of its big exhibitions that included some modern work, a two-century survey entitled "Berlin Sculpture from Schlüter to the Present Day." The renowned Fritz Klimsch, whose sculpture the National Socialists liked, was responsible for the selection. He capitulated under political pressure. As a result, the works of Ernst Barlach, Käthe Kollwitz, and Wilhelm Lehmbruck were removed.

Together with radical political measures came a much stronger grip on the arts. The international visitors to the Olympic Games had just left when in a speech in September 1936 in Nuremberg Hitler announced a rigorous cleansing of the arts. The attacks on the arts policies of the Third Reich intensified abroad. And Goebbels in the following year defended his ban on art criticism in front of the assembly of the Reich Culture Chamber:

The abolition of art criticism . . . was directly related to the goal-directed purging and coordinating of our cultural life. The responsibility for the phenomenon of degeneration in art was in large measure laid at the door of art criticism. In the main, art

Hans Schmitz. Peasant. 1936.
Cover for the magazine Kunst und Volk, *Berlin, 1937*

criticism had created the tendencies and the isms. It did not judge artistic development in terms of a healthy instinct . . . but only in terms of the emptiness of its intellectual abstractness. The people had never taken part in it. . . . Now the public itself functions as critic, and through its participation or non-participation it pronounces a clear judgment upon its poets, painters, composers, and actors.14

In this year—1937—the reins were finally tightened. Hitler made it clear that the "cliques of dilettantes and art forgers will be liquidated . . . they have had four years' time to prove themselves."15

It was the beginning of the greatest spate of looting and censorship in Germany's history. It was also the final victory of German art over modern art. It culminated in two exhibitions that made history: "Degenerate Art" and the first "Great German Art Exhibition." Both demonstrated the artistic credo of the National Socialist movement.

CHAPTER
5
THE ART OF

THE DEEPLY CONVINCED NATIONAL SOCIALIST ARTIST MUST LOGICALLY LIFT HIS WORK—BE IT

A SIMPLE FLOWER PICTURE OR THE LAST JUDGMENT—FROM THE STICKY MIASMA OF AN

AESTHETIC BASENESS INTO THE PURE AND COOL AIR OF DEVOTED SERVICE FOR HIS PEOPLE. IN

THIS WAY, WITH EACH OF HIS WORKS, HE BECOMES—QUITE UNWITTINGLY—THE PROCLAIMER OF

THAT PHILOSOPHY. IN HIS WORK THE PHILOSOPHY WILL APPEAR PURER THAN IN THE HARD BATTLE-

FIELD OF DAILY POLITICS. . . . WE MUST GO FORWARD. IF WE DON'T HAVE A NATIONAL SOCIALIST

ART, NATIONAL SOCIALISM WILL BE DEPRIVED OF ITS STRONGEST AND MOST EFFECTIVE ARMOR.

—*Professor Max Kutschmann, 1933.*[1]

SEDUCTION

The National Socialists endlessly proclaimed that the art of the Third Reich was the result of a *Weltanschauung*. Any evaluation of their art must therefore begin by looking at the radical social and cultural changes that they put into motion. According to the ideology of the National Socialists, art and life were constantly brought together. Art grew directly out of the life of the German people and was judged by its social values and implications. The Youth Movement, the homage to the family, the return to nature, the mass meetings, the glorification of the healthy body, the education for heroism, and the cult of heroic death all found their expression in the visual arts. Similarly, in the reverse sense, the pageantry, the mass marches, the sports arenas, the new homes and factories, the motorways, the public buildings all had their cultural significance, which was continually stressed.

Having gotten rid of the enemy, the Nazis launched the art of seduction. They presented themselves as cultured people. Art was to be brought to the *Volk*. "Art belongs to the whole complex of the racial values and gifts of the people," Hitler had said in 1935.[2] Orchestras played in factories, with the work of Beethoven, Brahms, and Bruckner featured heavily on the program. The music of Jewish composers like Mendelssohn had, of course, been banned. Writers spoke in schools, and libraries delivered books to the tiniest villages. Small towns that never had a theater suddenly saw actors, many in jackboots, putting up stages in the local

Ganz Deutschland hört den Führer

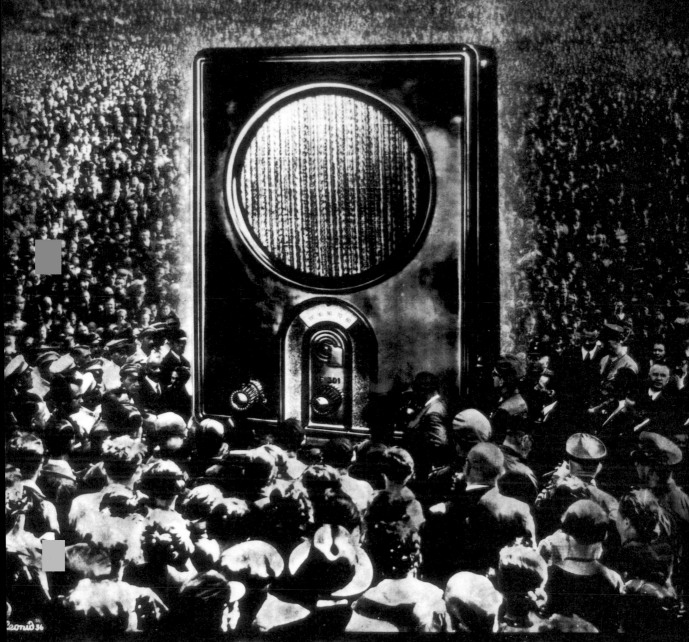

mit dem Volksempfänger

squares. Theater was no longer for an intellectual elite, it was for everybody. No one should—or could—opt out. The new ideology had to reach everybody. Taking art to the people and away from the elite did succeed. Cultural outings and events brought people together, people who never thought that art could be for them.

A highly organized cultural machine was put to work. The Deutsche Arbeitsfront (DAF; German Workers' Front) was given a special section—Kraft durch Freude (KdF; Strength Through Joy)—to spread art and culture on a massive scale. It was the Party's way of organizing people's spare time.

Alfred Rosenberg and Robert Ley took over responsibility for organizing and coordinating the cultural will of the German people. Workers traveled for a fraction of normal fares and stayed at reduced rates in special hotels. Tourism, formerly the preserve of the rich, was now for all. Party-sponsored mass tourism, with visits to theaters and concerts, was accompanied by the indoctrination of the travelers with racial and political ideas. It was all part of the package tour. And again people were seduced by it. Hitler with all of his "diversions" promised a new optimism, fun, and a sense of belonging. "The great statesman of the Germans is a kind of poet and thinker," declared Hermann Burte. "A new man has emerged from the depth of the people. He has forged new theses . . . and he has created a new people, and raised it up from the same depth out of which the great poems rise—from the mothers, from blood and soil. . . ."[3]

Hitler's notions of culture appealed to popular taste and prejudice and could therefore count on solid support. Here suddenly was a man who had the answer to everybody's problems. Everything was going to be different in this brave new world. The horrors were drowned under a mass of festivities, events, and folklore. People withdrew into moral indolence; life for most of them was much better than before.

Strength Through Joy was also in charge of fostering art education "to reinstate the organic link between people and artist in a systematic education." In 1934 a special Visual Arts Section was founded. Its aim too was to build a "bridge between artist and worker." "Workers of the fist and workers of the head shall join forces," Goebbels had asserted. In the first year the Visual Arts Section organized no less than 120 art exhibitions in factories. In 1937 there were 743 so-called Work Exhibitions. The emphasis in these factory shows was very much on education. Demonstrations of the making of a print or woodcut, or the construction

Paul Mathias Padua. The Führer Speaks. *"Great German Art Exhibition 1940"*

Opposite:
"All Germany Listens to the Führer on the Volk *Radio." 1936. Poster*

Advertisement for the
Leica camera

Model living room. "First
International Crafts Exhibition,"
Berlin, 1938

of a building from its first concept to the final model were as much a part of these as the examples of official art. Prices were kept low to enable workers to buy the art. Workers were encouraged to write their impressions, and prizes in the form of art were given for the best essay.

The artistic indoctrination of the factory floor was often strengthened by visits and talks by the artists themselves. Sometimes during lunch hour an artist could be seen painting or sculpting under the eyes of the work force. In the same way as Strength Through Joy chose pictures and sculptures to be exhibited, it also had total control over the artist. The selection of the artist for such a mission depended not so much on his artistic standing as on his membership in the Reich Culture Chamber, his political reliability, and his ability to deal with workers. Strength Through Joy also purchased artworks for canteen and community rooms. In meetings with the work force the choice of a particular work was often discussed. Traveling exhibitions visited villages and small towns, again in the presence of some artists. All these efforts were aimed at synchronizing taste.

"Your KdF Automobile."
Advertisement for the Strength
Through Joy automobile

"Functional and Simple."
Advertisement for the Württemberg
Metalworks

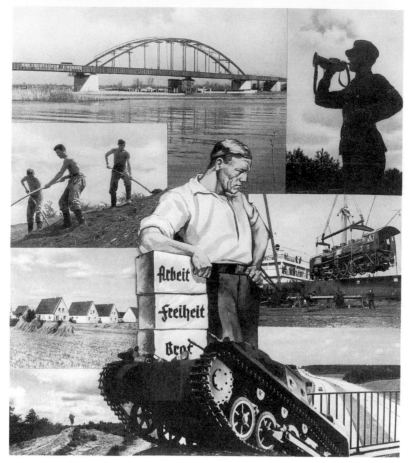

"Work, Freedom, Bread."
Magazine cover

The government formed another special department of the DAF, Deutsche Arbeitsfront (German Labor Front), in 1934 under the direction of Albert Speer: Schönheit der Arbeit (SdA; Beauty of Work). Its task was to embellish the workplace, especially in small factories. It pleaded for green spaces in factories and fostered such campaigns as "Better Light, Better Work" and "Clean People in Clean Factories." There were competitions for the most beautiful factory, and the campaign "Warm Meals at Work" led to the introduction of canteens into the factories.

The organization was meant to give the impression that Hitler cared for the well-being of the individual. It propagated the right furniture, the right cutlery, and the right spirit. The modern canteens came complete with the bust of the Führer and some new German art. Every improvement was celebrated in documentary films like *Beauty of Work*. Propaganda films showed the poor conditions of the past and the beautiful ones to come. They skillfully used simple emotional images. The new worker was of course healthy and useful. The building of sports and washing facilities stood high on the agenda. Through cultural changes Hitler wanted to create the New Man. "The German people with their newly awakened affirmation of life are seized with admiration for strength and beauty and therefore for that which is healthy and vigorous. Strength and Beauty, these are the fanfares sounded by this age, clarity and logic dominate its effort."[4]

In the guise of carrying out social improvements, the government set about controlling people's tastes and attitudes. Everywhere the same demands: simplicity, traditional values—a volkish design. The Ministry of Housing designed not only houses but also furniture, porcelain, and lamps. Here, too, the National Socialists borrowed from the past. The designs of the Bauhaus with their simple lines suited the volkish message and the shortage of materials, and found their way into the new production.

Communal work and harvesting were also encouraged. Paintings, films, and photographs constantly showed young people working on the land. It was one way to solve the problem of unemployment but it also took on deeper meanings: it was used to create a feel-

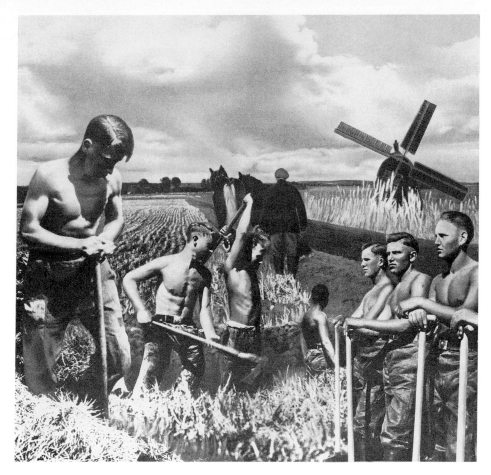

Young volunteers in the Reich
Labor Service. Magazine cover

ing of self-confidence, and to transform manual labor into a kind of ritual. The reclamation of land and swamps became the symbol of conquest and of belief in the future. The work was done with military precision. These were no longer simple workers. They had become the soldiers of the soil. "We conquer land, what gets in our way we kill" went a famous song. Hitler himself took part in endless inauguration ceremonies, digging, hammering, and troweling. He opened trade fairs and motor shows, and posters and propaganda films never ceased to stress the superiority of German technology.

New national feast days were invented with predetermined rituals, imitating the Christian calendar: the Day of the Accession to Power, Harvest Day, Hitler's Birthday, Labor Day, Mother's Day, Memorial Day. They consolidated a mythical Party history with the figure of the leader at its core. Hitler's assembly halls were to have bells, in order to become the churches of the future. In his speeches he borrowed freely from church liturgy in order to lend sacred overtones to his own services. His sense of theater was

combined with a bogus religiousness that involved frequent mention of God or the divine mission. There were, of course, special days devoted to German art, culminating in the large processions of the Day of Art in Munich to coincide with the opening of the "Great German Art Exhibition 1937."

There were a number of other rituals and public activities with quasi-religious overtones established with Party support. These had one purpose in common, to enfold Party members and, by extension, all Germans in a seamless web of propaganda. In due course a special office was founded to stage and coordinate these meetings and to fix a calendar of public celebrations.

Many events involved the young. Summer solstice, "the March to the Führer," and nightly meetings with pep talks and songs drew the young away from their homes into a marching and singing community. They borrowed from the Youth Movements of the Weimar Republic, with their marches and their idealization of an unspoiled countryside and the simple life. The Youth Leader, Baldur von Schirach, led millions of young Germans to Hitler. The ecstatic lyricism of his

MERCEDES-BENZ

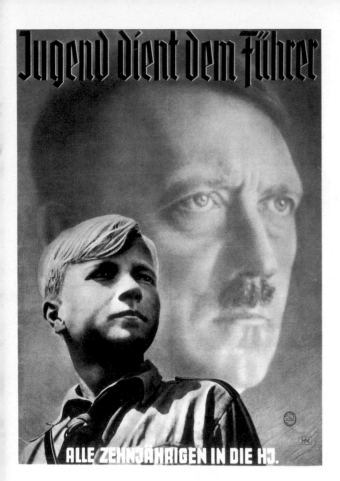

songs manipulated the feeling of purpose and self-confidence of those who follow a flag. He never tired of urging youth to give up their individuality in order to enjoy a mystical union with the community and, if necessary, even to be ready to die. His most famous song pledges, "We follow the flag; it means more than death."

The cult of a heroic death became a major obsession in the arts. Painting, sculpture, film, and literature constantly glorified death and the deeper meaning of sacrifice. Ceremonies like the mass oath of allegiance, the blessing of the flags, the singing of hymns were meant to weld the community into one.

In an eternal struggle for Germany they adopted venerated monuments like the Teutoburg Monument (1875), in West Prussia, celebrating a German victory over the Romans, and the Tannenberg Monument, in East Prussia, erected to commemorate a victory in World War One. The Walhalla, a hall of fame near Regensburg, built from 1830 to 1842, and the Befreiungshalle (Liberation Hall), near Kelheim, built from 1842 to 1863 to mark the Napoleonic wars, became important meeting places for the National Socialists. In this way, the dead of the past and those of the present became one. The National Socialists built many monuments of their own to the dead. Hitler

Above:
"Youth Serves the Führer. All Ten-Year-Olds into the Hitler Youth."
1936. Poster

"You, Too, Belong to the Führer."
1936. Poster

Opposite:
Advertisement for Mercedes-Benz

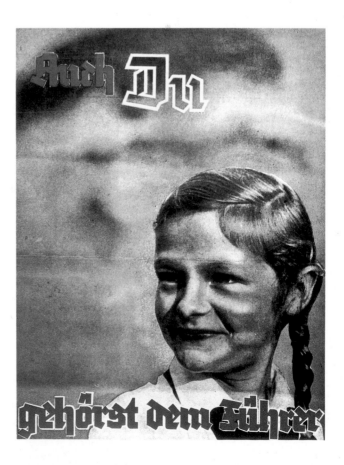

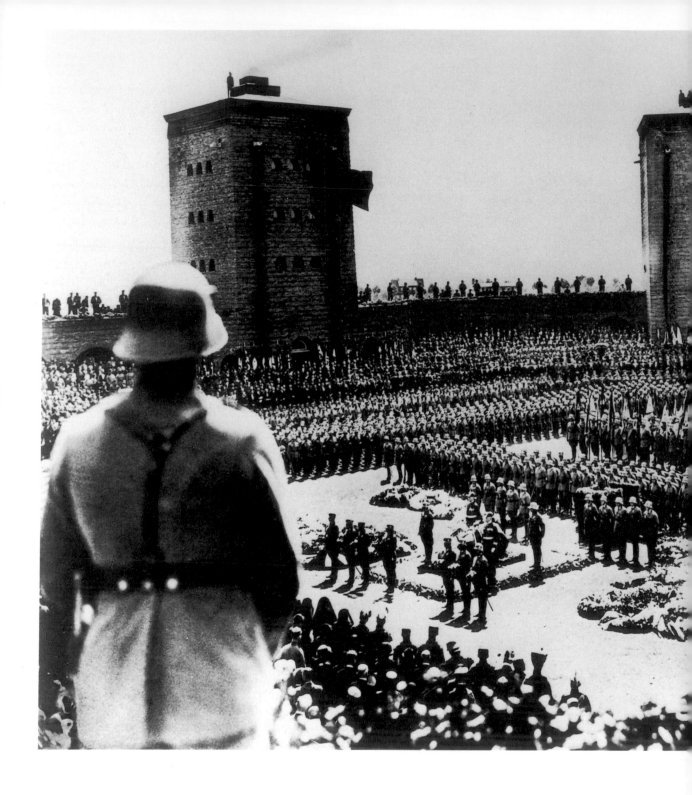

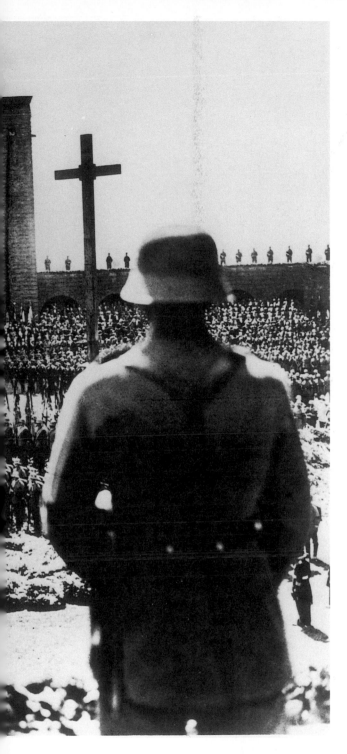

not only wanted to honor those who had already fallen, but also wanted places of worship for those who were prepared to do so. The architect Wilhelm Kreis planned monuments, fortresses, and cult centers all over Germany. Kreis, who had made a name for himself with his fantastic buildings for museums and department stores, was soon absorbed by the National Socialists. He became a specialist in the design of the necropolises with which Hitler wanted to pepper the Reich, from the highest mountain to the loneliest stretch of coast. For Berlin, Kreis planned a giant Soldatenhalle (Soldiers' Hall). Taking people's minds off the horrors and sufferings of the war, this hall was an invitation to consider dying for the Party and the state. In its crypt were to be housed the sarcophagi of the heroes. It would remind people that self-sacrifice was the ultimate gesture.

Another quasi-religious movement was the Thing Movement. "Thing," literally "assembly," referred to the old tribal council held around an oak. The "Thing" Movement was the reflection of a desire to return to a primitive earthbound religion, and to revive Teutonic fertility cults. Its use was now extended to mean "national festivals," celebrated in "Thing" theaters. A "Thing" theater was a ceremonial place with a chorus as well as audience participation, a combination of the open-air theater based on the Greek amphitheater and the church. The theaters mounted mostly mythical plays with a kind of all-embracing volkish theme that was to foster a sense of national self-awareness. The National Socialists had planned four hundred such theaters throughout Germany; about forty of them were built. One, in Berlin, the Dietrich Eckart Stage, was built by the architect of the Olympic Stadium, Werner March. The whole movement eventually petered out. The war, the harsh German weather, and the fact that rallies were a more effective way of controlling the masses spelled the end of yet another of the Party's absurd pagan revivals.

Tannenberg Memorial near Hohenstein in East Prussia during the state funeral for President Paul von Hindenburg. 1934

Walhalla near Regensburg. 1830–42. Architect: Leo von Klenze

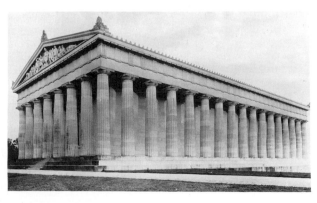

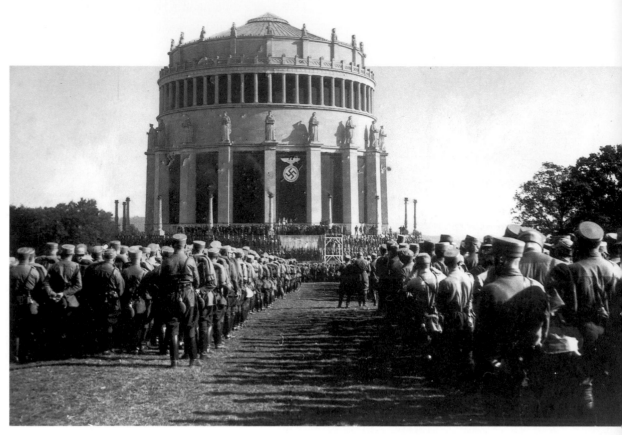

Befreiungshalle near Kelheim.
1842–63. Architect: Leo von
Klenze. Hitler speaking here on
October 22, 1933

The most powerful weapon in the National Social-
ists' propaganda arsenal were the mass meetings.
Many of the public and communal meetings were
modeled on the theater of the Weimar Republic. Col-
lective dreams had been staged by Max Reinhardt in
carefully rehearsed performances in which actors,
lights, and public were all fused in a kind of total art,
or *Gesamtkunstwerk*. These productions and the musi-
cals, with their giant staircase for large casts, became
the models for Hitler's mass marches. Hitler displayed
his pathological need to perform together with the
massed ranks of his followers for the first time on a
grand scale in 1929, when he held the big Party rally in
Nuremberg. Over two hundred thousand people ar-
rived in special trains. The colorful and noisy display
of their banners, uniforms, and marches would become
a hallmark of future rallies. Wave after wave of people
marched for five and a half hours in front of a leader
who was not yet in command, though his craving for
public display made it appear that he was.

In these mass marches the enthusiasm for the re-
gime was carefully orchestrated in the form of a

Rendering of the Bismarck Memorial on the Rhine. 1902. Architect: Wilhelm Kreis

Rendering of the Warsaw Memorial. 1941. Architect: Wilhelm Kreis

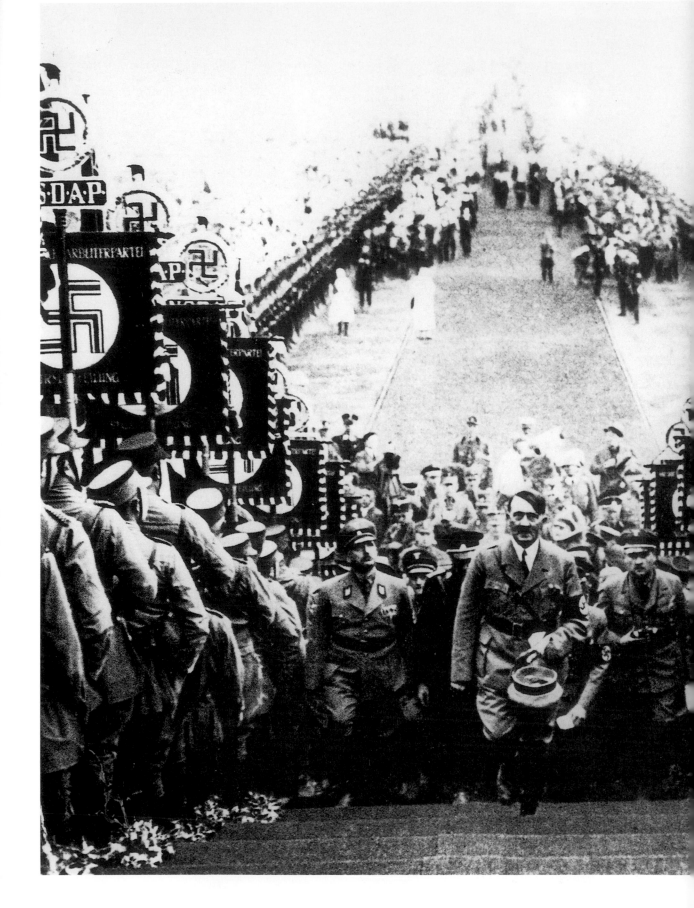

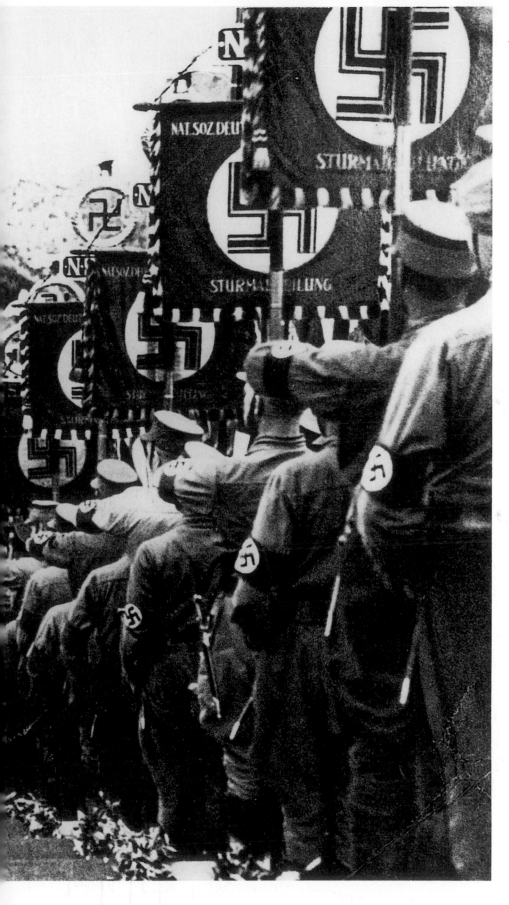

Hitler walking up to the reviewing stand. Still from Leni Riefenstahl's film Triumph of the Will, *1934*

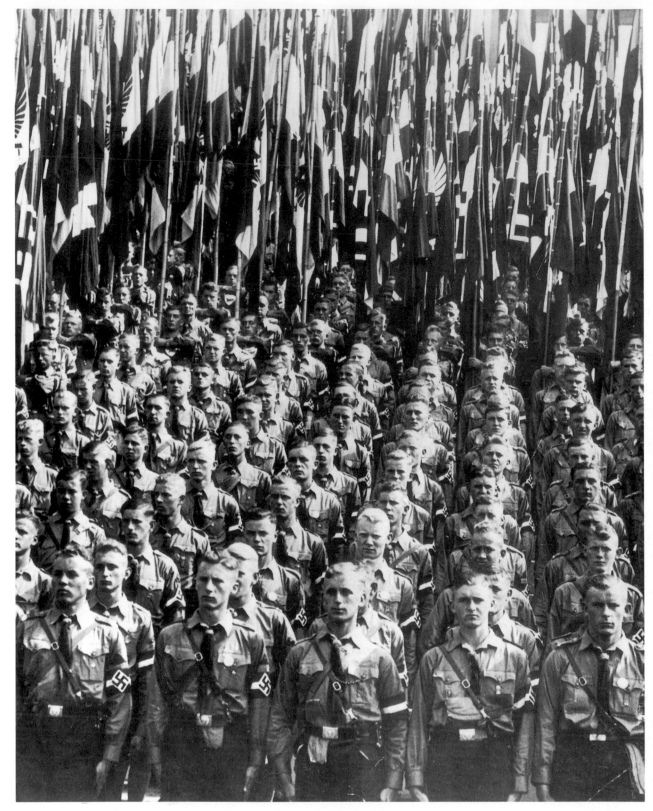

Hitler Youth with standards, Party Rally, Nuremberg, 1938

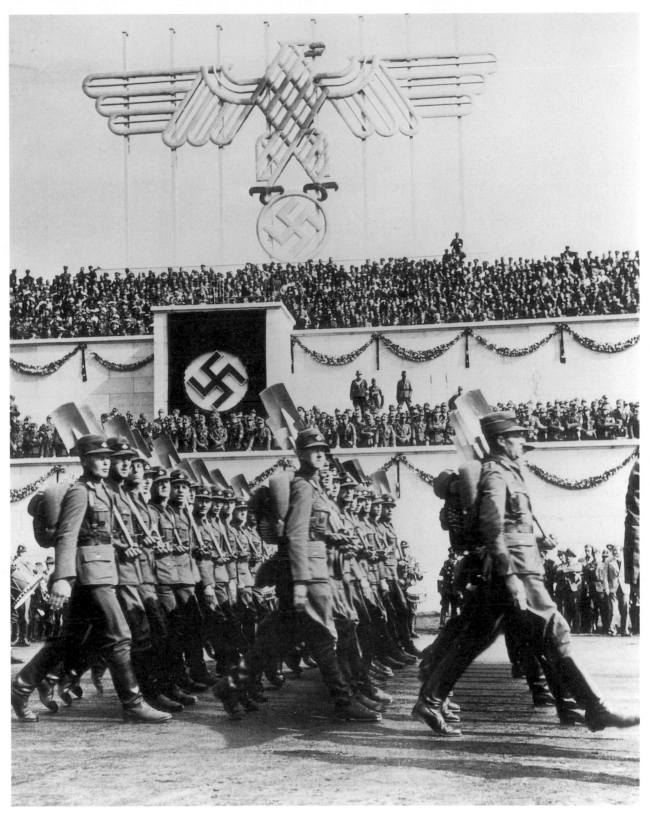

A brigade of the Reich Labor Service bearing spades in review before Hitler, Party Rally, Nuremberg, 1937

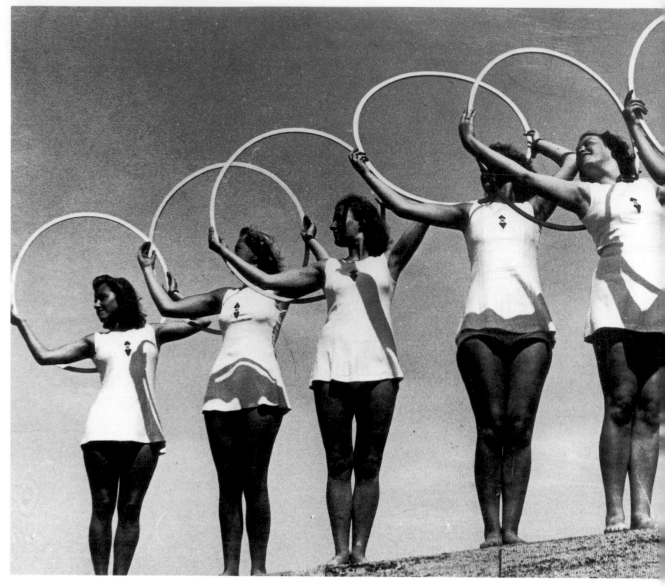

Gymnasts with hoops

complex visual arrangement of uniforms and group formations, choreographed like a ballet.

People are no longer a mass of individuals, a formless, artless mass. Now they form a unison, moved by a will and a communal feeling. They learn again to move in formations or to stand still, as if molded by an invisible hand. A new body feeling is born, beginning simply in the feature of lifting the arm for the greeting and culminating in the mass march. . . . The notion of a "communal body" is becoming a reality. Noble passion is stirred up, changing what is ephemeral into something lasting."[5]

Here too elements taken from the liturgy completed the ritual. Hitler said that "the concluding meeting in Nuremberg must be exactly as solemnly and ceremonially performed as a service of the Catholic Church."[6]

The Party rallies, the Reichsparteitage, in Nuremberg became for Hitler a kind of Wagnerian *Gesamtkunstwerk*. The whole of Germany had become Hitler's stage, and the audience was always guaranteed. The rallies expressed power, order, solemnity. The architecture, too, had its part to play, and the people became the attribute and ornament of the buildings. They gathered in and around *their* architecture, in orderly columns like those on *their* buildings. They became architecture themselves, answering Hitler's call for a "form-giving will." Flesh and stone became one, as stone and word had become one in *"Das Wort aus Stein"* (the word in stone), as he used to call architecture. It was the expression of a political idea. In these rallies, Hitler the theater fanatic—assisted by the mass orator Joseph

Goebbels and the architect Albert Speer, who built the settings for these spectacles—created his ultimate stage productions. Every occasion became an awe-inspiring event, a fascinating geometry. The mass became part of the set in a gigantic happening, a communal celebration that eliminated the brain and led to ecstasy.

All had the appearance of grand opera. Songs and the chanting of "*Heil!*" prepared for the Führer's arrival, with the chants finally erupting in a wave of hysteria. Then Hitler would go through the long channel cut through the crowd, "a *via triumphalis*," as Goebbels described it, to take up his high, solitary position, singled out like a god, standing aloof above the sea of flags.

In 1934, the Heidelberg art critic Hubert Schrade wrote:

We believe that the time has come for art to represent the deeper meaning of our life. . . . There are moments when this meaning becomes visible in a mysterious way. We have lived such a moment in the morning hour of last year's Party meeting, when we honored the dead. The culmination came with the Führer, after a slow march along the central road, pausing at the giant wreath in meditation. His thoughts became audible to all. . . . The music played "Ich hatte einen Kameraden" [I Had a Comrade]. . . . This ceremony was the ultimate life-giving form. It was achieved through greatness and mass: the Luitpold Stadium covered by the brown of the uniforms was overshadowed by the red sea of the flags. "Like a field of tulips," as a painter remarked. But it is not for its pictorial splendor that we recall this hour. Photographs and films have captured the unforgettable beauty for us. It was an hour of our time, an hour during which life became form. It brought together power and architecture; that is what gave it its shape and made it special."[7]

Revue with military precision. Film still from Janine, *starring Marika Rökk*

The timing of pauses and the stage management of climaxes were as important as the music and the banners. Expectation was heightened by long pauses before Hitler spoke his famous opening: "Countrymen and countrywomen." Then he paused again, to let the thunderous applause subside. The tension reached almost unbearable levels. His ending was no less calculated. It usually came with a call for Germans to unite. Few politicians have produced such adoration, even hysteria, as Hitler. He carefully studied his style and the effects he wanted to achieve. People still cannot understand how a man with the face of a psychopath could fascinate so many. Looking at film clips and photographs of him today, we find the image he created ridiculous and incredible. Yet at the time, he moved vast crowds of different kinds of people. Biographers describe him as a man with an iron will, driven by a single-minded vision that enabled him to mobilize forces in an unprecedented way. His gestures, too, look ridiculous today. They were borrowed from the silent movies. To us, used to the close-up intimacy of television and of microphones, their emotionalism seems ludicrous. The mobilization of the masses does not happen at mass rallies anymore. It takes place in front of the TV screen. It is there that we receive the call to national unity, to law and order, and to the beauty of a perfect, more harmonious past. Our reactions are synchronized by advertisements, pop concerts, sports events. There is no need to go out to become involved. All the filmed speeches by Hitler, Goebbels, and the other Party bosses show clearly how these actors drove the people into ecstasy—a mixture of mysticism and eroticism. Screams, shouting, outstretched arms, grimaces—all generated a hysterical response in the audience that only those who have attended large rock concerts can understand. But here the ecstasy was orchestrated; it was a "disciplined ecstasy," not a chaotic one. It created a pseudo-religious state of submission.

There was no casual spectator; everyone played a

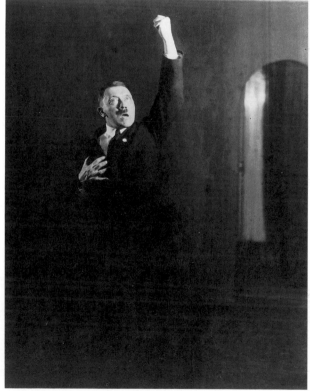

part. Discipline, obedience, self-sacrifice, loyalty, duty—these were the highest virtues. The individual had to enter the mass.

Many of Hitler's speeches dealt with culture. Even his most political speeches contained some references to the arts. But whether speaking in front of an invited audience or at a mass meeting, his message was always of the same triviality. It is hard to understand how he was able to convince anybody with his ideas, and yet his success was overwhelming. Hitler was a man who could deal in simple images. His success was built on oratory that fired the masses. The platitudes were uttered with a rare energy and charisma. It was not reasoning but passion that made him so convincing. He did not need reasoning. He appealed to the Germans' loss of pride and confidence, stirring up the most basic feelings. He played on what they wanted: stability, order, tradition in art. The contents of his speeches hardly varied: the same clichés—often peppered with religious metaphors. Hitler made political capital out of many streams of thought, fusing them together in his ideology. He sensed the mistrust of the masses toward liberal middle-class values and brought this slumbering resentment into the open.

People are still amazed that so much of Hitler's thought dealt with the arts. Many still do not realize that the arts for Nazi Germany provided a convenient means to gain the legitimation it totally lacked. Most of Hitler's ideas on culture and the arts stemmed from *Mein Kampf,* written in a verbose pseudo-educated style, with neurotic obsessions that made the book difficult reading—even for the most devoted. The egomaniacal craving for power and the total blindness to the rights of other people were all spelled out in Hitler's book. Despite the ten million copies printed, few people had actually read it. As with so many things—the concentration camps and the persecution of Jews—those who wanted to know could have known. But most preferred to turn a blind eye.

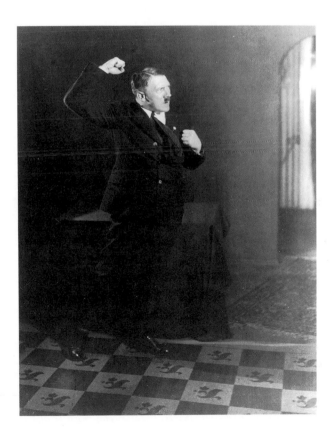

In photographer Heinrich Hoffmann's Munich studio Adolf Hitler practiced expressions and poses before the camera. 1926

CHAPTER 6 THE "GREAT GERMAN ART EXHIBIT

DURING THE YEARS BEFORE 1933 AND THOSE WHICH FOLLOWED THEM, I WAS CONVINCED THAT ONCE THE FIRST BUILDINGS WERE FINISHED, THE SCREAMS AND ATTACKS OF OUR CRITICS WOULD BE SILENCED. THE DECISIVE OPINION WOULD NO LONGER BE THAT OF THE ROOTLESS LITERATI BUT THAT OF THE PEOPLE. THE MORE THE NEW ART FULFILLS ITS TASK, THE MORE IT SPEAKS TO THE PEOPLE, WHICH MEANS TO BE ACCESSIBLE TO THE PEOPLE. IT DOESN'T MATTER WHAT A FEW CRAZY INTELLECTUALS STILL THINK ABOUT IT. . . . THE WEIGHT OF THE AFFIRMATION OF MILLIONS MAKES THE OPINION OF A FEW INVALID. THEIR OPINION IS CULTURALLY AS UNIMPORTANT AS THE OPINION OF SOME WHO ARE POLITICALLY MARGINAL. . . . AS THE REICH GROWS, SO GROWS ITS ART. . . . THE WHOLE FAKERY OF A FASHIONABLE DECADENT OR DISEASED AND UNTRUTHFUL ART HAS BEEN BRUSHED ASIDE. A PROPER STANDARD HAS BEEN REACHED. . . . WE NOT ONLY BELIEVE IT, BUT WE KNOW THAT THERE ARE SIGNS OF STARS IN THE GERMAN CREATIVE SKY. . . . FROM NOW ON, FROM EXHIBITION TO EXHIBITION, WE WILL APPLY STRONGER CRITERIA IN ORDER TO SELECT FROM THE WORTHY TALENT ONLY THE EXCEPTIONALLY GIFTED ONES. . . . I WOULD LIKE TO EXPRESS THE HOPE THAT IN FUTURE SOME OUTSTANDINGLY GIFTED ARTISTS WILL LEND THEIR TALENT TO THE EVENTS AND THE PHILOSOPHY OF THE TIME THAT GIVES THEM THE MATERIAL BASIS FOR THEIR WORK. HOWEVER MANIFOLD THE PREVIOUS HISTORICAL VISIONS OR EXPERIENCES WERE THAT EXCITED AND FERTILIZED THE ARTIST'S IMAGINATION, THE GREATNESS OF THE PRESENT TIME STANDS ABOVE ALL. IT CAN CHALLENGE THE GREATEST EPOCHS IN GERMAN HISTORY. —Adolf Hitler, 1939[1]

IONS"

If the first four years of
the National Socialist regime can be seen as a struggle
to pervert the history of art and to prepare the people
for a new mass aesthetic, the year 1937 marked a clear
break with the past. With the opening of the first
"Great German Art Exhibition" in Munich in July and
the last public showing of Modernist works, at the "De-
generate Art" exhibition, the battle was over. The new
German art, as the National Socialists saw it, was
firmly established.

As soon as Hitler took power, he commanded his
favorite architect, Paul Ludwig Troost, to build a
House of German Art in Munich. It was to replace the
Glaspalast, which had burned down in 1931 and with
it three thousand works of art, among them many
paintings by German Romantics like Caspar David
Friedrich and Moritz von Schwind.

The day the cornerstone was laid was declared the
first Day of Art. The museum was to be a great patriot-

1937

GROSSE
DEUTSCHE
KUNSTAUSSTELLUNG
1937
IM HAUS DER DEUTSCHEN
KUNST ZU MÜNCHEN

OFFIZIELLER AUSSTELLUNGSKATALOG

*The "Great German Art Exhibition
1937," House of German Art,
Munich. Cover of the exhibition
guide*

*Opposite:
Hitler visiting the "Great German
Art Exhibition 1939," House of
German Art, Munich, with (left to
right) Reichsführer SS Heinrich
Himmler, Propaganda Minister
Joseph Goebbels, Italian
Propaganda Minister Dino Alfieri,
unidentified person, Professor
Gerdy Troost, and Baron
Konstantin von Neurath*

ic gesture, a monument for the whole country. In front of the entire establishment, with many representatives from the art world, the church, the Party, and the cities, Hitler stressed, in an almost hysterical speech, his link with the Bavarian king Ludwig I—who had transformed his capital into a flowering, art-loving city and who had built many museums and palaces—and the cultural mission Hitler saw for himself and the city of Munich. Unfortunately the hammer broke on the cornerstone—not a good omen for the new art.

Three and a half years later, on July 18, 1937, the House of German Art was opened in a ceremony that vastly surpassed the first one in splendor and euphoria. If there were any doubts about the direction the cultural politics of the Third Reich should take, they were resolved with the opening of the first "Great German Art Exhibition." "May this house be devoted only to serious art, art that is in our blood, art that people can comprehend. Because only the art that the simple man can understand is true art," said a National Socialist newspaper.[2]

The "Great German Art Exhibition" had, according to Hitler, two aims: (1) "to give the honest German artist a platform on which to exhibit," and (2) "to give the German people a chance to see and purchase this work." Pictures were submitted in an open competition. "All German artists in the Reich and abroad are invited to participate."

The new museum was to be the model for all future German museums. "There will be no more museums in Germany which do not display German art prominently and centrally."[3] To define that further: "The new museum will separate clearly the national-stylistic from the national-sociological. The senseless mixture of art groups which confuses the visitor is no longer possible. German art is not every work of art made in Germany. German art is art made in Germany by German artists. Grown in Germany, not artificially raised."[4]

The press boasted that 25,000 works had been submitted for the first exhibition, whereas the real number was 16,000. Of these over 600 went on show. The president of the Reich Culture Chamber, the painter Adolf Ziegler, supervised the selection of paintings, while the sculptors Arno Breker and Josef Wackerle were responsible for the sculptures.

There was a tradition in Germany of annual exhibitions in which artists could display their work in the same way as at the academy or salon exhibitions in France and England. The "Great German Art Exhibi-

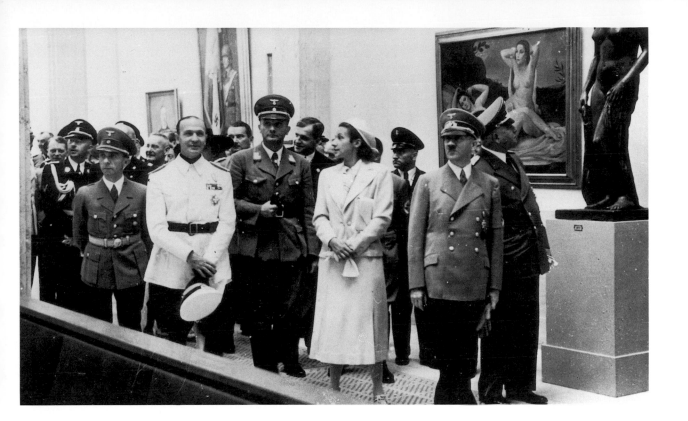

tions" were in this tradition. They consisted simply of works of art for sale. What was new was the intervention of the state as the main commissioner of art. They were "not an art fair with special reference to the newest, but the visual expression of the eternal—external and internal—values of our *Volk*. Created by artists of our time, as clear and truthful as the building, they are exhibited in a temple of art, not in a factory," as Werner Rittich, one of the leading art critics, put it.[5]

There were no formal criteria; the selection was based on Hitler's taste and on that of the judges. Hitler himself stepped in and rejected 80 pictures as "unfinished." "Mere sketching has been radically excluded; only pictures which have been 'worked' are shown. There is no room for questioning about the meaning of a work," reported a critic. "The most decisive element about the 'Great German Art Exhibition' is that it is the fighting call against any problematic. There is no room for experiments here. In this accomplished house only accomplished art shall enter. . . . Here we are shown what the new German art truly looks like. The result is a sharp rebuke of the past."[6]

Participation in one of the "Great German Art Exhibitions" became almost indispensable for an artist's reputation. The official arts magazine *Die Kunst im Dritten Reich* (Art in the Third Reich) and the general press

reviewed almost exclusively artists who had been exhibited in the Munich show.

"As in politics, so in the world of German art we are determined to sweep away slogans. Ability [*Können*] is the qualification necessary for the artist who wishes his work to be exhibited here," Hitler said. But the Nazis not only dictated the style of the works, they also made sure that the artists would choose the right subject. "The Führer wants the German artist to leave his solitude and to speak to the people. This must start with the choice of the subject. It has to be popular and comprehensible. It has to be heroic in line with the ideals of National Socialism. It has to declare its faith in the ideal of beauty of the Nordic and racially pure human being."[7]

A Cologne critic described the basic thematic structure of the show:

A walk through the exhibition proved that the principles of clarity, truth, and professionalism determined the selection. . . . The heroic element stands out. The worker, the farmer, the soldier are the themes. . . . Heroic subjects dominate over sentimental ones. . . . The experiences of the Great War, the German landscape, the German man at work, peasant life. . . . The life of the state with its personalities and developments. These are the new subjects, they demand new expressions and styles. . . . In accordance with the subject, the style of most of the works is clear, strong, and full of character . . . there is a whiff of greatness ev-

erywhere. Healthy, fresh, and optimistic artists are showing their work with manifold individuality. A new era of art has begun.[8]

The "Great German Art Exhibitions" were also supposed to provide an educational experience:

The annual exhibition in the House of German Art is more than a display of art. Other exhibitions do that too. This selection is the harvest of the artistic will. On its banner stand the words of the Führer: "Art is a mighty and fanatical mission." National Socialism has removed art for all times out of the sphere of individuality and has put it at the service of the community. Just as our philosophy gives each individual the strength to bind him-self to race and people, so does art return from solitude into the fold of the community. . . . Art has received the task of mirroring German life in its manifold richness, of mirroring the richness of the German soul in pictures which ring the political change. The artistic struggle is no longer an aesthetic one, but one for the mobilization of the German character. Artistic change is the symbol of political change; it lets the heart sing out when it concentrates on the silent forces of nature, man, plant, and animal. This is not an idyllic Biedermeier refuge or an empty pastiche. The young German art which passionately addresses the people and represents their soul also knows the heroic, the manly stance in the picture of the soldier's readiness to fight, or in the clear rendering of beauty so akin to antiquity.[9]

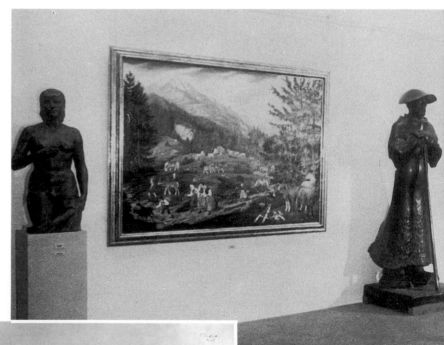

Exhibition "In Praise of Work," House of Art, Berlin, 1936. Center: Fritz Koelle, Ironworker; Helmut Schaarschmidt, Earth Work
"MAY THIS HOUSE BE DEVOTED ONLY TO SERIOUS ART, ART THAT IS OUR BLOOD, ART THAT PEOPLE CAN COMPREHEND. ONLY THAT IS TRUE ART THAT THE ORDINARY MAN CAN UNDERSTAND."
—HERMANN GÖRING

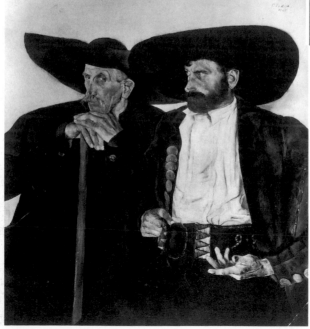

Paul Mathias Padua. Peasants from Ruhpolding. *1928*

The exhibition was supposed to be a cross section of the best in German art. It had a programmatic character, introducing the new art and clearly demonstrating the break with the art of the Weimar Republic. "For the first time in 150 years, culture no longer takes its orders from Paris. The forceful cultural renaissance comes from Germany and influences other countries. An art form which only yesterday was counted as exemplary has been unmasked. People are coming to their senses. In art they call for simplicity, honesty, and directness. We have overcome Impressionism, Expressionism, and New Realism and whatever other names there are, and we have attained clear images."[10]

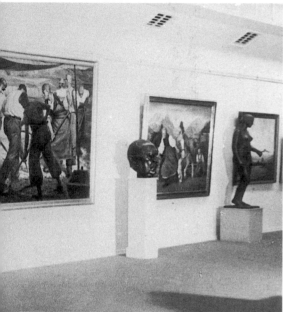

At this exhibition, as in the others to follow, the pictures were mostly displayed by subject—order was also expected in the arts. Flower painting, industrial landscape, the family, country life were all neatly categorized (see illustrations pages 116–17, 135–37, and 148–50). The exhibition was to be a mirror of the world, a confirmation of the regeneration that, according to Hitler, had taken place after painting and sculpture had been freed from all degenerate ingredients. The breakdown was: 40 percent landscapes, about 30 percent showing ordinary people, 11 percent portraits of historical figures, 10 percent animals, and 7 percent still lifes.

The majority of the entries were traditional. For almost every painting exhibited one could find a precursor in the history of art. In many aspects the exhibition did not differ from earlier southern German art shows, a further proof that the National Socialists did not invent a style which emerged overnight in 1933, but that the art of the Third Reich was the result of a continuous process, of something which existed before. Goebbels himself frequently bemoaned the absence of younger artists. In fact, of the exhibiting artists, 250 had showed their work in the Munich Academy exhibitions before Hitler came to power.

Fritz Erler (1868–1940) was over sixty when the National Socialists came to power. A respected and

Helmut Schaarschmidt.
Earth Work

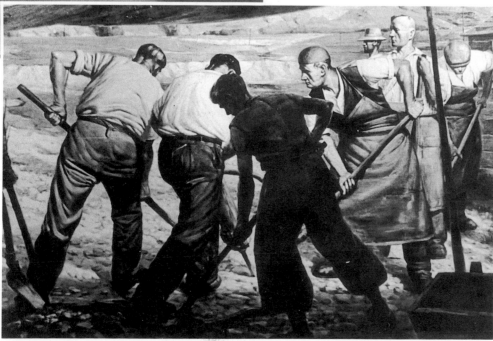

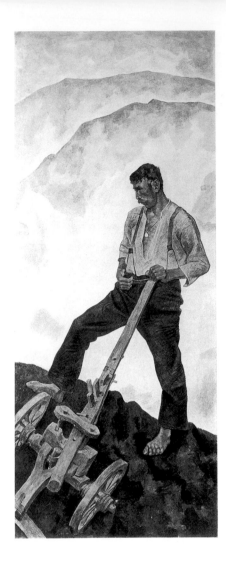

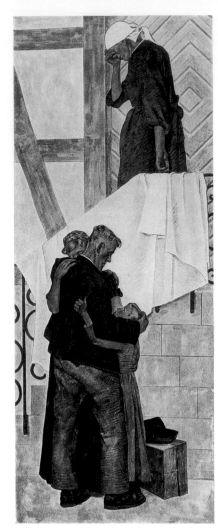

successful Munich painter from the Art Nouveau move-ment, he, together with Ferdinand Spiegel (1879–1950), was nevertheless lured by the new regime to make propaganda pictures for the military. He aban-doned the softer and more naturalistic style of his earlier peasant paintings for steely renderings of men from the SS and SA.

Paul Mathias Padua (1903–1961), another favorite of the Nazi elite, was younger, but like many others did not need the support of the National Socialists. A tra-ditionalist, he worked in the manner of the French realistic school, and his paintings of Bavarian peasants were very popular (see page 97). In style and expres-sion his earlier work did not differ from that exhibited in Hitler's "Great German Art Exhibitions." His is a typical case of a talented artist being absorbed into the political machinery. He had only to add a few de-tails, like a picture of Hitler or a *Volks* radio, in order to fit the requirements. As time passed, Padua was more and more sucked into the maelstrom of Nazi ide-ology. His picture *The 10th of May* (see pages 164–65), in which a German soldier beckons the people to fol-low him, was a blatant propaganda picture with which the artist celebrated the beginning of the invasion of France.

Other painters with no particular political aim let their work be used for the Nazi ideology. Hermann Ur-ban (1866–1946) was a successful landscape painter and contributed several so-called heroic landscapes to the official art exhibitions. This prompted Paul Schultze-Naumburg to write ecstatically about Urban's work as representing the artistic battles against the barbaric world. "His landscapes show us that all life is a battle. Those who do not take up the battle will be trampled underfoot."[11]

Franz Eichhorst (1885–1948), a painter of German peasants, was also easily won over. Relying on his ex-perience during World War One, he made a specialty of the heroic soldier. His giant frescoes (105 feet long and 13 feet high) for the Berlin city hall, Schöneberg,

which covered four walls, were a celebration of the rise of the Nazi movement. There was the whole National Socialist cast: the young couple, the mother and child, the workman, the farmer, and the soldier getting ready for the fight. All this was heavily decorated with Nazi insignia and a generous sprinkling of flags. "This is Germany's road during the last twenty-five years, a timeless picture of the destiny of a people in its fight for existence and for the future," wrote Robert Volz in *Die Kunst im Dritten Reich*, November 1938.

The very respectable Conrad Hommel, a favorite portraitist of the pre-Hitler era who had painted Marshal von Hindenburg and Albert Einstein, also fell into line. After Hommel had painted Göring, he became the favorite portraitist of the Party, turning out endless pictures of Hitler (see illustration page 105), Goebbels, and the other cronies. His paintings became increasingly pompous and empty.

Hommel was not the only painter of the old Munich Secession who "adjusted" his style to the new demand. The venerable Munich Secession, which grew out of the Impressionist school, furnished many painters for the "Great German Art Exhibition." Some, like Eduard Thöny (1866–1950), painted military subjects but maintained at least some artistic integrity by con-

Conrad Hommel. General Field Marshal Hermann Göring. *1939. "Great German Art Exhibition 1939"*

tinuing to paint as they did before. The same can be said about the Secession painter Leo Samberger (1881–1949). Paul Herrmann (born 1864), Elk Eber (1892–1941), and Hans Schmitz-Wiedenbrück (1907–1944) also furnished the new regime with paintings with National Socialist and war themes.

The best pictures of rustic genre scenes came from painters like Adolf Wissel (1894–1973; see illustration page 106), Thomas Baumgartner (born 1892; see illustration page 143), Constantin Gerhardinger (1888–1970; see illustration page 140), Oskar Martin-Amorbach (born 1897), and Julius Paul Junghanns (1876–1958; see pages 134–35). There were the strong horses and cows of Franz Xaver Stahl (born 1901). Most of these artists were past the middle years of their life; they painted as they had always done—traditionally, neatly, without artistic conflict. Their style and their message suited the National Socialists well.

If one did not know that Albin Egger-Lienz (1868–1926) painted around 1910, one could easily think that his work was done during the Third Reich. It was no accident that he became one of the favorite precursors of these new artists.

Werner Peiner (born 1897) is a case of artistic corruption of a different kind. A successful painter before Hitler, he became professor at the Düsseldorf Academy

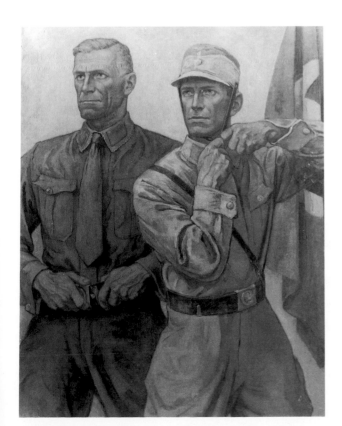

Elk Eber. Brown Shirts Take Over—February 23, 1933

Oskar Martin-Amorbach. Evening

Albin Egger-Lienz. Life.
1912. Detail

Julius Paul Junghanns.
Self-Portrait. *1935*

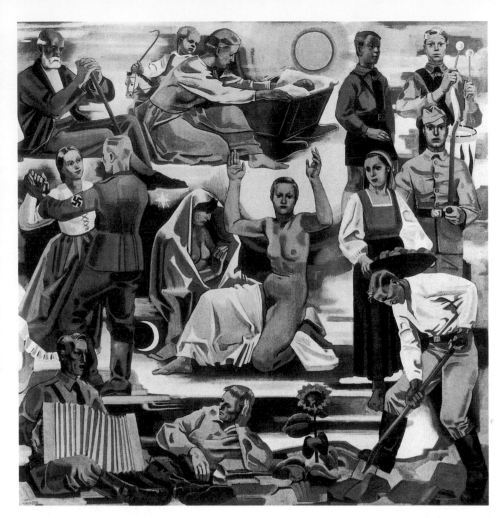

Rudolf Hermann Eisenmenger.
Mural behind the wall clock of the
Vienna office of the Reich Labor
Service

Werner Peiner.
Autumn in
the Eifel

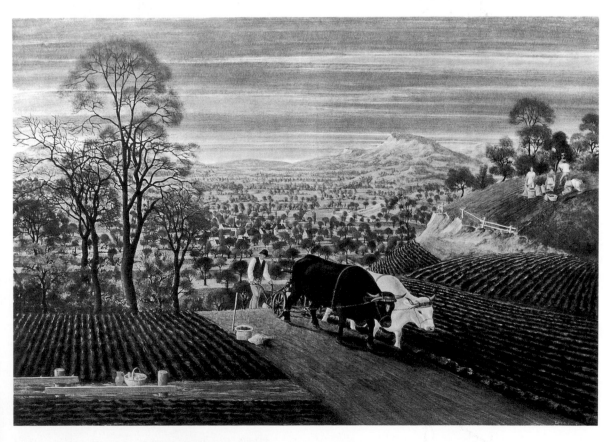

after other artists like Paul Klee, Jankel Adler, and Oskar Moll had lost their teaching posts. A volunteer in World War One, Peiner hesitated a long time deciding between the profession of architect and that of painter. Influenced by the old Italian and Dutch masters, he found the salvation of the world in the traditional values. Without the National Socialists he would have had a decent career as a realist artist. One cannot accuse him of changing his subjects to suit the National Socialists, but he allowed himself to be absorbed by them. His renderings of the earth, the changing of the seasons, the ripening of the corn were the very subjects of the blood and soil philosophy. And he lived well by these works. He became one of the most honored artists, the president of the Hermann Göring Academy for Painting, which was later to be called the Werner Peiner Academy.

Rudolf Hermann Eisenmenger was one of the few artists in the "Great German Art Exhibition" born in this century (1902). He studied in the twenties at the academy in Vienna and won the Rome Prize. His

Peasant women at the "Great German Art Exhibition 1943"

Visitors at the "Great German Art Exhibition 1943" in front of Rudolf Hermann Eisenmenger, Three Women at the Fountain

Carl Spitzweg. Childhood Friends. *ca. 1855*

peaceful landscapes and traditional portraits as well as
his nudes and allegories fitted comfortably into the
iconography of the Third Reich. In 1936 he won the
Olympic medal for painting. He also painted large fres-
coes (see illustrations pages 101 and 107), notably in
the Vienna city hall.

History has made us oversimplify. We tend to think
that those who turned their backs on the regime were
all good artists, and that those who remained were the
bad ones. We also have the notion that there was a
clear separation between those who embraced the re-
gime and those who rejected it, as if 1933 were a
magic moment that separated the whole of Germany
into two camps, the National Socialists and their op-
position. There were many shades. Some people
continued to work as they had always done, some re-
belled privately, and some stood in the wings, waiting.

Nevertheless, it is wrong to suppose that all the art
exhibited was nonart or totally third-rate. Much of it
was no better and no worse than that exhibited in the
so-called academy exhibitions of the pre-National So-

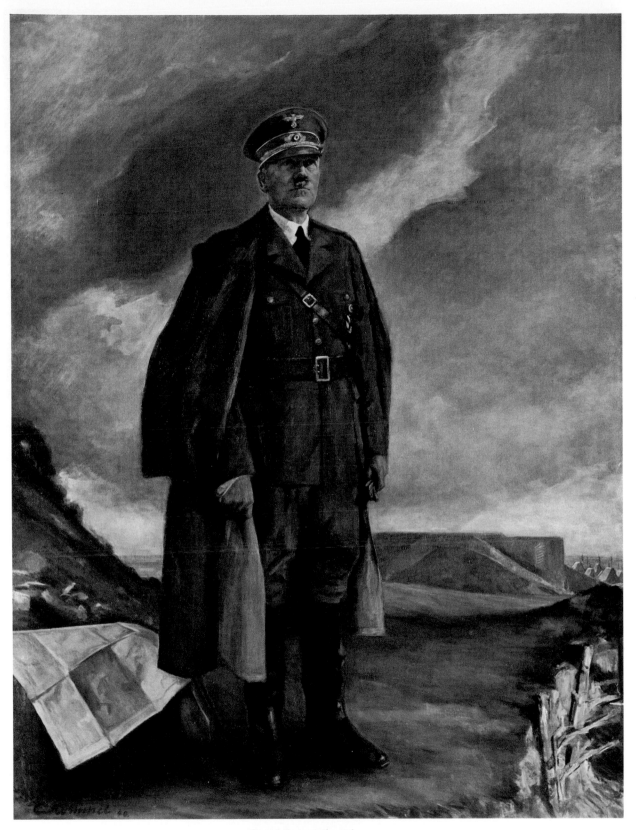

Conrad Hommel. The Führer
and Commander-in-Chief
of the Army. *1940. "Great
German Art Exhibition 1940"*
"AN EXAMPLE OF THE HIGH
STANDARD OF THE ART OF
PAINTING."—ROBERT SCHOLZ

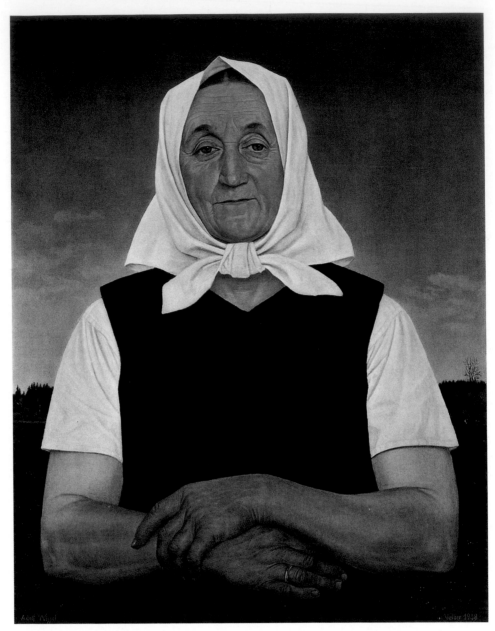

Adolf Wissel. Peasant Woman.
"Great German Art Exhibition
1938"

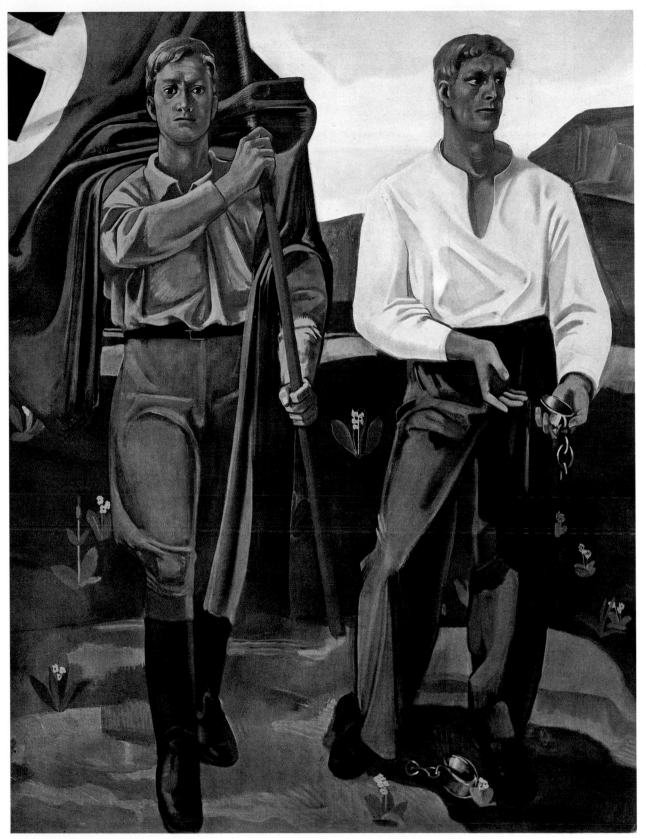

Rudolf Hermann Eisenmenger.
Homecoming from the Eastern
Front. *Detail of a mural*

Karl Alexander Flügel. Harvest.
*"Great German Art Exhibition
1938"*

cialist era. To be sure, many artists who had been members of the old Munich Secession had now changed their style to suit the new demands, throwing all integrity overboard.

Not all the officially accepted artists were vehement defenders of National Socialist ideas. Some tried to develop a working compromise between conformity and open rebellion. Like so many of their fellowmen, they were acquiescent. They profited from the state and on the whole continued to paint in the same way as they had done before. Some introduced titles which obeyed new demands. Sometimes the addition of the word "German" to the title was the only visible link with the ruling system. "German Earth" or "German Oak" sometimes sufficed; ideas which were actually not apparent in the picture but could be read into it. In this fashion artists willingly let their paintings serve as propaganda. Their participation in these exhibitions lent credibility to the regime. Even "apolitical" works served this purpose. Many artists complied, willingly shedding their principles.

There were many contradictions in the arts policies of the National Socialists. The decision about what was to be allowed and what was not was not always as clear-cut as it seems now. Some work by Ernst Barlach won the support of several more enlightened members of the leadership. Sometimes a publication slipped by. The Rembrandt Verlag published a volume of *Young Sculptors* which included among some official artists many semiofficial figures whose style and subject matter disqualified them from entering the big official "German Art Exhibition." Baldur von Schirach attempted as late as 1943 to show some semiofficial art in the Künstlerhaus in Vienna, with an almost subversive catalogue. Among the 173 artists were some representatives of the New Realism like Theo Champion and Ernst Thomas. There were many artists whose reputation had not been tarnished. Hitler sent his spies to the Künstlerhaus, and the show closed after one week; the ill feeling between Hitler and Schirach lingered on after this event.

There were contradictions also in the choice of what was allowed to be shown and what was not. The Cubist sculptor Rudolf Belling (1886–1972) had one work prominently displayed in the "Degenerate Art" exhibition, while another work of his—the bust of the boxer Max Schmeling—was shown in the first official "Great German Art Exhibition." Early in the Hitler years Göring commissioned another "degenerate" artist, Otto Dix, to paint portraits of his children.

Among the artists too there were many doubts, false hopes, and errors. There were those who originally embraced the National Socialist ideas and later bitterly regretted it. The most famous cases are those of the painter Emil Nolde, the poet Gottfried Benn, and the philosopher Martin Heidegger. The painter Franz Radziwill, a magic realist, had joined the Party in 1933. He became a professor at the Düsseldorf Academy and participated in the German pavilion at the Venice Biennale of 1934. One year later he was dismissed and his work banned.

Among art critics and art historians, there were also many followers, doubters, and fanatics. But for each critic speaking for the new German art there were also voices of dissent, like that of the eminent art historian Wilhelm Pinder. Some of the newly appointed museum directors, too, were unsure of the direction they should take. Some fought to show modern works. Up to 1937 Eberhard Hanfstaengl, director of the Berlin Kronprinzen Palais, managed to show works by the Brücke and the Blaue Reiter as well as by Klee, Kirchner, and other Modernists. Not all museum people were taken in by the National Socialists. Actually very few of the major German museums purchased works from the "Great German Art Exhibitions." Of course, this boycott of National Socialist art was not political but due simply to the fact that few works were good enough to be collected by a museum.

Most artists exhibiting in the official "Great Art Exhibitions" lived in the past and embraced the new traditional art policies. Painters like Ivo Saliger, Hans List, and Eberhardt Viegener did not disguise their love for the art of earlier centuries. It coincided with the preferences of the leadership. The Party members cherished old German masters, like Dürer, Altdorfer, Cranach, and the painters of the nineteenth century—Anselm Feuerbach, Philipp Otto Runge, and Hans Makart, whose empty and pompous theatricality appealed to Hitler's taste. Hitler's favorite painters were Carl Spitzweg, Wilhelm Leibl, and Hans Thoma. The paintings he surrounded himself with came from the late eighteenth- and nineteenth-century representatives of the Munich School: Franz von Lenbach (portrait of Bismarck), Franz von Stuck (*Die Sünde* [Sin]), Feuerbach (*Parklandschaft* [Park Scene]). In these much-loved painters Hitler and many of his contemporaries found the embodiment of everything that was true and real in Germans. They represented virtues to emulate. It was easy for Hitler to persuade people to accept an art modeled on these paintings.

In general, National Socialist paintings were based on traditional genre painting. They were in total contrast to work by the Modernists, who had broken free from this art form. Genre paintings suited the Fascist ideology. They implied a ready-made link with the past, with a golden Germanic age, which the National Socialists were so keen to forge. Their painting was basically a reworking of old-fashioned types and techniques.

Also, and most important, straightforward realistic paintings were easily overlaid with propaganda messages. Their static nature excluded any progressiveness. Their conservatism echoed the National Socialists' yearning for a wholesome world, and their contemplative character gave a feeling of depth and soulfulness. It was an art that did not ask any questions.

Each soldier, woman, and child in a painting was meant to elevate one group of people to the status of demigods, while condemning the rest to death. The evil in the National Socialist regime lay in the fact that, as Hannah Arendt observed, it decided who had the right to live. And art was used to drive this message home.

Titles were very important. They were to give the work a profound meaning. Landscapes became "Liberated Land" or "Fruitful Land." Seascapes became "Wind and Waves." Highways became the "Führer's Highways." Titles like "Through Wind and Weather," "Standing Guard," or "Ready to Work" showed the fighting spirit of the German worker. There were many images of fertility. One was never quite certain if "Forest Splendor," "Spring," or "Blessing of Earth" belonged with a flowery field or with the portrait of a woman.

The title gave the painting its function. All the themes of National Socialist ideology could be found in the exhibitions. They were like the credo of the Hitler faith, which had said:

. . . it is natural that the German figure *is a highly favored theme in our modern art. . . . our artists find their models . . . [in] closeness to the native soil, [and] the restorative powers of the landscape. . . . [Country women and girls] together with their male partners, they form the rugged stock of our people. . . .*
Artists stress above all else the role of the mother as the guardian of life. . . .
The portrayal of the female nude will always be the artist's most ambitious undertaking. . . . to show the healthy physical being, the biological value of the individual . . . the body as nature wanted it . . . a welcome contribution to our program of promoting national zest. Our country is particularly intent on cultivating

such happiness where it promises to enhance the performance of men and women in their basic duties of combat and fertility. . . .[12]

All the paraphernalia of the "Blood and Soil" motto could be found there. It is hard to believe that these naïve, even primitive, rural themes and codes could be so easily sold to a technically advanced urban society in the first half of this century.

In addition to allegorical and symbolic themes, the old techniques of woodcuts, tapestries, and weaving and the choice of triptychs all served to give the new German art a spurious link with the past. Art too had to do its share of the big rewriting of history, and millions swallowed it as taught in schools and even in universities. There was no room for a personal perspective or for comparison. Ingredients were taken out of their context and readjusted to promote a dream of German greatness written up, drawn, painted, and sung in mystical terms.

"What we are seeing here is another world—the images of history, recaptured. The language which is spoken here is powerful and awe-inspiring. Thousands upon thousands stand spellbound by the incredible beauty of this spectacle, a spectacle that dissolves the present. It is the distillation of centuries, 2,000 years of German culture," wrote a reporter in the *Völkischer Beobachter.*

The realism or naturalism of the paintings made them instantly readable and universally understood. They were also popular. This cannot be explained simply as a result of the brainwashing of a whole nation. There is no doubt that the success was built also on a genuine desire of many to see an art that told a story. The National Socialists were well aware of the discrepancy between the reality of an urban, industrialized society and the iconography of their idyllic rural art. The art of the Third Reich was not a mirror of the world, but a guideline to behavior and attitudes, disseminating messages.

In 1942, Adolf Feulner, a museum director, formulated the task in this way:

The longing for calm, realism, earthiness has permeated the arts. The essence of this change is the turning away from pessimistic negation and abstraction and the return to a simple world and to humanity. . . . Not only must artists solve artistic problems, they must also solve the problems of life. . . . The form must be universally understood and clear. Content must speak to all. The

Wilhelm Leibl. Three Women in Church. *1878–82*

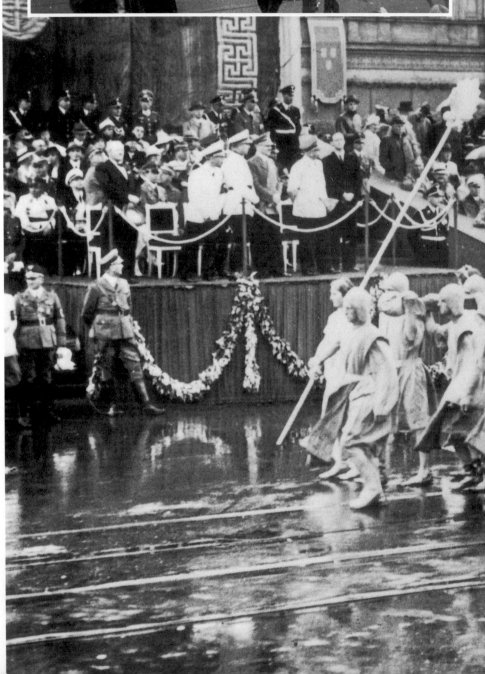

Riders on horses with swastika
banners in the pageant for the Day
of German Art 1938, Munich

Greek head in the pageant for the
Day of German Art 1939, Munich

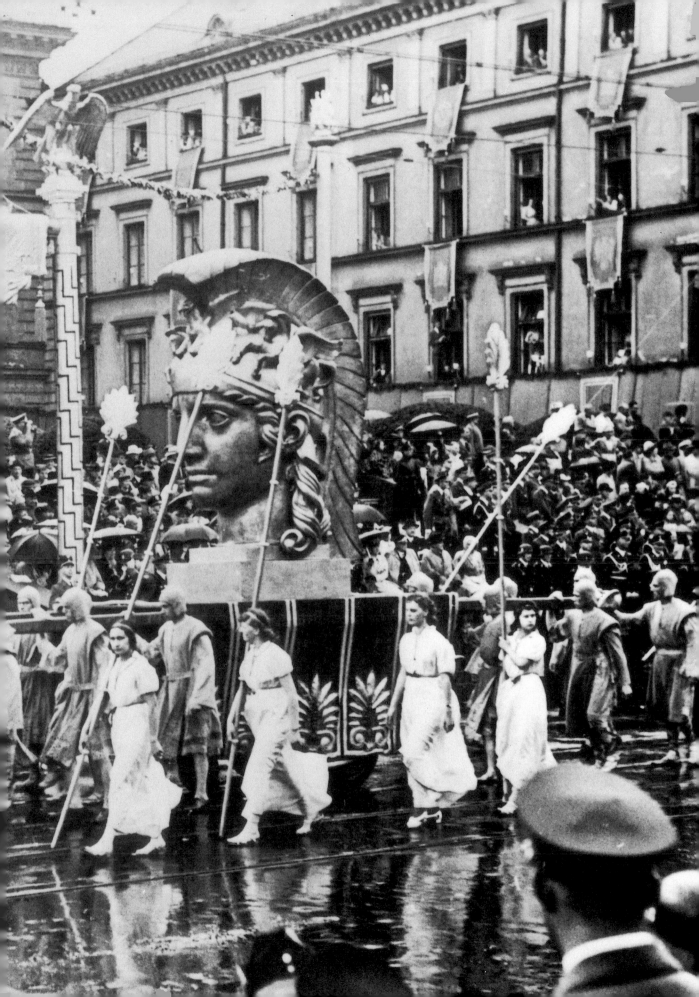

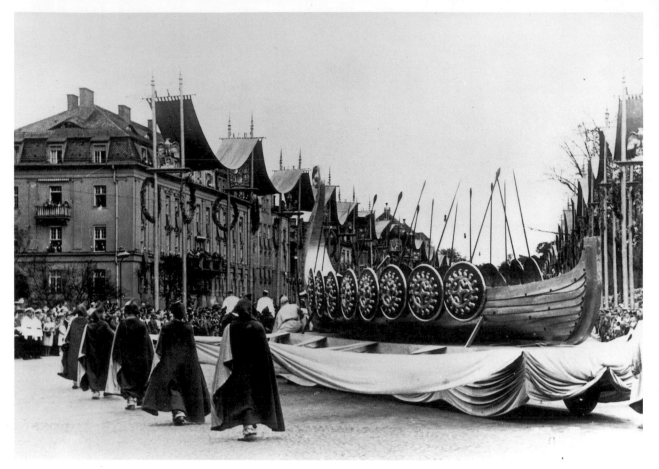

Model of a Viking vessel in the pageant for the Day of German Art 1939, Munich

artistic content is at the service of the philosophical
[weltanschauliche] *education of the people. Art has to become*
again, as in the past, a life force, representing the ideals of the
people. It must form anew the symbol of the people.[13]

Eight exhibitions of "Great German Art" were held
in the House of German Art, the first one in 1937, the
last one in 1944, one year before the war was lost.

The fascination with the world of art and architec-
ture, with the pageants and the display of banners and
colors was widespread, and people came in droves to
see the Munich exhibitions. For the opening exhibition
in 1937 there were 60,000 visitors. "Never before have
more people visited an exhibition. Never before have
more works been bought," boasted Goebbels. "An art
exhibition, previously an event for artists and a few art
lovers, became a national event. Tens of thousands
walked through the 'Degenerate Art' exhibition and
then entered the wide rooms of the House of German
Art with an elevated heart and a true feeling of happi-
ness, knowing that after years of terrible defeat
German art has found itself again."[14]

By 1942 the number of visitors to the annual exhibi-
tion reached almost a million, and 1,214 works were
sold. The large and steadily increasing number of visi-
tors was for Hitler an affirmation of his cultural policy.
Thousands of artists sent their work to the official art
exhibitions. These could not possibly have been
painted especially for these shows. Can we really
imagine that so many artists suddenly submitted to
an official decree by renouncing their own style and
ideas?

Each Day of German Art, celebrating the opening of
the official Munich exhibition, was considered a prime
event of pageantry. In 1937, 26 floats, 426 animals, and
6,000 people in period costumes paraded models of
the art of all time and models of the new buildings
around the city. Large crowds of cheering people
watched those gigantic annual parades celebrating the
2,000-year history of the Reich. There they saw figures
of Neptune, of Uta of Naumburg, of Father Rhine, and
of Pallas Athene, and naturally giant statues of the
Führer. A mixture of costume ball, carnival, and kitsch,
these parades were a celebration of the *Volk*; they dis-

played old crafts and symbols. National Socialism was made to look like the legitimate heir to all German history. A public display of the regime's belief in the 1,000-year future of the Reich. The Day of German Art was to help to fuse the nation together, to bridge class differences.

The Day of German Art demonstrates how much art is the concern of the nation and the people in which it is anchored. It is also a message to the world. . . . The free spectator stands side by side with the free artist. The artist understands freedom in a deeper sense. He understands the commitment to his people and his country. . . . The only law that governs him is an ethical one: his responsibility for his people and its spiritual tradition. . . . Out of his freedom will come the great flowering of his work. It will proclaim the victory and the joy of a people for generations to come. A people which was able to celebrate its art. The Day of German Art is a happy occasion, a commitment to the present.[15]

Hitler was always presented as the great patron of the arts. He was seen opening exhibitions, purchasing pictures for Party buildings. He became the best client of the "Great German Art Exhibitions," spending large sums of money at each. From the second exhibition in 1938 he bought no less than 202 works, over half a million marks' worth. (Once a work was sold, it was taken off the walls and replaced by another one.) The number of works bought by the Führer increased steadily. In 1941 he bought nearly 1,000, which he distributed throughout ministries and public buildings. The label "Purchased by the Führer" was highly prized. "No age can claim to free itself from its duty to foster art," Hitler had said. "It would lose, if it did so, not only the capacity for artistic creation, but also the capacity to understand, to experience art . . . through his work the creative artist educates and ennobles the nation's capacity for appreciation . . . the great cultural achievements of humanity were at all times the highest achievements of the life of the community."[16]

The Academy of Art in Munich gave Hitler a golden medal. On the front was the head of Pallas Athena. The back featured Pegasus. The medal carried the following inscription: "To the leader of the German people, Adolf Hitler, who has put national thought in the center of our spiritual life and who has rendered back to art its old rights. His prophetic plans have given art its own task, to be the language of the people."[17]

Only with the help of the mass media were the National Socialists able to show that they were the creators and guardians of a great new culture. If we understand this, we can see why the reporting of art became so important and that criticism or any discussion which served any purpose other than the propagation of this idea had to be stopped.

The dissemination of art became more important than the making of it. Exhibitions and new buildings became media events. Hitler and Goebbels gave long cultural speeches. The distribution of art through leaflets and books, through postcards and stamps, was more important than the art itself, and the postcard business boomed. Illustrated newspapers reported regularly on exhibitions. The work of the official architects and artists was celebrated on their anniversaries. Hitler's famous cultural speeches (he made six in all entirely devoted to cultural matters) were widely distributed through radio and the press. There were quite a few German art magazines which propagated the new German cultural ideology. *Kunst und Volk* (Art and the People) reveled in articles about medieval Germany and old sagas, linking them with subjects of the Nordic race. Besides reproductions of new paintings there were illustrations of the beloved precursors Dürer and Riemenschneider. But the most important arts magazine of the Nazi era was *Die Kunst im Dritten Reich*, which was founded in 1937. The editor was Alfred Rosenberg; his collaborators were Werner Rittich, Walter Horn, and Robert Scholz. *Die Kunst im Dritten Reich* was printed in an edition of 8,000 copies, later to increase to 50,000, which was considerable at that time. Its layout and format were that of a respectable art publication. The magazine, printed in green and gold, spelled luxury and trustworthiness. Its link with a great tradition was obvious. In its format and content it was designed to appeal to an educated reader. The cover design used symbols borrowed from classical antiquity. It combined the insigne of the Reich with a torch and the head of Athena.

Athena is the goddess of war and art. She personifies the strong, fresh spiritual strength of the human being. She stands freely, upright. She recognizes, measures, and uses the strength of all things in the victorious battle with the enemy and in the conquest of nature for the creation of art. The picture of the goddess is the fitting expression of the heroic character of the Führer and the National Socialist movement and, in the deepest sense, of the art the Führer wants. An art form for which the artist has to fight in a serious and concentrated working procedure so that he may receive a blessing from it.[18]

In 1939 the magazine changed its name to *Die Kunst im Deutschen Reich* (Art in the German Reich; in this book, we will call the magazine *Die Kunst im Dritten*

Reich throughout, to avoid confusion—Ed.). This followed a decree from Hitler, who decided not to use the expression "Third Reich" any longer. Even when faced with defeat in 1944, Hitler favored the expression "Grossdeutsches Reich," "Greater German Reich." A French edition was published in France during the Occupation.

How is it that so few people noticed the messages that were constantly confronting them? Messages that were neither disguised nor subtle. Thousands of artists painted these pictures, the educated flocked to the exhibitions to be elevated by them, without recognizing the underlying ideas. Art historians, academics with high ranks at universities and art schools proclaimed the most banal ideals of National Socialist ideology and published their shallow and absurd ideas in serious books, magazines, and dissertations.

Over the years the number of entries in the "Great German Art Exhibitions" increased. There were more than 600 works in 1937; the number rose to 1,400 in 1941, only to level off slightly in the last few years. The number of artists accepted followed similar patterns—550 in the first year, going up to 750 during the war. One might wonder why so many artists freely offered to be part of this venture. There were of course the obvious Nazi painters with their rendering of the men of the SS and the German soldiers: Otto Hoyer, Elk Eber, Wolf Willrich, and Willy Waldapfel. There was Adolf Ziegler, who, because of his embarrassing nudes, became known as the "Master of the Curly Pubic Hair." But for many it was a good place to sell. Prices were

often kept low to enable the German people to decorate their walls with German art. But the favorite painters of the regime often obtained inflated prices.

This characterized the attitudes of many of the official artists, who had great financial and artistic advantages and privileges due to Hitler's patronage. And many threw all integrity to the wind. "Venerable Reich Chancellor, the artists and musicians of the Prussian Academy would like to assure you of their devotion and gratefulness for your memorable words in Nuremberg and Munich. They underlined the importance of the arts for the nation and the state," the vice president of the music section and his sidekick from the visual arts section wrote Hitler.[19]

On the whole, Hitler was quite lenient about artists' membership in the Party: as long as they delivered the art he wanted, they were sure of his personal support. The opportunism of the artists worked by itself. They were, after all, his fellow artists, and remembering his hardships as an artist, he said, "My artists shall live like princes [*Fürsten*]," and the leading artists of the Reich did precisely that. The artists were very much Hitler's. The painter Sepp Hilz received a personal gift of 100,000 Reichsmarks from Hitler to build himself a studio. Gerdy Troost, the widow of Hitler's favorite architect, received large sums annually for the decoration of her husband's buildings, of which she was in charge. Arno Breker paid only a token sum in taxes, and in 1940 he received a large private house with a park and a sizable studio as a personal gift from the Führer. Large studios, the *Staatsateliers*, were

built for Albert Speer and Josef Thorak. Less well-known artists were also financially rewarded and were given *Juden Wohnungen*, apartments sequestered from Jews.

In 1937 Hitler decreed a considerable arts budget to finance the cultural mission of the National Socialists. Never before in Germany had such large financial aid been given to the arts. To obtain the money, the government sold special stamps, and Hitler is said to have put the royalties from *Mein Kampf* into the arts budget. Special collections also provided funds, and, of course, there was the money obtained from Jewish property.

Hitler himself made the decision to honor artists with prizes. Special medals were minted for those deemed to merit them. The granting of "honorary professorships" was another way for Hitler to assure himself of the allegiance of the artists. The architects Albert Speer and Hermann Giesler were made honorary professors. So were many painters—Elk Eber, Constantin Gerhardinger, Hermann Kaspar, Wilhelm Petersen, Franz Treibsch, Adolf Wissel, and many others. But Hitler, despite his vaunted liberal attitude toward his artists, could also be vindictive. When Gerhardinger refused to send pictures for exhibition in Munich for fear of their being bombed, he lost his title as professor and Hitler ordered him dismissed from the academy.

Stung by the attacks on its arts policy by the foreign press, the German government was eager to prove to the world that its artists were not only looked after but also free. "Foreign circles hostile to Germany often attempt to project an image of the contemporary German artist as an oppressed and beaten creature, who, surrounded by laws and regulations, languishes and sighs under the tyrannical dictatorship of the culture-less, barbaric regime," said Goebbels in 1937 at the annual meeting of the Reichskulturkammer. He thundered on:

What a distortion of the true situation. The German artist of today feels himself freer and more untrammeled than ever before. With joy he serves the people and the state. National Socialism has wholly won over German creative artists. They belong to us and we to them. . . . How could the German artist not feel sheltered in this state? . . . He again has a people that awaits his call. He no longer speaks to empty rooms and dead walls. . . . National Socialism has also drawn the German artist under its spell. . . . It is he who fulfills the task that a great time has assigned to him. A true servant of the people.[20]

Of course, the truth was very different. As the major client and sole promoter of the arts, the government set the standards and thus determined form and content.

One cannot stress enough the fact that everybody who built, painted, wrote for the regime, who approved of or encouraged the National Socialist art world, supported at the same time the political system which ruled over it. But one should also not forget that not all artists cooperated. A small number withdrew into a kind of "internal immigration." Most of these were too deeply rooted in Germany or too old to start a new life in a foreign land with a different language and culture. Otto Dix, Ernst Barlach, Oskar Schlemmer, Karl

Sepp Hilz.
Rural Trilogy.
Maids, Horn of
Plenty, Servants

Schmidt-Rottluff, to name just a few, remained in Germany. It was often a brave position to take. They led a secluded life, isolated from exhibitions and from critical coverage. They were not allowed to purchase artists' materials, they were constantly visited by the Gestapo, and their paintings were liable to be removed and destroyed.

But the majority of the people applauded the new arts. The output of art was enormous; exhibitions multiplied.

The great national exhibitions were complemented by many local ones. In 1941, with war raging, over a thousand art exhibitions were held. The new German art was shown in galleries, museums, and even factories. Art exhibitions were held in the occupied territories. But there were many other exhibitions of official art throughout Germany, notably in Berlin, Düsseldorf, Karlsruhe, Stuttgart, and Dresden. Berlin's old Kronprinzen-Palais of the Prussian Academy was refurbished, often showing works previously seen in Munich. Some regional exhibitions were organized on themes like "Blood and Soil" or "Race and Nation" or "Pictures of the Family." The Maximilianeum in Munich also organized regular exhibitions, specializing in local Bavarian artists.

The number of museum visitors was on the increase; 700,000 people came to see the Munich exhibition in 1942. It introduced 251 artists who had not exhibited in the House of German Art before. The press boasted about the young new talent that stood side by side with the old. Sixty percent of the work was sold. But greater participation did not bring any renewal or greater variety to the art. Having attacked the multitudes of styles and tendencies which characterized the art of the Weimar Republic, the National Socialists were constantly stressing the common elements in the new work. Despite diverging ideologies and rival policies, they wanted to show a unified picture of the arts. Despite differences in temperament, background, and age, all artists had to serve the same cause, display the same attitude, pursue the same aim. This explains the boredom one feels looking at the catalogues or reading the art magazines of the Third Reich.

Articles and reviews in *Die Kunst im Dritten Reich* and other publications by the leading National Socialist art historians repeated the same platitudes and trivial observations as Hitler's cultural speeches. Nowhere a real discussion, no arguments. Modern art was simply ignored. Hitler had successfully banned criticism. In exchange he received bragging arts reports of the most

philistine and stupid kind. The headlines of the articles said it all. "Style of Discipline and Feeling," "The Face of the Leader," "The War as an Experience of the Soul," "Art and Community." When works were reviewed, words like "characterful," "sincere," "soulful," "healthy" were constantly used. "Pictures . . . breathed and affirmed life"; they were "deeply felt" or spoke "to the heart." There was no comment on the style or quality of the painting; the only formal criterion was the technical accomplishment, expressed with words like "honest," "well crafted," or "attention to detail." Exhibitions were always labeled a "prime event," "a step forward on the road to a new art." Adverse criticism did not exist; all works were perfect. The artist too was "proud," "unique," "in unison with the people," their task was "great," and "leading into a glorious future." Page after page was filled with the same message. It is unbelievable that educated people could write and read such empty, bombastic rhetoric.

The intellectual standards of the leading arts commentators did not improve over the years. The lack of real artistic innovation prompted them to talk frequently about "the threshold of a new art." With promises like "Painting is only at the beginning of an important development" or "The artistic and handicraft level of painting goes from strength to strength," they tried to silence doubt about the merit of the art on offer. Year after year the leading art historians, Rittich, Scholz, Horn, and many others, repeated the pseudoscientific ideas of their mentor, Alfred Rosenberg, and offered their anachronistic and chauvinistic view of the arts. The banality and simplism of the propaganda messages that the official arts press offered to a highly educated public are unbelievable today. And yet millions were taken in. One cannot help suspecting that the shallowness of the arguments contributed significantly to their popular success.

Similarly, public speeches also did not offer anything new. For the opening of the 1938 "Great German Art Exhibition," Hitler gave one of his famous cultural speeches. In it he summed up once more the National Socialist arts theory and repeated the same old clichés. The National Socialists understood better than most that repetition is one of the most important elements of propaganda. There were the obligatory attack on the international art market and the usual snipe at "Jews, Dadas, and Cubists." Hitler stressed again and again that the German people have a new affirmation of life. They are filled with admiration for the "strong and beautiful, the healthy and those capable of

surviving"—all thoughts that aligned the arts theory with the theory endorsing the annihilation of the sick and the "racially inferior." He boasted that "the cultural program of the new Reich is of a unique greatness in the history of the German people." There were the usual references to the art of Greece and to German art as the mirror of the German soul. But the speech also contained the first doubts. Stung by the attacks in the foreign press, Hitler tried to justify his arts policy and especially his decision to mount the exhibition of "Degenerate Art" by declaring that it was necessary to "draw a hard line, in order to make way for the only possible task for German art: to follow the way of the National Socialist revolution. . . ." Demanding clarity and logic from the artists who wanted to continue to work in Germany, he tried to show himself magnanimous toward those artists who had fled the country: "We have no hate. Let other democracies open their progressive doors to them, let them live, but not in Germany."[21]

The speech also showed his first doubt about the quality of the works exhibited. He conceded that the aim of the first "Great German Art Exhibition" was to "open up the way for the decent and honest average, which gave hope for greater talents in future times."[22]

It is possible that Hitler's disenchantment with the new paintings was real. For him the flowering of German art had been concluded with the nineteenth century. From 1938 he increasingly turned his attention to the other arts, to sculpture and, most of all, to architecture.

Hitler's doubts about the quality of the new art are also reflected in the lack of contemporary works in his private collection, as can be easily established from photographs of his two favorite residences. In the Braune Haus in Munich, the first home of the National Socialists, the only new German painting was Ziegler's *Four Elements*, which the French ambassador is supposed to have called "The Four Senses" ("Taste is missing"). In his country retreat, the Berghof, there were no contemporary works—despite the fact that he bought thousands of pieces in the official art exhibitions. But compared with the work of older masters, this number was still relatively small. Among the 3,423 art works Hitler stored away during the last years of the war in the mines of Bad Aussee, only 24 were contemporary works, among them 2 paintings by Troost obviously kept for sentimental reasons, a picture by Albin Egger-Lienz and one by Sepp Hilz, plus a portrait of Troost.

Goebbels too tried constantly to reassure people that new art was forthcoming:

Our enemy's cry that it is impossible to expel the Jew from German cultural life, that he cannot be replaced, still rings in our ears. We have done precisely this and things are proceeding better than ever! The demand of National Socialism has been thoroughly carried out in this field and the world has visible proof that the cultural life of a people can also . . . be administered, led, and represented by its own sons. . . . Everywhere people are painting, building, writing poetry, singing, and acting. The German artist has his feet on a solid, vital ground. Art, taken out of its narrow and isolated circle, again stands in the midst of the people and from there exerts its strong influences on the whole nation.[23]

But he had no illusions about the new art and he added:

It cannot be doubted that in a history-making time, so highly tension-ridden, as our own, political life absorbs a host of talents which normally would have been partly at the disposal of cultural life. In addition, there is the fact that the great philosophical ideas which have been set in motion by the National Socialist revolution, for the moment operate so spontaneously and eruptively that they are not yet ripe enough for elaboration in artistic form.[24]

Among many artists, criticism of the dominating provincial Munich school could be heard. The Bavarian *Heimat* (native land) style, with its blue skies, well-tended fields, healthy farmers, and well-fed cows, was not to everyone's liking. People living in the modern cities grew tired of the constant glorification of the fatherland and the German peasant.

On the whole, in all these works the style and iconography were the same. There was little development during the next few years, except for the introduction of war paintings, which took an increasingly important place. There were some who hoped that the approaching war would release new artistic energies. In the event, the paintings of the tanks and battle scenes which resulted brought a new realism to the art scene, but most of the paintings were just as undemanding and boring as the previous genre paintings. With a few exceptions mediocrity ruled, right to the end.

THE EXHIBI "DEGEN

TION OF
ERATE ART"

"It is not the function of art to wallow in dirt for dirt's sake, never its task to paint the state of decomposition, to draw cretins as the symbol of motherhood, to picture hunchbacked idiots as representatives of manly strength," Hitler had declared at the Party rally in Nuremberg in 1935.[2]

In July 1937 Hitler and Goebbels decided to clear museums of all remaining modern works and to mount an exhibition of modern works as an example of what they considered the most horrific art ever created. "The custodians of all government and private museums and art collections are busy removing the most hideous creations of a degenerate humanity and of a pathological generation of 'artists,'" the magazine *Der SA-Mann* reported triumphantly in September.[3]

And the director of the German Art Association had this to say to the cultural theorist Alfred Rosenberg: "Throw this decaying foulness out of the art of the awakening Germany! Out also all those who still allow and foster cultural Bolshevism! . . . The undersigned knows that the Führer and you, Herr Reichsleiter, cannot do everything alone. . . . Therefore we make ourselves available to fight unreservedly, with all our strength and ability, for a German philosophy [*Weltanschauung*], for the fertility of German life, and through this for German art. We are at your command. Heil Hitler!"[4]

A commission under the painter Adolf Ziegler, president of the Reich Culture Chamber, aided by some art historians, including the director of the Folkwang Museum in Essen, Klaus Graf von Baudissin, seized over

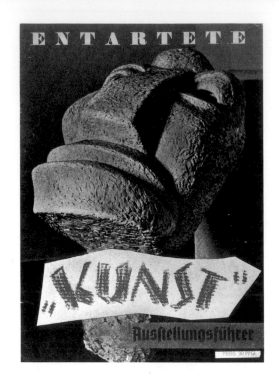

5,000 works from private and public collections, Among the works were: 1,052 by Emil Nolde, 759 by Erich Heckel, 639 by Ernst Ludwig Kirchner, and 508 by Max Beckmann. They also took works by Alexander Archipenko, Georges Braque, Marc Chagall, Giorgio de Chirico, Robert Delaunay, André Derain, Theo van Doesburg, James Ensor, Paul Gauguin, Vincent van Gogh, Albert Gleizes, Alexei Jawlensky, Wassily Kandinsky, Fernand Léger, El Lissitzky, Franz Masereel, Henri Matisse, László Moholy-Nagy, Piet Mondrian, Edvard Munch, Pablo Picasso, Georges Rouault, and Maurice Vlaminck. Göring had made sure to reserve and appropriate 14 works from the confiscated loot, among them 4 van Goghs, 4 Munchs, 3 Marcs, 1 Gauguin, 1 Cézanne, and 1 Signac.

Right from the start the National Socialists began to stage propaganda exhibitions of what they considered the most blatant examples of modern art. The League for the Defense of German Culture had organized a

Above:
"Degenerate Art," Munich, 1937. Cover of the exhibition guide with the sculpture The New Man *by Otto Freundlich*

Right:
Hitler at an early "Degenerate Art" exhibition, Dresden, August 1935. Paintings: Erich Heckel, Seated Man; *Ernst Ludwig Kirchner,* Five Women; *Hans Grundig,* Boy with Broken Arm; *and Johannes Tietz,* Double Image
"AS IN ALL THINGS, THE PEOPLE TRUST THE JUDGMENT OF ONE MAN, OUR FÜHRER. HE KNOWS WHICH WAY GERMAN ART MUST GO IN ORDER TO FULFILL ITS TASK AS A PROJECTION OF THE GERMAN CHARACTER. I OPEN THE EXHIBITION OF 'DEGENERATE ART.'"—ADOLF ZIEGLER

show in Karlsruhe in 1933 which showed "official" art in Germany from 1918 to 1933. "Official" in these terms were the works by Die Brücke and Der Blaue Reiter as well as paintings by Max Slevogt, Lovis Corinth, and Munch. Each of the works on show had a price tag to indicate how much the museum had paid for it. The aim was to incite the public by showing them how, in times of economic hardship, taxpayers' money was spent. Stuttgart followed with an equally critical show of the works of Marc Chagall, Max Beckmann, and Otto Dix. As soon as the Dresden Museum was cleared of its modern art, the city hall put on a show of the confiscated works entitled "Mirrors of the Decadence in Art." The Nuremberg and Dessau museums also opened their own "Chambers of Horrors," displaying modern art. The National Socialist commissar Gebele von Waldstein wasted no time. In the spring of 1933 he opened an exhibition of "Cultural Bolshevism" in the Kunsthalle in Mannheim; the show

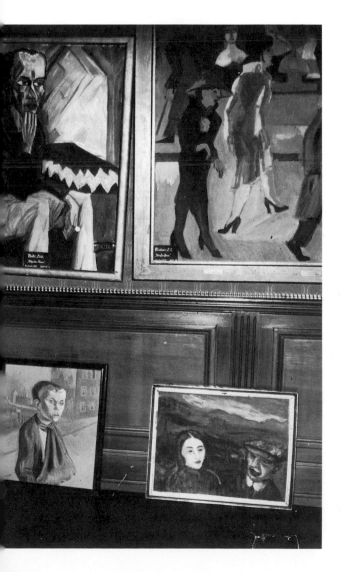

then traveled to Munich and Nuremberg. The painter Hans Adolf Bühler, the director of the School of Fine Arts in Karlsruhe, quickly followed with an exhibition caricaturing the art sponsored by the previous government: "Official Art from 1918 to 1933." All these defamatory exhibitions were widely publicized and attracted many visitors. In Munich, "The Eternal Jew," an exhibition of Jewish history in theater, film, painting, and sculpture, attracted 150,000 visitors.

In 1936, Hitler decided to stage his own show of the hated modern art. An official exhibition of "Entartete Kunst" (Degenerate Art) opened in Munich on July 19, 1937, a day after the opening of the first "Great German Art Exhibition," to which it was a pendant. With great satisfaction, Goebbels announced:

How deeply the perverse Jewish spirit has penetrated German cultural life is shown in the frightening and horrifying forms of the "Exhibition of Degenerate Art" in Munich. . . . This has nothing at all to do with the suppression of artistic freedom and modern progress. On the contrary, the botched art works which were exhibited there and their creators are of yesterday and before yesterday. They are the senile representatives, no longer to be taken seriously, of a period that we have intellectually and politically overcome and whose monstrous, degenerate creations still haunt the field of the plastic arts in our time.[5]

The exhibition of "Degenerate Art" was installed in the old gallery in the Hofgarten. In his opening speech Adolf Ziegler announced: "Our patience with all those who have not been able to fall in line with National Socialist reconstruction during the last four years is at an end. The German people will judge them. We are not scared. The people trust, as in all things, the judgment of one man, our Führer. He knows which way German art must go in order to fulfill its task as the expression of German character. . . . What you are seeing here are the crippled products of madness, impertinence, and lack of talent. . . . I would need several freight trains to clear our galleries of this rubbish." He added proudly, to thundering applause, "This will happen soon."[6]

The "Degenerate Art" show in Munich was the most radical and most vicious of its kind. The pictures were jammed together with labels so insulting that even Hitler thought some of them too strong. In its arrangement the directors, strangely enough, borrowed from the much despised Dadaists. The way of hanging the pictures, the aggressive slogans resembling graffiti on the walls, the whole idea of wanting to shock had all been done years before by the Dadaists. Hitler and Goebbels came to look at the cream of Cubism, Dada-

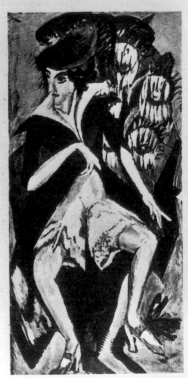

Die Dirne wird zum sittlichen Ideal erhoben!

Was die bolschewistische Jüdin Rosa Luxemburg an der russischen Literatur besonders liebte: „Die russische Literatur adelt die Prostituierte, verschafft ihr Genugtuung für das an ihr begangene Verbrechen der Gesellschaft..., erhebt sie aus dem Fegefeuer der Korruption und ihrer seelischen Qualen in die Höhe sittlicher Reinheit und weiblichen Heldentums."

Rosa Luxemburg in „Die Aktion" 1921.

"The Harlot Is Elevated to a Moral Ideal!" Page 17 of the "Degenerate Art" exhibition guide. Paintings: Karl Schmidt-Rottluff, Portrait of a Woman; Paul Kleinschmidt, Duet at the North Café; Ernst Ludwig Kirchner, Yellow Dancer

ism, and Expressionism: approximately 650 works by 112 artists, among them Barlach, Beckmann, Corinth, Grosz, Heckel, Kandinsky, Kirchner, Klee, Kokoschka, Nolde, and Pechstein.

Young people were barred from the show so that the organizers could underline the obscenity of the exhibits from which decent German youth had to be protected. They even wanted to go so far as to place museum directors and artists next to the work "so that the public could spit at them."

But the apparently chaotic display had a kind of order built into it. The exhibits were classified by subject just as in the other official exhibition. Only the themes here were "Farmers Seen by Jews," "Insult to German Womanhood," "Mockery of God." The spectacular and sensational way in which the art was displayed was aimed at mobilizing vigorous popular protest. It was meant to be the last chapter of a barbaric age, while the official show signaled the dawn of a new one. Over two million visitors came, nearly three and a half

Dummheit oder Frechheit — oder beides — auf die Spitze getrieben!

Ein wertvolles Geständnis:

„Wir können bluffen wie die ab-
gesottensten Pokerspieler. Wir
tun so, als ob wir Maler, Dichter
oder sonst was wären, aber wir
sind nur und nichts als mit Wol-
lust frech. Wir setzen aus Frech-
heit einen riesigen Schwindel in
die Welt und züchten Snobs, die
uns die Stiefel abschlecken, parce
que c'est notre plaisir. Wind-
macher, Sturmmacher sind wir
mit unserer Frechheit."

Aus dem Manifest von A. Undo in „Die
Aktion" 1915.

"Stupidity or Impertinence—or Both—Pushed to the Limit!" Page 32 of the "Degenerate Art" exhibition guide. Paintings: Max Ernst, La Belle Jardinière; Willi Baumeister, Figure with Pink Stripe III; Johannes Molzahn, Twins

times as many as attended the official art exhibition. "Does this not sufficiently prove the necessity for such an education through the horror chambers of degenerate art?" boasted one of the prominent members of the League for the Defense of German Culture.[7]

There is little consolation in the fact that many people came to say good-bye to the art they liked. And the press joined in the tirades against the modern artists and announced proudly that the "cleansing of the temple of German [art] was complete." The aim of the

show was to kill off modern art, and for most people it succeeded. Goebbels had achieved his aim of making it appear that the public was the true judge of art:

Had the representatives of decadence and decline turned their attention to the masses of the people, they would have come up against icy contempt and cold mockery. For the people have no fear of being scorned as out of step with the times and as reactionary by enraged Jewish literati. Only the wealthy classes have this fear. . . . They succumb all too easily to that kind of demi-culture which is coupled with intellectual pride and conceited ar-

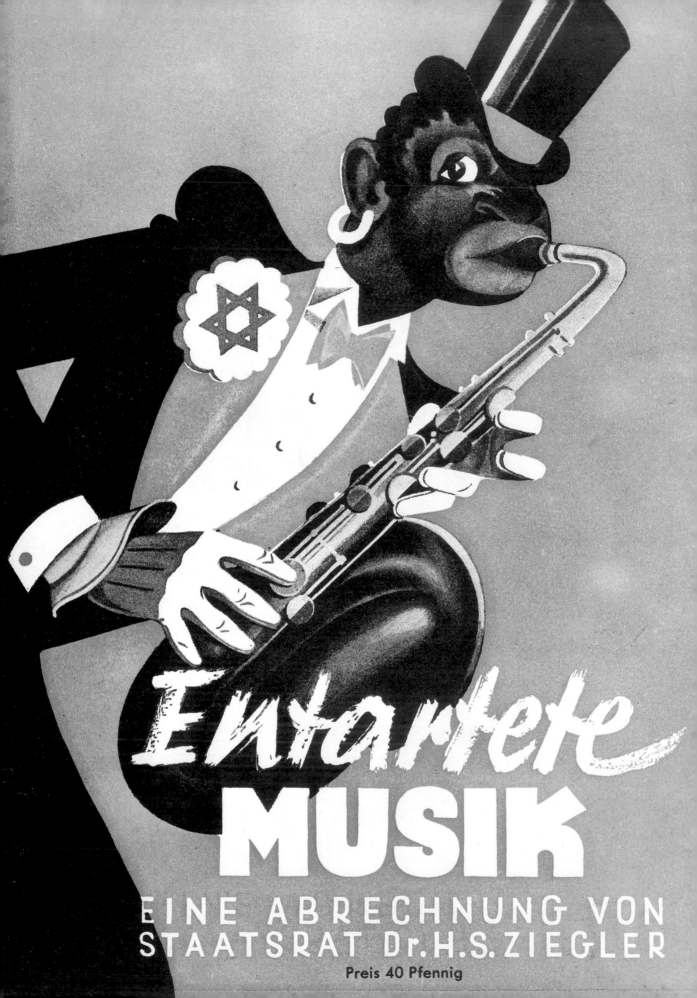

rogance. These defects are familiar to us under the label "snobbism." . . . Snobbism is sick and wormeaten. . . . We have had the courage to reject the products of its insolent arrogance. Today they are assembled in the "Exhibition of Degenerate Art," and the people, by the million, walk by this blooming nonsense, shaking their heads angrily. . . . In fact, the Führer had acted in the fulfillment of a national duty when he interfered here and again established order and a sure footing in this chaos.[8]

There were suggestions that the remaining works be burned, and on March 20, 1939, 1,004 paintings and 3,825 watercolors, drawings, and graphic works were burned in the courtyard of the fire station in Berlin. The confiscation of the moderns from the museums also provoked hectic activity among national and international art dealers. The Berlin art dealer Karl Buchholz "offered his services" in the cleansing action in order to take over some works. Karl Haberstock, a

Munich art dealer who organized an auction of banned art in Lucerne in 1939, is said to have proposed a "further cleansing action." Dr. Franz Hofmann of the Degenerate Art Commission proposed to sell these "unsalable" works. Goebbels hesitated, but Hitler, realizing that this art could be a source of considerable income, decided to sell it.

Soon the London dealer P. D. Colnaghi, trying to outbid the two Jewish dealers from Paris, Wildenstein and Seligmann, offered to take over the entire stock of the "Degenerate Art" exhibition, referring to the fact that he was the only prominent English art dealer never to have offered degenerate art from any country for sale.[9]

Ultimately it fell to the Galerie Fischer in Lucerne to organize the sale, in June 1939.

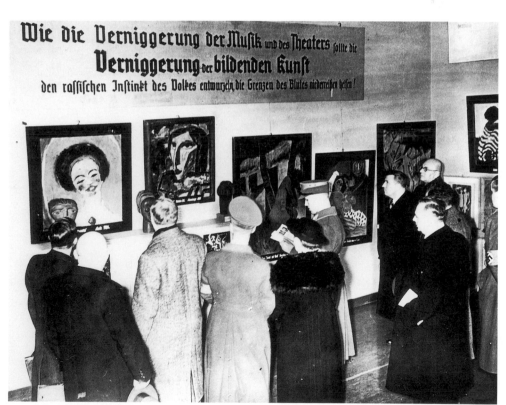

Opposite:
"Degenerate Music," Düsseldorf, 1938. Cover of the exhibition guide by Hans Severus Ziegler

Above:
Installation view of the "Degenerate Art" exhibition. Paintings: Emil Nolde, The Mulatto; *Karl Schmidt-Rottluff,* Portrait of B. R.; *at far right, a portion of Emil Nolde,* Man and Woman

"THE 'NIGGERIZING' OF MUSIC AND THEATER AS WELL AS THE 'NIGGERIZING' OF THE VISUAL ARTS WAS INTENDED TO UPROOT THE RACIAL INSTINCT OF THE *VOLK,* AND TO TEAR DOWN BLOOD BARRIERS."—WALL STATEMENT

CHAPTER 8 THE VISUA NATIONAL

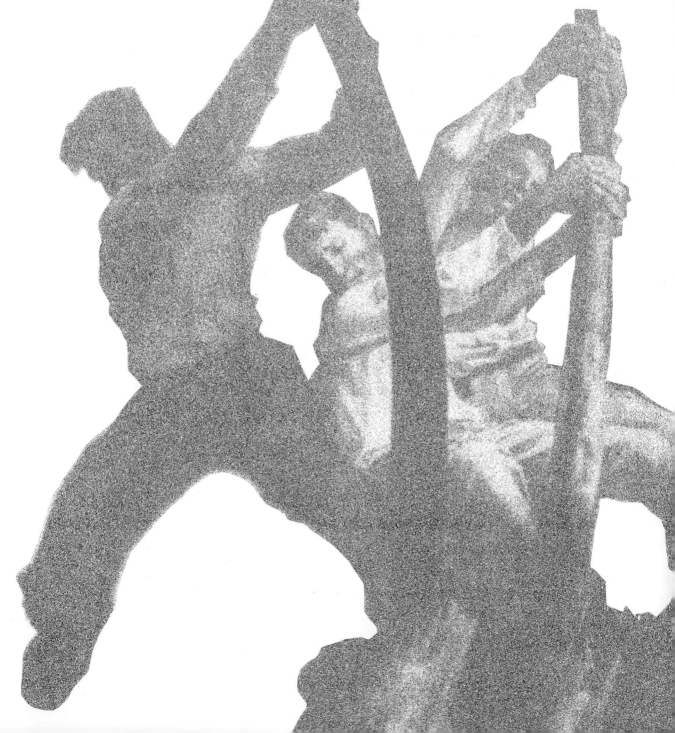

LIZATION OF SOCIALIST IDEOLOGY

WHILE WE ARE CERTAIN THAT WE HAVE EXPRESSED THE SPIRIT AND LIFE SOURCE OF OUR PEOPLE CORRECTLY IN POLITICS, WE ALSO BELIEVE THAT WE WILL BE CAPABLE OF RECOGNIZING ITS CULTURAL EQUIVALENT AND REALIZE IT.

—Hitler, Party Day 1935, Nuremberg[1]

It is a widely held view that all twentieth-century totalitarian systems produced the same kind of art. Stalinist art or that sponsored in Italy under Mussolini or in Spain under Franco often looks similar. But National Socialism is the only regime which excluded all but the approved art forms right from the start. The iconography of National Socialist art was very limited. A few themes, endlessly repeated, sufficed to express the whole message. A close look at the subjects the National Socialists favored and vigorously promoted shows that art was not only the direct expression of their political ideas, but also at the base of their political system in all its aspects.

NATURE

"German art represents homeland and longing for the home. In landscape paintings the soul is expressed. It is the language of the homeland which speaks even in an alien atmosphere or in foreign lands. . . . When one speaks German, then the soul speaks. If one speaks with an alien tongue, a cosmopolitan, fashionable Esperanto, then the soul is silenced."[2]

In all the official "German Art Exhibitions" landscape painting dominated. It was often the one kind of painting artists could do without declaring too close an allegiance to

National Socialist theories. But it was also seen as the genre in which the German soul could best be expressed.

Again and again the idea of the *Volk* was linked with the landscape. The country was a place of belonging. The nineteenth century, too, had dreamed of a medieval and rural Utopia in which man and nature could be fused together (see the Bruegel-like landscape of Karl Alexander Flügel on page 108). The National Socialists picked up these ideas and made them one of the central themes of their philosophy of art. But what for the Romantic painter was an idealized dream became reality for the new painters. Their landscape represented the Germans' *Lebensraum*, their living space.

The new landscape painting followed closely the tradition of the Romantic painters, especially Caspar David Friedrich and Philipp Otto Runge, both artists Hitler cited in his speech at the opening of the House of German Art. Their feeling of longing and the specific mood they expressed appealed to many beyond the leadership. But landscape for the new artist was not only a place of contemplation, it was also a space for living, for action. The landscapes of Werner Peiner share with the Romantics' landscapes a longing for expansive distances, but Friedrich's landscape was an imaginary one; the landscapes of the new painters were meant to be real. Landscape, in National Socialist thinking, was always the German landscape. "The painters of today are nearer to nature than the Romantics. They do not look for a religious mood but for elementary existence. Each landscape is a piece of the German homeland which the artists illuminate with their soul. . . . Above all art today stands the law of the people."[3]

The style of new German landscape painting was also seen as a direct reaction to the Impressionists: "Artists create again under the spell of the silent forces which reign above and in us. The German landscape painter rejects the virtuosic rendering of the impressions of light and air. He searches for the unity between man and landscape; he interprets the eternal laws of organic growth."[4]

For the National Socialists questions of style or form did not exist. All artistic problems were metaphysical ones. Richard Wagner's dictum that art is "the presentation of religion in a lively form" was fully subscribed to by the ideologists of the regime. "The desire of the Germans to create always grew from the two roots: a strong sensuous feeling for nature and a deep metaphysical longing. The capacity of the Germans to make the divine visible in nature, and to illuminate the sensuous with spiritual values, fulfills Wagner's demands for art to become religion," wrote Robert Scholz.[5]

The act of creation was seen as a mysterious pseudo-religious event. "Painting is not a matter of artistic decision, of composition or formal choices. The

Caspar David Friedrich. Two Men
Observing the Moon

Werner Peiner. German Soil

Fritz Bernuth. The Fight

Michael Kiefer. Meadow near Chiemsee: Eagles.
"Great German Art Exhibition 1943"

hour of creation is one of the great secrets of creation; it has to be faithfully prepared and humbly awaited."[6]

Nature was not only seen as an antidote to the city, but was also enjoyed as the arena in which the strong dominated the weak, in which the elements ruled, and where animals shared a life-giving force. As in the heroic landscape, a genre the Nazis took from Dutch landscape paintings and the Romantic school, nature was seen as a fighting ground.

Animal paintings took on a kind of monumental, even heroic, stance. The eagle, the lion, and the bull were the favorite symbols of victory and courage. The proud eagle and the storm trooper's gaze are two sides of the same coin. Michael Kiefer's soaring eagles were the painter's version of another of the Nazis' favorite emblems: the symbol of ruling. In the paintings by Carl Baum and Julius Paul Junghanns, even horses and cows became symbols of strength, the animal equivalent of the naked hero.

Junghanns (see illustrations pages 65, 100, and 134–35), Germany's most prestigious animal painter, had taught since 1904 at the Düsseldorf Academy. Un-

der the National Socialists his animal paintings took on a new meaning. Hitler personally selected his work for the first "Great German Art Exhibition." How much this painter of apparently harmless alpine landscapes, with animals and simple peasants, could be bent to suit the National Socialists is best demonstrated by the presentation of his work in the magazine *Die Kunst im Dritten Reich.* According to the interpretation of the new era, Junghanns's work had little to do with the traditional animal paintings of the Dutch school, where animals were merely shown as friends of the humans. "Julius Paul Junghanns has done more than merely paint people and animals, he has shown them as monuments. Monuments of a speechless, heroic attitude and strength, the most dignified witnesses of our time."[7]

COUNTRY LIFE

Hand in hand with the longing for deep communication with nature came the call for a simple life, with the peasant as the incarnation of the true German (see illustrations pages 136–37 and 142–44). "Traveling

"Germany, Your Colonies!" Poster

through the German countryside today, one still finds among our peasants customs which have survived for a thousand years. . . . Everywhere one will find primordial peasant customs that reach far back into the past. Everywhere there is evidence that the German peasantry . . . knew how to preserve its unique character and its customs against every attempt to wipe them out, including the attempts of the Church. It preferred to go under rather than bend its head to the alien law imposed upon it by the lords. . . . Despite this thousand-year effort to alienate the German peasant from his nature, the common sense and the deep blood-feeling of the German peasant knew how to preserve his German breed. . . ."[8] There was a tradition of earthy peasant paintings, especially in Austria. The Tyrolean painters Franz Defreger (1835–1921) and the younger Albin Egger-Lienz were seen as the great precursors of the National Socialist peasant painters.

The paintings of Michael Kiefer, Franz Xaver Wolf (see illustration page 146), Georg Ehmig, Franz Eichhorst, Hans Ebner, Oskar Martin-Amorbach (see illustrations pages 136, 144, and 153), and Friedrich

Kraus all celebrated simple country life on their canvases—especially harvesting. They represented the National Socialist ideal of "Blood and Soil." They pictured peaceful country life, uncomplicated decent people, clean and earthy. The paintings advertised the eternal values of peasant life as a source of strength, as opposed to the destructive life of the city in which there is no continuity, and in which everything is constantly uprooted. ". . . the German man emerged from the German peasantry. Princes, Church, and cities were able to place their stamp on a special kind of German man, but nevertheless, the German peasant down the centuries has been the raw material and . . . the foundation,"' R. Walther Darré, Minister of Works, proclaimed in 1934.[9]

Also left out was any sign of the increased mechanization of agriculture: the farmer was mostly depicted in a primitive earthbound state, sowing, plowing, mowing the grass with a scythe. The eternal and timeless repetition of a farmer's work was shown as a quasi-religious ritual. Cows and horses and the rainbow; all nature is harmony (see illustrations pages

136–37). Work in the country was always seen as diligent and strong. In the painting by Heinrich Berran, *Bergheuer* (The Haymaker), the farmer brings the hay down like Atlas carrying the earth on his shoulders. In Lothar Sperl's *Rodung* (Clearing the Land), the workers are shown as fighters dominating the soil. In Willy Jäckel, the arresting image of the laboring plowman is heightened by a menacing sky.

Exhibitions with rural themes multiplied. This kind of painting was very popular, especially in southern Germany, where the representation of village life had always been part of the local iconography. But a harmless local genre was shamelessly used for propaganda purposes. In the autumn of 1935 an exhibition called "Blood and Soil" opened in Munich. A newspaper

critic wrote: "The exhibition . . . aimed to collect healthy and good and earthbound art and to fight for a new strength in art against decadence. . . . As a preface to the exhibition stand the words of Professor Schultze-Naumburg: 'Art has to grow from the blood and the soil if it wants to live.'"[10]

THE FAMILY

". . . the eugenic concept of 'family' in its deepest essence is synonymous with the Christian concept of a 'religious-moral family,' which rests upon the twin pillars of 'premarital chastity' and 'conjugal fidelity.' . . . monogamy also stands at the beginning of our culture. . . . It was good morals for a woman to have several children. A childless married woman was re-

Georg Ehmig. Returning from the Alpine Meadows

Julius Paul Junghanns. Hard Work. *"Great German Art Exhibition 1939"*

Oskar Martin-Amorbach. Harvest.
"Great German Art Exhibition
1938"

Right:
Lothar Sperl. Clearing the Land
"THE MOUNTAIN LANDSCAPE
FORCES THE ARTIST TO BE
REAL; NOT TO SHOW THE
FARMER IN ARTIFICIAL
HOLIDAY POSES BUT RATHER
AS SOMEONE FIGHTING
HARD FOR SURVIVAL, A MAN
WHO UNDERSTANDS HIS
LIFE THREATENED BY
NATURE AND THE ELEMENTS
AS GIVEN BY GOD; IT IS THE
ARTIST, WHO SEES THE
TRACES OF DESTINY IN THE
FARMER'S FACE."—WALTER
HORN

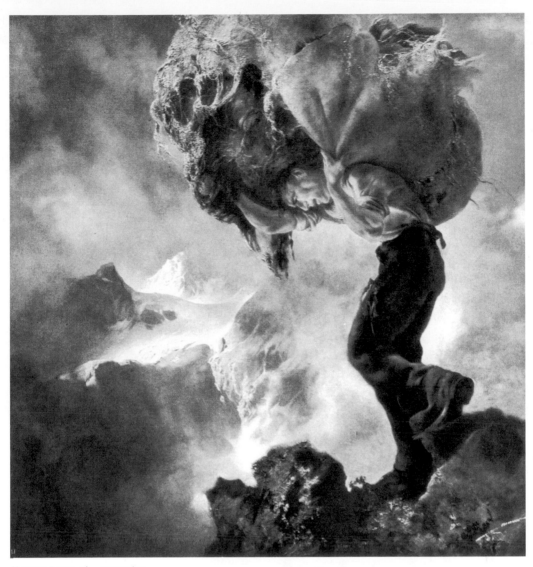

Heinrich Berran. The Haymaker

Right:
Willy Jäckel. Plowing in the
Evening. *1938*
"A SYMPHONY OF COLORS IN
A LIGHT-FLOODED SKY. THE
FARMER WALKING THROUGH
THE ROARING ELEMENTS, A
SYMBOL OF CARE FOR
GROWTH AND GROWING."
—WALTER HORN

garded as inferior, as was a woman who had many miscarriages, or who brought deformed, sick, or sickly children into the world,"[11] according to Paul Hermann, an expert in racial purity.

Closely linked with the idea of peasant life was the idea of the family. The family was more than just individual children and parents. The German people as a whole was seen as an interlacing of all German families of the same race. Here too art became a prime spokesman of National Socialist philosophy. The family became an important subject of the visual arts. The family of the farmer in particular was seen as the nucleus of the nation. The National Socialists hoped that the farm family's renewed popularity would lead to an earthly paradise, an order based on nature. "Those to whom Germandom is an essential entity see in the family the health, the salvation, and the future of the state. Around the family table are the sheltering and protecting qualities of the soul: the homeland, the landscape, the language of the community . . . in the soul lives the child, the songs, the fairy tales, the proverbs, the native costumes, and furniture and tools."[12]

The ideal father and mother were the pillars of a family of several children, happy and in harmony, fertile and bound to nature, as in Adolf Wissel's *Farm*

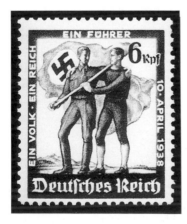

One Nation. One Reich. One Führer. 10 April 1938. *Commemorative stamp*

Family from Kahlenberg (see illustration page 148), a finely executed painting very much in the south German tradition with its love of details, but the perfection of the execution and the immobility of the scene render it lifeless. Constantin Gerhardinger, Thomas Baumgartner, and Wilhelm Petersen also painted several family pictures.

Films, books, and paintings all praised the virtue of the family. "In it lie the ultimate energies of primordial folk art. . . . In it lies also the salutary and profound

feeling for the family arts: folk music, work music, dance music, family music have here their last abode. Here they can work their potent health-giving magic. . . . How laughable, puppet-like, the art groups of the big cities appear. Their changing art fashions are best compared with exotic animals inside the cages of the zoos of the big cities."[13]

The religious role elevates the family to the status of an altarpiece. They listen to the Führer on the radio in Paul Mathias Padua's *The Führer Speaks* (see illustration

Rudolf Warnecke. Carpenters

page 73), or look at the official art magazine in Udo Wendel's *The Art Magazine* (see illustration page 221)— actually a self-portrait of the artist with his parents. No presentation of social conflict or hardship was allowed to disturb the dream. The overriding requirement to express a racial ideal prevented any real characterization.

The Nazis themselves claimed that their paintings had nothing to do with "realism," however realistic their style. The word "realistic" figured only rarely in the vocabulary of art critics in the Third Reich. A realistic rendering of the present would give a limited picture. The new German artist was creating for eternity. "God forbid that we should succumb to a new materialism in art and imagine that if we want to arrive at the truth, all we need is to mirror reality," wrote Baldur von Schirach. "The artist who thinks he should paint for his own time has misunderstood the Führer. Everything this nation undertakes is done under the sign of eternity."[14]

The restful composition, symmetrical design, and frozen gestures of many paintings were supposed to evoke feelings of unchanging universal truth. Here too the ideologist stopped at nothing; even the Bach family was enlisted to serve as a shining example of the purity of race and Germanic virtue:

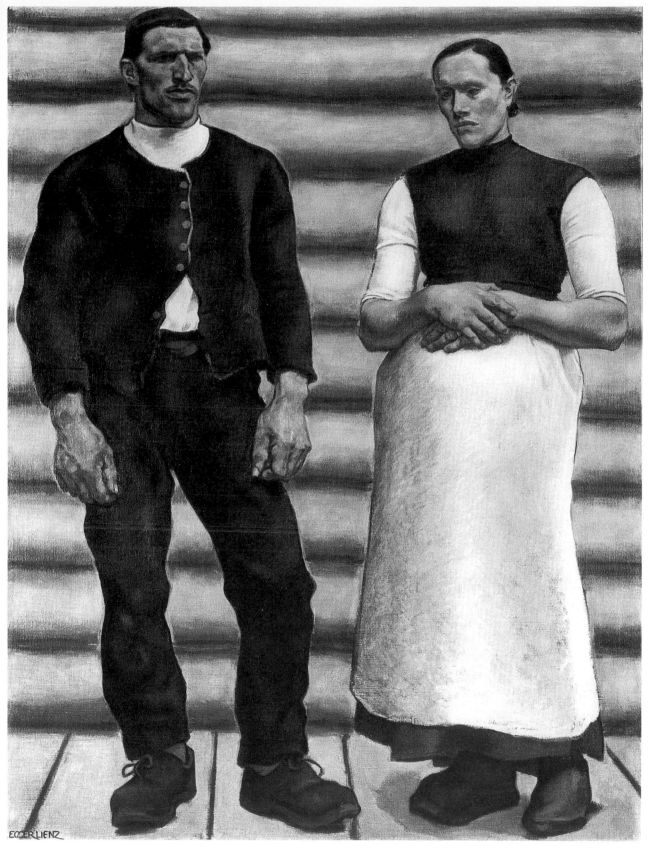

Albin Egger-Lienz. Husband and Wife, *Study for* Life Cycles. *1910*

Thus biological investigation has uncovered a series of families in which, as a result of the entry of individuals or even only one person of low-grade quality, the whole subsequent generation was ruined. . . . On the other hand, we are acquainted with a sufficient number of families in which the preservation of a family tradition . . . has engendered a great number of high-grade persons. Here I shall mention the clan of Johann Sebastian Bach of Thüringen, which has been thoroughly investigated biologically, and which rightly can serve as a textbook example of the preservation and higher development of a good biological heritage.[15]

All the people depicted in this art were racially pure. They did not mirror society but served as role models for it. They had become the incarnation of the National Socialist idea. The arts program was not an intellectual one but one transmitted through the senses, through the eye. That is why everything had to be beautiful, perfect, harmonious.

Unlike the genre paintings of the seventeenth-century Dutch and nineteenth-century German schools, which the new painters tried to imitate, these works did not present a realistic picture of the living and working conditions of their time. They were in fact totally anachronistic, a form of cultural camouflage

and a lie. The world of the Third Reich was far from peaceful and beautiful. The old paintings were lively and real because they grew out of the life which surrounded them. The Third Reich paintings were produced in a vacuum. That is why they looked wooden and lifeless. Form and content were in contradiction. The integration of the artists into the social and political conditions of their times, which the National Socialists proclaimed so loudly, could not be brought about as long as the artists were called upon to propagate the official lie.

THE GERMAN WOMAN

"The woman has her own battlefield. With every child she brings to the world, she fights her battle for the nation. The man stands up for the *Volk*, exactly as the woman stands up for the family," proclaimed Adolf Hitler in a speech to the National Socialist Women's Congress in 1935.[16]

The National Socialists left nothing to chance. If art advertised the role of the family, the Party also used art to define the social role of woman and the image

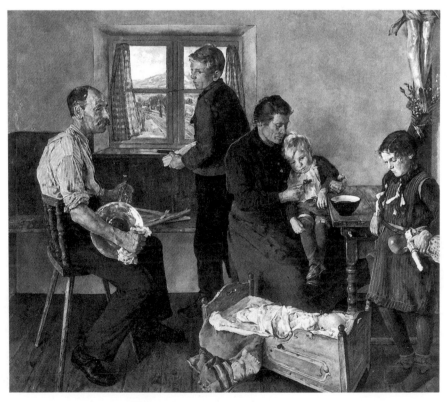

Constantin Gerhardinger. Family Portrait

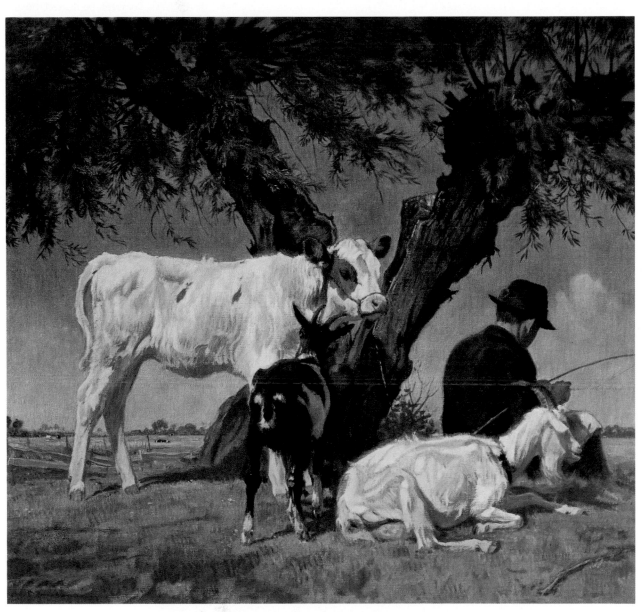

Julius Paul Junghanns. Rest Under the Willows

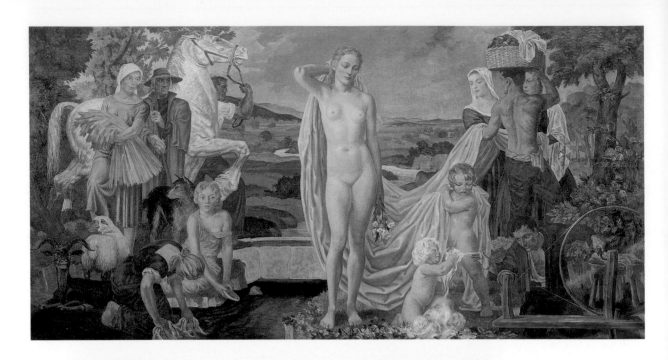

Gisbert Palmié.
Rewards of Work

Gisbert Palmié.
Rewards of Work.
Detail: Fruit Harvest

Thomas Baumgartner. Weaver from Tegernsee. *1936*

Albert Henrich. Country Still Life. *1940*

Oskar Martin-Amorbach. The Sower. *1937*

Fritz Erler. Fritzl

Franz Xaver Wolf. Parting. *1940*

Leopold Schmutzler. Farm Girls
Returning from the Fields

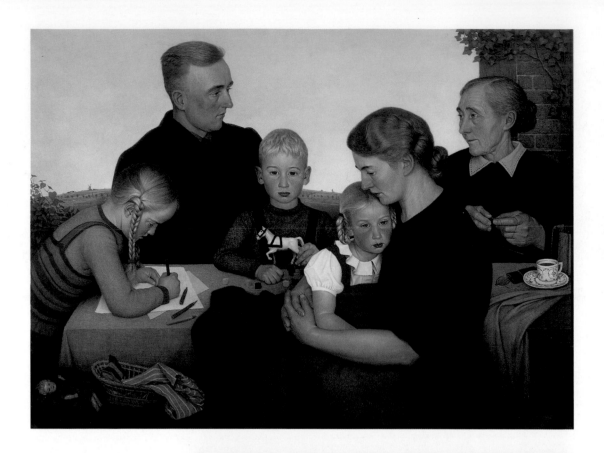

Adolf Wissel. Farm Family
from Kahlenberg. *1939*
"A YOUNG ART THAT
CONTAINS ITS PASSION
IN SIMPLE REALISM
REPRESENTS THE NEW
POLITICAL THINKING OF OUR
EPOCH."—WALTER HORN

Adolf Wissel. Farm Family from
Kahlenberg. *Detail. 1939*

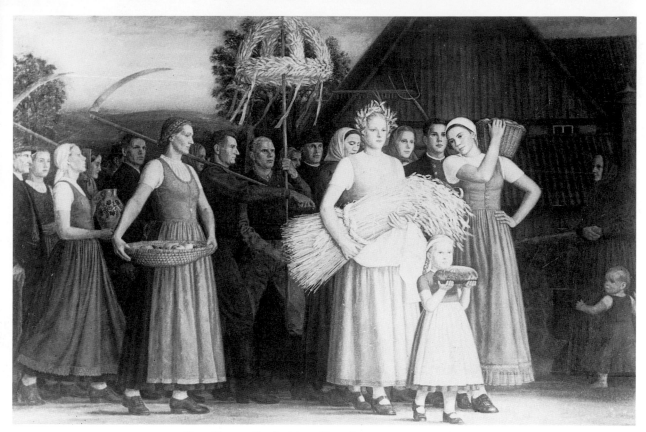

Jürgen Wegener. Thanksgiving. *"Great German Art Exhibition 1943"*

she should have. In his novel, *Michael*, Goebbels had written: "The mission of woman is to be beautiful and to bring children into the world. . . . The female bird pretties herself for her mate and hatches the eggs for him. In exchange the mate takes care of gathering the food, stands guard, and wards off the enemy."[17]

The ideal women were tall, blue-eyed, blonde representatives of the Aryan race. The ideal beauty had to correspond to the type of human being that was politically sound. For Hitler beauty always involved health: "We only want the celebration of the healthy body in art." The woman was preordained by nature to be the bearer of children, "the sacred mother." The man was preordained to fight. In Hitler's view only this interpretation of the role of man and woman could produce fine art. "We want women in whose life and work the characteristically feminine is preserved," said Hitler's deputy Rudolf Hess. "Women we can love. We grant the rest of the world the ideal type of woman that it desires, but the rest of the world should kindly grant us the woman who is most suitable for us. She is a woman who, above all, is able to be a mother. . . . She becomes a mother not merely because the state wants

it, or because her husband wants it, but because she is proud to bring healthy children into the world, and to bring them up for the nation. In this way she too plays her part in the preservation of the life of her *Volk*."[18] Madonna-like renderings of mother and child became a favorite genre.

About a tenth of the paintings shown were nudes. The increasing number of nudes in painting, and especially in sculpture, was a reflection of the new body feeling. Nudes were part of the nature culture. The demand for naturalness, vitality, and sensualism found its visual counterpart in the presentation of the naked body. Here too it was antiquity, the Renaissance and the old masters, that provided the models: the nudes of Titian, Tintoretto, Michelangelo, Rubens, and Rembrandt. The nudes of the Impressionists, especially Edouard Manet's *Olympia*, were rejected as a mere "experience of the eye, the body painted for its own sake, the carrier of colors." But not the expression of a moral, sociological, and religious attitude, which was supposed to determine the nudes of the Third Reich. The presentation of the devil woman, the prostitute, as modern artists often depicted her, was not only un-

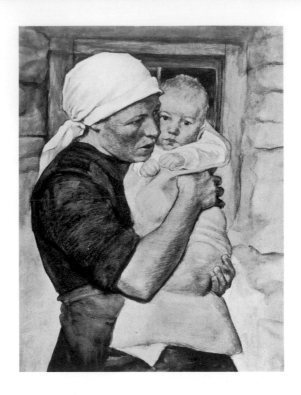

thinkable but was considered an insult to German womanhood. If man was shown as the dominator of nature, woman was represented as nature itself. She was the beauty of nature, or the playfulness of nature, and of course was as fertile as nature. She was shown over and over again in a state of ripeness (see the renderings of women in myth by Friedrich Wilhelm Kalb and Ivo Saliger, pages 222 and 223). This was the body

Above:
Franz Eichhorst. Mother and Child

Lower left:
Alfred Kitzig. Tyrolean Peasant Woman with Child

Opposite:
Fritz Mackensen. The Baby

"IN THE REFLECTIVE SERIOUSNESS OF A MOTHERLY WOMAN LIVES THE PENSIVE SPIRIT OF AN ARTIST WHOSE BRUSHSTROKE IS LADEN WITH THOUGHT."
—EDMUND PESCH

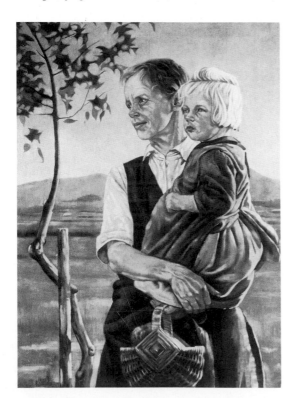

to be desired and adored. Titles such as *Abandon* and *Morning* spelled out the role woman was expected to play. Two themes dominate: the woman in a pose of expectation, and the woman as mother.

If most of the male pictures showed very little individuality, the representation of woman was even more stereotyped. The surface was smooth, with no bulging flesh, no natural folds of skin, no wrinkles. Woman was described with soft lines and gentle contours, the image of devotion and cooperation. Woman was an object; her role was subservient, to be looked at, to be fertilized. Her own sexuality was denied. She was usually seen facing front, without pubic hair. In the past, nudes often cowered, hiding their breasts. The new woman, as in Ivo Saliger's *Diana's Rest*, stood upright, proudly displaying her naked body to the viewer, who, in certain pictures, was also the male judge of its attractions, as in Adolf Ziegler's *Judgment of Paris*.

The president of the Reich Chamber for the Visual Arts, Adolf Ziegler, painted one of the main works for

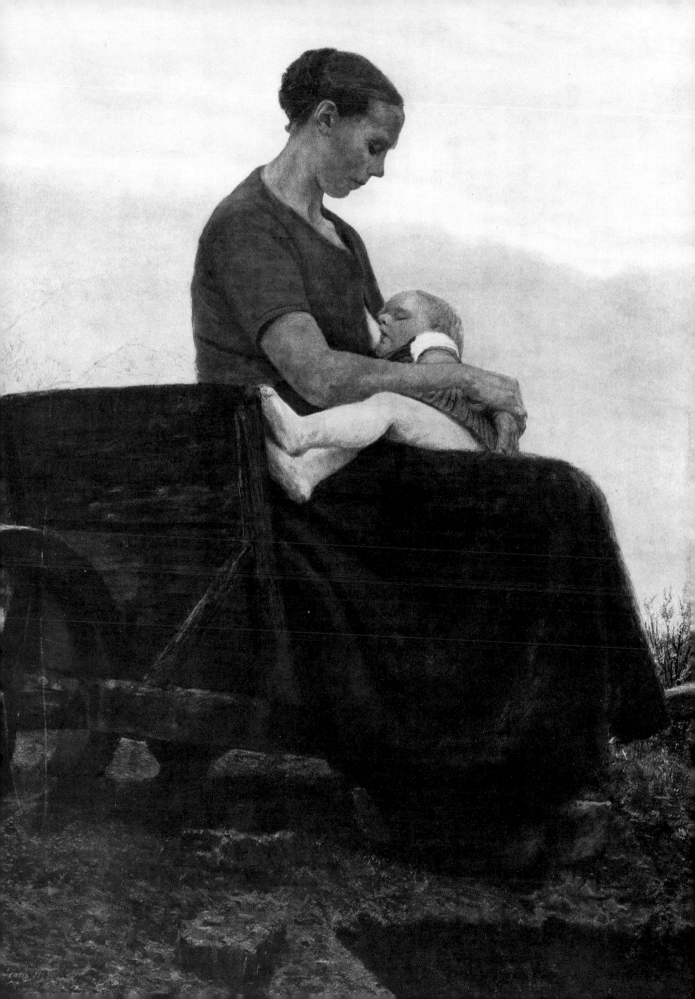

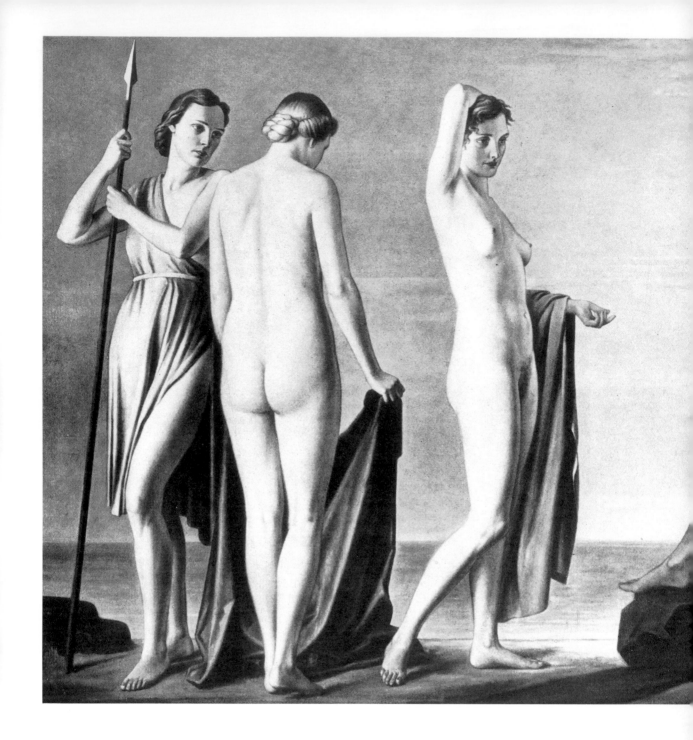

the 1937 exhibition of German art. It became famous almost overnight through frequent reproduction. Hitler acquired it, to hang in his living room in Munich above the fireplace. Ziegler wrote: "Our work represents our philosophy." What is the philosophy spelled out by this picture? Bodies are celebrated, the photorealistic representation of perfect bodies. The sleek, perfect surface detaches the body from reality. The four women representing the four elements, offering themselves to the onlooker, are like four priestesses; they sit on a bench as though on an altar. But they are

also ready for sacrifice. Willingness to be sacrificed for the nation was widely stressed. The combination of priestess and sacrificial object was iconographically new.

This flat and boringly executed painting was obviously much liked, judging by the enormous numbers of postcards and reproductions of it sold. The National Socialists' slick celebrations of the human figure without conflict or suffering were immensely popular. While the Salon paintings of the nineteenth century gave women at least some sensuality, the nudes by the

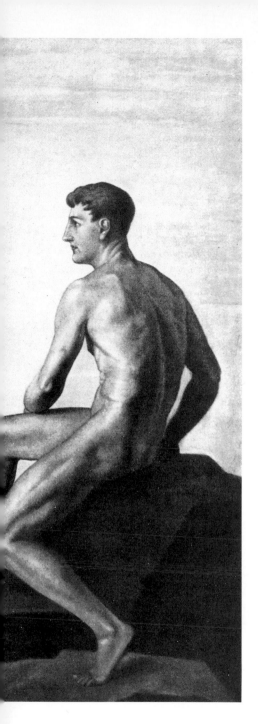

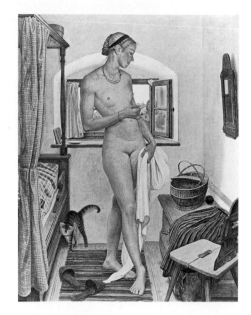

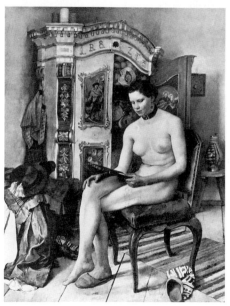

Left:
Adolf Ziegler. Judgment of Paris.
*"Great German Art Exhibition
1939"*

Upper Right:
Oskar Martin-Amorbach.
Peasant Grace
"A STRONGER LINEAR STYLE
SO TENDER IN ITS
FEELING."—ROBERT SCHOLZ

Right:
Sepp Hilz. Peasant Venus.
*"Great German Art Exhibition
1940"*

favorite painters of the National Socialist regime like Ziegler, Saliger, and Friedrich Kalb were totally passive and impersonal.

From year to year nudes gained in popularity both in painting and sculpture. Many painters of nudes came from the respected Munich Secession, a group much influenced by the French Impressionists. But the Secessionists soon gave up all integrity. The demand for more naked flesh corrupted many, like Oskar Martin-Amorbach in his *Peasant Grace*, or Sepp Hilz, known as "the Master of the Rustic Venus." Their clean

and scrubbed nudes, clad in titillating socks or a choker, resembled pornographic postcards or advertisements.

Gradually, an increasing number of lascivious nudes were exhibited and eagerly bought by the National Socialist leadership, which was a sign of increasing decadence at the center of this health-conscious nation. The painting *Leda and the Swan* by Padua created quite a scandal when it was exhibited because of its salaciousness. It was nevertheless bought by Hitler himself. The offerings of nudes multiplied. There were

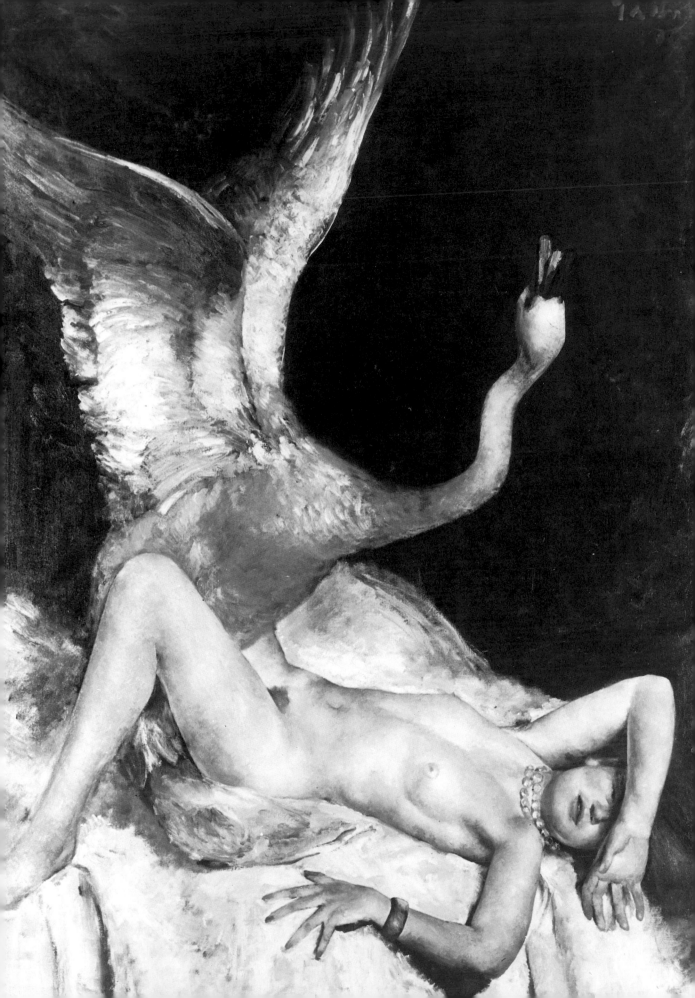

the sensual and lingering nudes of Karl Truppe. Gerhardinger, Oskar Graf, Ernst Liebermann, Johanna Kluska, Johann Schult, Richard Klein, and many others furnished the exhibition with "healthy Aryan flesh."

Women were often represented as allegories of honor, purity, and faith, and as Victoria crowning the hero. These paintings say, "I am like you, you can be like me": an invitation to identify, an accessible ideal, not a distant goddess. That is why artists brought the myths up-to-date: a Venus with a permanent wave. The National Socialist aesthetic required that their figures look smooth and fashionable, as if they had just emerged from the hairdresser or had been sunbathing. That is why these women look so embarrassingly artificial. They were supposed to be the image of motherhood but they are slick and cold. They offer no gentleness, no warmth. The paintings of the nudes belie the claims that the new art grew out of a new dynamic physical sensuality and a depth of feeling. The nudes were meant to be the ultimate synthesis of nature and spirit. In reality, they were—like the farmers, the family, and the men—the embodiment of a racial idea. They were not a reworking of the humanistic ideal of the Greeks, they too were stereotypes.

FEMALE PORTRAITS

Female portraits, especially of leading actresses and the wives of Party bosses, were also popular. Most of them showed the sitter in a demure, ladylike pose. Hand in hand with the demand for naturalness came the demand for simple unaffectedness. The deeply pu-

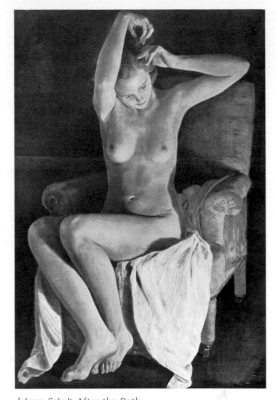

Johann Schult. After the Bath. *"Great German Art Exhibition 1940"*
"PAINTING THE RIGHT AND GOOD WAY! WITH THE RIPE EXPERIENCE OF THE EYE AND THE KNOWLEDGE OF THE LAWS WHICH GOVERN THE BODY."—ROBERT SCHOLZ

Opposite:
Paul Mathias Padua. Leda and the Swan

Karl Truppe. Youth

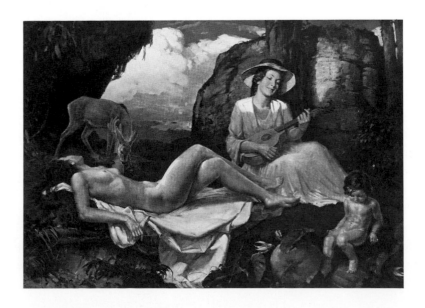

ritanical attitude of most totalitarian regimes also prevailed in Germany and brought forth the most hilarious requirements: ". . . painted and powdered women will be forbidden entry to all NSBO [National Sozialistischer Betriebs Obman; National Socialist Foremen] gatherings. Women who smoke in public—in hotels, in cafés, on the street, and so forth—will be expelled from the NSBO."[19]

"Germany does not need women who can dance beautifully at five o'clock teas, but women who have given proof of their health through accomplishments in the field of sports. 'The javelin and the springboard are more useful than lipstick in promoting health,'" reported the *Frankfurter Zeitung* in 1937.[20] Tea dances equal black music equal Jewishness equal city life—the simplistic equations never stopped.

"Fundamentally, . . . we should reject the custom of the five o'clock tea which came to us from England, where it is already a degenerate social form. . . . First it was the modern way of life, shaped by the Jewish spirit . . . a social gathering in which one cultivates not conversation but gossip. In particular, it is thought that through this abominable American custom (namely, eating and drinking standing up) an especially agreeable and spontaneous conversation can

develop, whereas actually only chatter is achieved. . . . These are not community-conscious, sociable German men, but 'stray international gypsies on a parquet floor.'"[21]

The National Socialist leaders saw themselves increasingly as a feudal caste. A clique that did not mix with others, except for a few actresses who were allowed into their inner circle, they stayed to themselves. Their growing wealth allowed them to adopt the style of the upper middle class, whose taste and aspirations they began to imitate in the country estates they established for themselves.

As well as this idealized image, there were pictures of the idealized traditional housewife turning her attention to old handicrafts. "It must seem amazing that women and girls should return to work at spinning wheels and weaving looms. But this is wholly natural. . . . This work must be taken up again by the women and girls of the Third Reich," declared the *Völkischer Beobachter* in 1936.[22]

THE GERMAN MAN

"If anything, the new age of Germany will create the image of the German man. There has never been a richer time for the presentation and interpretation of

the German character. World War One showed us how little mere strength, diligence, and conscience mean nowadays. Everything depends on the persuasive power of the images provided so that a whole people can identify itself with them."[23]

Representation of the heroic man was usually reserved for sculpture. But with the beginning of World War Two, the man as hero became a powerful iconographic element in painting, too. The war absorbed much of the energy of the country, but it never totally extinguished the National Socialists' preoccupation with the arts. The director of the National Museum in Berlin boasted that, while the British Museum and the Louvre fearfully had begun to evacuate their treasures, the German museums "have not been silenced like those of the enemy, waiting for the sad end of this war. The German museums do their duty by serving the people and waiting for victory."[24]

The "Great German Art Exhibitions" were also widely used as a morale booster. Hitler made sure to attend the openings, at least at the beginning. Later, preoccupied with the losing war, he left this task to Goebbels and Hess. Opening the fourth exhibition, in the first year of the war, Goebbels stressed the role of art as the best way of uplifting people in times of sor-

row and deprivation. In fact, 751 artists displayed 1,397 works. Many rooms were now devoted to war art. The war became the new inspiration for the artist, but not the horror of it: the heroic sacrifice was always stressed. The war was a new source for artistic creation, and many artists elevated the soldier to a symbol. The restrained pain in the face of the wounded soldiers and the expression of the finished battle were designed to move the people deeply.

"The opening of the 'Great German Art Exhibition,' during a war forced upon us, is the strongest demonstration of our cultural need and our cultural strength," wrote Robert Scholz, in 1940, in his capacity as director for the visual arts in Rosenberg's office for the supervision of the intellectual training of the NSDAP. "The fact that Germany continues its cultural mission, undeterred and protected by its glorious weapons, is part of the miraculous inner renewal of the people. A philosophy has brought out creative forces. The part the visual arts play in this process of cultural renaissance is the miracle of all miracles. . . . War, which a Greek philosopher called 'the father of all things,' is a great challenger. German visual arts have met the challenge. This exhibition is proof of the strong impulses that our Führer's ingenious willpower

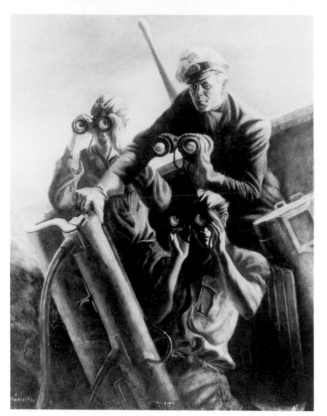

Rudolf Hausknecht. Lookout on a U-Boat

and his ingenious creative strength have brought to the arts. His example spurs every creative force to the highest."[25]

The war was seen as a battle for the salvation of German culture. "In this war, the German *Volk* fights not only for its material existence, but also for the continuation and security of its culture," declared Hitler on the occasion of the 1942 exhibition of German art. "German artists, too, have been called upon to serve the *Heimat* [nation] and the front."

Documentary films, shown in movie houses all over the country, broadcast the artistic message to a large number of people. "Filled with creative joy, our artists have this year, too, despite hardship, produced great works of art," boasted one commentary. Among the "great works of art" the viewer saw were four sculptures: Thorak's *Last Flight*, a sentimental rendering of a woman holding a dead soldier; the bombastic relief of Breker's *The Guardian*, a soldier drawing a sword; and the statuary stereotype rendering of the naked woman, as in Fritz Klimsch's *The Wave* or Anton Grauel's *Pensive Nude*. The example of what the National Socialists con-

Gisbert Palmié. Sniper Aiming a Rifle. *1944.*

sidered "great" paintings was not more inspired. There were Julius Paul Junghanns's naturalistic renderings of strong horses and cows; Rudolf Hermann Eisenmenger's allegory *Die Nacht begleitet den Morgen* (The Night Accompanies the Morning), three half-nude ladies; Joseph Piper's *Drei nackte Jünglinge am Meer* (Three Nude Youths at the Sea); and two giant cartoons for Werner Peiner's gigantic tapestries *Die Schlacht König Heinrichs I* (The Battle of King Heinrich I) and *Die Schlacht im Teutoburger Wald* (The Battle of Teutoburg Forest). Of course, the filmgoer was also given a generous helping of war art: a giant triptych, *Infantrie* (Infantry), by Rudolf G. Werner; the fierce rendering of

Walter Schmock. Soldiers

gates for the third time during the war is strong proof of the certainty of the spiritual fundament upon which the battle of our destiny stands. What unites the individual exhibits is the emanation of optimism and a strong artistic idealism. This belief in a future is in times like this the strongest proof of the strength of the German soul. Just compare these works with those of the First World War. . . . What marked the work of those artists was a deep pessimism. The darkness of their colors, the heaviness of their style announced the collapse of their spirit. . . . The inner strength and the general tenor of the present day are of a different mold. . . . The optimism . . . is visible in the many works that depict the lasting values and subjects in art, such as man, animal, and landscape.[27]

Hitler's pathological military nature was directed toward war. All his politics were aggressive. Their justification was conquest. "Only he who struggles with fate has Providence on his side." Hitler firmly believed that mankind could realize itself only through struggle, and so to him the purpose of art was also a preparation for war. The suffering of war was almost totally absent. Reviewing the frescoes of Franz Eichhorst (see illustration pages 160–61), Robert Volz wrote, "The beauty and singularity of these frescoes is

Die Flammenwerfer (The Flame Throwers), by Rudolf Liepus; the Hitler portrait by Gerhard Zill, and of course Hans Schmitz-Wiedenbrück's *Kämpfendes Volk* (Fighting People).

Art was constantly presented as a sign of optimism. Its role was not so much to help to overcome the increasingly difficult problems of life as to hide reality. Hitler had occupied France and was heavily engaged in Russia. Hundreds of thousands of soldiers had died in battle. The civilian population was spending night after night in air raid shelters, but art was constantly used to bolster the lie of a victorious Germany. "All forces, the physical as well as the spiritual, fight for the final victory. Art is today, more than ever, a political factor of a high order," wrote Walter Horn, reviewing an exhibition of the Prussian Academy in 1940. "The victorious war has not diminished the creative strength of the Germans. On the contrary. Everything serves to strengthen our will to fight and our determination to defend our soul."[26]

In 1942, when the House of German Art inaugurated the vast annual exhibition, the journalist and art functionary Robert Scholz bragged:

Millions flock to see our art, they come from all parts of Germany. The fact that the "Great German Art Exhibition" opens its

Elk Eber. Dispatch Courier. *1938–39*

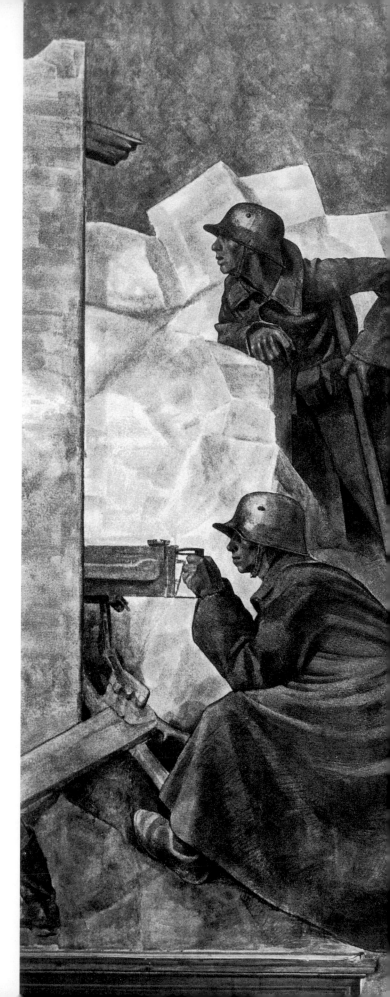

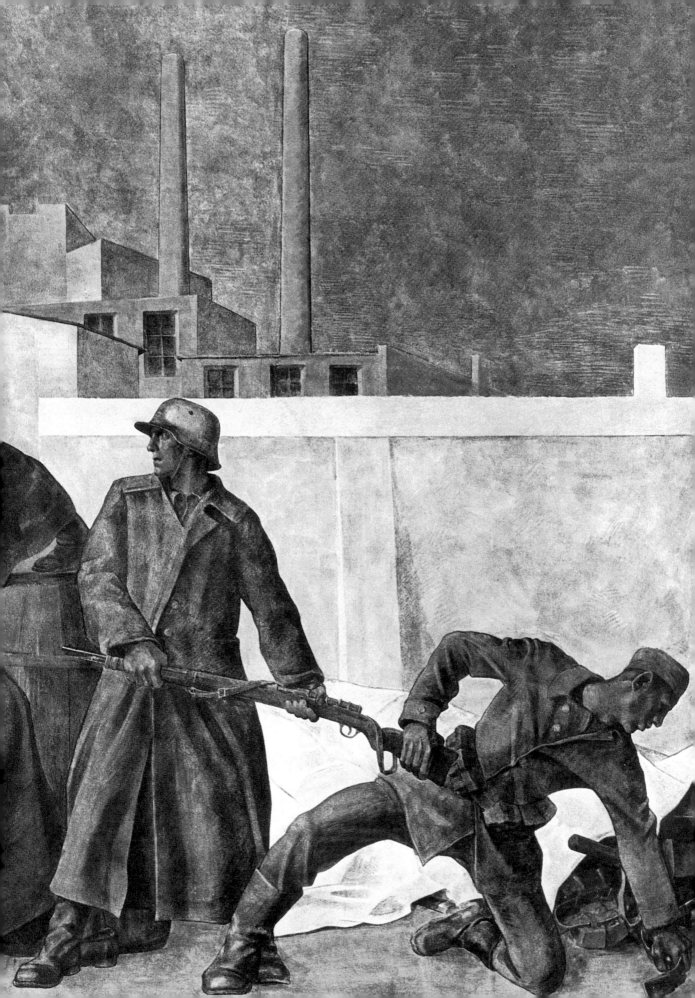

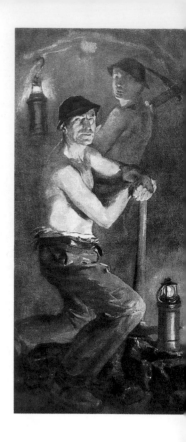

the almost total absence of blood and screams, the unbearably realistic has been avoided . . . the idea of readiness to fight and to be sacrificed, the loneliness of heroism overshadows the horrors of reality. What remains is the idea of the destiny of a people."[28]

The role of the artist was either to portray the struggle for the survival of a peaceful German world or else to represent this world, which had to be defended at all cost.

Painters like Elk Eber, Fritz Erler, and Franz Eichhorst glorified soldiers, Aryan fighters fierce and victorious. "Show the pupils the pictures of soldiers painted by Erler or Spiegel, compare them with the vulgar and horrid works by Dix or Grosz. Every pupil will recognize immediately what decadent art is. . . . The strength of the real artist is in his blood, which leads him to heroism."[29]

Eber became one of the particular favorites of the regime. He joined the Party early and received many honors. His paintings were widely distributed through postcards and reproductions. Eber was forty-one years old when Hitler came to power. He quickly became one of the most fanatical painters of the National Socialist movement. His pictures were always prominently exhibited and widely reproduced in the press. His paintings of soldiers and SA men, with their fierce profiles, displaying their weapons, were favorite subjects for postcards. *The Dispatch Courier* was especially popular. They embodied the worst of National Socialist art with their call to fight and to sacrifice. "Elk Eber was one of the strongest artistic personalities of our time," declared a colleague in Eber's obituary in the *Völkischer Beobachter,* in 1941 "He drew the war as he saw and lived through it, the heroism of the German soldier during battle. Also his own deprivation and suffering and sometimes even the proud bearing of the soldiers when the battle was hopeless. . . . *The Last Hand Grenade* was one of the most remarkable pictures in the 'Great German Art Exhibition,' because it expressed the attitude of the Party and the whole people. . . . Professor Elk Eber had basically only one theme: the soldierly, heroic masculinity of our time."[30]

Hans Schmitz-Wiedenbrück's painting *Workers, Soldiers, Farmers* borrowed the traditional format of the triptych to carry a Fascist message. It represented the

three pillars of the state, elevated to icons, symbolizing their contributions—almost but not quite equal. The army dominated the picture, not only by its central position but also by the fact that it was painted as if seen from below, a well-known artistic device for creating awe and emphasis.

Paul Mathias Padua's *The 10th of May 1940* celebrates the Germans' opening of the western offensive. The leader of the fifteen men crossing the Rhine was seen as someone who was beckoning the whole nation to follow him with an almost religious gesture.

An increasing number of war paintings filled the walls of the House of German Art. In them the readiness to fight and to die for the nation was seen as the highest virtue. The soldier was shown mostly as the glorious victor. The horror of war or even death was only rarely portrayed. The National Socialists believed it was not the role of art to augment the anguish of war. It was the task of art to lead people away from reality into an emotional dream world: "The willingness for sacrifice which fills the whole German people is visible in all the works. . . . They are the artistic visualization of a communal experience, the representation of the spiritual attitude of their time." Paintings that could have given an accurate, realistic picture of the

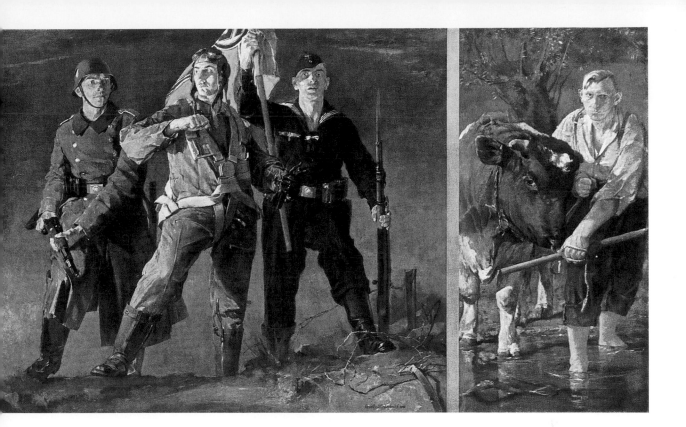

social and historical circumstances of a people at war were censored by the leadership. The National Socialists kept the realistic language of painting, but they restricted its range. The artist was encouraged to adopt a polished photographic style but not to use it with conviction. Once more the emptiness that stares us in the eye when we look at almost any of these paintings stems from the artist's total divorce from reality.

Paintings of the great battles in German history glorified the country's military tradition and justified the continuing struggle. Werner Peiner had become one of the most prolific battle painters of the National Socialist regime. In 1937–44 he created the cartoons for his series of large tapestries, four devoted to the subject of the falcon hunt, ten to the virtues of women, five to the five continents, and the rest to the major German battles throughout history. By 1945 only five tapestries were finished. They were huge works, along Gothic and Renaissance models, commissioned by Göring and Hitler for the new Reich Chancellery Speer had designed. They were supposed to be the building's most significant and impressive decorations, launching a monumental modern art form. These historical subjects gave the German Reich a historical

context. The description of these tapestries in 1940 lauded Hitler as the greatest of patrons, who was bringing about the renewed flowering of the art of tapestry. This series by virtue of its scale would outshine those produced in the Middle Ages. It was the triumphant theme that spoke of the heroic spirit of the Reich, and confirmed the rebirth of a vigorous Germany after the shame of the Versailles Treaty and the defeat of World War One.

Ferdinand Spiegel's *Tank*, a giant mural which combined the modern army with the old Prussian cavalry, also celebrated the continuity of battle. The colonization of the past never stopped. The great German battle scenes and the representations of warriors from previous periods all helped to legitimize the present war. The celebration of the precursors of the new Germany was used to tell the story of those who had prepared the ground for National Socialism.

Many artists were selected to become official war artists under the leadership of Luitpold Adam, who had been a war artist in World War One. At the start, Adam's Staffel der Bildenden Künste (Division of Visual Arts) included forty-five official war artists; eventually there were eighty. The quantity of war art turned out was enormous. All work belonged to the

government. It was used for special exhibitions, which toured the country. "The Invasion of Poland in Pictures," "The War," "Northern Land," "German Greatness," "Painters at the Front," "A *Volk* at Work" were all meant to show the cultural and heroic effort of Germany undiminished despite adversity and hardship. Artists were encouraged to create directly from their experience of war. The magazines went to great lengths to prove that the idea that distance was necessary for the artist to gain sufficient perspective to render a great event was false. The direct and subjective experience of war gave their art its artistic stamp. The fact that the artist was at the same time a soldier and no longer a mere observer gave him a special re-

lationship to the events. "Art is the mirror of the soul," wrote Walter Horn in 1942. "It reflects the character and shows if it can master the task of history or if it is defeated by it. Only a soldier-like character, filled with intense feelings, is able to transmit the experience of war in artistic form."[31]

The works of the war artists were more than personal documents; they were the highest artistic expression of an experience which involved the whole nation. "[They] are documents of the German soul. Their content and style are signs of the creative strength, the philosophical [*weltanschauliche*] attitude and the soldierly spirit. . . . The ethical and brave ideals of the SS, the highest volkish values, honor and

Paul Mathias Padua. The Tenth of May 1940
"THE SINGLE EPISODE DEPICTED IN THIS IMAGE IS OF NO IMPORTANCE, NOR WILL ANYBODY MISTAKE THE SOLDIERS' HEADS FOR PORTRAITS. THE VIEWER IS INFLUENCED BY THE MYSTICAL CONTENT RATHER THAN BY THE EPISODE OR PORTRAITS."—ROBERT SCHOLZ

faithfulness, find here their artistic representation. In this way the visitor not only experiences an art exhibition, but conceives a picture of the character of the SS."[32]

Not all the work done by the war artists was National Socialist propaganda. For quite a few painters, to be a war artist meant not to have to fight. With the exception of the very fanatical National Socialist devotees among them, much of their work is not any different from that of the war artists of other nations. Many just painted what they saw, although their work was not so prominently featured in magazines. Some might have secretly made some works which rendered the real face of war, but of course they could not have been shown. There were many drawings and watercolors which simply rendered the life of the soldiers or the landscape. There were even pictures which showed some compassion for the prisoners and the destroyed villages of Russia. But among the many thousands of works preserved, there is not one single drawing showing the absurdity of war. The picture one gets from these works is of a gentle war, of blonde nurses, comradeship, and friendly faces. It is not a picture of blood and tears, of gangrene and death.

THE WORKER
Labor, which was one of the key words in the National Socialists' vocabulary, was usually represented by the

Werner Peiner. Frederick the Great at Kunersdorf. *Cartoon for a cycle of tapestries* "SINCE GERMANY HAS REVIVED LONG-DESIRED MONUMENTAL ART, WE ARE WITNESSING A RECOVERY OF TAPESTRY WEAVING AND ITS ELEVATION TO MONUMENTAL PAINTING." —JOHANNES SOMMER

Werner Peiner. Frederick the Great at Kunersdorf. *Detail*

farmer. There was a notable absence of machine art. All work was done by brawny arms, tough muscles. Many paintings were simply an advertisement for the strong worker, often indistinguishable from posters. Sometimes work was seen as a battle, the worker as the hero, with his tools symbolizing conquest. The problems of modern industrial society did not exist. The portrayal of work as a chore, as seen in paintings by modern artists like Käthe Kollwitz, is almost totally absent. National Socialist artists depicted a world ennobled by hammers and muscles, not a world of exploitation and exhaustion; a world of the idealized worker, not one of sweat and toil. It seems odd that such a highly technological country did not portray technology more in its art. Some painters celebrated achievements like the Autobahn (Oskar Graf), or the great building sites at Nuremberg (Paul Herrmann). Where modern industry is represented, it is the factory rather than the worker that is shown, or the workers are rendered so small that they became just props. The miracle of technology and industry alone was to be celebrated.

The representation of the individual man in the factory was considered a sign of past liberal times that, according to the philosophy of the National Socialists, saw a kind of salvation in technology. In 1942, an article entitled "Kunst und Technik" (Art and Technique) appeared in *Die Kunst im Dritten Reich*, which castigated

Ferdinand Spiegel. Tank. *Mural*

even the socialist realist art of the Soviet Union with
its "mechanical dehumanization, blind adoration of the
machine, and its crude materialism." Both liberalism
and Communism put technology above man. The Na-
tional Socialists stressed the fact that behind the
machines stood the will not of a single man but of the
people. "The measure of all things is no longer man or
machine but *Volk* and community."[33]

This communal will of the German people was ex-
pressed in pictures of flaming furnaces, smoking
chimneys, and howling wharves, the battlefields of the
workers, where the individual counted for little.

Many paintings represented the community, the na-
tion; the demonstration of the unity of all people in
which the individual is part of the whole. In Hans
Schmitz-Wiedenbrück's *Nation at War*, the mother is en-

Olaf Jordan.
Two Russian
Prisoners of
the Germans.
1943

Olaf Jordan. Alexej
Pawlowitsch Bondar,
Volunteer in
Germany's Cossack
Division.
1944

*Wolfgang Willrich. "Neuberger, Karl
28388. Eastern Front squad leader
from Sauerlach, near Munich, 44
years old, married, 4 children.
Construction worker. Maternal
ancestors farmers in Bavaria."*
—Legend on picture

169

Arthur Kampf. In the Steelworks.
*"Great German Art Exhibition
1939"*

throned like a madonna, in her hands the child and
the letter from the front. Destiny links the front with
the *Heimat.* As the guardian of the nation she sits in
the middle. She is surrounded by the other compo-
nents of the nation, as on a stage: the farmer on her
left, the worker on her right, and above her head the
soldier riding under a rainbow into battle. We find the
nation again in Georg Poppe's *Portrait of the Führer.* This
time the mother looks up to the Führer who is sur-
rounded by scientists, farmers, and workers. Behind
him is the military.

Knirr. Hitler
"THE HARD EYE OF THE COMMANDER IS LIKE LIGHTNING OR THE FLASH FROM A BULLET SHOT."
—WILHELM WESTEKER

Below:
Walter Einbeck. Hitler

PARTY PORTRAITS, PORTRAITS OF HITLER

The so-called Party pictures, depicting top Nazi personalities or events, were an important part of art production, but they were by no means the overriding subject. Elk Eber's fierce SA men, with their armbands designed by Hitler himself, were typical. Party members of the SS were also represented, set in seemingly harmless landscapes or in the midst of peasant lives.

Portraits of Hitler of course dominated. "The Führer is the highest gift to the nation. He is the German fulfillment. An artist who wants to render the Führer must be more than an artist. The entire German people and German eternity will stand silently in front of this work, filled with emotions to gain strength from it today and for all times. Holy is the art and the call to serve the people. Only the best may dare to render the Führer."[34]

Hitler was often painted full length in order to convey his divine role (see illustration page 210). A seated portrait would look too relaxed and familiar, unless it

was formal and enthroned. Unapproachable, he was never shown at home, in personal surroundings, and at ease. In group portraits he always stood out, dominating, as in Emil Scheibe's *Hitler at the Front.* But primarily he was portrayed alone. There was Hitler the leader or the head of the army, often authoritative, sometimes pensive, gazing into the distance (see Franz Triebsch's portrait, page 21). Fritz Erler pictured him in front of a monumental sculpture making him look like a giant. He appeared on stamps (mostly designed by Richard Klein). Sometimes he was seen as a friend of the family but usually as the icy leader.

Conrad Hommel (see page 105) was Hitler's portrait painter and the Third Reich's court painter in general. He painted Hitler in the pose of the *Feldherr* (commander-in-chief), the map of the world at his feet, the bunker in the background. Hommel's portraits made wonderful postcards, which were snapped up by the millions.

In Hermann Otto Hoyer's *Am Anfang war das Wort* (In the Beginning Was the Word), a title with strong religious connotations, Hitler stands on a dais in a dark room. Behind him is an SA man with the flag. Hitler is the glorification of the National Socialist idea heightened into religion by the title alone. The light over him falls on the listener. Hitler is the bringer of light, the illuminator.

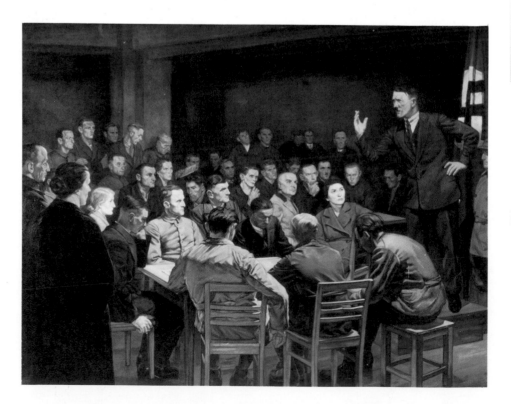

Above:
Emil Scheibe. Hitler at the Front. *1942–43*

Hermann Otto Hoyer. In the Beginning Was the Word

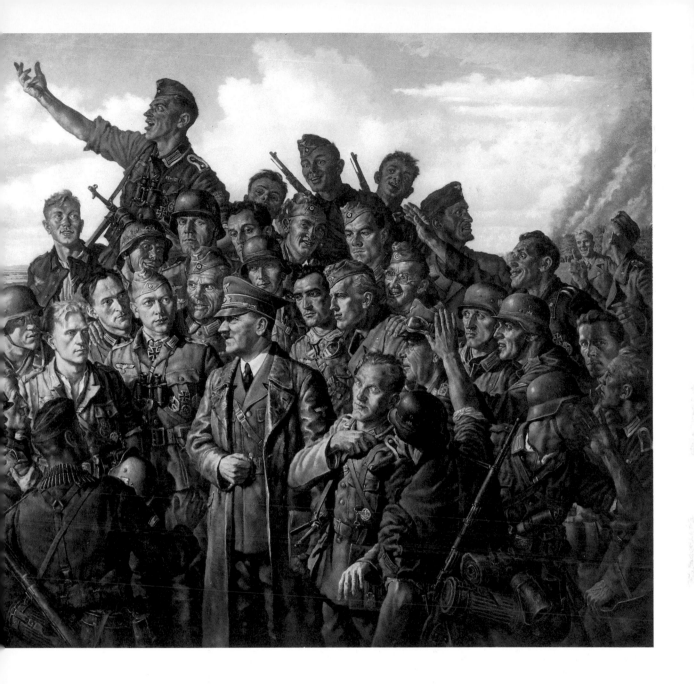

ANTI-SEMITIC AND OVERTLY DOCTRINAIRE PAINTINGS

The fine arts were certainly an instrument for the dissemination of National Socialist propaganda, but in effectiveness in swaying the masses, they were overshadowed by the mass meetings and the mass media, which had a much larger audience. While cartoonists and filmmakers indulged in orgies of anti-Semitism, we find very few traces of anti-Semitic propaganda in the fine arts. Maybe the notion that the artist created lasting works on a higher plane kept such themes at arm's length. Adolf Reich's *Um Haus und Hof* (All Their Worldly Goods; see illustration page 279) is a picture of the manifestation of greed. A Jewish speculator ap-

propriates the homestead of an honest peasant couple who has run into financial difficulties.

Sometimes the political message was more subtle. Franz Weiss's *The Seven Deadly Sins* (see illustration pages 282–83) is a painting very much in the tradition of the paintings of the Renaissance. It seems to have no political message whatsoever until one discovers in the bottom corner the portraits of Neville Chamberlain and Winston Churchill as gluttons. After all, art was to concentrate on the good, and the good had to be beautiful, and consequently there was no place for the Jew in it. He would have debased German art just by being there.

CHAPTER 9

SCULP

THE YEARS OF SEARCH AND PROBING THAT MARKED THE FIRST YEARS IN POWER HAVE BEEN BRUSHED ASIDE. STRONG, PROUD CHARACTERS HAVE TAKEN OVER. THE STORM OF SPIRITUAL REVOLUTION HAS WON THE DAY. GRANDEUR OF FORM, WHICH IS AN APPROPRIATE ICON FOR OUR ERA, BESTOWS ON SCULPTURE A NEW AUDACIOUS LANGUAGE. THE GIANT SCULPTURES HAVE BECOME A SYMBOL OF THE CREATIVE POLITICS OF THE STATE. TOGETHER WITH OUR MONUMENTS OF ARCHITECTURE, THEY PROCLAIM THE EVENTS OF OUR TIME FOR GENERATIONS TO COME. PAINTING STILL FIGHTS FOR AN EQUAL PLACE NEXT TO SCULPTURE AND ARCHITECTURE. IT REPRESENTS THE EXPERIENCES OF THE SOUL AND THUS CREATES THE EQUILIBRIUM BETWEEN INDIVIDUAL AND COMMUNITY, THE HARMONY BETWEEN DAILY HAPPENINGS AND FESTIVE ONES, BETWEEN CLEAR POLITICAL WILLPOWER AND ROMANTIC LONGING. THE GIANT SCULPTURES CREATED FOR THE BUILDINGS OF PARTY AND STATE—LIKE THOSE BY THORAK AND BREKER—ON THE OTHER HAND, GREW OUT OF A DIFFERENT FEELING. THEIR GROUND IS THE MANLY CHARACTER OF NATIONAL SOCIALISM, THE FORCES OF ORDER, COURAGE, AND HEROIC STRUGGLE. —Walter Horn[1]

TURE

At the first "Great German Art Exhibition" 200 sculptures were shown. As time wore on, the numbers grew; 440 works by 237 sculptors were shown in 1940. The increasing number of sculptures showed that painting was losing ground. This was due not only to the fact that Hitler was disappointed with paintings, but also because sculpture seemed better able to express the National Socialist obsession with race and biology. It offered a body language people could identify with and on which they could model themselves. Sculpture was seen as an enduring faith carved in stone. Painting did not have the same suggestive force. Another important factor was that art was increasingly viewed as a complement to architecture. Frequently sculpture and low reliefs were used on and in conjunction with buildings, enhancing the idea of architecture as art.

How much importance the National Socialists assigned to sculpture is further emphasized by their desire to let foreign countries know about German achievement in this art form. Stung by the many foreign reports that German art had come to an end, artists felt prompted to show the art they had the most confidence in. Much of the art displayed on the occasion of the Olympic games was aimed at foreign visitors. For the 1937 world's fair in Paris the Germans devised a large sculptural program, which included not only sculptures by the leading artists on the exterior of the German Pavilion but also two exhibition halls

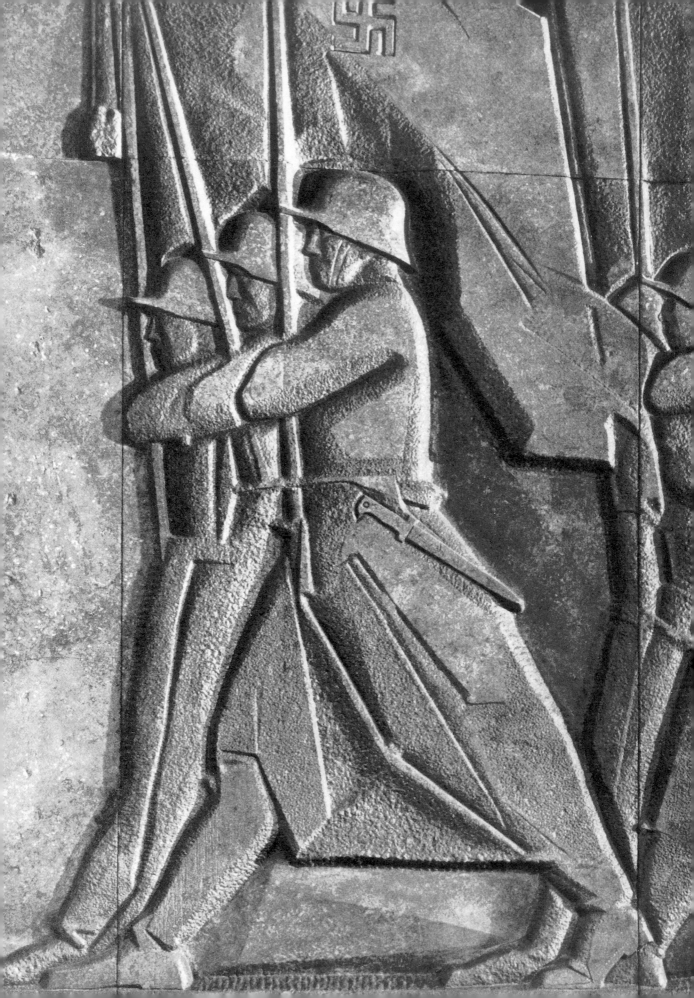

holding their work. Breker, the leading German sculptor, was asked in 1938 to organize an exhibition of German sculpture in Warsaw; it included 130 works by 37 sculptors.

Destined to be exhibited in public spaces, sculpture is more susceptible to political manipulation than painting, which is meant primarily for the intimacy of the home. Nineteenth-century sculpture also celebrated nationalistic, traditional state-approved values such as honor, heroism, and loyalty.

The National Socialists were quick to recognize that the traditional role of sculpture gave it power as political message carrier. But the role of sculpture as the most visible expression of National Socialist ideology called for a new kind of sculpture. The representation of humanistic values based on the consensus of society was no longer enough. Sculpture now had to be the carrier of specific National Socialist values. Added to the inherited codes of "warriors" or "soldiers" were "the war," "the Party," "comradeship."

Many themes expressed in painting also found their way into sculpture. Motherhood, the fertile female body, the peasant. But it was most of all the virile beauty of the male body that dominated sculptural output. Modeled on antiquity, the sculptures displayed steely masculinity. Hitler claimed that "the present is evolving a new type of human being . . . a new type which we watched as it appeared in its shining, proud, physical strength and beauty, in front of the whole world at last year's Olympic Games. This type is the symbol for our new age."[2] Hitler believed that only the Germans were called upon to render sculpture its former beauty.

The common roots with Greece, the eternal link with the past, filled not only the heads of the politicians; art historians too did not tire of proclaiming the message of the eternal German art. "Our time is once more able to be Greek," wrote a government spokesman, Wilfrid Bade, in a preface to the book *Deutsche Plastik unserer Zeit* (German Sculpture in Our Time). "At this moment, when Germany is overcoming foreign influences of a thousand years and is returning to pure forms, works are created which are in their maturest and noblest examples the equivalents of Greek art."

But the new German sculptures were meant to be not mere copies of antiquity, but something equal to

Arnold Waldschmidt. Soldiers. *Relief. Detail*

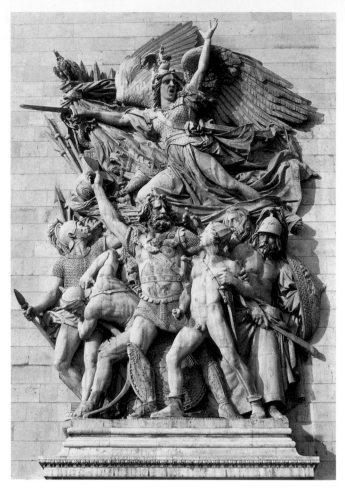

François Rude. The Marseillaise.
Arch of Triumph, Paris. 1833–36

it: a Nordic equivalent of the Greek model. The National Socialists left no doubt that these were German bodies.

The image of the new man—an idealized male nude—became the absolute image of the Fascist human being. "The subject is primarily the naked body and the portrait. There is no baroque drapery, no theatricality which marks monuments with literary themes. These bodies repose in themselves, they do not lose themselves in insignificant unsculptural details. Their artistic level can well stand up against anything done in the rest of Europe."[3]

The male nude was tall and broad-shouldered, with narrow hips. He represented the ideal of the Aryan race, embodying the virtues of the regime: comradeship, discipline, obedience, steeliness, and courage. It was not just an ideal of beauty that the National Socialists postulated but an ideal of being. These powerful messengers dictated men's moral code. "By

embracing the beautiful and the harmonious, art lifts man above himself. Reality is transformed into an ideal world; the experience of the individual becomes the experience of the whole people. If you have seen these works of art, you are bound to feel a nobler person."

To be naked also meant to be in control and to be classless, too. While at the beginning bodies were still clad, with the passage of time all was revealed. The new man knows no shame because his soul is noble. "We have nothing to hide, we are the master race, strong and healthy," these men were saying.

They were godlike creatures above reality: timeless, eternal, absolute, and universal. "The Ideal of Beauty, of antiquity, will be eternal as long as people of the same pure character and race exist. . . . The race that marks the whole life of a people will also look at the arts with special eyes. . . . Each politically heroic epoch will immediately build a bridge to another equally heroic past. Greeks and Romans will suddenly become near to the Germans, because their roots lie in the race."[4]

For the National Socialists, the naked man repeated the classical ideal of the heroic athlete in his naturalness. The Olympic spirit became identical with the German character, the order of antiquity the best bastion against the chaos of modern art. Exhibitions of Greek sculptures under the title "Sports of the Hellenics," or "Olympia and the German Spirit," and the big international Olympic art exhibition held in 1936 in Berlin all promoted this idea, which Leni Riefenstahl captured in her film *Olympia—Feast of Nations* by skillfully dissolving between naked sportsmen and antique statues. In Breslau, *The Decathlon* by Georg Kolbe (1877–1947) stood next to a figure of a Greek ephebe.

Everywhere there was the usual assortment of discus and javelin throwers, rowers, and runners. The link between sports and art was further promoted by introducing special courses for artists at the official Gymnastic Academy. Organized by the Reich Chamber for the Visual Arts, these courses were designed to familiarize artists with the bodies of the athletes who would be sketched by artists during their exercise. But despite all this hankering for naturalism, in sports sculpture, too, the presentation of the individual sportsman or sportswoman was lifted into the realm of universality. They were supposed to represent the spontaneity and joyfulness of physical activity. Yet the many runners, discus throwers, rowers, and jumpers

do not transmit any feeling of physical freedom. Each muscle, each tendon, had to express strength and force. In their disciplined, steel-like bodies they were representatives of a disciplined, steely nation. The next step, the presentation of the warrior, was only a small one. It was always the same basic principle: the celebration of conquest and victory. The discus thrower became the symbol of the dynamic force of the whole nation. If an earlier presentation of sport still showed the athlete clad and with shoes, the universality of the figures demanded now that these garments be shed. The only attribute was the spear or the discus, and even those were often disregarded. The statues of athletes which Kolbe, Karl Albiker (1878–1961), Arno Breker (1900–1991), and Josef Thorak (1889–1952) created for the Olympic stadium were simply nudes; their activity was indicated only by the titles: *The Athlete, The Decathlon, Young Wrestler.* "Artists who create wrestlers do not want to show an example of how to wrestle, but to express human strength and fighting nature."[5]

Of course the nudity was chaste, and did not suggest voluptuous sexuality. "The new generation, steeled in exercise and sport, knows more about the human body than the previous one. A healthy young boy does not think about the steamy studio atmosphere of the previous century with its genre 'artist and model' when he looks at the work of Kolbe or Breker or Thorak's interlaced couple. He knows that a profound knowledge of the body is necessary to create such sculptures," wrote the art historian Kurt Lothar Tank.

The nudes appear sexual and asexual at the same time. They are pin-ups of sexual fantasies. It is surprising that a puritanical regime, which put homosexuals into concentration camps, would celebrate the nude male body to such an extent. This was but one of many contradictions in the National Socialist aesthetic.

Specific personal values were elevated to universal ones. Nudity lifted these figures into a classless and timeless realm. Their attributes too were timeless, the sword rather than a pistol or gun, which could be historically dated.

The public display of sculpture and the enormous publicity its creators received explains why, even today, the names of the leading sculptors of the Third Reich are more familiar to us than those of the leading painters.

Sculptors in many periods have found their inspiration in Greece. At the turn of the century many

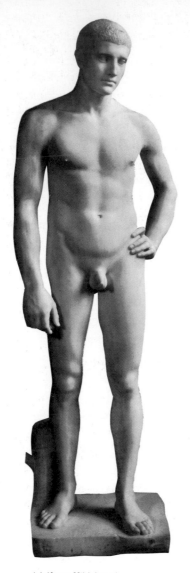

Adolf von Hildebrand.
Youth. *1884*

Opposite:
Fritz Klimsch in his studio
"GERMAN LIKE ALL WORKS
BY KLIMSCH, BUT A NEW
BREATH INSPIRES THE
WORK, A NEW AIR AND
ATMOSPHERE EMANATES
FROM THESE STRONG AND
PROUD LIMBS, EXPRESSING
A VAST, DEEPLY STIRRING
LONGING."— ULI KLIMSCH

German sculptors had looked to antiquity. The classical ideal as preached by the sculptor Adolf Hildebrand in his book *The Problem of Form in the Visual Arts*, which was published in 1893, had a wide-ranging influence on German sculptors. Many of them, Adolf Wamper (born 1901), Willy Meller (born 1887), Kurt Schmid-Ehmen (1901–1968), and Anton Grauel, who all worked under the influence of Hildebrand, were easily adopted by the National Socialist art scene. The enormous demand for public sculpture prompted the Führer to commission many monuments from these artists. Only those who were considered too modern, like Gerhard Marcks, were rejected.

At the beginning of this century there were very few modern sculptors. Since abstraction developed much later in sculpture than in painting, relatively few sculptures of the earlier period had to be declared "degenerate." The National Socialists also banned the work of Rudolf Belling (1886–1972), Ernst Barlach (1870–1938), Wilhelm Lehmbruck (1881–1919), and a few others. Their elongated forms or rough surfaces were considered "un-German." In this context the work of Rodin was out, while Maillol's sculptures won much praise.

Many of the leading sculptors the National Socialists accepted were prominent artists before Hitler came to power. Fritz Klimsch (1870–1960), Georg Kolbe, Richard Scheibe (1879–1964), and even Josef Thorak were popular in the twenties. Although at the beginning of the regime Kolbe was attacked because he had done monuments to the Jewish poet Heinrich Heine and the Jewish statesman Walther Rathenau, Scheibe shared the same fate because of his monument to the Socialist Friedrich Ebert for the Paulskirche in Frankfurt. But both sculptors were soon allowed into the fold.

The works of Kolbe, Klimsch, and Scheibe were seen as the best examples of the realist school; they worked in the tradition of Maillol, which was widespread in Germany. The National Socialists embraced their work because, as a leading art historian put it: "We know that we owe to these three masters the salvation of a strong German form in the midst of decadence."

Like the painters, most of the honored sculptors belonged to the older generation. Klimsch was already sixty-three years old when Hitler came to power, Kolbe fifty-six, and Richard Scheibe fifty-four. After 1933 their work showed a heroic and monumental tendency, but on the whole it remained lyrical and expressive. The impressionistic modeling of the surface did not blend easily with the smoothness of the architecture that

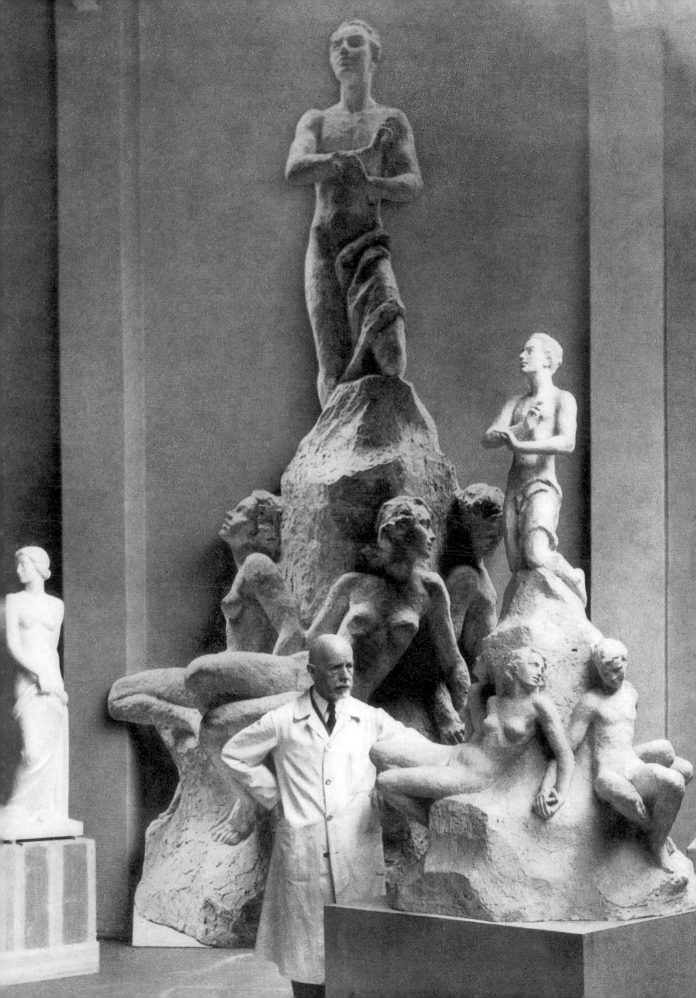

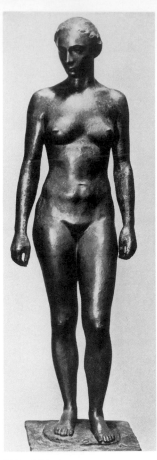

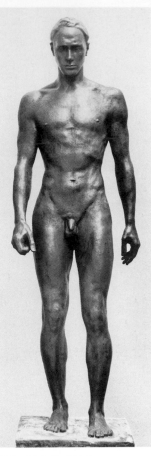

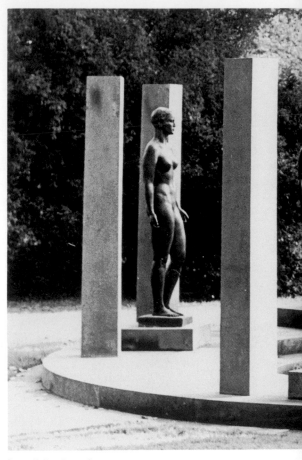

Richard Scheibe.
Standing Female

Richard Scheibe. Thinker

Georg Kolbe. Ring of statues.
Rothschild Park, Frankfurt-am-Main

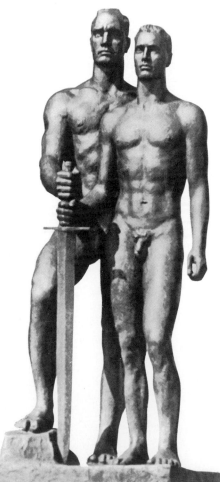

Georg Kolbe. Commemorative
memorial. Stralsund. 1935

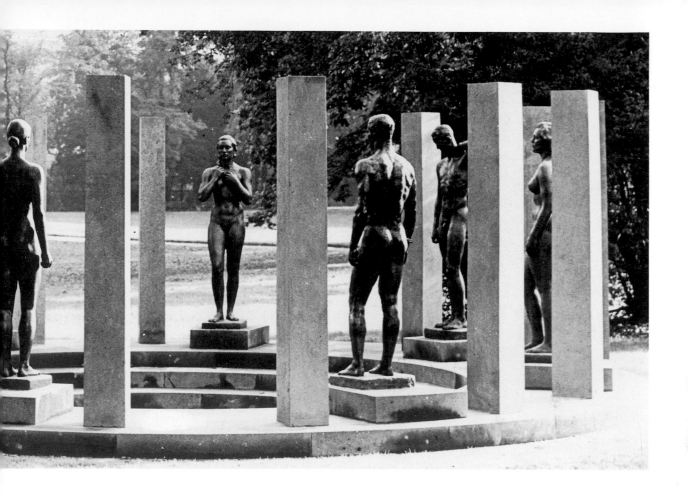

was the ultimate setting of these sculptures. Nevertheless, the sculptors continued to work, and the National Socialist state became one of their great sponsors.

Kolbe's role during this period is ambivalent. His work fitted very neatly into the National Socialists' preconceptions, but he refused to be drawn into the monumental tradition. He remained on the human scale. Unlike Breker and Thorak, Kolbe could never become an official artist of the Third Reich; his work was too private. However, Klimsch's work was easily absorbed into the official program. He was a favorite of Hitler. Klimsch nudes stood in almost every town, and in 1942 a large exhibition of his work was sent to the Venice Biennale.

Another case of absorption was that of the south German Josef Wackerle (1880–1959). He became one of the most popular sculptors of the regime. His work decorated the National Socialist leadership's compound in Obersalzberg and many facades of official buildings in Munich.

Originally Wackerle was not a monumentalist. From 1906 to 1909 he directed the Nymphenburg Porcelain Manufactory. Although he worked in the tradition of the Munich school with its baroque elements, he too fitted easily into the new cultural programs. His first monumental sculptures—two horsemen—were created for the Olympic Stadium in Berlin in 1935. An interesting compromise with the regime can be seen in his *Neptune Fountain* in Munich. The horse and the triton are carved in the Baroque tradition but the figure of Neptune is brought up-to-date: a young heroic man, the idol of the new era.

In sculpture, as in the other arts, the year 1936 meant a consolidation of the National Socialist aesthetic. Any impressionistic rendering or lively surface was shunned in order to harden the style. With increasing monumentalism the traditional materials of wood and stone gave way to the smoother and more precious bronze. "The visual arts have returned to simplicity and to naturalness, and therefore have returned to truth and beauty," wrote Albert Speer in a preface to the book *Deutsche Plastik unserer Zeit*.

The appetite for sculpture as the perfect propaganda tool was voracious. More and more sculptors allowed

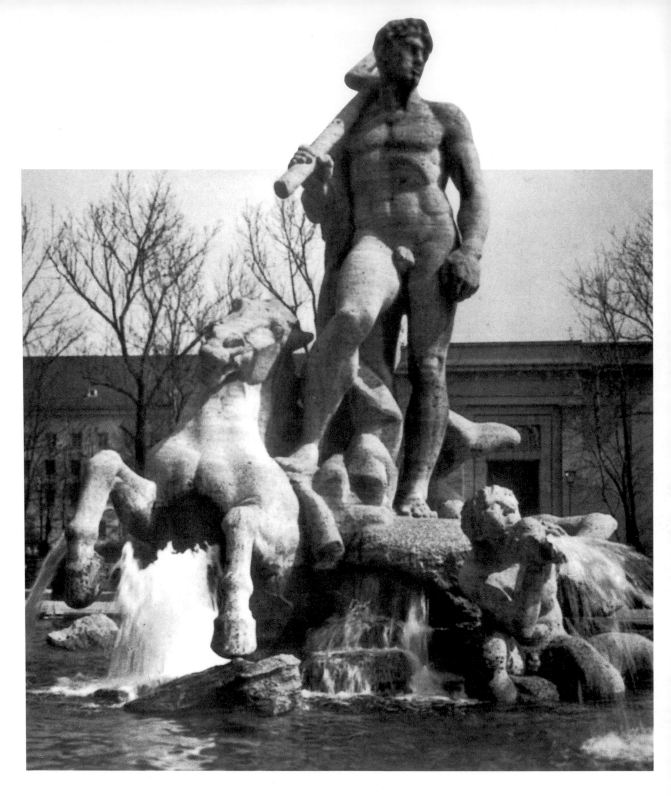

Josef Wackerle.
Neptune
Fountain.
Munich. 1937

themselves to be yoked to the National Socialist cart.
Bernhard Bleeker (1881–1968) had created many mon-
uments in Munich, ranging from a figure group,
Sleeping Soldiers, to fountains, from oversize lions to na-
ked youths. During the National Socialist period he
also created many portraits of Party bosses.

Karl Albiker, whose sculpture was influenced by
Maillol, worked in Dresden. Beginning with small
sculptures, he more and more opted for the monu-

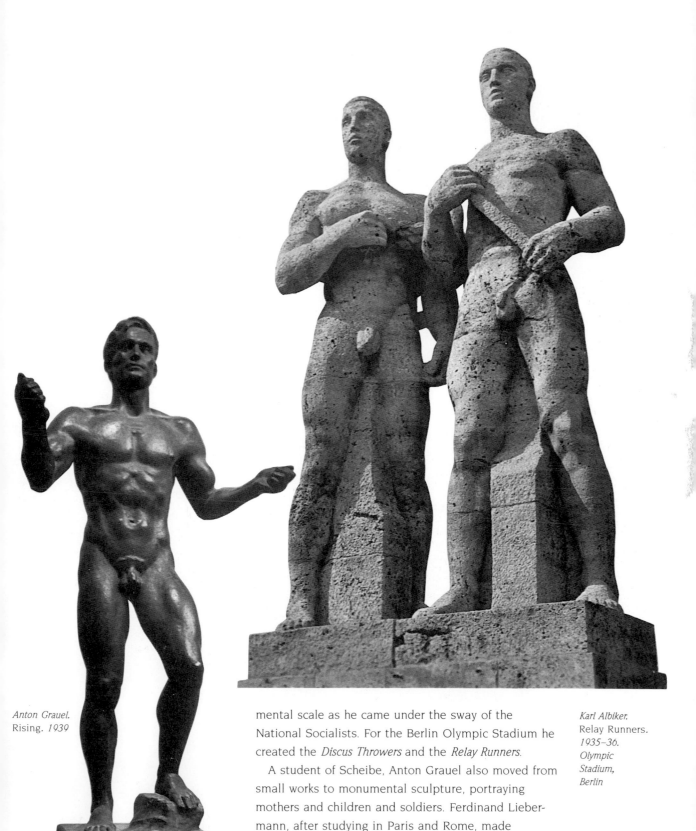

Anton Grauel.
Rising. *1939*

Karl Albiker.
Relay Runners.
1935–36.
Olympic
Stadium,
Berlin

mental scale as he came under the sway of the
National Socialists. For the Berlin Olympic Stadium he
created the *Discus Throwers* and the *Relay Runners*.

A student of Scheibe, Anton Grauel also moved from
small works to monumental sculpture, portraying
mothers and children and soldiers. Ferdinand Lieber-
mann, after studying in Paris and Rome, made
portraits of Hitler and Rosenberg. Arnold Waldschmidt
(1873–1958) was a military officer who came late to

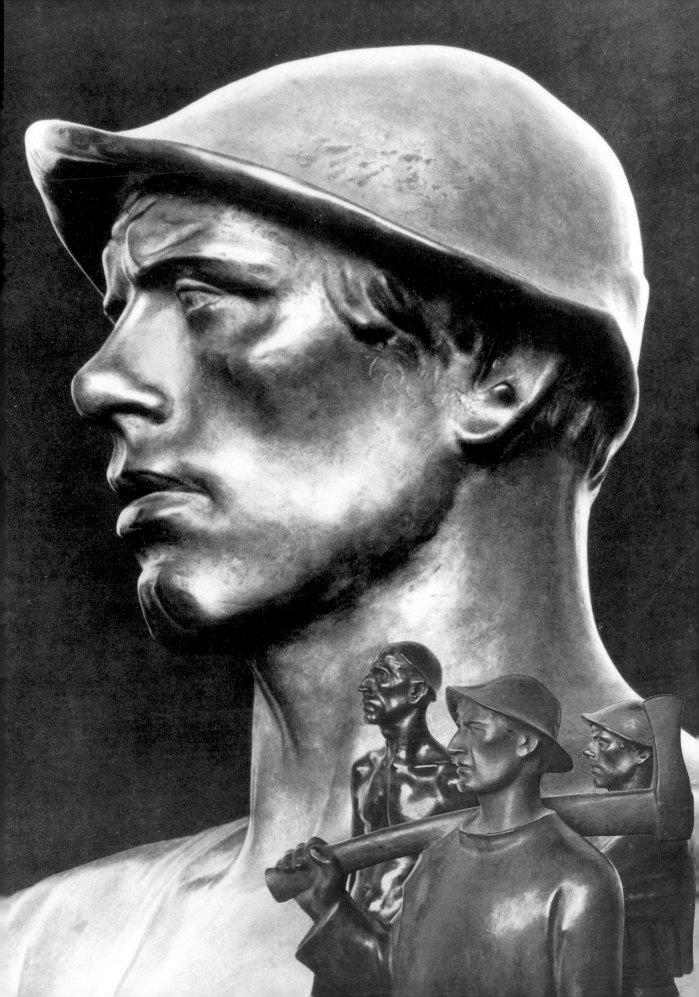

sculpture. The National Socialists were quick to commission him to make monuments to the German soldier. Some sculptors, like Otto Winkler, Ernst Kunst, and most of all, Fritz Koelle, specialized in bronze figures celebrating the heroic worker.

Sculptures of workers were relatively rare, however. Sometimes half-clad, undressed as opposed to the nudity of the godlike hero, they usually carried the insignia of their trade. The absence of industrial workers was the logical result of the National Socialists' idea that the worker should be seen as an artisan, linked with medieval craftsmanship, thus saving him from the image of the urban proletariat.

The demands for monumental sculpture increased; the new stadiums and public squares required more and more giant works. Besides Breker and Thorak, Willy Meller, Adolf Wamper, and Kurt Schmid-Ehmen were called on to create monumental works. Wamper created many of the monumental figures in front of Party buildings: *Icarus*, in front of the Aviation House in Berlin; *The Genius of Technology*, *Hercules with Hydra*, and the giant figures like *Agriculture and Industry* or *The Genius of Victory* for exhibition halls in Berlin. Willy Meller created the large eagles, the carrier of the flame for the Ordensburg Vogelsang (the school for leadership training in Vogelsang), and the *Goddess of Victory* for the Olympic Stadium in Berlin. Schmid-Ehmen, a pupil of Bleeker, was commissioned to sculpt the war memorial for the Feldherrnhalle (Memorial Hall) after

Opposite:

Fritz Koelle. Miners. *Detail*

Fritz Koelle. Miners

Below, left to right:

Ernst Kunst. Knife Sharpener

Otto Winkler. Ironworker

Willy Meller. Commemorative Memorial, Dülken

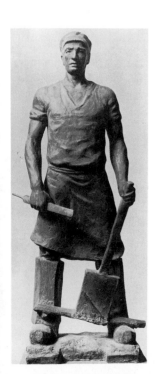
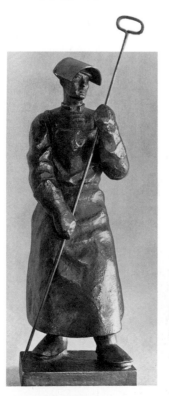
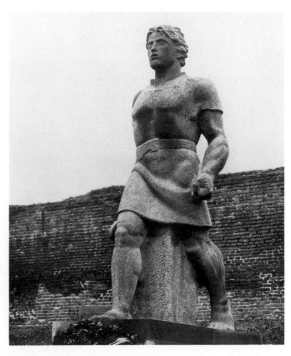

a project by Troost. The work, nearly twelve feet high, was officially unveiled in 1933. Schmid-Ehmen's official career was assured. He never stopped making eagles: for the Party buildings in Munich, the new Chancellery in Berlin, the House of German Art in Munich, the Party Congress Grounds in Nuremberg, and for the crest of Speer's German Pavilion at the 1937 world's fair in Paris (see illustration pages 246–47). For the Zeppelin Field in Nuremberg he made the figures *Faith*, *Fight*, *Sacrifice*, and *Victory*, spelling out the four aspects of the National Socialist mission.

Female sculptures were also created in abundance, although they were mostly on a less monumental scale than their masculine counterparts. If the statues of men broadcast vitality and strength, those of women were always full of erotic promises. As in painting, the women were always "blossoming," "flowering," and "young," and appeared in a lying, sleeping, or walking position. The iconography was always the same: the representation of woman made by and for man, determined by her biological function. She was the fulfillment of man's desire. But the study of these women reveals nothing natural. What dominates is a forced body style, artificial poses, and affected eroticism.

Antiquity and mythology furnished the themes. There were Venus, Olympia, Diana, Flora, Daphne, Leda, Europa—goddesses of fertility or the female erotic—as well as the lovely Galatea, just as the men were always gods of titanic strength and ecstasy—Zeus, Prometheus, Apollo, Mercury, and Dionysus, a Fascist Olympus forming a link between the Third

Reich and the gods. All this was meant to ennoble the art of the Third Reich and endow it with a spurious continuity by giving it an eternal validity. It also helped to convey a picture of man that had nothing to do with reality. The presentation of a naked body was not enough; it had to be lifted into universal truth, into the symbol. While painting at least attempted to give a feeling of reality by depicting everyday happenings, sculpture freed its human beings from any earthbound link. Of course, the frequent use of allegorical figures also allowed artists to paint nudes in fairly erotic situations. In using a well-established pic-

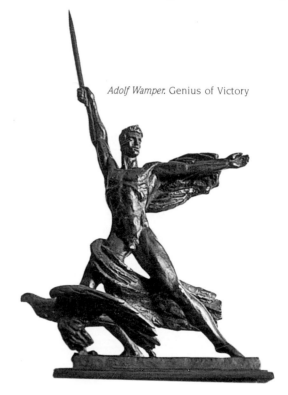

Adolf Wamper. Genius of Victory

Adolf Wamper. Genius of Victory. *Detail*

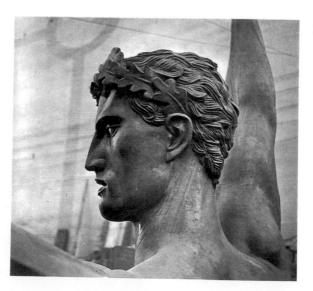

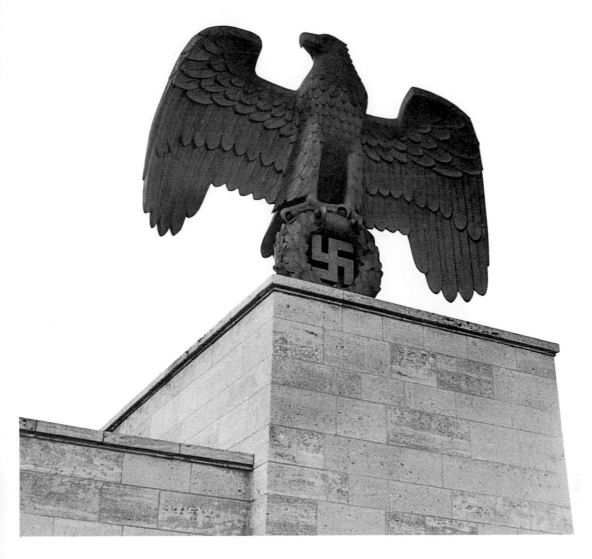

Eagle for the Luitpold Arena, Party Rally Grounds, Nuremberg, 1934. Designer: Kurt Schmid-Ehmen

torial tradition, they did not offend the much-touted decency of the German woman.

Small sculptures in porcelain, plaster, or bronze also were popular. They were considered part of the tasteful middle-class apartment.

Portraits too found many buyers. Besides the numerous Hitler busts, there were those of the leading personalities of the movement. The idealized head was also shown in young girls and women and in determined, fighting men.

Animal sculpture flourished, from the quaint domestic representations of the deer and the cat to the fighting eagle and the untamed horse. The taming of nature was symbolized by numerous statues of men dominating wild horses. Many National Socialist sculptors took up this old motif of the horse tamer of antiquity—Wackerle for the Olympic Stadium and

Thorak for his giant 60-foot-high statues for the Olympic Stadium.

The most famous of all National Socialist sculptors were Arno Breker and Josef Thorak. They became the official state artists, the exponents and inventors of the official National Socialist style. Both were offered many public honors, and the number of commissions they received for public buildings was phenomenal. Their prestige and their rank put them far above any other sculptors of this period, outdoing Wackerle in their size and vulgarity.

Josef Thorak had learned pottery in Vienna. After decorating the king's castle, he began to make a name for himself as a sculptor. Before 1933 he lived in Berlin and had many Jewish patrons. The distinguished art historian Wilhelm von Bode, director of the Berlin museums, wrote a famous monograph about him, and the Municipal Collection of Berlin purchased a work of his in 1928, *The Pious*. It was Alfred Rosenberg who made Thorak one of the attractions of National Socialist art theory by giving him an exhibition in 1935 in Berlin, in which monuments Thorak had created for Turkey were

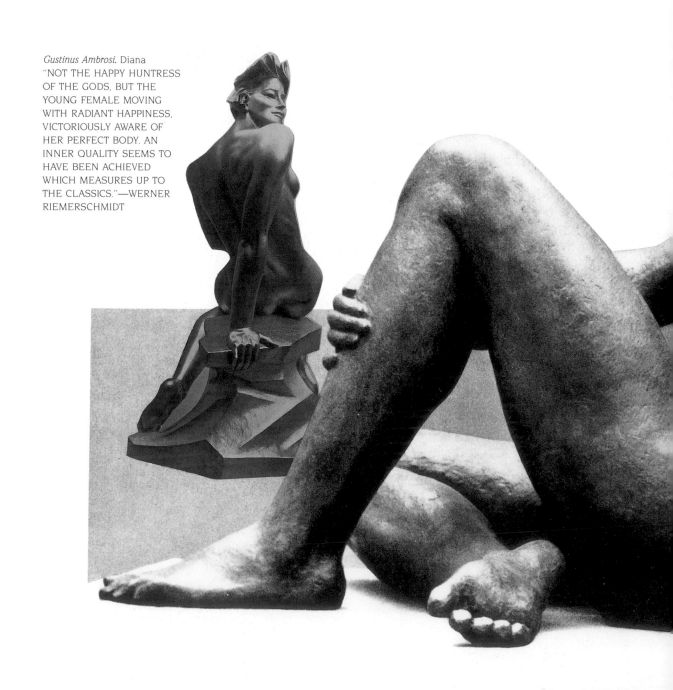

Gustinus Ambrosi. Diana "NOT THE HAPPY HUNTRESS OF THE GODS, BUT THE YOUNG FEMALE MOVING WITH RADIANT HAPPINESS, VICTORIOUSLY AWARE OF HER PERFECT BODY. AN INNER QUALITY SEEMS TO HAVE BEEN ACHIEVED WHICH MEASURES UP TO THE CLASSICS."—WERNER RIEMERSCHMIDT

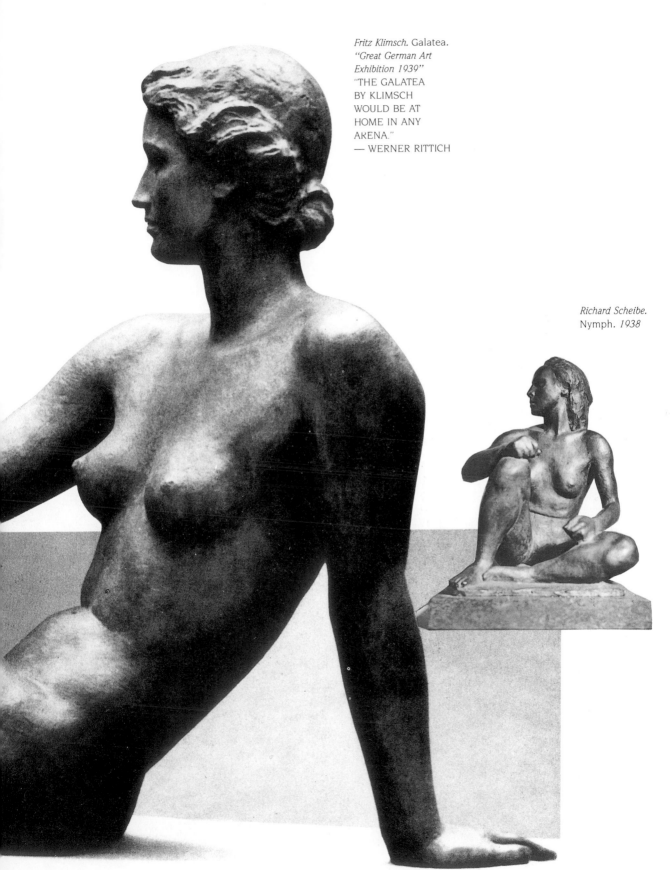

Fritz Klimsch. Galatea.
*"Great German Art
Exhibition 1939"*
"THE GALATEA
BY KLIMSCH
WOULD BE AT
HOME IN ANY
ARENA."
— WERNER RITTICH

Richard Scheibe.
Nymph. *1938*

191

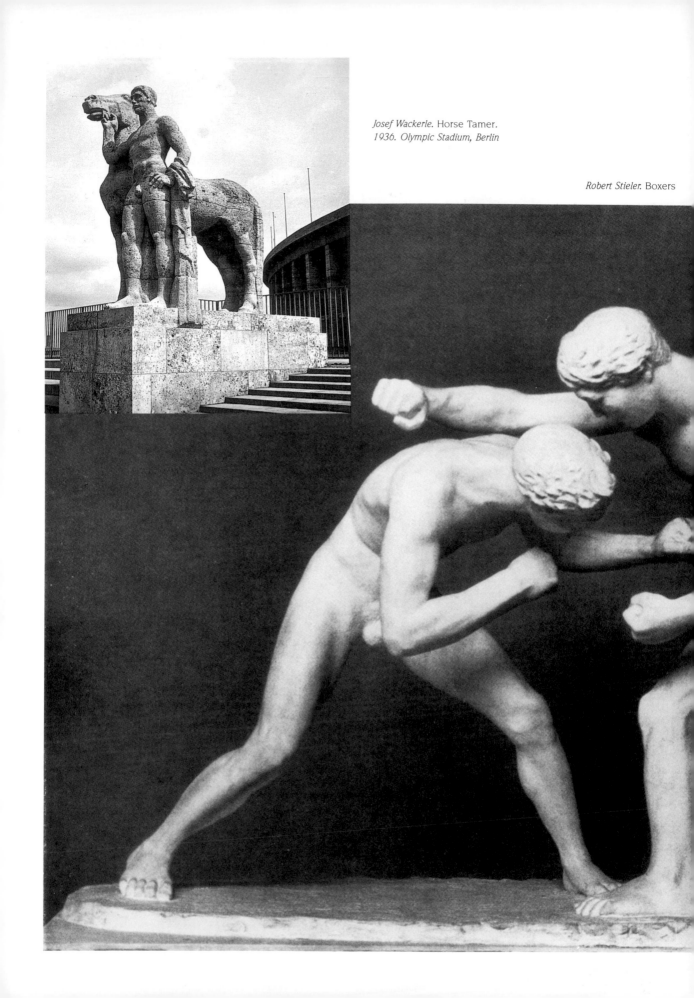

Josef Wackerle. Horse Tamer.
1936. Olympic Stadium, Berlin

Robert Stieler. Boxers

The javelin thrower. Still from Leni Riefenstahl's film Olympia—Feast of the Nations. *1936*

shown. The critics were quick to point out the change that had come over Thorak's work. His personal and impressionistic style had given way to sculptures in which "the powerful and strong is expressed," and the widening of his subject matter had "led to a monumentalism."[6]

In 1938 the state gave Thorak a huge studio in Baldham, near Munich, designed by Albert Speer. In it he worked on 65-foot-high models for his giant sculptures, destined for the Nuremberg stadium (see illustrations pages 242–43). A widely shown documentary film depicts the master at work, using a live horse, which easily fitted into his studio. We see Thorak, "the master of the largest studio in the world," dwarfed by his own plaster models, like the *Horse Jumping*—creations that reached nearly 60 feet up. "Colossus after colossus awaits its final version in stone," pronounced the pompous film commentary,[7] abetted by heavy music. Most of the giant sculptures were first modeled in clay and then enlarged in plaster. In most cases the war prevented casting of the final version, which was supposed to have been in bronze.

In 1941, in the House of German Art, Thorak exhibited a work called *Couple*, depicting a man and a woman. The title indicated the universality of its message: it was the ideal Fascist couple, not lascivious, but tender, ready for action. Love should not be al-

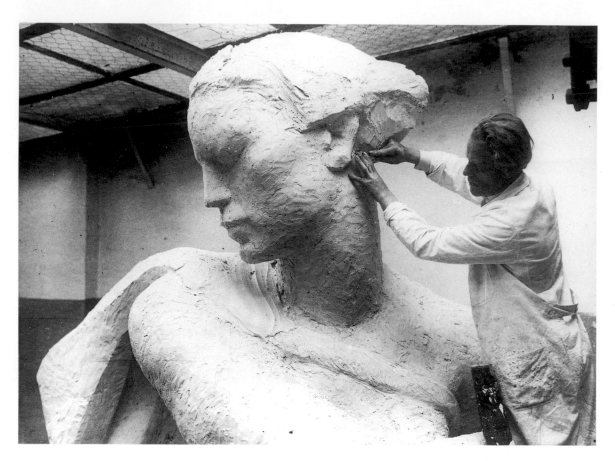

lowed to distract the man from his task of fighting for the nation. The art historian Kurt Lothar Tank had this to say in *Deutsche Plastik unserer Zeit*: "If Rodin's figures overflow with sensuality, Thorak's figures expressed something else . . . here is no sensual desire. The figures are, so to speak, chaste, yet there is happiness, the fulfillment of our life. It pervades the whole sculpture." Thorak's *The Judgment of Paris*, made for a fountain, expressed all the demands for an ideal beauty and a readiness to conceive offspring.

Thorak also designed the huge *Monument to Work* to be erected on the Reichsautobahn. The universality and symbolic nature of the project was underlined by Tank: "The essence of the Germans is work. Here we see five people pushing a huge stone but they are not five individual people, five insignificant slaves. They are five human beings, united through work. They are doing this work for the whole *Volk*." Once again art had to show that only by becoming a mass can individuals gain any significance.

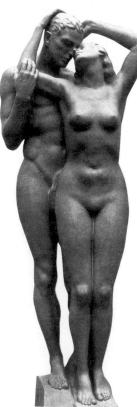

Above:
Josef Thorak working on a model of Goddess of Victory

Left:
Josef Thorak. Couple
"HEIGHTENED AND SENSITIVE CREATIVITY. THE HIGHEST AND BEST SPIRITUALIZATION EXPRESSED IN A MOVING AND SHY GESTURE AND POSE."—WERNER RITTICH

Opposite:
The Largest Studio in the World. *Drawing by Hans Liska of Thorak's studio.* Berliner Illustrirte Zeitung, *1938*

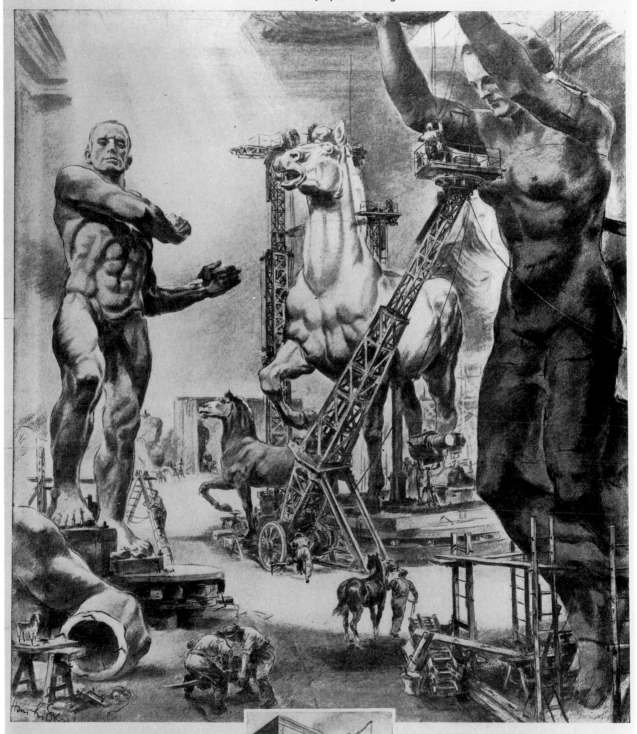

Im größten Atelier der Welt

„Professor Thorak schreitet mit mir", so erzählt Hans Liska, „durch sein riesiges Atelier in Baldham bei München, das im Auftrag des Führers nach einem Entwurf von Professor Albert Speer erbaut wurde, und spricht von seinen Werken und Gesichten, von vollendeten und zukünftigen Dingen. Das Glück eines Künstlers ist bestimmt durch die Größe seiner Zeit, und gewaltig ist die neue Aufgabe für

Professor Thorak: Eine gigantische Gruppe entsteht für das mächtige März-Feld in Nürnberg. Nach dem lebenden Modell (z. B. einem Pferde) wird eine kleine Ton-Skizze geschaffen, die sich dann zu einer vier Meter hohen Modellform wandelt. Nach dieser entsteht dann endgültig die Riesenplastik. Scheinwerfer leuchten die Figuren aus, die Licht-Effekte werden geprüft, auf hohen Arbeitsränen werden die Feinheiten vom Künstler selbst herausgearbeitet. Dann rollen die Standbilder, von Treckern gezogen, aus dem Atelier zum Gleisanschluß, wo Kräne die gewaltigen Einzelteile der Kolossalfiguren auf Waggons verladen."

Hitler's initial love for Thorak's work soon began to pale beside his regard for Arno Breker. Breker, who was born in Wuppertal, had learned his craft in the studio of his father, a stonemason and sculptor. He then studied at the Düsseldorf Academy under the sculptor Hubert Netzer and the architect Wilhelm Kreis. Breker also went to Rome, where, together with Ernst Steinmann, the director of the Bibliotheca Hertziana, he worked on the restoration of Michelangelo's *Rondanini Pietà*, which the artist himself had partially destroyed.

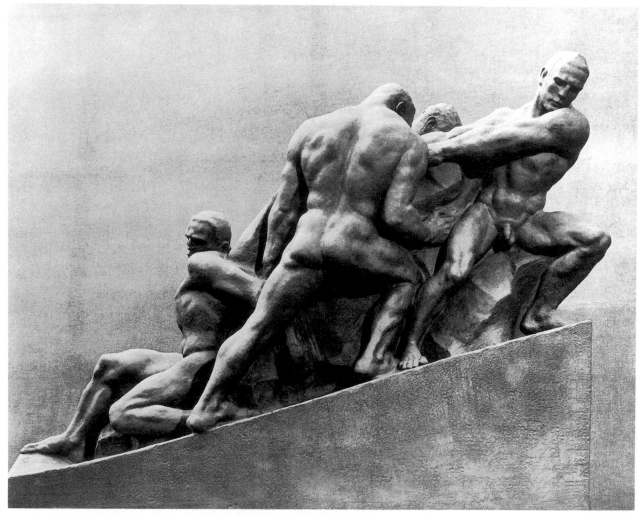

Josef Thorak. Monument to Work. *Reichsautobahn*

In Rome, Breker met Joseph Goebbels for the first time. From 1927 to 1933 he lived in Paris. At that time the influence of Maillol and Rodin became evident in his work, which included sensitive drawings and some fine sculptures. But as time went by individual traits and anatomical details were abandoned, and Breker opted for a smoother surface.

A flowery and very telling commentary to the change in Breker's style from the more impressionistic rendering of his early work was given in a widely dis-

Arno Breker and Albert Speer during a sitting in Breker's studio

tributed documentary film. Making much use of bombastic music, the camera tracks through Breker's studio, passing his early portraits, lingering on the casts for the statues for the Reich Chancellery (see illustration pages 256–57), and ending with a close-up of his portrait of Hitler. "The early heads are marked by an uncompromising penetration into every detail of the face. Every thought is revealed, every individual trait has been captured with unfailing determination. Only a change in the philosophy of the artist could alter his passionate search for the subjective. A change that would lead to a form which showed what is generally valid rather than what is individual. Force has replaced sensitivity, hardness the fluidity shimmering in the light." And while the camera brings up the stern profiles of his warriors and heroes, the commentary continues: "Everything that moves and deeply concerns our entire people is expressed in these heads. This head . . . does not tell the story of an individual; it says: 'I am the concentrated strength of man! I am anger against cowardice! I hate the enemy of my people. YOU SHOULD BE LIKE ME!'" And finally ending on the Hitler bust, with the music reaching a crescendo, the voice reaches its final pathos: "The images have changed, the face of the moment has become THE MONUMENT. Times are hard and the sword decides the vital questions of the people. The work of the artist has become a political confession."[8] Here is everything that marked the art theory of the National Socialists, the *raison d'être* of their art, its political aim and context and the constant invitation to the onlooker to identify with the images paraded before him.

Breker's monumental reliefs *Comradeship* and *The Avenger* were exhibited in two consecutive years, 1940 and 1941, in the House of German Art. Numerous reproductions were distributed also in the occupied foreign countries, a sign of the importance of these

Arno Breker. Comradeship. *1938. Model* "EMBODIMENT OF VIRTUES AND QUALITIES THAT EXPRESS THE VALUE OF THE GERMANS. EPOS OF TIMELESS AND TIMELY GERMANIC-GERMAN CHARACTER."—WERNER RITTICH

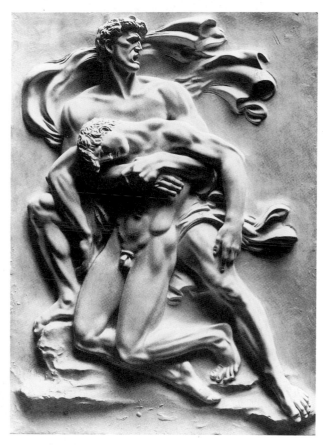

works for the National Socialist propaganda machine. They were part of a sculptural program which would eventually provide twenty-four giant reliefs. Breker's monumental reliefs were not only telling examples of the new sculptural style; "the devastating effect of these works lies in their all-embracing symbolic import," wrote Dr. Werner Rittich in the magazine *Die Kunst im Dritten Reich.*[9] By this he meant that these works expressed the heroic will to fight and the readiness to be sacrificed, two qualities which became

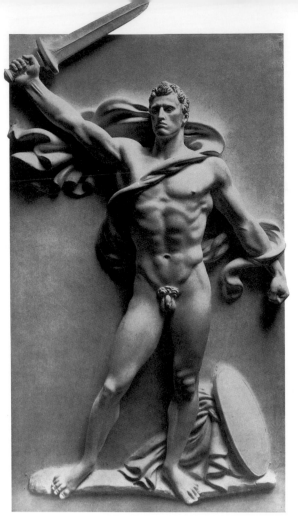

Arno Breker. Warrior's Departure

Homeland, with the figure of a woman, describing her role in accepting the sacrifice of men; *The Caller*, taking up once more the theme of the torchbearer; *Warrior's Departure*, a figure with a sword; *Vengeance*; *The Sacrifice*, a picture of a fallen soldier; *Domination*, and finally *Destruction*—the whole gamut of the philosophy of the Third Reich, deeply embedded in a deadly war that prevented these works from ever being made. All the claims of the timelessness of these works, of their mission for the future of the Reich, even for the entire Occident, were as hollow as the works themselves.

Under the National Socialists' influence Breker developed an increasingly bombastic style, and with it a brutal hardness and a feeling for the triumph of strength—although some of his portraits, like that of Max Liebermann (1934) and Aristide Maillol (1943) still echoed the subtlety of his earlier phase.

His real break came in 1936 when, in an art competition that demonstrated links between achievement in sports and the arts, he won two silver medals for his sculptures *The Decathlon* and *Victory*, for the Olympic Games. For Hitler's birthday in 1937 he was nominated

more and more necessary in a time of losing battles.

The two stone reliefs that visitors to the "Great Exhibition of German Art" saw were only a "small" version of the planned final version. Small in National Socialist terms meant 16½ feet. The final reliefs, in green granite, were intended to be twice that size. Together with the twenty-two other monumental reliefs, they were destined to decorate a giant building to be erected along the East-West Axis in Berlin. The axis was eventually to display eighty reliefs. Measuring over 50 feet high, Breker's works would force the onlooker to look up at them: a gigantic row of pictures all celebrating the heroic virtues of the German race. It was hoped that the exaggerated and overdramatic execution of the relief would attract the eye from far away.

The plans for the giant building were kept secret, but the public was informed about the gigantic task for the sculptor. Plaster models three feet high were made in Breker's studio for the other reliefs—in a scale of 1:10. They included *The Flag Bearer*; *Awakening of the*

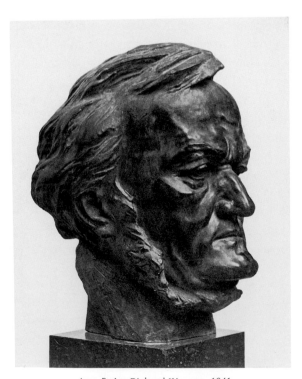

Arno Breker. Richard Wagner. *1941*

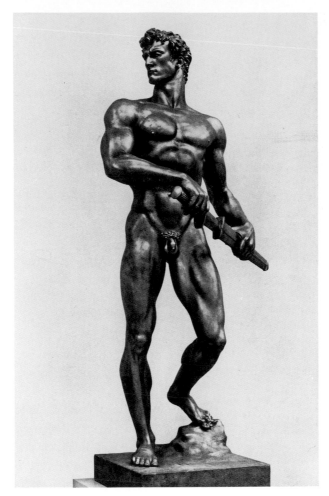

Arno Breker. Readiness. *"Great German Art Exhibition 1939"*

"Official State Sculptor," which entailed not only a professorship, but also the gift of a giant studio (which had previously belonged to the sculptor August Gaul). Breker employed forty-three people, among them twelve sculptors. Hitler also paid large sums for the restoration of a castle in which Breker lived, and for a second studio, which employed over a thousand people. Accommodation for them and a church and school were also planned.

Breker's honors were numerous and included a Mussolini Prize and a large exhibition in occupied Paris in 1942. His bust of Wagner stood in the Berghof. In 1938 he was commissioned by Hitler to sculpt two bronze figures for the inner courtyard of the Reich Chancellery. Hitler considered Breker's *The Army* and *The Party* among the most beautiful works ever made in Germany. "I have chosen the two pillars upon which each state is built, the man of the spirit represented by the torch, and the defender of the Reich by the man with the sword," wrote Breker. The figure of the former holds a torch which greets the onlooker and invites

Auguste Rodin. The Age of Bronze. *1876*

the function of this piece was to divert people's attention from reality and lead them into a dream world in which work and love, battle and achievement were formed into a new popular myth.

The National Socialists hoped that the extreme details of rendering and its enforced realism would seduce the onlooker to identify himself with the figures and what they stood for. And yet we have no idea what they feel or think, only what they represent. If we look at a figure of antiquity we can see the living image of a person; individuality is clearly visible. The gesture is natural. It emanates from feelings we can understand. The National Socialist figures strike a pose. A gesture is personal, a pose is synthetic, imposed from the outside. The frozen pose became the ideal instrument of political indoctrination, the elimination of personal freedom. It explains the feeling of unreality and deceit which we experience when we look at these statues. How could people have thought that these figures represented real persons, real living beings?

The forced and tortured poses of Breker's and Thorak's figures look even more artificial if one compares them with nudes by Auguste Rodin. Rodin's aim was to visualize feelings which came from within. Everything about them is full of infinite possibility and of yearning; they are human and warm. Breker's statues are cold and self-contained. In short, they radiate a superbly tailored lifeless perfection. These statues are merely the messengers of a program im-

him to lend his support. The figure lights the way: it is Prometheus. The *Army* figure holds the sword, emblem of victory. They were meant to inspire confidence in the two powerful foundations of National Socialist society.

The two sculptures encapsulated the basic aesthetic Hitler demanded from this art form. They were also supposed to express a longing for eternity. They were to inspire admiration and legitimize the system. Everything about them is idealized: their hair, lips, bodies. It is the faultless picture of man modeled on antiquity. Everything is noble, even the material, and yet they look hollow and totally artificial. The statues do not breathe, do not live.

The title of Breker's *Readiness* of 1939 implies that this is man ready for battle, an impression emphasized by the half-drawn sword. The muscles of the legs and arms are overemphasized. The hand is forceful, designed to grasp. The interplay between stillness and movement in the pose creates a deliberate tension that is the result of the contrast between reflection and aggression. As in many art works of this period,

Arno Breker, Warrior, *above a door in the round room in the Chancellery, Berlin*

Arno Breker in his studio with a delegation of French artists, November 26, 1941

posed on life. Their attributes, like the sword or the torch, are interchangeable. They are like coat hangers on which symbols have been hung. In Rodin each gesture is dictated by an inner necessity.

Breker was asked to design many sculptures for the new Berlin, most notably a huge square with a fountain in the middle of which two jets of water were to rise 100 feet into the air beside a giant statue of Apollo 20 feet tall.

Breker's figures became increasingly filled with empty rhetoric; musclemen of iron with grim expressions (Breker's model was the athlete Gustav Stührk). This was not an ancient Greek idol, but a muscleman. The sinewy bodies, trained in the gym, bursting with energy, represented the new ideal. All Breker's sculptures seemed to be destined for the sports field or the swimming pool. His statues expressed nothing except tension and wrath. The sound of empty pathos and its boastful brutality says much about the spirit of the whole regime. It was a far cry from the humanity of the antiquity they tried to emulate. Breker's statues were images of masculinity and power. Their aim was to se-

duce the young German into becoming a fighter and to identify with a carefully planned ideal of omnipotent manhood. For this, intellectual probing or doubting was not required. Taken out of their political context, these figures look ludicrous.

In April 1942, during the occupation of France, the German government staged an Arno Breker exhibition in the Orangerie in Paris. For this occasion Jean Cocteau wrote an enthusiastic introduction in the exhibition catalogue, apotheosizing Breker "because the great hand of Michelangelo's *David* has guided you. In the fatherland where we are compatriots you speak to me about France."[10] The French sculptor Charles Despiau, whom Breker knew from his earlier years in France, also wrote a sympathetic book about the German sculptor.

Breker's exhibition included quite a few of his earlier works, to show, as the German press pointed out, the change that had come over this artist due to the new philosophy. There were many of his latest sculptures: *Comradeship, Prometheus, Dionysus, Readiness, Daring,* and others.

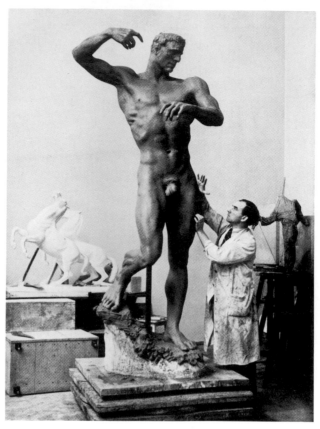

Arno Breker working on Prometheus

Die Kunst im Dritten Reich put out a special edition, with color reproductions of Breker's work, boasting of the tremendous success of the exhibition, which allowed "the Parisian art world to study the art will [*Kunstwollen*] of the new Germany."[11] The exhibition was highly publicized by the special propaganda department installed in Paris to monitor the art world in France.

Abel Bonnard of the Académie Française opened the show. A year earlier, at the instigation of Hitler, a delegation of French artists had, in the limelight of the press and the newsreels, visited Breker and Thorak in their studios. In the delegation were Despiau, André Dunoyer de Segonzac, Henri Bouchard, André Derain, Kees van Dongen, Othon Friesz, and Maurice Vlaminck. The National Socialists extracted the maximum in publicity from this visit. It gave them much-needed international legitimation. On his return, Bouchard, the French sculptor and director of the Ecole des Beaux-Arts, wrote:

The German state wants the well-being of the artist. He shall no longer suffer from the critics. . . . The care of the state also extends to his personal life. Well-known artists and sculptors like Arno Breker in Berlin and Thorak in Munich have been given large studios in order to fulfill state commissions for monuments which represent a gigantic and heroic humanity. . . . In this way a great country honors its artists and their work, its intellectual culture and the dignity of human existence. It has recognized the value of art as a historical necessity.[12]

The trip created much ill feeling after the liberation of Paris, and the participants had to defend themselves against the accusation of collaboration. Nevertheless, after the war Breker sculpted the heads of Jean Cocteau, Ezra Pound, and Maurice Vlaminck, as well as Céline, Henri de Montherlant, Serge Lifar, Jean Marais, Salvador Dali, Konrad Adenauer, Ludwig Ehrhard, the art collector Peter Ludwig and his wife, and many of the members of the Wagner family. Breker was consistent in his choice of sitters, who were

largely drawn from the right-wing establishment and the collaborators.

Breker bought many of his remaining sculptures in a private auction in 1961. For the rest of his life, another thirty years, they stood in his garden near Düsseldorf. The sculptures which were exhibited in the Orangerie in Paris in 1942 had remained in France. Confiscated as enemy property, they were sold by the famous French dealer Durand-Ruel. As an ironical postscript one might mention the fact that some of Breker's gold-painted figures still stand in a Russian military sports field in the former East German Republic. Another one stands, brought up-to-date by Breker himself, outside a hospital in what was West Germany. This raises the questions of the interchangeability and emptiness of Breker's message.[13]

Under National Socialism the stone relief flowered. Like the large wall frescoes, the mosaics, and the many new fountains, it was meant to show the renewal of old traditions and forms. Fusing sculpture to architecture and giving it a function was also seen as a visible battlecry against *l'art pour l'art* tradition. The scenic storytelling possibilities of the reliefs were widely exploited. All the monumental sculptors of the Olympic Stadium were commissioned to make stone reliefs. There was hardly a new building, from banks and insurance companies to ministries and hospitals, that did not feature stone reliefs.

One of the largest was *Soldiers* by Arnold Waldschmidt (see illustration pages 176–77), for the so-called pillar hall of the Reich Aviation Ministry in Berlin. The large pillars formed niches, which Waldschmidt filled with a row of marching soldiers. There was a storm troop, guards with a band, the leader on a horse taking up the central position, and a troop of flag carriers. It was begun in 1937 and finished in 1941. "In its contents, composition, and rhythm this work is the presentation of the soldier-like, disciplined Prussian spirit," said *Die Kunst im Dritten Reich* in January 1941.

Of course, not all sculpture reflected the same empty rhetoric as that which characterized the later works of Breker and Thorak. Scores of artists were seduced to create monumental works for the sports arenas in Berlin and Nuremberg and for the new public squares in front of new official buildings. Although Kolbe, Scheibe, and Klimsch, too, especially Klimsch, fell into the trap of presenting "Aryan types" rather than human beings, many of their works can stand up well to the figurative sculptures in other countries.

Josef Wackerle's *Horse Tamer* in the Olympic Stadium in Berlin is a very good example of the monumental sculpture of the 1930s.

In 1934 a special decree was issued requiring the use of sculpture on all public buildings. Sculpture was to be taken out of the elitist confines of the museum and placed in public squares and sports fields. Sculpture was either fused with the building, in the form of reliefs placed in a predetermined space on top of the building, or displayed in front of a smooth wall. Many statues were conceived with an architectural framework in mind. They are frontal, with no attempt made to reveal them from any other angle than head-on.

For the long facade of the House of German Art, with its twenty-two pillars, the architect Paul Ludwig Troost had planned to fill the twenty-one intervals with statues—which certainly would have enlivened the facade. For the Great Hall planned to go in front of the Reichstag in Berlin, Speer had also planned an extensive sculptural program which would fill a pillared chamber. Hitler's own sketches show that most buildings were to be adorned with statues and reliefs. The wide display of sculptures in the Olympic Stadium in Berlin gives an idea of the kind of program planned. The entire area is peppered with gigantic sculptures, making it something like a sculpture garden. Sport, mass assembly, and art were thus fused to bring the message home.

The competition for the decoration of the sports fields was an open one. There were of course Breker's work for the House of German Sport and Thorak's *Fighters* and a Hitler bust, this last by special request of the Führer. The rest of the many works ranged from Wackerle to Kolbe.

The Olympic Stadium is one of the few remaining complexes where one can still get an idea of some of the big sculptural projects. Among those standing today are: Karl Albiker's *Relay Runner* and *Discus Thrower*, Willy Meller's *Goddess of Victory*, Adolf Wamper's reliefs, and Breker's *Victor* and decathlon figure. But on the whole, not many of the sculptures survived. The Custom House in Munich has only a few smaller figures, mostly portraits of Hitler and other Party bosses. Many of the monumental works were never cast, and the gigantic plaster models that populated the studios of Breker and Thorak were destroyed. Only the two documentary films of Breker's and Thorak's studios bear witness to the megalomanic undertaking. The monumental sculptures by Willy Meller in Vogelsang are still there, but much damaged. Still intact is Wackerle's

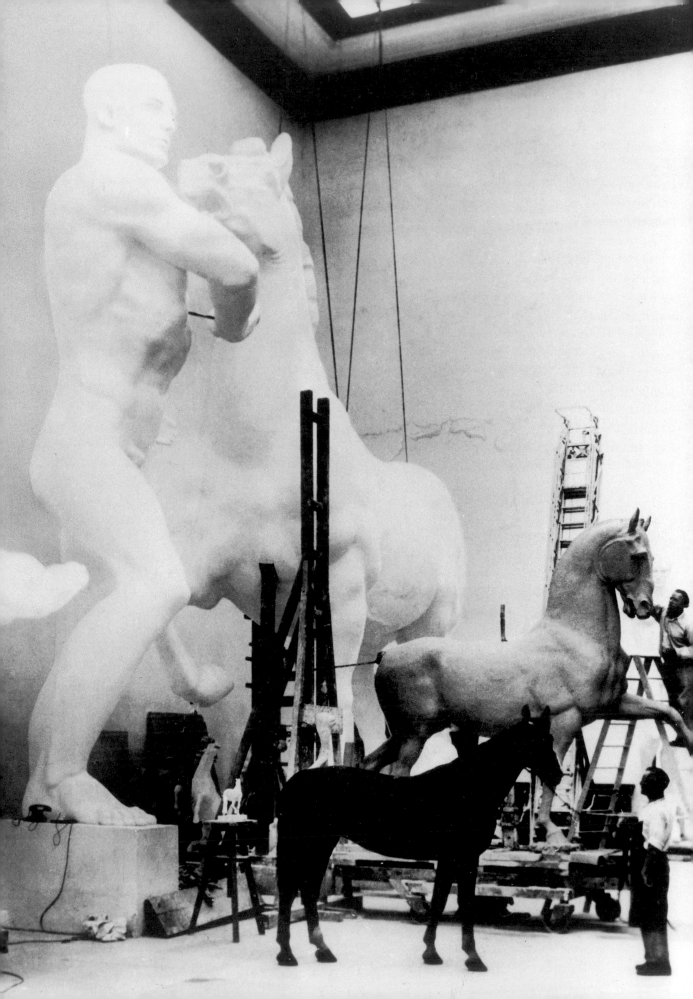

Neptune Fountain in Munich. Some of the representations of eagles can still be seen in parks or on houses, often with the National Socialist insignia removed.

For Nuremberg, too, a huge sculptural program was planned. Thorak had been commissioned to produce several large groups for the Luitpold Arena and the Marzfeld (a military review field). Some of the statues, many still only the original plaster casts, which were shown in the official exhibition at the House of German Art, were destined for Nuremberg. Schmid-Ehmen's life-size gilded statues of *Female Nudes* were meant to adorn the Hall of Honor together with two Breker statues, *Victory* and *Battle*. It is typical of the interchangeability of messages that the two *Female Nudes* were later renamed *Faith* and *Honor*. The sculptural program continued, but time, money, and most of all, talent were missing. For the time being the eagle and swastika had to suffice.

The importance of sculpture to architecture can be seen in the German Pavilion that Albert Speer built in Paris for the 1937 world's fair. Thorak's two large groups in front of the pavilion, *The Family* and *Comradeship*, form a triangle with Schmid-Ehmen's eagle on top of the building (see illustration pages 246–47). They not only complement the architecture but they also broadcast a political message, the prime virtues of the regime: the eagle is the symbol of power. A third statue by Kolbe, *Spirit of Proclamation*, gives the building a religious flavor (in German the same word is used for "proclamation" and "annunciation"). As in so many of the regime's buildings, sculpture and architectural decorations like pillars and braziers gave the building a pseudo-religious aura, which in this case camouflaged a trade fair, selling German technical prowess.

Right up to the end of the war sculptors continued to turn out figure after figure depicting the same tedious subjects. With art criticism successfully eliminated, a commentary in a film about an exhibition of sculpture would go like this: "The young man rides in noble dignity on his amphibious horse. The sower sows the corn. The warrior, his arm lifted in sorrow, mourns the passing of his dead comrade. The orator convinces with the power of his word. It is the task of the artist to proclaim manly strength and manly attitude and to reveal the beauty and soul of the woman. The works that bear witness to the creativity of German artists are documents of our being [*Wesen*], for which we fight."[14] The commentary did not even bother any longer to mention the name of the individual artist; he and his work had become mere carriers of messages. In the same way, the sculptures were no longer mere works of art; they had been elevated to symbols. "The symbol is the highest and the most difficult and therefore the proudest task of art. Here, it is no longer enough for the artist to portray the deep feeling of a slice of life, to let his fantasy loose, to create a dreamlike world. Here he has to find the most economical, meaningful expression of the thoughts and feelings of his *Volk*. Not just the representation of any figure taken from reality, but the creation of a figure that is the ideal image of the people."[15] There was no room for any critical intellectual discussion in an art which had been made into a pseudo-religious credo.

Josef Thorak's studio with plaster models of the monumental sculptures for the Mars Field in Nuremberg

DIVINE DESTINY HAS GIVEN THE GERMAN PEOPLE EVERYTHING IN THE PERSON

OF ONE MAN. NOT ONLY DOES HE POSSESS STRONG AND INGENIOUS STATESMANSHIP,

NOT ONLY IS HE INGENIOUS AS A SOLDIER, NOT ONLY IS HE THE FIRST WORKER AND THE FIRST

ECONOMIST AMONG HIS PEOPLE BUT, AND THIS IS PERHAPS HIS GREATEST STRENGTH, HE IS AN ARTIST.

HE CAME FROM ART, HE DEVOTED HIMSELF TO ART, ESPECIALLY TO THE ART OF ARCHITECTURE,

THIS POWERFUL CREATOR OF GREAT BUILDINGS. AND NOW HE HAS ALSO BECOME THE REICH'S BUILDER.

—Hakenkreuzbanner *(Swastika Flag), June 10, 1938*[1]

CHAPTER 10 HITLER AND THE

ARCHITECTS

Hitler saw himself as the artist of the nation, and above all as its architect. He often said that if he had not gone into politics he would have become an architect. He liked to show off his architectural knowledge, often drawing details of buildings, facades, pillars, and vaults.

His delight in the architecture of Vienna—its neo-Baroque and Neoclassical buildings—never left him. In most of his own drawings he favored a pompous, monumental style. He read extensively about architecture while imprisoned in Landsberg, and his private library contained quite a few books and magazines on the subject. He also had an extraordinary memory for architectural details and often astonished his associates with his extensive knowledge of buildings in foreign countries, sometimes down to the most precise details. England's neo-Gothic Houses of Parliament he considered the perfect expression of a civilization. Everything large and impressive found favor with him. Rome's Colosseum, Basilica of Saint Peter, and Pantheon were for him the best examples of monumental buildings, an architecture produced by the community. These and the Madeleine in Paris, and especially the dome of Les Invalides, inspired his building plans for Berlin. All the buildings had to be clear and light. He

disliked the excessive playfulness of Gothic cathedrals; they were not really German for him. He preferred the solidity of the Romanesque. The models for his new cities were those of the Ring in Vienna or Haussmann's Paris.

Heinrich Hoffmann, Hitler's photographer, reports that when Hitler was asked once why he had not become an architect, he replied: "I decided to become the master builder of the Third Reich."[2]

He liked to be photographed and painted with plans and models. "We are realizing the ideas of the Führer," wrote Albert Speer. Hitler the supreme builder was proclaimed in signs on buildings which read: "We owe it to the Führer that we build here." A large portrait of Hitler the architect and sculptor by Fritz Erler hung at the entrance to the "Great German Art Exhibition 1938."

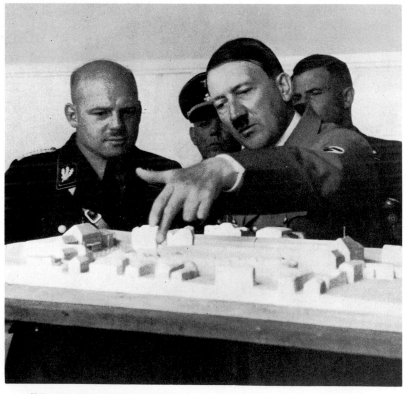

Hitler with the model of Adolf Hitler Square, Weimar. Photograph Heinrich Hoffmann

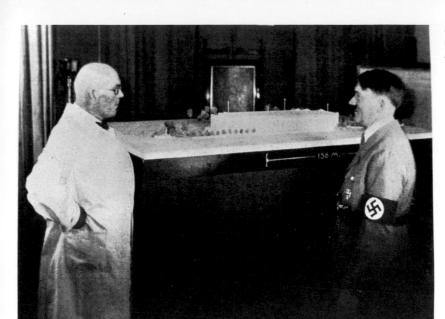

The obsession with architecture never left Hitler. At
the end of his life, he spent hours in the bunker of the
Reich Chancellery looking at models for a new town
center for Linz, and while the country collapsed
around him, he would talk about new buildings with
the architect Hermann Giesler.

Hitler was eager that many buildings should be
linked with his name, especially those in which he had
been actively involved either by furnishing drawings or
by making concrete suggestions. He wanted to be seen
as the mentor and initiator of German architecture.
But he also took great care that only those buildings
in which he actually played a part were allowed to
mention this fact. The accolade Architektur des Führer
(architecture of the Führer) was not given to just any
building. Architecture was for him the highest form of
art. "Architecture leads all other arts. It shows, every-
where, the great hand of our Führer. From him come
the greatest impulses for the creation of and the
search for new ways. In this way, architecture, too, has
a political and cultural role to play," said a speaker at
a conference of several hundred architects in Munich
in 1937.[3]

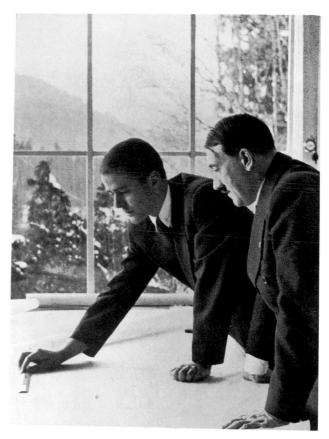

Buildings, better than anything else, were able to
express National Socialist thoughts in, as Hitler be-
lieved, a permanent form. His faith in the superiority
of architecture was total; to him it was a discipline
above mean, transient criticism. "Who can be so ar-
rogant as to measure, with our small minds, the work
of the creative, god-blessed nature of the very great?
Great artists and architects have a right not to be

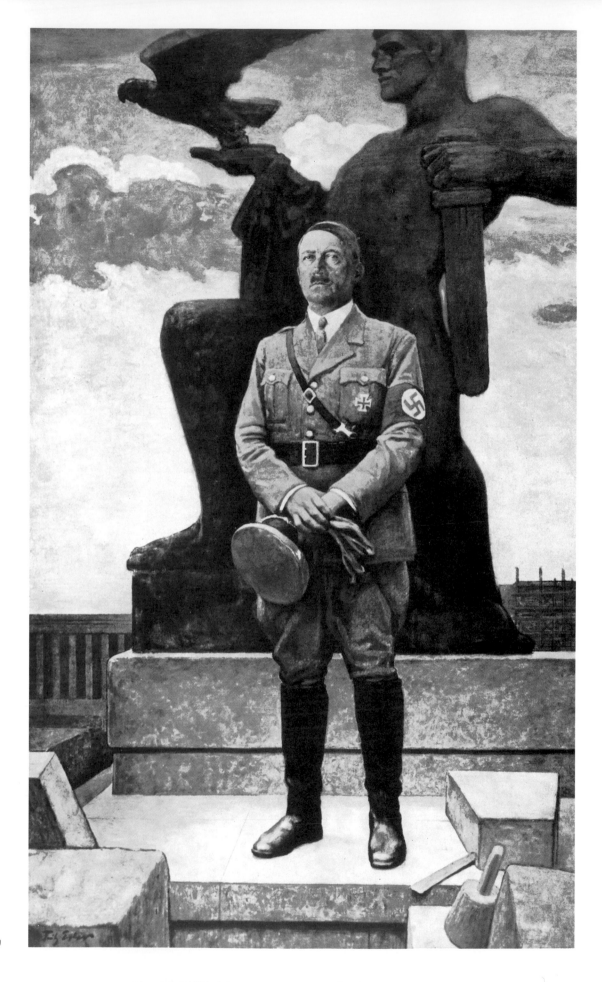

judged by small contemporaries. Their work will be assessed by the centuries. . . . Do not forget that in this hour we lift the curtain to reveal works which will mark not decades but centuries . . . that will endure, strong and irrevocably, by their beauty and their harmonic measure."[4]

Architecture was seen as part of the German revolution, buildings as an act of faith; no longer the work of individual architects, but the work and holy concern of the whole nation.

Hitler's plans for large national buildings dated from the early twenties. As soon as he came to power in 1933, he began to realize some of these projects: in Munich, the Braunes Haus, the layout of the Königsplatz, and two large Party buildings, the Führer Building and the Administration Building of the NSDAP. In October of the same year he also laid the foundation stone for a new House of German Art, in Munich. For Berlin too he began to initiate buildings, which were based on plans he had devised in the 1920s.

His love for architecture explains perhaps why he left architects alone, and bowed to their professional experience. He gathered around him a group of efficient pliable architects able to realize his dreams: Paul Ludwig Troost, Albert Speer, Hermann Giesler, and Fritz Todt. Hitler considered Troost the greatest German architect since the nineteenth-century Neoclassicist Karl Friedrich Schinkel. Theirs was a kind of pupil-master relationship. After Troost's death Hitler even toyed with the idea of taking over his architectural practice.

It was the one art that did not disappoint him, the one art in which he felt that new things were emerging. He felt that architecture was able to unite people behind a strong aesthetic idea, to celebrate the lasting quality of the Reich, and most of all to give his regime authority. "Our enemies will guess it, but our own people must know it: new buildings are being put up to strengthen our new authority," he said at the Reichspartei meeting in 1937.

Again and again he repeated that great buildings were products of historic times, as well as manifestations of absolute political power. "The great building program is a tonic against the inferiority complex of the German people," Hitler had said. "He who would

educate a people must give to it visible grounds for pride. This is not to show off but to give self-confidence to the nation. A nation of 80 million has the right to own such buildings." The buildings also represented absolute power. "Our enemies and our followers must realize that these buildings strengthen our authority."[5]

They were securing Hitler's power for all time. Generations would recognize them as they recognize Gothic or Renaissance architecture. "The magnitude of these works is not measured by the need of 1938, 1939, or 1940 . . . our task is to give the people who have existed for a thousand years, with their millennial past of history and civilization . . . a millennial city for the limitless future which lies before them."[6]

Architecture became the most forceful expression of the National Socialist idea. Here "the word had become stone" in order to express true German greatness. "Philosophy is more visible in architecture than in any other art form. . . . The buildings of the Führer are the signs of the philosophical change of our time. They are National Socialism incarnate. . . . Hitler formed in these buildings the noblest qualities of his people. . . . The greatness of the German soul eternalized in stone, witnesses of heroism . . . they are the holy shrines of our people. Their destiny is to proclaim our philosophy."[7]

National Socialist ideas about architecture, like those about the visual arts, were often contradictory. In the beginning there was an overlap of the old and the new. Until 1930 the Party did not openly criticize the industrial and social building programs of architects like Walter Gropius or Mies van der Rohe. And even later, motorways, many factories, the newly built airports in Berlin at Gatow and Tempelhof made much use of modern functionalism and technology borrowed from the Bauhaus architects. "There is a danger that we might relapse into a senseless and soulless imitation of the past. The architect will not hesitate to use modern building materials just as he will not hesitate to return to those elements of form which in the past were invented by the genius of a race similar to his own. Buildings created by the people must represent the whole of the people."[8] For Hamburg, for instance, which struck Hitler as somewhat American, he wanted an 820-foot skyscraper. He claimed that Hamburg, open to the world, needed its own style.

During the first few years National Socialism did not slavishly follow one architectural style. Not all the architects who came to prominence were Party hard-

Fritz Erler. Portrait of the Führer. *The House of German Art is in the background at the left*

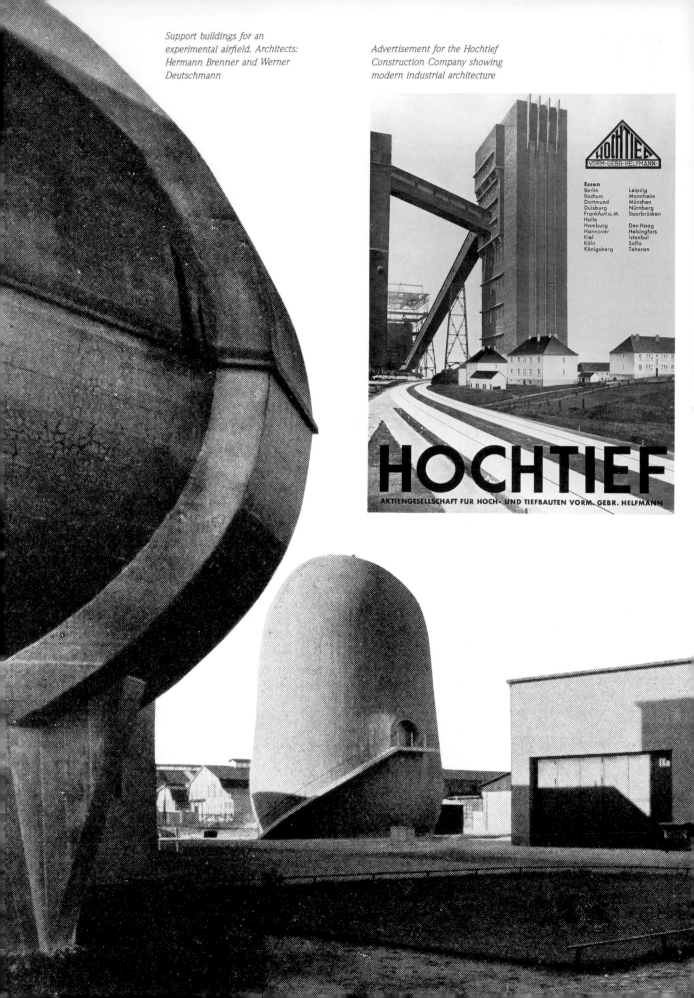

Support buildings for an experimental airfield. Architects: Hermann Brenner and Werner Deutschmann

Advertisement for the Hochtief Construction Company showing modern industrial architecture

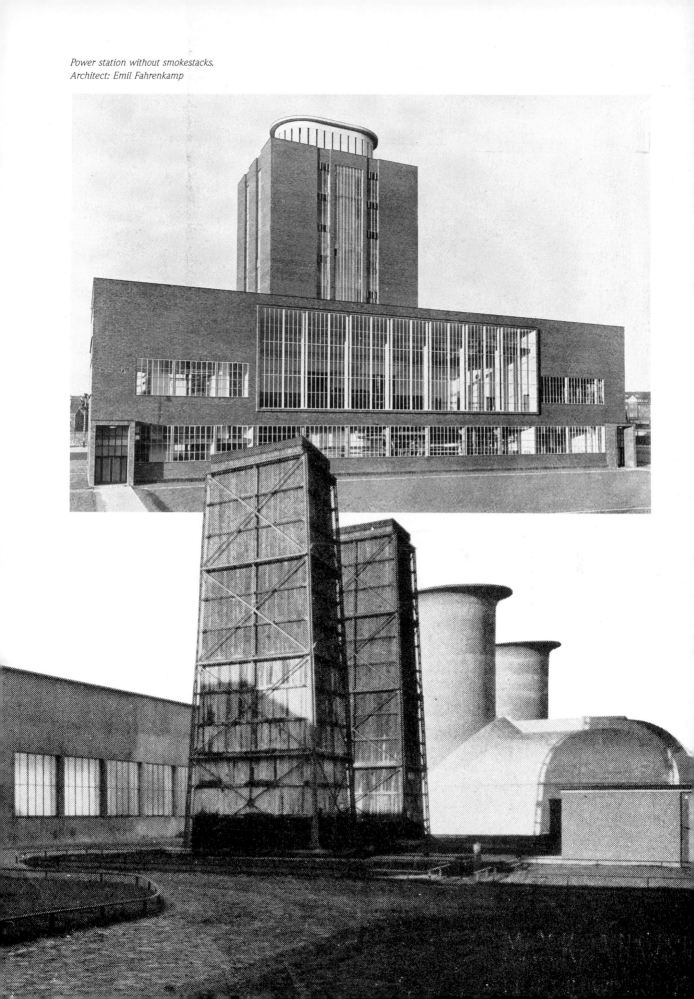

Power station without smokestacks.
Architect: Emil Fahrenkamp

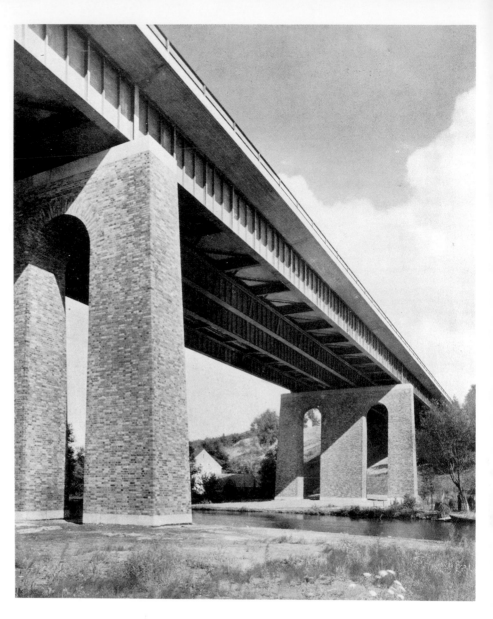

Autobahn bridge near Rüdersdorf

liners, nor did they all follow the same style or aes-
thetic principles. There were those who favored a
vernacular style and those who followed Neoclassical
models. Ernst Sagebiel and Roderich Fick supported
the official building program. But in 1936 the influen-
tial magazine *Moderne Bauformen* reproduced their work
next to the modern buildings of Hugo Häring in
Berlin's Siemensstadt and Mies van der Rohe's modern
apartments in the Afrikanische Strasse.[9]

Modern architects such as Heinrich Tessenow
(1876–1950) and Peter Behrens, both opponents of the
National Socialist Party, were allowed to continue to
design, at least for a while. Some, like Paul Bonatz,
who was not a member of the Party, and Werner March
(1894–1976), were not, at least in the beginning, op-
posed to modern solutions. German Bestelmeyer
(1874–1942) and Paul Ludwig Troost were stern de-
fenders of the new architectural theories, based on

historical styles; Paul Schmitthenner (1884–1972) pursued a vernacular architecture. But even Hitler did not like Paul Schultze-Naumburg's Biedermeier and his volkish excess.

What soon united National Socialist views on architecture was the rejection of a modern style. A quaint vernacular style for housing and a monumental style for public buildings became the order of the day. "In the future there will be no more 'boxes for living,' no churches that look like greenhouses, no glasshouse on top of columns . . . built as a result of professional incompetence. No prison camps parading as workers' homes, subsidized by public money. Get compensation money from those criminals who enriched themselves with these crimes against national culture," wrote the infamous Bettina Feistel-Rohmeder, castigating the modern *Siedlungen* (multiple-dwelling complexes) of Le Corbusier, Mies van der Rohe, Bruno Taut, and other representatives of the modern movement (see page 32).[10]

In architecture, Jews and Communists were barred from the official Chamber of Architects, which meant they had little chance of building anything. In an open competition for a design for the State Bank, Mies van der Rohe, Walter Gropius, and Hans Poelzig submitted entries. The winner selected by Hitler was Heinrich Wolff. His proposal, traditional in its form, modern in its construction, shows what was the favored Party style.

The National Socialists did not wholly reject modern technology. They often used the most advanced building techniques hidden behind Neoclassical facades. In the same way as Hitler liked to show off the technical advances made by Germany in the field of cars, cameras, and airplanes, so he also boasted of technical advances in architecture. "The rise of Germany since National Socialism took power is unique. Our constructions are the most exemplary of their kind. The precision of German workmanship does not have to fear anything done by foreign countries; on the contrary, it is technically the very best," boasted Hitler, opening a motor show.[11]

The motorways became one of the best examples of modern technology and design and were much admired by foreign countries, a fact Hitler never ceased to stress. "The British press says, 'The German motorways are second to none and lead the world.' The Dutch say, 'We are filled with admiration for this great German achievement.' Yugoslavia: 'As the pyramids record the history of the Pharaohs, so too the motor-

ways will remind the German people forever of the most extraordinary figure in its history. A man of the people who single-handed, with no other help, by virtue of his own will has created a new German Reich,'" went the commentary in a documentary film about the new German highways. The motorways were another symbol of the glorious and relentless advancement of the National Socialist movement. It inspired such verses as:

A ribbon of stone doth span our land,
A people hath built with all its might,
Stands ready now for a new fight.
The Führer's mind did think it out,
A faithful people brought it about.
A triumph of power, the work is done.
The first battle has been won.
A people free of want and shame,
The future calls with higher aim.
The Führer gives us faith again.[12]

Autobahns were the best means of giving people work and of getting the economy going. But most of all they were seen as yet another achievement to boost the confidence of the nation, elevating it into a powerful symbol. "The new German autobahn network is not only in its concept the most powerful in the world but also the most exemplary. It will help more than anything else to bind the areas and the states and force them into a unity." The documentary film in

Kettler. Organisation Todt

which Hitler made this statement brought the message home. In it workers proudly proclaimed to the interviewing reporter: "Tell the people at home that we are building bridges unlike any that existed before, and that we all work together, and that we know what is at stake."[13]

The fascination was total, and difficult to resist. It is hard for us nowadays, used to cars and motorways, to understand the enthusiasm that greeted each new bridge with its four-lane highway. Hitler was filmed in an open Mercedes, followed by a fleet of brand-new Mercedeses and Volkswagens in neat formation, driving down every new stretch of the motorway, crossing bridges decorated with large columns and eagles carrying swastikas. Thousands lined the roads and cheered the spectacle of gleaming metal and shining leather coats.

While the building of such an innovatory and vast motorway network was politically and strategically motivated, it was also an extraordinary technical and aesthetic tour de force. Even today much of the Hitler myth is based on his "achievement" with the motorways. A powerful symbol of political strength, willpower, and achievement, they were meant to provide the conquering military with easy access to the rest of Europe. They were called "Hitler's streets," although the Reich's motorways were actually Mussolini's idea. In Germany plans for the first motorway date from 1926; the first test road between Cologne and Bonn was opened in 1932.

*Autobahn bridge, Waschmühltal.
Architect: Paul Bonatz*

*Below and opposite:
Autobahn suspension bridge.
1938–41. Architect: Paul Bonatz*

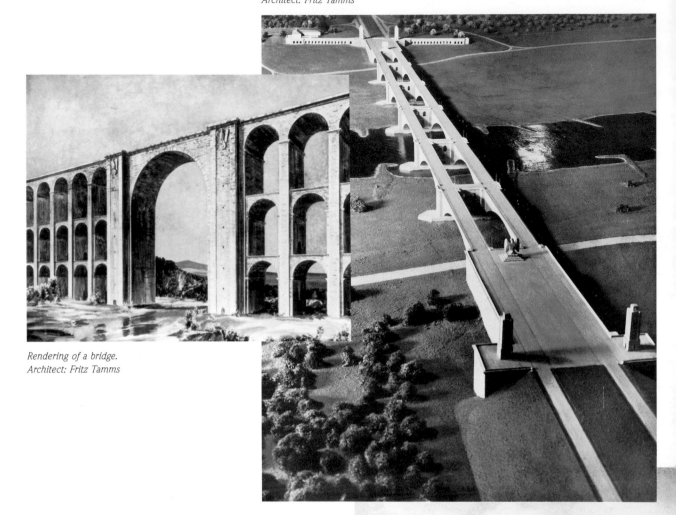

*Model of an Autobahn bridge
across the Oder River.
Architect: Fritz Tamms*

*Rendering of a bridge.
Architect: Fritz Tamms*

With their stunning bridge constructions and sweeping lanes, the autobahns were a remarkable piece of modern architecture built by the best architects to blend with the landscape. Roderich Fick built a bridge over the Isar mostly made of wood to blend with local architecture. Bonatz designed a bridge near the Romanesque cathedral of Limburg that reminded one of a Roman aqueduct. Gasoline stations were often built in a modern style growing out of the Bauhaus teaching.

The autobahns were masterminded by Fritz Todt, an early Party member, a nature- and music-loving German who became a hero, especially among the young, for the exploits of his Organisation Todt. With the help of this organization, Todt—an engineer, not an architect—conquered land and cleared swamps. He was considered one of the highest artists in the land,

and honored as such. His autobahn was not just a road but technology elevated to art. He was sensitive to the details of traditional craftsmanship and included them in his bridges. Todt was open-minded enough to consult Mies van der Rohe and to employ architects such as Bonatz, who was reputable and not known for Party faithfulness. Albert Speer took control of the motorways after Fritz Todt died in a car crash in 1942.

The controversy over modern architecture was vehement during the Weimar Republic; the fight over gabled roofs dominated architectural discussion in the twenties in Germany. Buildings by modern architects were widely criticized and only the Deutsche Werkbund, the Bauhaus, and some intellectuals mostly associated with the left supported a new building style. Many smaller building firms and many construction workers feared that a more industrialized building industry fostered by this new style would mean a loss of jobs for manual workers. They were easy converts to Hitler's architectural policies.

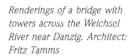

Renderings of a bridge with towers across the Weichsel River near Danzig. Architect: Fritz Tamms

Autobahn bridge. Detail. Architect: Fritz Tamms

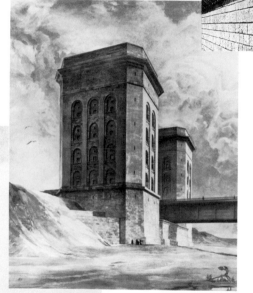

Having banned the great architects of the twenties, Hitler looked for new talent. Some of the architects, most of whom no one had ever heard of, jumped into the breach. Among them was the talented Fritz Tamms (born 1904). Franz Moraller spoke for many: "We architects want to create a new architecture, based on tradition. It reflects our philosophy of life. Bad building, empty effects, and the search for the sensational must be stopped. The great buildings of the movement are not built for their own sake. They must demonstrate to the German people the determination, unity, strength, and power of the state. . . . The style of the buildings must reflect the will which formed it."[14]

From 1938 onward there were representative "German Architecture and Craft Exhibitions" in Munich, which Hitler opened personally. There were only three official German architecture exhibitions, the first in January 1938, the second in December of the same year, and the third in July of 1939. The war stopped all

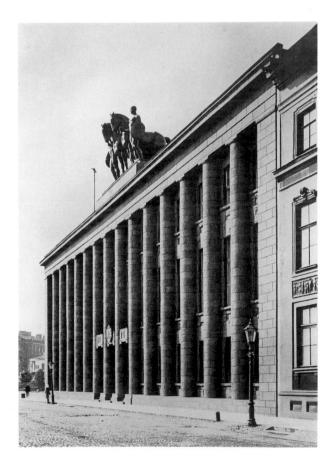

further displays. Other similar exhibitions toured the country. The exhibitions showed mostly plaster models of the new buildings; large wood and plaster models were also carried in processions through the streets of Munich during the Day of Art parades.

These exhibitions, like the buildings, were widely reported in the press, but as in painting, architectural criticism hardly existed, despite the large number of books published on this subject. Instead, the same devoted National Socialists reiterated the same tired phrases. Werner Rittich, co-editor with Robert Scholz of the racist magazine *Die Völkische Kunst* (Volkish Art), became one of the leading National Socialist writers on architecture, as did of course Rosenberg and Schultze-Naumburg. To all of them architecture was a political weapon, a domain in which to fight out ideological battles.

On the whole, the architecture of the Third Reich closely followed, in form and content, the architecture of the past. There was no revolution, not even a break. The two prevailing trends for public buildings were

German Embassy in Saint Petersburg. 1911. Architect: Peter Behrens

Udo Wendel.
The Art Magazine.
1939–40
"THE NEW REALISTIC
TENDENCY, THE MOST EXACT
RENDERING OF EACH
DETAIL."
—ROBERT SCHOLZ

Friedrich Wilhelm Kalb.
Searching, Finding, Losing
(Daphne, Eros and Psyche,
Eurydice and Orpheus)

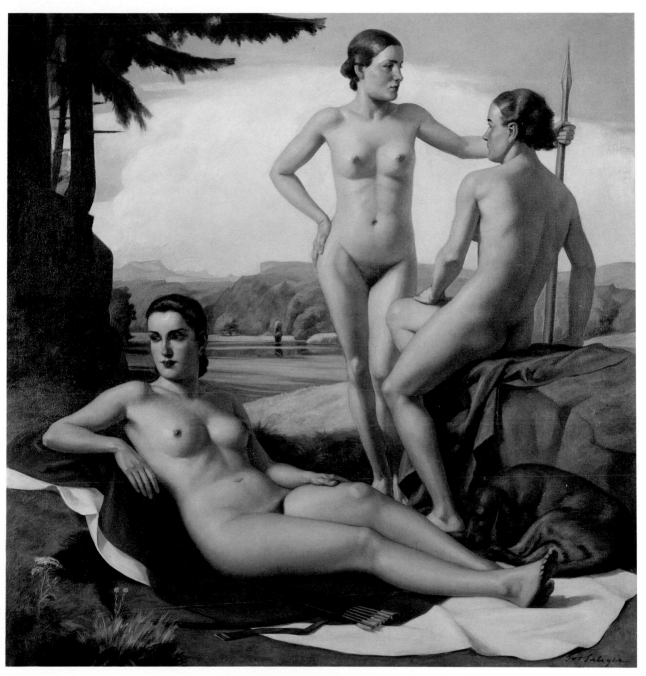

Ivo Saliger. Diana's
Rest. *1939–40*
"A TIME OF AFFIRMATION OF
THE BODY, A CELEBRATION
OF HELLENIC ATTITUDES
AND VIRTUES."—ROBERT
SCHOLZ

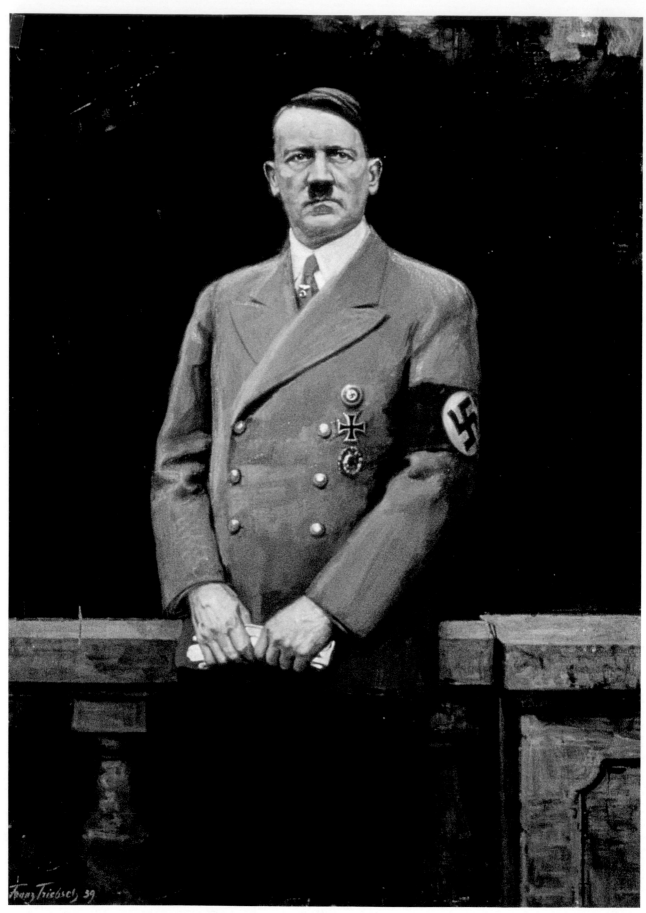

Franz Triebsch. Hitler

monumentalism and Neoclassicism. Neoclassicism has long been the language of political power. It was by no means exclusive to Germany or to totalitarian systems. It was the official style of many countries. France, Russia, Italy, and the United States had all used it for their town halls, public libraries, universities, railway stations, and museums. In the nineteenth century a system of codes was invented by architects and architectural theorists that echoed a general nostalgia for a stable world, a world of historical continuity. Classical, Gothic, and even Egyptian elements satisfied these longings.

Hitler too looked for buildings which were already "programmed" this way. The Walhalla and the Befreiungshalle, both designed by Leo von Klenze (1784–1864), were only two buildings that Hitler "occupied" for his own ends. He made them his buildings, frequently holding celebrations and meetings there. Their pathos of eternity, expressed by massive architecture in heavy stone, entered the architecture of the Third Reich.

For the National Socialists each building was not merely a building. It had to be a monument. Even administration buildings had to express the ideology of the regime. "These works of ours shall also be eternal, that is to say, not only in the greatness of their con-

The Chancellery, Berlin. Architect: Albert Speer

ception, but in their clarity of plan, in the harmony of their proportions, they shall satisfy the requirements of eternity . . . magnificent evidence of civilization in granite and marble, they will stand through the millennia . . . these buildings of ours should not be conceived for the year 1942 nor for the year 2000, but like the cathedrals of our past they shall stretch into the millennia of the future," Hitler proclaimed.[15]

The Nazis were consumers of cultures, not makers of it, and they concocted a conglomeration of traditional styles. Despite the public announcements of a new era in architecture, there was no unifying overall National Socialist style. But many of the public buildings share nevertheless a specific handwriting which makes them instantly recognizable as the product of the Third Reich. There were the stripped-down porticos, the stark rectilinear look emphasized by the heavy horizontals of cornices and rows of windows with deep frames.

A monumental symmetry dominated their facades, thanks to ranks of windows set in walls of roughhewn stone. The shallow windows in such heavy walls were designed to evoke images of fortresses and give the

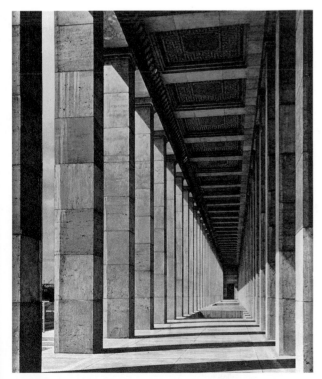

Peristyle of the grandstand,
Zeppelin Field, Nuremberg. 1934. Architect: Albert Speer

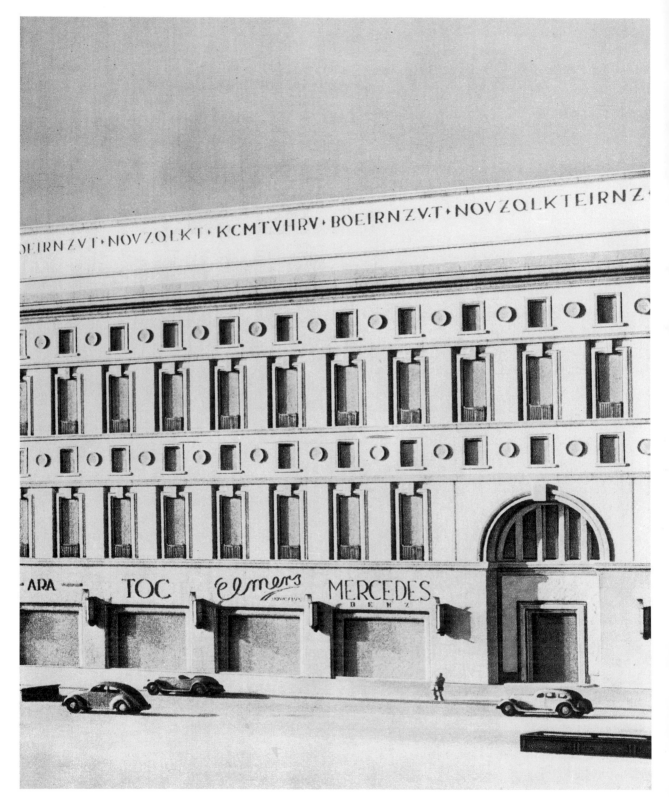

Model of an office building for the
north-south axis road, Berlin.
Architect: Gotthold Nestler

building a feeling of impenetrability. The cambered walls and massive timbered gables were meant to impress and to command respect.

Much of the public architecture of the late nineteenth century was smothered in ornaments. The National Socialists, in contrast, shunned too much ornament in their drive for clarity. "To be German means to be clear" was one of Hitler's often-quoted phrases. The facades of the Third Reich were simpler than those of their predecessors. Pillars and pilasters that had structural functions were admitted into a modern combination of technology and decoration. And of course there were decorations in the form of mosaics, friezes, and the near-obligatory wreaths surrounding the swastika, which was sometimes stylized into geometrical patterns, and finally, the ubiquitous eagle.

Another distinction was the emphasis on the material used. The symbolic meaning of stone was stressed. The feeling for material was more intense than the feeling for buildings. The use of stone upheld the fiction of a living handicraft tradition. There was also a practical reason for the use of granite and other local stone. The medieval hand-hewn finish of the buildings in massive stone and wood saved on steel and concrete, which was needed to build bunkers. Words like "austere," "sober," and "Nordic" were used by the architectural press to describe those buildings.

One critic spoke of a "self-willed style" and of "severe beauty." Much of National Socialist architecture looks military, and in fact, most buildings were part of an extensive network of underground air-raid shelters. The structures were blank and orderly, like obedient soldiers. All decoration was severe. There was no room for playfulness. The human being was dwarfed by the scale of the buildings, reduced to an insignificant prop, which took on value only in an organized and choreographed mass. In a drawing by Hans Liska depicting the studio Speer built for Thorak, one can see the dwarfed studio assistants chiseling away to create the New Man.

Like Hitler's speeches, his architecture was huge and repetitive. Buildings had stodgy and massive proportions. Despite some good work in details, a feeling of emptiness and monotony prevails. The architects used the language of classicism—portals, pillars, and stone—but they were reduced to empty decoration. Of the measured classicism of the great architects of the nineteenth century, like Schinkel, little was left. A total loss of any sense of scale characterizes most of the architecture of the Third Reich.

But if the National Socialists' buildings were meant to impress and to intimidate, they were also meant to unite the people. They were the result of a collective effort like the one that had produced the great buildings of the past, the cathedrals of the Middle Ages, the great monuments of Rome. Buildings became objects of identification. Together with their flagpoles, braziers, grandstands, and the people who filled them, they became lighthouses illuminating the way for a whole nation into a bigger and brighter future.

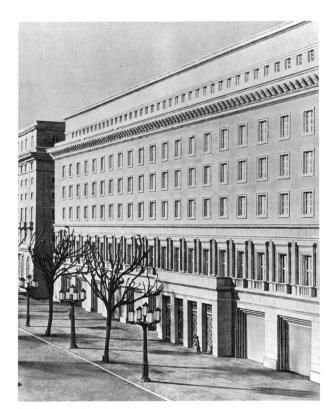

Model of an office building for the
north-south axis road, Berlin.
Architect: Hans Freese

CHAPTER

11

HITLER'S BUILDING SITES

MUNICH

Hitler had decided quite early to make Munich the capital of the National Socialist movement. In 1927 he had enthusiastically shown Otto Strasser plans for the new Munich. Two years later, the NSDAP bought the Palais Barlow, a purchase financed with private funds, mostly from the powerful industrialist Fritz Thyssen. Hitler engaged the architect Paul Ludwig Troost for the alterations to this three-story Neoclassical building. The onetime "palace" became the Braunes Haus, "brown" taking its cue from the brown shirts worn by the Storm Troopers.

Troost (1878–1934) was a successful south German architect. He had built several villas for upper-middle-class Bavarian society in the much-loved traditional style of the region: a vernacular architecture with gabled roofs and shuttered windows, as well as some

Braunes Haus, formerly the Palais Barlow, Munich. Renovation: Paul Ludwig Troost

Neoclassical houses. He was also an interior designer, mostly known for the decoration of luxury liners for the Hapag Lloyd shipping line. It was Troost's love of Neoclassicism and his distaste for anything modern that made him the ideal architect for Hitler. Troost was not an outspoken National Socialist but had joined the Party as early as 1924.

Many features of the Braunes Haus, especially the decoration of the rooms, were based on Hitler's ideas. The standard for future Party buildings was to be set here. Hitler's enthusiasm was total, so much so that Goebbels worried about what he called "the damned Party house." "It will break our neck," he wrote in his diary.[2]

The flamboyance of Hitler's and Troost's plans, for a party not yet in power, indeed bordered on the absurd. There was much earnest wood paneling on walls and ceiling, extolling the German virtues of solidity, dignity, and clarity. A large hall of honor displayed the "blood banners" of the National Socialist movement. A vast staircase led to Hitler's office, with its portrait of Frederick the Great over a large desk. There were also pictures of Prussian battles. The link between Hitler and the great Prussian tradition was clearly intended. A senate chamber was constructed, decorated with a generous sprinkling of swastikas, sixty chairs in red leather, with swastikas on their backs, for sixty senators around a vast conference table—a tangible exercise in empty rhetoric, since Hitler never intended to have a senate.

Despite its pomposity, the Braunes Haus was not monumental enough. Hitler left his office to Rudolf Hess, and together with Troost immediately set to work on proper, model buildings, a house for the Führer and an administration building for the Party. In 1931–32, Troost and Hitler had already made tentative plans for these two big projects.

But first the Königsplatz, one of Munich's most attractive and characteristic city squares, which was to become the setting for the new Party buildings, had to be restructured. The Königsplatz, with its Neoclassical buildings—Leo von Klenze's Glyptothek (1816–30) and the Propylaum (1846–62), and Georg Friedrich Ziebland's (1800–1878) Exhibition Building (1838–48)—was the creation of King Ludwig I (1825–1848), who had marked the architecture of Munich more than any other monarch.

Hitler saw himself as the successor of this enlightened king. He often stressed a comparison with kings, as did others. If in earlier years of his "reign"

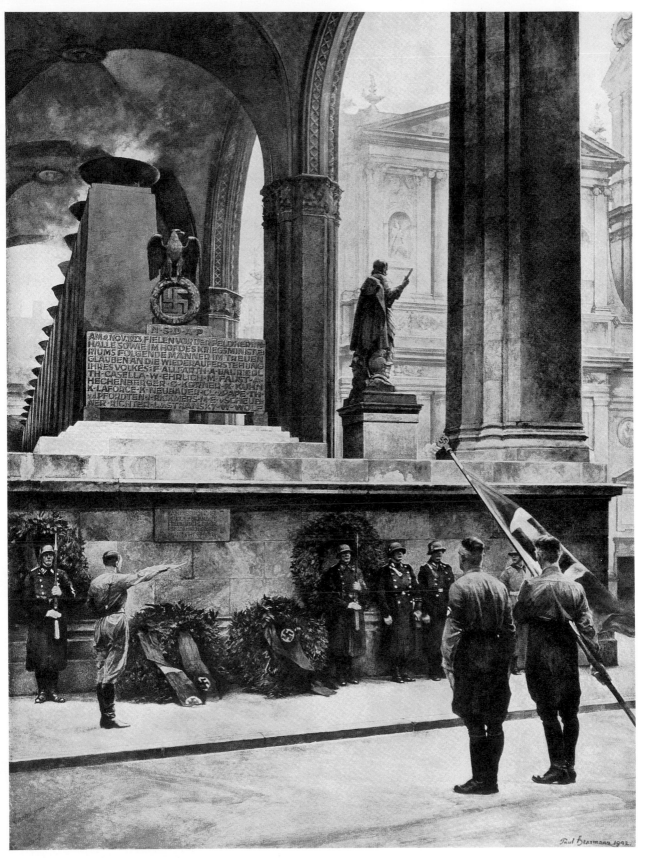

Paul Hermann. But Victory Is Yours, *showing the monument to the dead of the 1923 putsch inside the Feldherrenhalle, designed by Paul Ludwig Troost and Kurt Schmid-Ehmen*

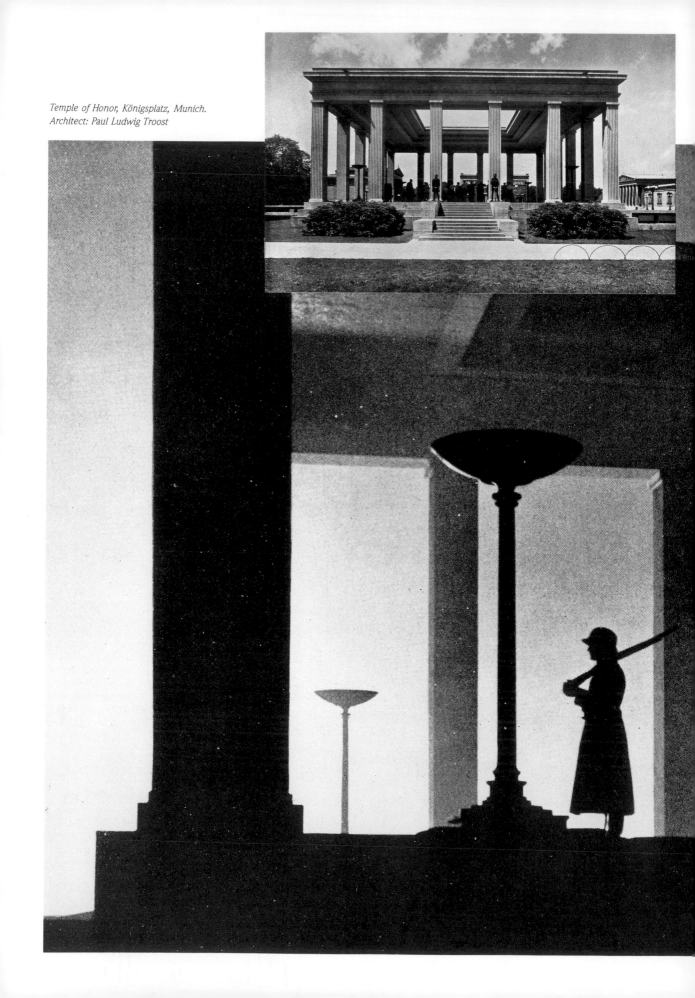

Temple of Honor, Königsplatz, Munich.
Architect: Paul Ludwig Troost

Hitler emulated King Ludwig, the great builder king, in his later years, Hitler was constantly compared to the great war king Frederick the Great of Prussia. The comparison did not stop at royalty. Hitler was also the Messiah, as Leni Riefenstahl portrayed him—emerging from the clouds in an airplane—in her film about the Nuremberg rallies, *Triumph of the Will.*

The Königsplatz was also the square where the National Socialists had often assembled at their early rallies. It was an obvious choice. Hitler had the lawn paved over with 24,000 square feet of granite, quarried from all over Germany to underline the community feeling. Traffic was banned.

"It needed the Führer to give the chaotic urban development a new order and direction. With his ingenious philosophical foresight he has recognized the new possibilities. Despite his other great tasks he finds time to supervise architectural developments. . . . a monumental ceremonial square for his people. . . . In no other creation can one see the heroic character of the movement, in its clear and cultural aspect. . . ."[3]

A great number of public spaces were created or altered to become the architectural settings of mass meetings for the government's ritual celebrations. Open spaces appeared free of plants or ornaments, symmetrically paved. They were to be magical places for pontification.

"On the Königsplatz, new Party buildings and old museums form a marching ground. What is their style? To call it classicist is not enough. Something new has been created. A political credo, in its deepest sense. One understands the decisive difference when one sees how the German people assemble . . . on these giant squares of granite, filled with thousands of uniformed soldiers."[4]

On November 9, Hitler had unveiled a monument by Troost and Schmidt-Ehmen, with a socle of marble, to the memory of the dead of the putsch of November 9, 1923. It was erected inside the nineteenth-century Feldherrnhalle, thus providing a historical continuum such as Hitler was keen on. Like the *Blutfahne*, the flag dipped in the blood of the victims, it became a relic. There in endless ceremonies, flags were touched by the sacred cloth, turning each flag into a "blood flag."

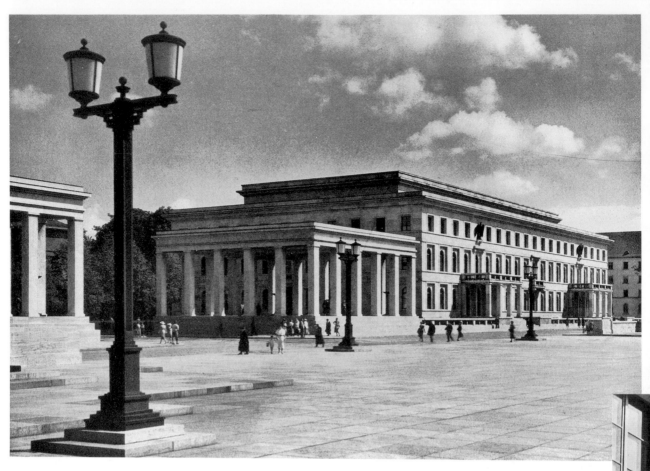

Führer Building, Munich.
Architect: Paul Ludwig Troost

Soon after taking power, Hitler commissioned Troost to erect on the Königsplatz two temples of honor dedicated to the victims of the 1923 putsch. Each of them was incorporated in the plan for the Party buildings by joining them to a common garden at the rear. In their architecture and in their role, they were supposed to be a "sacred blessing."

The two temples became a central place of Nazi ritual worship, the altars of the new movement. Their fascination for the masses lay in their mixture of religious and secular architecture. Hitler used them in the same way. Each temple displayed eight coffins of the putsch martyrs under an open sky on a dais framed by twenty pillars of yellow limestone. Huge braziers glowed.

The two temples were inaugurated—"consecrated" would be a better word—in 1935 in a spine-chilling ceremony of pseudo-religious and military fervor. The ceremony began on the night of November 8, 1933, in the darkened city. Hitler and his followers passed pylons draped in blood red, with the names of the "fallen heroes." The cortege moved solemnly to the Feldherrnhalle for the last roll call in front of the cof-

*Staircase in the Führer Building,
Munich. Architect: Leonhard Gall*

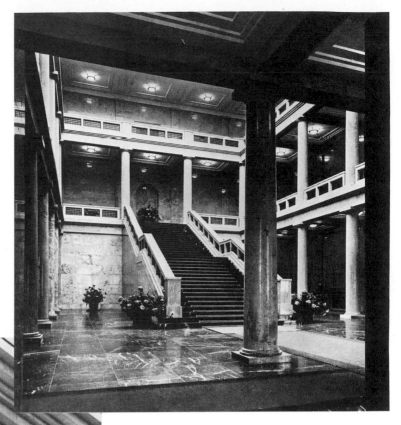

*Entrance to the Führer Building,
Munich. Detail of the balcony.
Architect: Paul Ludwig Troost*

fins. The names were called out and the crowd shouted "Present." The next day the coffins were transferred to their last resting place to "hold the 'eternal watch,' a permanent example and reminder to a whole people of the duty, the need for readiness to fight, and for sacrifice."[5]

In the same year the two new Party buildings were built. Troost had chosen a Neoclassical style, which was to echo the older buildings on the other side of the square. "Pillars have again become an important element; they are not, as in the seventeenth and eighteenth centuries, mere decorative elements but are an integral part of the architecture. The 'spirit of the Gothic,' which lives in the German character, with its emphasis on the vertical, has been married to Greek horizontal harmony. Verticality and the horizontal share the reign."[6]

Hitler was totally involved in the building, right to the smallest detail. "At Troost's, plans for Königsplatz, monumental. Führer in his element," noted Goebbels in his diary for January 27, 1935.[7] And August 19, 1935, Goebbels wrote: "With the car to Munich. . . . Immediately to the Party buildings. . . . Here Hitler has truly

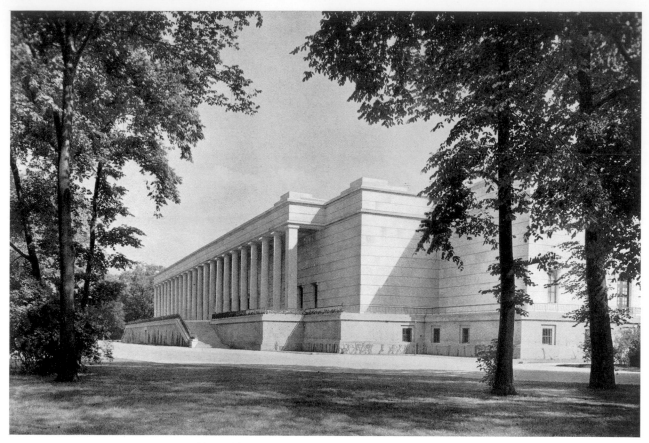

House of German Art, Munich. Architect: Paul Ludwig Troost

written his will in stone. . . . We climb through cellars and attics. Everything is supposed to be ready in a year's time. The Führer is proud and happy."[8]

Almost identical, the two Party buildings consisted of three stories of massive limestone with porticoes, eagles, and wreathed swastikas. Both had Führer balconies from which the great statesman-architect could, above the crowd, look down on his work: his people and his buildings. The critics spoke about "distinguished simplicity and restrained dignity." "What characterizes this noble building, from the outside alone, is its readability, its inbuilt harmony and beautiful order."[9] The heavy facade was marked by a severe line of windows spaced out in regular intervals of thirteen feet. They were deeply set in the frame, often under a semicircular architrave. The heavy cornice emphasized the horizontal lines of the buildings.

Like all of Hitler's buildings, however much they paid lip service to traditional styles, they were built using the most modern techniques. They also had air conditioning and huge air-raid shelters that linked the two buildings beneath the road.

Gerdy Troost, the widow of Paul Troost and one of Hitler's confidantes, who continued to head Troost's ar-

chitectural office, wrote that these first monumental community buildings were the "symbol of the fundamental strength that is renewing the German *Volk.*"[10]

Since the Führer Building was for official receptions, its interior was much richer than that of its twin, the Administration Building. Two large atrium halls, in red marble, were crowned by a broad staircase. It led the visitor in one giant sweep to the first floor, which contained the reception area and Hitler's offices. A large hall destined for receptions was paneled in precious wood and hung with nine large tapestries representing several of Hercules's deeds. The walls of Hitler's own office were covered in red leather. They displayed some of Hitler's favorite painters of the nineteenth century— Franz Lenbach, Arnold Böcklin, Franz Defregger, Anselm Feuerbach, and Adolph Menzel. In this room the historic meeting of Neville Chamberlain, Edouard Daladier, Benito Mussolini, and Adolf Hitler took place in 1938—the meeting that sealed the fate of an independent Czechoslovakia and opened the floodgates to World War Two.

Hitler's living hall—"room" would be too modest a word—had a gilded ceiling. Over the doors were golden emblems representing the arts, "theater, music,

painting, and sculpture." In the center a giant fire-place, crowned by Adolf Ziegler's painting *The Four Elements* (see illustration page 282). Its colors were echoed in the furniture, curtains, and wall hangings. There was a dining hall with chairs in gray-blue leather. The lamps were gilded. The doors were framed in local marble. Instead of being painted, the walls were decorated with stucco reliefs with scenes of the Storm Troopers, Hitler Youth, and League of Girls. The furniture and the pompous interior were the work of Gerdy Troost and the architect Leonhard Gall. The National Socialists were only at the beginning of their reign, but their first building had all the trappings of a status-craving elite.

Munich became the capital of the arts also. In order to demonstrate publicly the importance he gave to the city, Hitler began, in his first year, to plan for a new art gallery, a House of German Art. Troost was again the chosen architect. Hitler laid the foundation stone in October 1933 on the first Day of Art.

Troost did not live to see his new House of German Art completed. The work was finished by Leonhard Gall and Troost's widow, Gerdy. Hitler also took an active part in this project. It was a Neoclassical structure, a heavier version of Schinkel's Old Museum in Berlin (1823–30). Constructed of the same stone as the Regensburg Walhalla and the Kelheim Befreiungs-halle (see illustrations pages 81 and 82), the House of German Art took its place self-consciously in German tradition. In 1935, midway in the building process, a critic wrote:

It is no accident that the new House of German Art is not built in the style of German Gothic or Baroque. It has a classical character, the classical as a counterpoint to the Germanic-Nordic. There is a deep spiritual necessity for a movement that also fights in its politics the shadows of German individualism and particularism, [which] also chooses in its artistic expression a form that embodies discipline and order, as well as simple functionalism and objective clarity. . . . The new character of the building manifests itself in its attempt to combine, harmoniously, the Nordic idea of race with that of Greece.[11]

The building was gargantuan in scale; the portico measured almost 575 feet in length. Two large braziers stood on a pylon at each end of the facade. It was praised as a "Temple of German Art, one of the new monuments of a new time," and indeed the temple form announced a noble art, reaching back to antiquity. Hitler said of it: "The building is as notable for its beauty as it is for the efficiency of its services . . . but it is a temple of art, not a factory . . . the result is a house fit to shelter the highest achievements of art and to show them to the German people." Here the nation was to display the most noble and heroic in art. As usual, it was built using the latest engineering techniques, including a complex air-conditioning system and an air-raid shelter.

Several more buildings were built in the new style, most notably the House of German Law, designed by Oswald Bieber, and the House of German Medicine, designed by Roderich Fick. There were many other buildings planned for Munich but most were never even started. Opposite the House of German Art, Hitler wanted an even larger House of German Architecture. It was planned by Troost.

After Troost's death, Hitler appointed Hermann Giesler (born 1898) as the architect of the new Munich. The new "counselor for the capital of the movement," a devoted follower of Hitler, set to work on some of the Führer's plans, dreamed up while he was imprisoned in Landsberg in 1923–24. There was to be a giant new railroad station, the largest steel construction in the world. Its new system was to link Munich with Istanbul and even Moscow. A 394-foot-wide, four-mile-long east-west axis road was also planned.

On this avenue the official buildings were to rise, among them a skyscraper for the National Socialist publishing house Eher, which was to be, of course, the largest publishing house in the world. As no roads were supposed to cross this avenue, intersecting roads were to be put underground. It would have a broad center strip for marches. The road was to end at a 700-foot obelisk, a monument to the Movement, again sketched by Hitler himself. With its diameter of 80 feet and an eagle 108 feet high, it was to be one of the many giant monuments planned for the Third Reich.

Hitler also wanted a new opera house with over 3,000 seats (outdoing Paris and Vienna). It was planned by Waldemar Brinkmann with a huge entrance, marked out by eighteen marble columns. Hitler intervened personally in the plans. "Examined plans for new opera house according to Hitler's own plans. Now they make sense and have form," notes Goebbels in 1937 in his diaries.[12]

Hitler's projects for Munich also included a Forum for the Party linked by a bridge with a mausoleum for himself, designed by Giesler. No lesser building than the Pantheon would do as a model. The cost for all these plans was gigantic; five to six billion Reichsmarks was the conservative estimate. Hitler did not bother much about the financing of his plans.

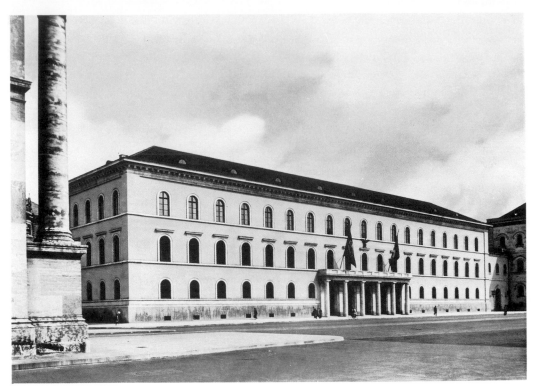

House of German Law, Munich. Architect: Oswald Bieber

Schemes always seemed to be outstripping others, and bigger and bigger they grew. Sometimes Hitler tried to justify the size of the buildings by pointing out that he built for many people. He was hypocritical enough to attack the Protestant church for having built a church in Berlin for merely 2,450 people, when there were 3½ million Protestants in Berlin. It should have provided for 100,000, he declared. A theater, built with only 1,200 seats, did not fare better. He was incapable of thinking in smaller numbers; buildings had to be crowd containers.

Few of these plans materialized. All nonessential building came to a halt with the outbreak of war. The National Socialist buildings that had been built now serve other purposes: the Führer Building today is the Academy of Music, the Administration Building is an art school, the House of Law belongs to the university, while the House of German Art is now simply the House of Art.

NUREMBERG
Nuremberg was, until its destruction in World War Two, one of the best-preserved medieval cities in Germany. Its appropriateness to Hitler's idea of patriotism was obvious. It was here that Hitler planned his giant

meeting sites. The existing sports field was enlarged to five times its original size, and a huge area of over eleven miles, the size of a small town, was planned by Troost. On Troost's death in 1934, it was handed over to Albert Speer (1905–1991).

If Hitler's relationship with Troost was that of pupil to master, in Speer, Hitler saw a much younger, talented, but inexperienced architect, one he could form to his will. And Speer was the perfect tool. A fervent believer in Neoclassicism, he became the best-known architect of the Third Reich. He attended several technical universities before graduating from the university in Berlin. He became an assistant of the famous Berlin architect Heinrich Tessenow, who pleaded for a modern style based on regional characteristics.

Speer's conversion to National Socialism was easy and quick. After hearing Hitler speak at Berlin's Technical University in 1931, he joined the National Socialist Party. This obviously paid off. The following year, the Party asked him to redesign its headquarters in Berlin. The plan faltered because of lack of funds, but in 1933, Speer became commissioner for the artistic and technical organization of the Party rallies and mass demonstrations. Speer was a man of the theater and his display of flags and standards became an essential element at these events. For the May demonstration at Tempelhof Airfield in Berlin, he designed his first light spectacle: a cathedral of lights created by 150 searchlights throwing their beams 10 miles into the sky.

Other mass meetings organized by Speer were the memorial service for President Paul von Hindenburg at Tannenberg in 1934 and the National Socialists' first giant harvest festival in Bückeberg. Hitler was tremendously impressed. Here was a man able to design the theatrical backdrops he needed to enthuse the masses. "In the festive hour of the night the dignified tribunes, the flags strung between the pillars, and the wreathed swastikas glow in the lights. Hitler, the community, and the symbols are forged even more closely together when the lightdome created by hundreds of spotlights surrounds them."[13]

"The actual effect far surpassed anything I had imagined," wrote Speer. "The hundred and thirty sharply defined beams, placed around the field at intervals of forty feet, were visible to a height of twenty to twenty-five thousand feet, after which they merged into a general glow. The feeling was of a vast room, with the beams serving as mighty pillars of infinitely high outer walls."[14] And the British ambassador, Sir Neville Hen-

derson, wrote that "the effect, which was both solemn and beautiful, was like being in a cathedral of ice."[15]

It is as well to remember that this moving spectacle was achieved only because Speer was authorized to commandeer all the searchlights that Göring's Luftwaffe possessed.

In 1934 Hitler made Speer the head of Beauty of Work (Schönheit der Arbeit), a branch of the German Labor Front (Deutsche Arbeitsfront). Its task was to improve working conditions in factories.

But, although only twenty-nine, Speer was asked to design architectural plans, and to take over the building of Nuremberg from Troost.

Following the tradition of Schinkel and his short-lived contemporary Friedrich Gilly, Speer liked to use simplified colonnades, porticoes, and heavy cornices in his buildings. He even considered himself a second Schinkel.

Speer rose fast within the ranks of the German cultural elite and was given a preeminent role in the Reich as the nation's chief architect and as the Minister of Armaments.

Hitler had held his early Party rallies of 1927 and 1929 in Nuremberg. In 1933 he surprised and rather shocked the city fathers when he expressed his wish to enlarge the existing Luitpold Arena, and demanded 10 million Reichsmarks from the town. He also produced several drawings, and in 1934 he sent Speer to Nuremberg to begin the enlargement.

Nuremberg, too, was constructed according to Hitler's plans, many drawn during his imprisonment in Landsberg. Some of them Speer incorporated into his final plans. Hitler had asked for "living space for a community." He wanted a forum for the Party, an agora for the highest feast days of the nation. It was to be the largest complex of its kind in the world. "This calls for a gigantic field, because it is for large armies, for the soldiers of the political army of the Führer."[16]

A few figures suffice to give an idea of the size of this megalomaniac undertaking. The building site spanned 6,300 square miles! An area 3,400 feet by 2,400 feet was set aside for the army to practice minor maneuvers. The Luitpold Arena was redesigned by Speer in the shape of a crescent around which a wall of banners would hang. At each end was a large stone eagle. But the old arena, capable of holding 200,000, was not large enough, and so Speer was commissioned to build the Zeppelin Field Stadium, which accommodated 340,000 spectators. Hitler approved immediately. Speer's plan for the Zeppelin Field was

*Light sculpture above the Sports
Arena during Mussolini's visit,
Berlin, September 28, 1937.
Designer: Albert Speer*

presented in a huge plaster model, which was revealed to the public in Munich on the occasion of the first architectural exhibition, and building began at once in order to have the first platform ready for the next Party rally. At one end of the Zeppelin Field there was to be a large Hall of Honor with a Memorial Chapel within. It reminded people of the Tannenberg Memorial in East Prussia, which predated the rise of the Nazis. The tribune was flanked by two pylons decorated with the wreathed swastika and crowned with large bronze braziers. In the center of its pediment was a huge swastika. The tribune gave the impression of a fortress.

In 1938 a third field was begun, the March Field, a huge parade ground for 500,000 people. It took its name from Germany's Rearmament Day in March 1933. Its tribunes were to be punctuated by 24 travertine towers over 130 feet in height, crowned by eagles. (Only nine were built; they were blown up after the war was over.) On the center platform the figure of a giant woman was planned, 202 feet high, surpassing the Statue of Liberty by 45 feet. The March Field opened out onto a processional avenue a mile and a quarter long and 264 feet wide. Paved in granite, it was a model for streets to come. Here the military displayed their tanks, Stukas, and troops in rows 165 feet wide. This was no longer the celebration of a national cult; it was the display of naked and absolute power in all its brutality.

The German Stadium, which was never built, was to have had seating capacity for 400,000 spectators, who would be armed with binoculars so as not to miss a trick of the gigantic display Hitler would stage for them. One entered the stadium through a temple-like hall built of reddish-gray granite to last centuries. Thorak's giant bronze statues, 79 feet high, were supposed to be erected here on 59-foot-high pedestals, which would reach a combined height of 138 feet. There were also 328-foot towers with the eagles of the Reich. The entire complex was, as Gerdy Troost wrote, "a shrine for the whole nation." Another writer proclaimed proudly that "now the communal experience of the Führer and his *Volk* was possible."

The arenas and large avenues were geared for the stage management of mass demonstrations. The colossal architecture inflated the myth of the Führer into gigantic proportions. The marches were arranged in a way that complemented the architecture. "When in future decades, even centuries, people write the history of the architecture of our people, they will see that,

with the year 1933, a new chapter has begun. . . . Architecture singles out the place of the Führer, which is always in front of the assembly. . . . This eye-to-eye position of the Führer with his people is always the underlying principle. The elevation of the Führer is the result of his position, a man who with all his deeds is always the leader of his people. He forms the center of the great picture. . . ."[17]

The idea of the sacrosanct central position of the Führer was often stressed. It underlined the godlike image of the leader. "The Gothic man knows only one leader, God. . . . But the fight between pope and emperor is over. . . . There is a change now. The altar, so long elevated as the place for the priest, has been taken over. Distance and separation from the crowd is still granted to the Führer, but only an alien Führer

needs the throne, the artificial elevation. The good German wants his Führer to stand out by his wisdom, knowledge, and most of all, by his character. But he wants his Führer to stand, for all eternity, on the same ground, as he does. The ground, which is the source of our blood and our existence."[18]

Hitler also demanded a large Congress Hall. Nuremberg had in 1927 commissioned such a hall from the architect Ludwig Ruff. Hitler approved the old plans but asked Ruff and his son Franz to enlarge it, to create seating capacity for 50,000 spectators. They would face a stage able to seat 2,400 people and 900 standards. It was supposed to house a huge theater and assembly room. The latest technology in lighting and heating was to be used. The giant roof was to be suspended without supporting pillars. A huge window was

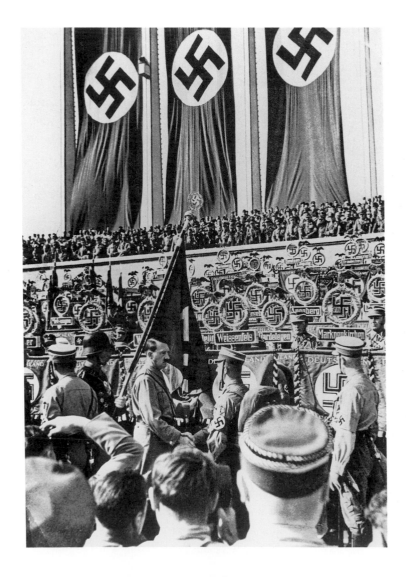

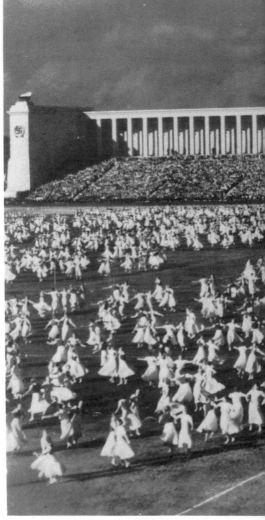

Right:
Entrance to the Zeppelin Field,
Nuremberg. Architect: Albert Speer

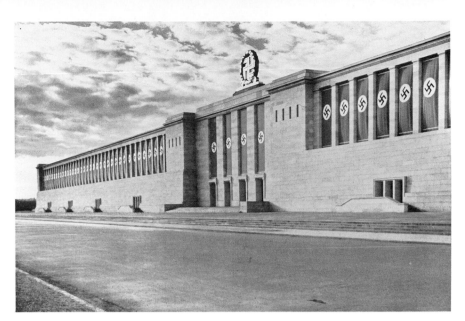

Below, left:
Hitler at the Party Rally, Zeppelin
Field, Nuremberg, September
1934. Still from Leni Riefenstahl's
film Triumph of the Will. *1934*

Below:
Performance of the Youth
Organization for Girls during a
Party Rally, Zeppelin Field,
Nuremberg

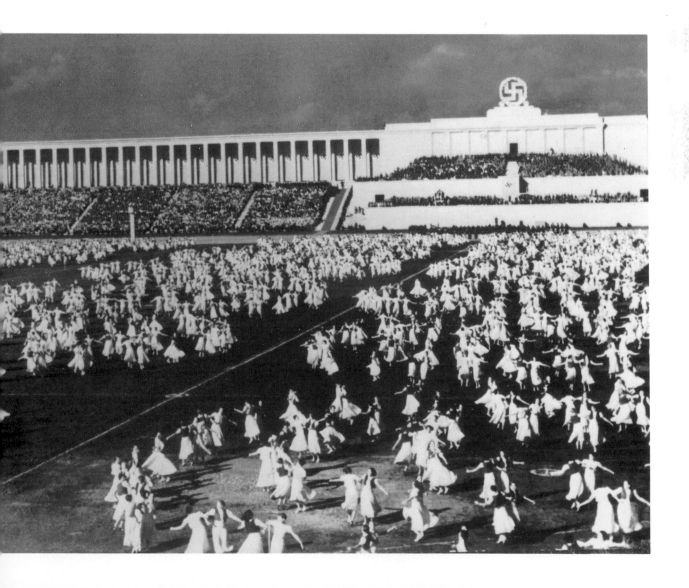

to be open to the sky. Hitler also decided that the original material, concrete, should be replaced by granite. It was to have an arcade running around its curved length. Two rows of arched windows above were to strengthen the massive feeling of permanence. Building on this site continued from 1937 to 1939. "Quarried from German soil, mastered by Germany's inherited knowledge, formed after the idea of the Führer, this is a testimony of German willpower, German strength and determination."[19]

With the war all work stopped. Today a few buildings of the Party complex remain; the stadium is overgrown with grass, and the carcass of the Congress Hall is used to store goods.

The German Pavilion for the 1937 International Exposition in Paris was designed by Speer. French officials had decided that it should be built right opposite the Soviet Pavilion, designed by B. M. Iofan in a similarly pompous style. This enraged Hitler, but Speer found a solution which appeased him. Discovering a secret drawing of the Soviet Pavilion which featured a group of sculptures 30 feet tall astride a high platform triumphantly facing the German Pavilion, Speer wrote, "I therefore designed a cubic mass, also elevated on stout pillars, which seemed to be checking this onslaught, while from the cornice of my tower an eagle with the swastika in its claws looked down on the Russian sculptures. I received a gold medal for the building; so did my Soviet colleague."[20]

Speer's pavilion was conceived as a monument, another symbol of German pride and achievement. It was to broadcast to the international world that a new powerful Germany and its technical achievements were the result of a mass will and restored national pride. Although it was intended only as a temporary exhibition hall, no cost or effort was spared in its building. It was said that 1,000 railway cars brought 100,000 tons of building material to Paris for the pavilion. It stood on the Right Bank of the Seine, in front of the Palais de Chaillot. The square tower, 215 feet high, was surrounded by 9 pillars, some with gold mosaics and red swastika patterns. Spotlights were cleverly hidden behind the pillars, which at night gave the impression of a huge crystal rising into the sky. Metal braziers in an antique style strengthened the sacred nature of this architecture. Thorak's 23-foot statues of the family and comradeship, and the obligatory giant eagle, were complemented by another swastika over the door to make sure that the National Socialist symbols and message were understood. The overloading of National

Socialist symbols continued inside on wallpaper, railings, and stained-glass windows.

Like his friend Arno Breker, Speer kept in close contact with some of the French artists, dining with Jean Cocteau and Charles Despiau at Maxim's. Part of the history the French also like to forget is an article that appeared in 1939 in the distinguished magazine *L'Architecture d'Aujourd'hui*: "It is impossible to describe German architecture of today without referring to the one man who directs building and urban planning with passionate interest. The man is Adolf Hitler. Indeed the Führer who leads Germany to a new destiny is also the 'architect' who started his life modestly as a student in the Architecture Department of the Vienna Academy." The author, Maurice Barret, continues: "Under the guidance of Adolf Hitler architectural and urban masterworks are being built everywhere. Their grandeur and technical perfection cannot be denied, although one might disagree about the taste."[21]

Speer also redesigned the German Embassy in London. But his biggest task, the rebuilding of Berlin, was yet to come.

This is not the place to examine how this well-educated man from an upper-middle-class background became so caught up with the National Socialist movement. Seduced, according to his own account, by the personality of Adolf Hitler and by the opportunity to build, he accepted the concentration camps and deportations, the banal and empty rhetoric, and the ludicrous aesthetic of the Nazi regime. Speer was not an outspoken ideologist of the Party, but he was ambitious and German to the core. His attitude sums up that of many prominent artists, the Brekers, Thoraks, Riefenstahls: "I felt myself to be Hitler's architect. Political events did not concern me. My job was merely to provide impressive backdrops for such events. . . . I felt that there was no need for me to take any political positions at all. Nazi education, furthermore, aimed at separatist thinking; I was expected to confine myself to the job of building."[22]

He might not have approved of Hitler's concentration camps, as he always claimed, but he gladly accepted their inmates and organized the influx of deported foreigners whenever there was a shortage of labor on his sites. In his memoirs he has claimed that his ambition and his love and admiration for Hitler and Germany blinded him to the political implications of his buildings. There were far more innocent proclaimers of public power. They too must be seen through the lens of Auschwitz, whose many inmates

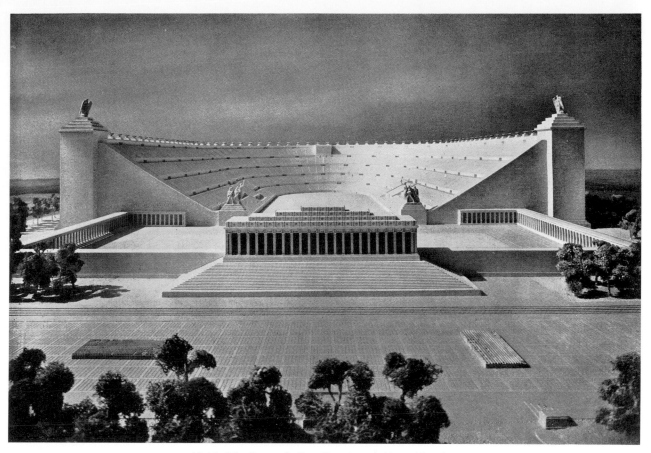

Model of the German Stadium, Nuremberg. Architect: Albert Speer

were forced to work on Speer's building sites. After the
war Speer admitted that even if he had recognized
Hitler's real nature, his role as Hitler's architect had
become indispensable for him, for he saw in front of
him the most exciting possibilities an architect can
dream of.

BERLIN

Hitler hated Berlin: it was not Vienna or Paris; it was a
modern city with modern "horrors" built by Bruno
Taut, Erich Mendelsohn, and Walter Gropius. "If Berlin
suffered the same destiny as Rome did, then our fu-
ture generations would consider the department stores
of a few Jews and the hotels of a few societies the
monumental buildings which characterized the culture
of our days," Hitler had written in *Mein Kampf.* Berlin
was to be totally re-formed. With its five million peo-
ple it was to become the biggest and most beautiful
capital in the world. Large, but still green, generous,
and airy. In 1933 he listed the buildings he especially
wanted for Berlin: an Olympic stadium and giant axis
roads running from east to west and from north to
south.

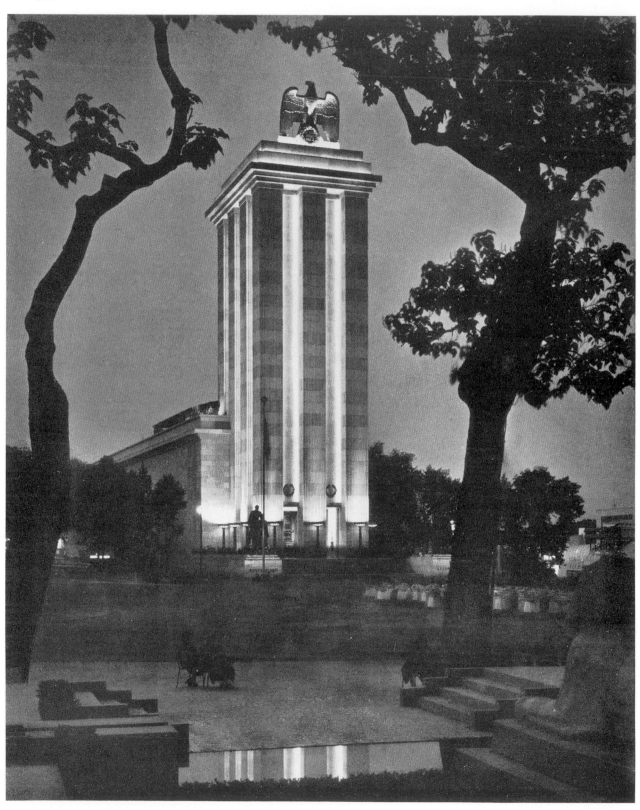

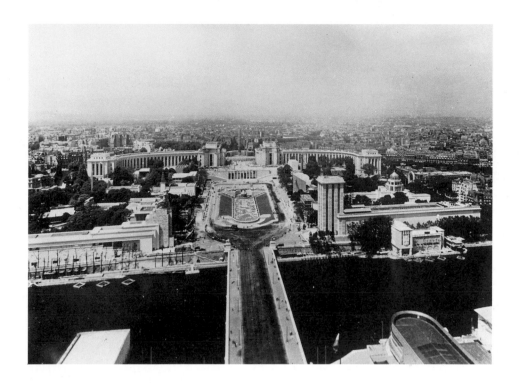

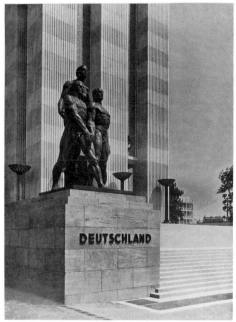

With increasing control and power, his interest in individual buildings was overshadowed by an appetite for large construction schemes, which entailed the restructuring of entire towns. In most of these Hitler planned a central axis and a large square designed as a parade ground. This was to be flanked by several Party buildings. The size of the projects mushroomed in inverse proportion to the country's fortunes in war. As Hitler's power diminished, the buildings increased in size.

Above:
Josef Thorak. The Family.
Sculpture in front of the German pavilion

Top:
International Exposition on the banks of the Seine, Paris, 1937

Right:
The Soviet (left) and the German (right) pavilions, International Exposition, Paris, 1937

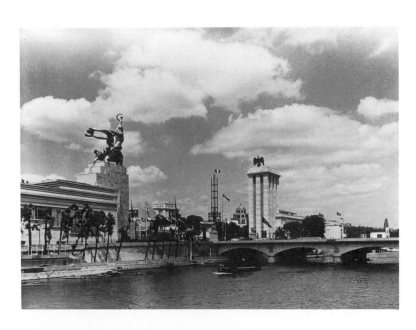

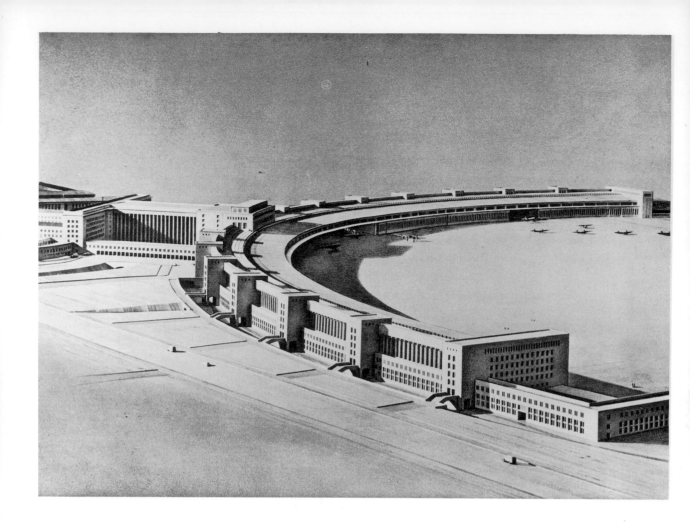

Above:
Model of Tempelhof Airport,
Berlin. Architect: Ernst Sagebiel

Opposite:
Hall of Honor, Ministry of Aviation,
Berlin, with an eagle designed by
Douglas Hill. Architect: Ernst
Sagebiel

Hitler's involvement with the architectural plans for Berlin was again total. He visited the sites and took control. In 1934, his second year in power, he had mentioned for the first time a giant triumphal arch and an assembly hall for 180,000 people, both based on plans he had drafted in the late 1920s. In the same year he also initiated the building of Tempelhof Airport, which was to be the most beautiful and largest in the world. The work of Ernst Sagebiel, it was a gigantic structure with over 2,000 rooms, built in only eight months. It was opened in 1935. Its facade, with a near-total absence of decoration, is military to the core. Panels of stone reliefs record the military heroes of the past. As the indefatigable Mrs. Troost reported, it had "grown out of the spirit of the Luftwaffe, tough, soldierly, disciplined."

On the whole, Tempelhof and, even more, the second Berlin airport, in Gatow, are modern in design. The hangars were the best examples of modern technology and architecture at the time they were built. The air force, which considered itself the aristocracy of

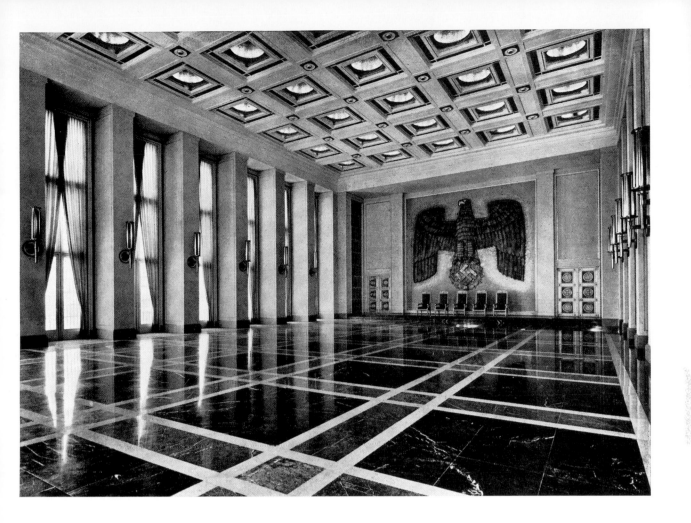

the services, resisted the blatant National Socialist style and saw to it that their buildings were more modern in outlook. Not so the Ministry of Aviation, also built by Ernst Sagebiel in 1934.

Hitler had visited the Olympic site in 1933. In one of the suburbs of Berlin, the Grünewald Stadium had been built by Walter and Werner March between 1925 and 1928. It was in a Neoclassical style. Hitler decided immediately to enlarge it and in 1934 he commissioned Werner March to draw up plans for a stadium for 100,000 spectators. Money was again no obstacle. Hitler laughed at the 1.5 million Reichsmarks set aside for the original stadium. He immediately gave 28 million. Eventually the stadium cost 77 million marks, but Hitler considered any complaints niggardliness, and shrugged them off with the remark that the foreign visitors to the games brought in half a billion.

For the new stadium, March had originally designed a concrete structure with glass partitions. When Hitler inspected the building site, he became very angry about the constricting partitions and threatened to

cancel the games. He wanted a wide arena. March changed his plans.

The Olympic Stadium, like the Nuremberg Zeppelin Field, was more than a mere sports arena. It was designed as a huge assembly place for hundreds of thousands to celebrate Nazi rituals and experience group exhilaration. It was a place where the spectator would become a participant. The monumental square in front of the main entrance to the stadium, which consisted of a massive paved concourse flanked by flagposts, spelled out the importance of the stadium as a great meeting place for Germans. The whole complex was laid out in a strict symmetrical pattern.

Besides the large sports arena there were administration buildings and a giant parade ground, the May Field, with terraces for 40,000 people, crowned by the 255-foot Olympic Tower. Other towers, named after ancient Germanic tribes or sites, emphasized the fortress-like character of the complex. Inside the Langemarck Tower, for example, there was a memorial hall for the heroic dead, decorated with the 76 regi-

mental flags which had flown at the historic Battle of Langemarck, considered the site of the first poison gas attack, in 1915, and the site of heavy fighting during World War One. It was yet another demonstration of the Party's taste for death cults.

There was an open-air theater, the Eckart-Bühne, a Germanic fantasy version of an amphitheater of antiquity. The "German Oak," as the architect March noted, "replacing the sacred olive at the entrance to the temple of Zeus."

The great stadium was built of German stone, from Franconia. The Olympic flame, burning in one of the many braziers that were to become a National Socialist hallmark, stood at the Marathon Gate. The decoration of the stadiums, with sculptures by Breker

and Wackerle, was Hitler's own idea. He also decided upon the names of the various towers and areas, which were peppered with giant sculptures by his favorites and which were financed by the cigarette manufacturer Reemtsma.

The 1936 Olympic Games had been scheduled for Berlin prior to 1933. When Hitler came to power, he saw in this event a unique opportunity to play host to the world and to show Germany in the best possible light. When the new stadium was officially opened, in 1936, Hitler presented his new architecture and the new German man. Gone were the calls for a "Blood and Soil" ethic, for the simplicity of country life. Berlin gave itself international and urban airs. Gone also were the ugly anti-Semitic slogans that defaced the

Olympic Stadium, Berlin. Entrance of the French team at the opening ceremony of the Olympic Games, 1936

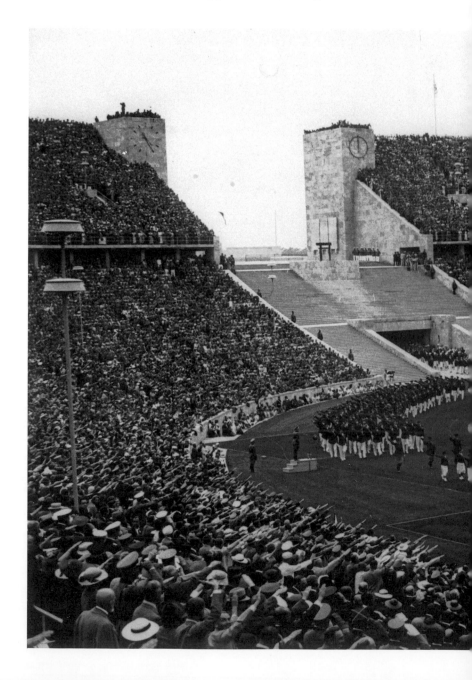

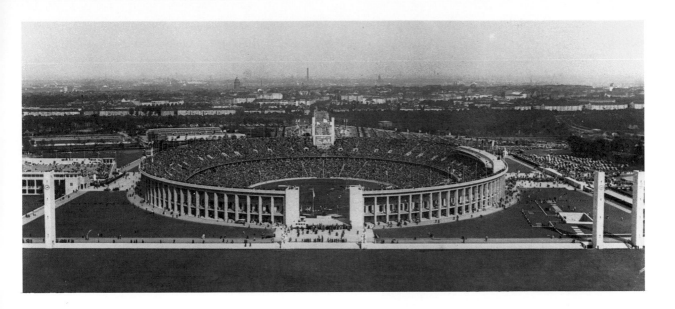

Olympic Stadium, Berlin. Opening ceremony of the Olympic Games, 1936

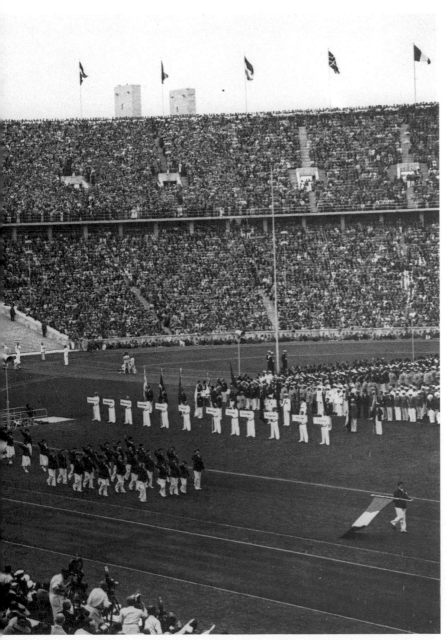

Poster for Leni Riefenstahl's film
Olympia—Feast of the Nations.
1934

Opposite:
Olympic Stadium, Berlin. Closing
ceremony of the Olympic games,
1936

walls. In front of a greatly impressed international crowd Hitler opened the games. And an international audience applauded. A choir sang the Olympic hymn, especially composed by Germany's most prestigious and famous composer, Richard Strauss. The receptions the Party bosses gave in their own homes for the international visitors were sophisticated and brilliant.

The Olympic Games had all the trappings of the regime, the showing of athletic bodies, the pseudo-religious ritual at the opening and closing ceremonies. The English were among the few who refused to execute the National Socialist salute, but the English reporters wrote positively about the new Germany. Leni Riefenstahl, the Party's leading filmmaker, made a film, *Olympia—Feast of the Nations*, in which the distinction between reality and art was abandoned. Images of enormous suggestive power celebrated the perfect body as the symbol of the perfect spirit. A magical cult of the pure and strong body was promoted to millions with the help and the skill of the new medium: film. In

Riefenstahl's opening sequence we see a naked runner bringing the flame from Greece to Berlin. In this scene Riefenstahl captured one of the stage tricks of the regime to perfection: the transposition of the antique ideal into the modern world.

On January 30, 1937, Hitler handed the building of Berlin over to Speer, who, although only thirty-two years old, became one of the most powerful cultural figures in Germany. Hitler kept a close eye on all developments. Goebbels reported enthusiastically: "At the Führer's to look with him and Speer at the new plans for Berlin. A fantastic conception. Calculated for 20 years. With a giant avenue from south to north. It will have the representative buildings. In this way Berlin will be elevated to a leading capital. The Führer thinks in a great and audacious way. He is 100 years in advance."[23]

The plan drew objections from the city, mostly aimed at the cost, and Mayor Lippert resigned. But in June 1938 Goebbels announced: "The new building program will begin June 17, on 16 sites. The most grandiose building program of all time. The Führer has overcome all resistance. He is a genius."[24]

Previous German chancellors had resided in the old Chancellery, dating from the first half of the eighteenth century and situated on the famous Wilhelmstrasse. Until 1918 various modernizations had taken place. Hitler had moved in in 1934 and considered it only fit for a manufacturer of cigarettes, with its exterior resembling a storehouse or a fire station. A long campaign to justify the building of a new Chancellery began. First Hitler claimed that the building was in terrible condition. "In downpours," he wrote, "a stream ran into the rooms at the ground floor, increased by the water coming from all possible openings, including the water closet. Since my predecessors could generally count on terms lasting only three, four, or five months, they did not bother to clean away the dirt or to do anything so that the successor would have it better."[25] One can hardly believe that this was the voice of the Führer of the great German nation. But the distinguished magazine *Die Kunst im Dritten Reich* did not forbear to print such concièrge-like outbursts of complaints that the Führer included in the official justification of his new building plans. On the basis of Troost's plans, he began in 1934 to modify the Chancellery, which included a reception room designed by Gall. Speer also was involved in these first alterations. Hitler paid for all this, he claimed, out of his own pocket.

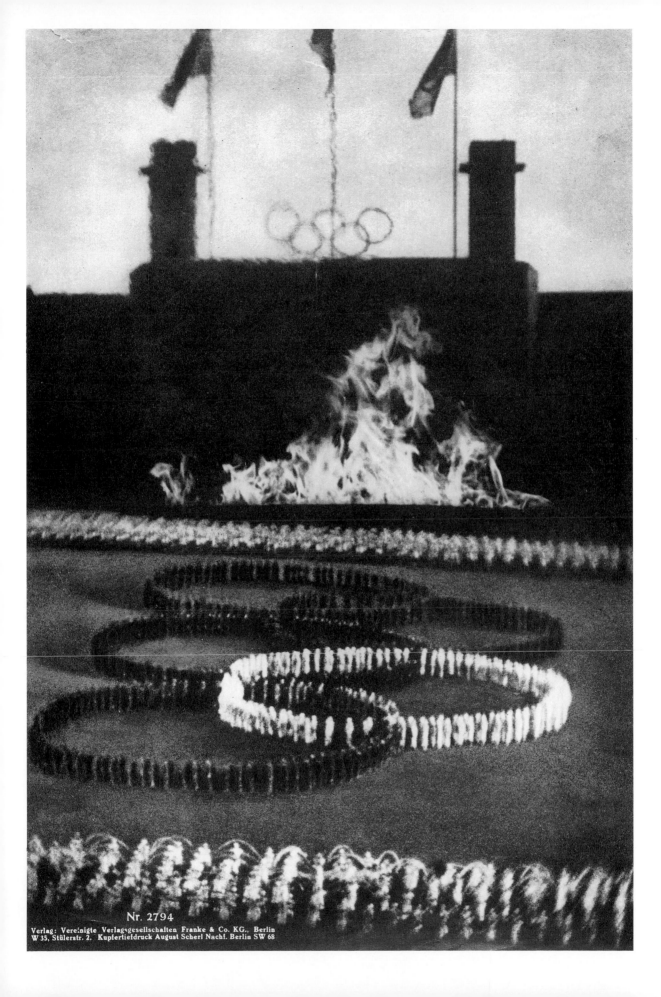

Entrance to the Chancellery, Berlin, with the Party insigne designed by Kurt Schmid-Ehmen. Architect: Albert Speer

Opposite:
The map table (at left in the photograph of Hitler's study below) with view of the Chancellery garden

The Führer's study, Chancellery, Berlin. Sculptures above the doors at rear designed by Richard Klein, eagle by Kurt Schmid-Ehmen

But of course he wanted a place in keeping with his imperial rank. In January 1938 he commissioned Speer to enlarge the old Chancellery. He was obviously no longer embarrassed to order such extravagant extensions. In reality, his early sketches for the extension date from 1935. At the same time he had begun to buy the surrounding buildings. None of this was made public.

Hitler gave Speer only one year: "The cost is immaterial. But it must be done very quickly and be of solid construction."[26] The urgency was also kept secret. More neighboring buildings had to be bought and part of the street pulled to the ground. In the end, Speer had only nine months to build. Even Hitler for once was amazed. He praised the genius of Speer and his outstanding organizational talent. Seven thousand workers toiled day and night in two shifts. Hitler assembled most of them in the Sportspalast and gave a pep talk: "I stand here as representative of the German people. And whenever I receive anyone in the Chancellery, it is not the private individual Adolf Hitler who receives him, but the leader of the German nation—and therefore it is not I who receive him, but Germany through me. For that reason I want these rooms to be in keeping with their high mission. Every individual has contributed to a structure that will outlast the centuries and will speak to posterity of our times."[27]

Only part of the old Chancellery was kept, but not much remained visible. The new three-story Neoclassical facade consisted basically of three sections, two

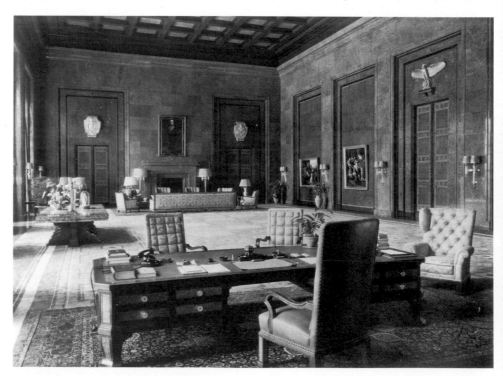

identical side wings and an important middle section, set back from the road. The middle section was slightly higher, but an ingenious optical illusion made all three parts appear the same height. The side wings contained the two general entrances: two pillared portals, each headed by the obligatory wreath of swastikas and eagles.

The garden side was less severe and far more pleasing. The middle part was a giant portico. Steps led up to a large terrace with two bronze horses by Thorak. Behind the facade, marked by six pairs of fluted columns with bronze-gilded capitals, was Hitler's personal study, overlooking the garden, with a fountain, a wrestler with a bull by Louis Tuaillon, and a conservatory with a colonnade. The formal entrance for official receptions was on the other side of the building, on the Wilhelmstrasse. Here was a large double portal, with bronze doors leading to the large (223-by-85-foot) court of honor, a 59-foot-high atrium of gray marble, large enough for cars to drive in and, if needed, to serve as parade ground. At the end of this impressive forecourt, under the open sky, stood Breker's two statues *The Party* and *The Army*, flanking the entrance to the building proper. These guardians of the Chancellery and of the whole nation were eight times the size of the visitor. Ten steps led up to the entrance, formed by huge columns and crowned by the eagle and swastika, by Schmid-Ehmen.

Hitler's two buildings—the Führer Building in Munich and the Chancellery in Berlin—were seen, also in their architecture, as the logical progression of the National Socialist movement. "Two masterworks of the political rise to power. . . . The Führer Building is a symbol of the newly found faith in a German future. . . . Troost's building with its Doric economy and severity shows the very image of the fighting Party. . . . In Speer's Reich Chancellery speaks the eminence and richness of a Reich which has become a superpower,"[28] was the accolade of the architect Hermann Giesler to his younger colleague, who presented here his first complete building. He was compared to Gilly and Schinkel and even to Brunelleschi.

The words that described the new Reich Chancellery were the same as for all the other buildings—a reiteration of the well-worn claims. The repertoire was limited, but its repetition worked on the masses. Newspapers and magazines described it, and it was shown also in the cinema. Hitler threw the doors open to prove to the world that Germany had arrived. The phrases about the "expressions of the will of the peo-

ple" poured out. It was not the work of one man, but a communal effort with stones and marble from the whole Reich. It carried all the outward signs of National Socialist buildings—a heavy cornice and horizontal lines with rows of windows. Contemporary critics praised its "austerity," its German character, its imposing Prussian style. It was supposed to suggest security and order.

In contrast to the stark exterior was the flamboyant and theatrical interior, a reflection of the *nouveau riche* taste of Hitler and his decorators. "Walking through the rooms," wrote one critic, "makes one feel as if one were seeing a magnificent play."[29] Inside, it was calculated to impress the visitor and to force him into a subservient mood, precious window dressing borrowed from a feudal society. Everything—the size of the rooms, the large staircases, the giant decorations, the chandeliers—was to broadcast that here people of a high order were at work.

The arrangement of the rooms was very much like a progression: "the road to the head of the state." The sole idea was to display highness and dignity in order that, as Giesler put it, "the visitor is forced to stride instead of merely perambulating."[30]

A marbled anteroom led to the mosaic hall, a room of gigantic proportions, its walls and floors of red marble. The mosaic work was carried out by Hermann Kaspar and used all the National Socialist symbols. It led into a top-lit circular room, the Runde Raum. There was a plan to adorn the round room with two sculptures by Arno Breker, *Daring* (*Wager*) and *Reflection* (*Wäger*), a rather ironical verbal touch devised by Speer. Ultimately the round room had only two reliefs by Breker, *Fighter* (*Kämpfer*) and *Genius*. It was also to have had three female nudes by Breker, *Grace* (*Eos*), *Flora* (*Anmut*), and *Psyche*, standing next to the *Wäger* and *Wager* as symbols of fertility and love.

From the round room, guests were ushered through a long marble gallery nearly 500 feet long, 40 feet wide, and 33 feet high. This room impressed the Führer especially, because it was twice as long as the hall of mirrors in Versailles. Hitler hoped to stun foreign dignitaries who would have to walk 720 feet, the equivalent of almost three city blocks, to meet the emperor. "On the long walk from the entrance to the reception hall they'll get a taste of the power and grandeur of the German Reich!" he remarked to his architect.[31]

Eventually the stunned visitors were led into the inner sanctum, Hitler's office. This was adorned with

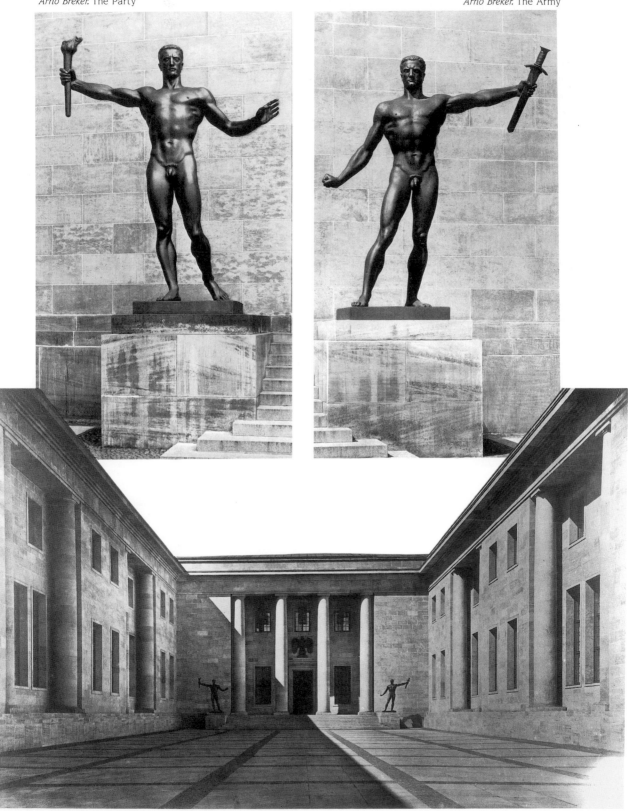

*Court of Honor, Chancellery,
Berlin, with Arno Breker's
sculptures* The Party *(left)
and* The Army *(right)*

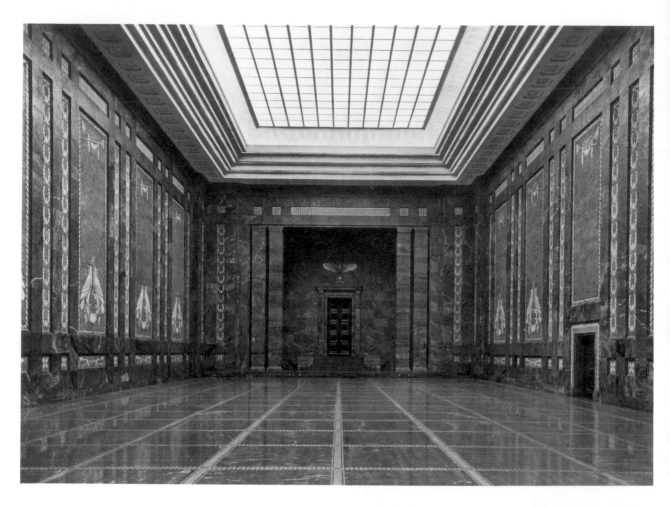

The mosaic hall, Chancellery,
Berlin. Designer: Hermann Kaspar

The door (at the right in the
photograph of Hitler's study)
leading to the marble gallery,
Chancellery, Berlin

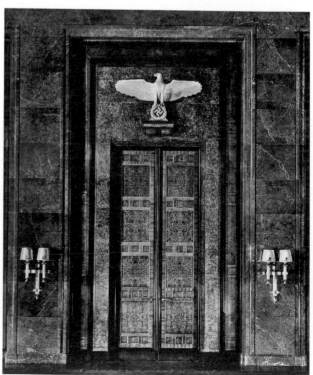

candelabra and hung with tapestries. It was intimate in comparison with the other rooms. "One enters the room with humility because of the creative presence of the man who works in here, who lends the room its blessed peace. The furniture and decorations create a great sense of space."[32] This gallery, lit by 19 high windows, was to take Werner Peiner's large tapestries of German battles. For the time being tapestries from the Vienna Kunsthistorisches Staatsmuseum representing the life of Alexander the Great had to do. Care was taken to make it look noble and dignified, rather than the result of a passing fashion. "Through the noble materials a serene but forceful color scheme has been found which the Führer loves when he is working." The doors were crowned by four gold panels representing the four virtues: Wisdom, Prudence, Fortitude, and Justice. History was spelled out in walls of polished wood and marble. Franz von Lenbach's *Portrait of Bismarck* hung over the mantelpiece. The Führer's desk dominated the room. "Great thoughts arise here, decisive conversations," wrote one critic.[33]

Hitler's own quarters had a living room and a small dining room for fifteen people, the only spaces with a personal touch. They contained drawings by Schinkel, a painting by Kaulbach, and several small nude studies by Josef Wackerle. The rest was a feast of ostentatiousness: a large reception room for the New Year's reception for the diplomatic corps, lit by huge chandeliers and garnished with tapestries; a dining room, and a cabinet room, completed the lavish interior. A big conference room was never used except as a mere stage set like so much else.

The whole thing was a hodgepodge of historical power styles borrowed from the Doges' Palace in Venice and the temples of the Pharaohs. In its lavishness it was supposed to lend an eternal symbolic value to the regime.

While Troost's buildings retained a certain severity, those done by Speer reflected Hitler's taste for overbearing rhetoric. Today nothing remains of the Chancellery but a heap of rubble under a grassy mound. The destruction can be said to have begun in 1940, one year after its inauguration, and the war then did the rest. The huge bronze doors were melted down in that year and turned into artillery. Winston Churchill, in July 1945, walked through what remained of the building before it was razed. From its stones the Russians built their War Memorial in Berlin Treptow.

Many of the foreign diplomats who had paid their respects to Germany's leader were angry when they

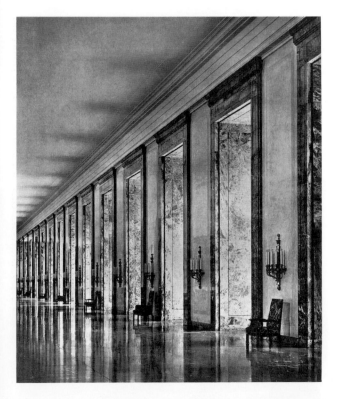

The marble gallery, Chancellery, Berlin

heard about other aspects of Hitler's new city plan. He had decided to house all embassies in Grunewald, a leafy suburb away from the center of the city. The reason was that his designs required the destruction of many embassies traditionally located in the center of Berlin. The plan was to build identical buildings for each embassy, so that they would line the avenue like soldiers. It met with unanimous rejection. Hitler was persuaded to modify part of his scheme; he agreed to erect the new diplomatic quarter in the old Tiergarten section near the Brandenburg Gate and the fashionable Unter den Linden boulevard.

The Tiergarten had long been the favorite part of the city, where rich burghers had their town villas. Several diplomatic missions had already been established in those large free-standing houses. A resettlement program began: the embassies of Switzerland, Denmark, Spain, Argentina, Yugoslavia, Czechoslovakia, Italy, and Japan were to receive entirely new premises. Only Finland and France were to move into old buildings, converted for their new purpose. The Argentine embassy was never built—nor was the Czechoslovakian, because of Hitler's attack on the country in the summer of 1939.

The most splendid embassies were those of Hitler's two allies, Italy and Japan. The Imperial Japanese embassy was the work of Ludwig Moshammer; the sumptuous interior was by Caesar Pinnau. The pompous building, with a porch formed by six colossal pillars, was set in a prestigious part of the quarter. Four buildings had to be demolished to make room for it.

The Italian embassy stood right next door. Six buildings had to be demolished to accommodate it. Speer commissioned Friedrich Hetzelt to do the work. He was also to build the Italian Fascist Party building in Berlin, a present from Hitler to the Duce. The embassy, altogether a more elegant building than the Japanese one, paid lip service to Italian Renaissance palaces.

Most diplomatic buildings in the Tiergarten section were destroyed or badly damaged in the World War Two bombing. Ironically, the two most costly buildings, the embassies of the two Nazi allies, were chosen to form part of a much discussed reconstruction program during the Architectural Exhibition in Berlin in 1987. Badly damaged during the bombing, the Italian em-

Tea reception for boxing champion Max Schmeling and his wife, the actress Anni Ondra, in the Chancellery, Berlin

Hitler (fifth from the left) at a ball in the reception hall, Chancellery, Berlin 1939

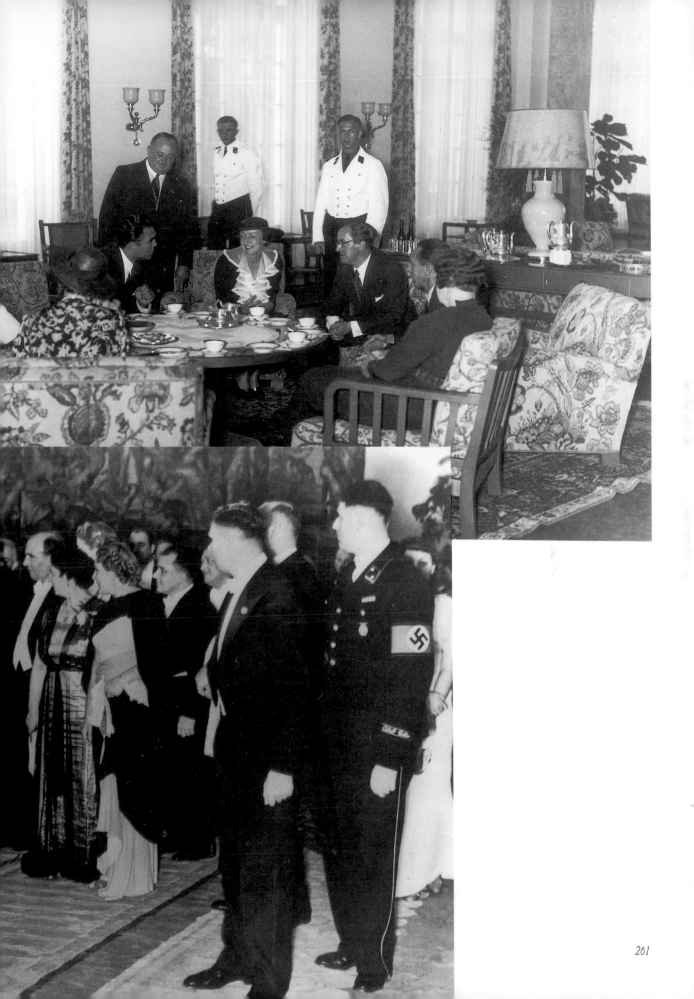

bassy was restored to house the Italian Consulate and a science institute. The Japanese embassy was almost faithfully reconstructed—a fact which aroused many protests—and serves today as the Japanese Center.[34]

In Berlin, too, Hitler oversaw the rebuilding of a number of public squares, like the Opernplatz, the Wilhelmplatz, and the Gendarmenmarkt. Several buildings were erected in the official style, most notably the Aviation Ministry by Sagebiel in 1935–36, and the buildings surrounding the Fehrbelliner Platz, some of them built in 1931 by Emil Fahrenkamp (1885–1966). There were also the exhibition halls at the Funkturm (Radio Tower) by Richard Ermisch in 1934–36, with a Hall of Honor 130 feet high. They faced the Haus des Rundfunks (Broadcasting House), built from 1929 to 1931 to the design of Hans Poelzig, an architect the

The former Italian embassy in Berlin. Architect: Friedrich Hetzelt

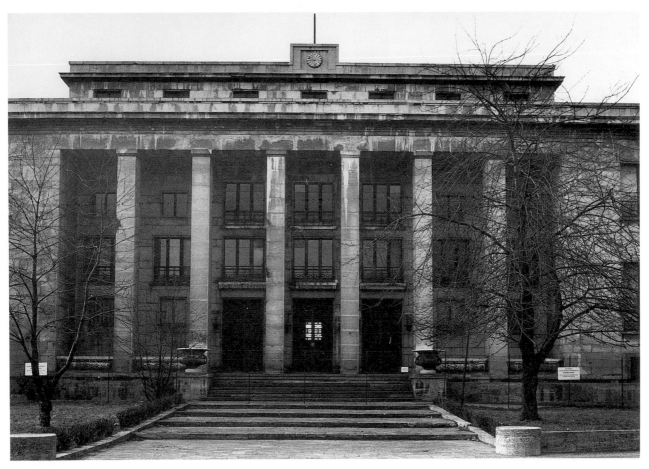

The former Japanese embassy in Berlin. Architect: Ludwig Moshammer

National Socialists rejected. Ermisch's buildings, like those on the Fehrbelliner Platz, are less rhetorical than most official buildings. They survived the war to continue to be used in the same way as before.

In 1925 Hitler had sketched a triumphal arch and a large assembly hall, both of which were to become the symbols of the new Berlin. From 1934 onward he began to talk about the total reshaping of the capital, and he announced to the city fathers that during the next twenty years he was willing to put 60 million Reichsmarks a year into a Berlin building program, provided the town would match this sum with 70 million more. These were substantial sums, but little did the city know what Hitler ultimately had in mind. He loved Rome and Paris, and considered Baron Haussmann the greatest city planner of all time, but the new Berlin was to triumph over both capitals in size and splendor.

The old nineteenth-century city, representing the old order, or disorder, was to be replaced by a city representing the new order. Under Speer, Berlin was to become the ultimate architectural realization of Na-

tional Socialist ideology. On Hitler's birthday, April 20, 1937, Speer presented his Führer with the plans. They carried a dedication, "Developed on the basis of the Führer's ideas." Some 10-foot-high architectural models were made, which, floodlit, stood in the garden of the Reich Chancellery. There Hitler indulged his fantasies as the great artist-politician, the patron of an architecture which would outdo Babylon and Luxor.

One year later, again on Hitler's birthday, Speer gave him the first part of Berlin's Great Axis Avenue, 4 miles long, flanked by 400 streetlights that he had designed. "The east-west axis which the shaping hand of our Führer has cut through the chaotic development of the old city is an expression of his farsighted genius," said a newsreel commentator.[35] Bordered by the great official buildings of the Reich, this avenue was to be the highlight of the new city. Eventually it was to stretch over 30 miles from east to west and 25 miles from north to south. It would offer the imperial perspective worthy of a great world power, ending in a colossal square with a triumphal arch and a complex of buildings. Hitler wanted the Axis Avenue in this way

Cast-iron streetlamps.
Drawing by Albert Speer

Cast-iron streetlamps, Berlin.
Designer: Albert Speer, 1938

Street decoration in the Unter
den Linden, Berlin, during
Mussolini's state visit in 1937

to resemble the Champs-Elysées, which ends in the great palace of the French kings, the Louvre. Hitler envisioned instead a house of deputies bigger than any national assembly in the world. The dimensions of the building, with seating for 1,200 deputies, would give an indication of the size of the new Reich that Hitler hoped to conquer. It presupposed a population of 140 million, almost twice the population of Germany at that time.

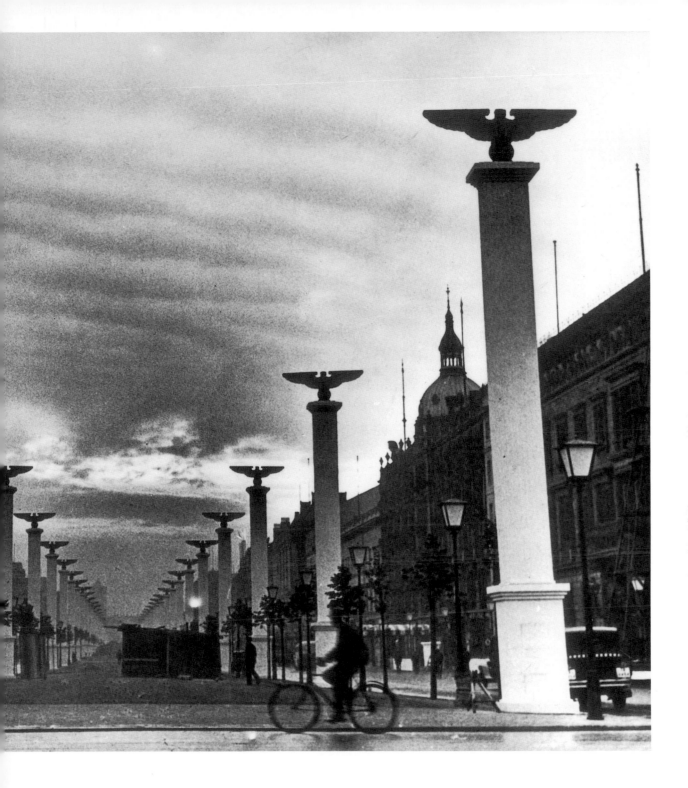

The triumphal arch was to span a distance of 285 feet and rise 325 feet, dwarfing not only the Arc de Triomphe but also the Eiffel Tower. On it the names of the fallen heroes of the Great War were to be inscribed.

There was to be a Great Hall known as the Kuppelhalle ("Kuppel" means dome) on account of the huge domed hall with a seating capacity of 180,000. The cupola, based on a drawing by Hitler from 1925, would rise 1,050 feet. It was to be larger than the cupola of the Pantheon, which had served Speer as a model. Hitler was obsessed with a domed building and was rather upset when he learned that the Russians were also planning a giant domed building to honor Lenin. The outside of the cupola was to be covered in patinated copper. It was crowned by a 100-foot-high Eagle of the Reich grasping the world in its talons, symbolizing Hitler's role as ruler of the world.

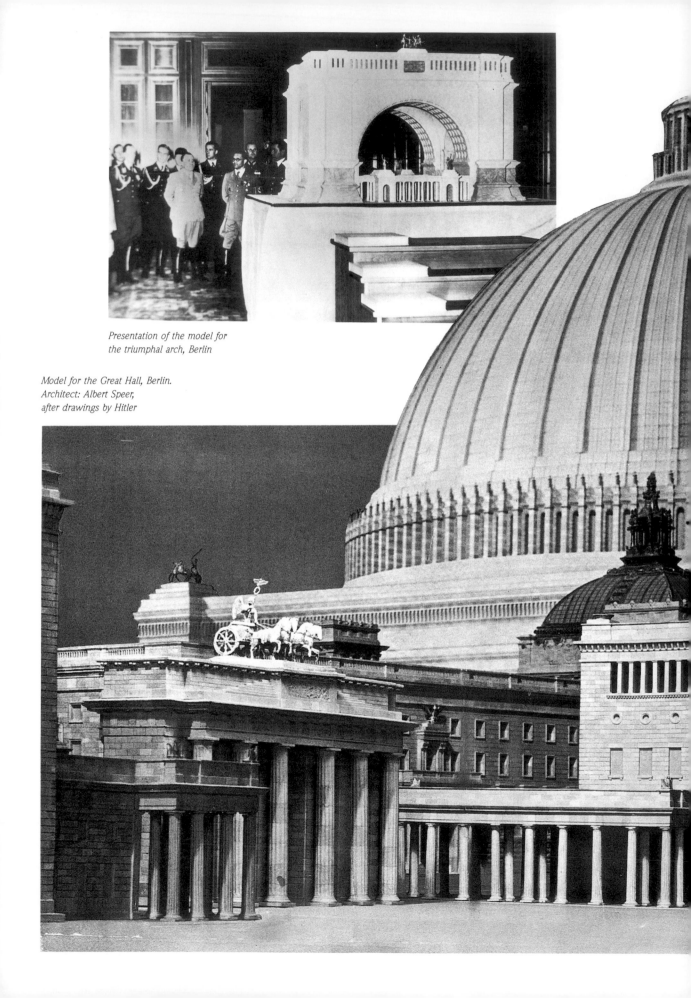

*Presentation of the model for
the triumphal arch, Berlin*

*Model for the Great Hall, Berlin.
Architect: Albert Speer,
after drawings by Hitler*

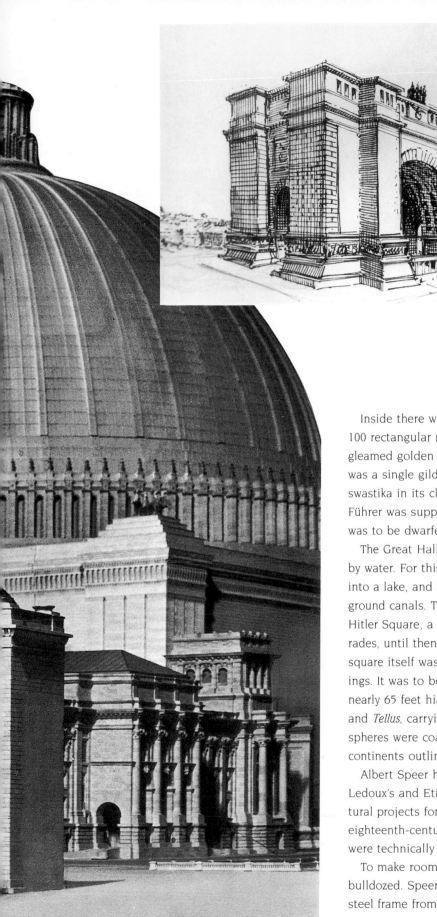

Hitler's drawing for the triumphal arch to be erected over the Brandenburg Gate, Berlin, 1925

Inside there was a three-tiered gallery and a circle of 100 rectangular marble pillars. In huge recesses gleamed golden mosaics. The only other decoration was a single gilded sculpture of a German eagle with a swastika in its claws, 46 feet high, under which the Führer was supposed to have his podium. For once he was to be dwarfed by his own megalomania.

The Great Hall was to be surrounded on three sides by water. For this the river Spree was to be widened into a lake, and the river traffic diverted into underground canals. The fourth side was to be the Adolf Hitler Square, a new space for the annual May Parades, until then held at the Tempelhof Airfield. The square itself was to be flanked by more Party buildings. It was to be adorned with two giant sculptures, nearly 65 feet high. They were Hitler's choices: *Atlas* and *Tellus*, carrying the world and heaven. The two spheres were coated in enamel, with the stars and the continents outlined in gold.

Albert Speer had thought to emulate Claude Ledoux's and Etienne Le Boullée's grandiose architectural projects for France. But in contrast to these eighteenth-century masters, he thought that his plans were technically realizable.

To make room for the Great Hall, whole streets were bulldozed. Speer began to construct a skeleton of a steel frame from which the shell of the dome would be suspended. A big sample of the concrete floor, which was supposed to support such a structure, was sunk

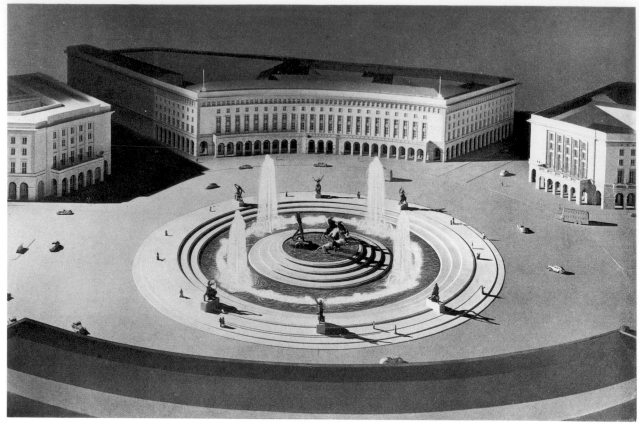

Model for a circular plaza, Berlin. Architect: Albert Speer

into a plot of earth in the suburbs of Berlin to test its quality. This dirty gray slab and some drawings and photographs are all that remain today. For the vast Adolf Hitler Square, Berlin's old Königsplatz was covered in granite and enlarged to hold up to one million people. The sculptor Arno Breker was asked to design a fountain 410 feet in diameter with a figure of Apollo reaching 20 feet into the sky. "Imagine my joy in creating a fountain of that dimension. . . . I remained faithful to my Greekness and sketched Apollo with the chariot of the sun. . . . The main group of Apollo was framed by four pillars of water, 50 feet high. Spotlights in the middle of the water pillar transformed them at night into giant silvery gleaming towers. On the edge of the huge basins stood, in the axis of the six avenues, six maenads in flowing robes, announcing, so to speak, the great event: the arrival of Apollo."[36] This was to be the showpiece of a new Germany, surpassing anything other nations could ever boast.

On June 23, 1940, immediately after the "Armistice" in France, Hitler visited Paris for the first time. In a Mercedes sedan, Hitler, as usual sitting next to the driver, set out on a city tour with Speer, Hermann Giesler, and Arno Breker. A newsreel recorded the con-

queror's flying visit in the early hours of the morning. They stopped at Charles Garnier's neo-Baroque Opera House, Hitler's favorite building. After that they passed the Madeleine and went on to the Trocadéro. Hitler stopped at the Arc de Triomphe and at the Panthéon. All the buildings were rather predictable tourists' choices. The great edifices of Paris—the Louvre, Notre-Dame, the Palais-Royal—did not interest him. Only the sugary copy of a medieval church, Sacré-Coeur, held his interest. After the visit Hitler ordered a change in his architectural plans. "Our architecture is too heavy," he complained. "It does not know the play of variety and details." The Arc de Triomphe impressed him particularly.

Back in Berlin he complained to Goebbels about his "living conditions," and his minister noted in his diary: "This can't go on, he lives like an impoverished country aristocrat and at the same token he dominates Europe and Berlin is destined to become the central point of this continent."[37]

In his craving for status, Hitler wanted yet another Chancellery. He had already been formulating plans for it while the other one was still under construction. Of course, it had to outshine all the other great palaces

of past emperors; Speer talked about an area of several thousand square feet. The long walk that had pleased Hitler so much in the old Chancellery was to be doubled in length. He declared that "whoever enters the new Chancellery should have the feeling that he is meeting the master of the world." The new Chancellery was to have reception rooms and eight vast entertainment halls for thousands of people. There were plans for a private theater with seating for 400 guests and a special box for Hitler. He could reach the great halls by special covered galleries from his private quarters.

The costs mounted. Speer had estimated that all the new projects would devour 4–6 billion Reichsmarks; the Great Hall alone was to cost 2½ billion; the new Chancellery 750 million. By comparison, the one in the Wilhelmstrasse had cost a pittance at 138 million. But there was no one able to stop Hitler. He wanted more and more. He furnished a sketch for a monument to Mussolini: a Mussolini station that was to have a special hall for the arrival of heads of state. The people knew nothing about the horrendous costs. The enormous expense of these schemes was constantly

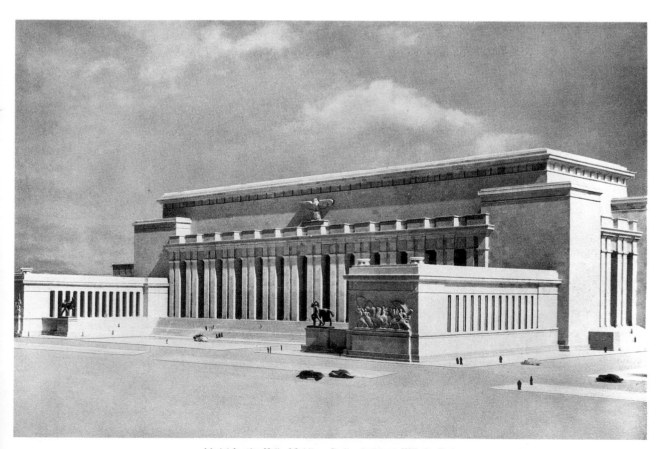

Model for the Hall of Soldiers, Berlin. Architect: Wilhelm Kreis

Model for the Armory, Berlin. Architect: Hans Hermann Klaje

justified by the employment they would provide and by the prestige they would bring to the nation, but Hitler reserved the power to veto anything to be built with government money.

The new city Hitler planned was completely out of proportion, dehumanizing the people who lived in it. Hyperbole knew no limits. Berlin was to be renamed Germania. Goebbels wrote in his diaries: "The projects are truly grandiose. They are of a dimension that will suffice for the next three hundred years. Their construction means that Berlin will be the metropolis of the world from the point of view of architecture as well."[38]

It was estimated that the building program would take twelve years to complete. In 1944 Goebbels boasted that 150 architects were feverishly making plans to turn Berlin into the biggest and most beautiful city in the world. There was talk of two new airports and a third airport in the lakes for seaplanes.

The forest of Grunewald was to become a big center for leisure activities. Work began in 1938 and was stopped in 1942. Part of the east-west axis road was built; the rest remained on the drawing board.

THE OTHER CITIES

Hitler was an architectural dreamer, who, when faced with the total destruction of his Reich, still spent hours looking at his plans and at the models his architects Speer and Giesler had made for him. They, too, dreamed extravagantly. Originally Hitler made master plans for Berlin, Munich, and Nuremberg. He relied on Himmler to find the necessary forced labor in his concentration camps. By 1941, while the war was raging, twenty-seven other cities—among them Hamburg, Augsburg, Cologne, Münster, Hanover, Dresden, Bremen, Linz, and Weimar—were supposed to be rebuilt as visible monuments to the new German Reich. Cities

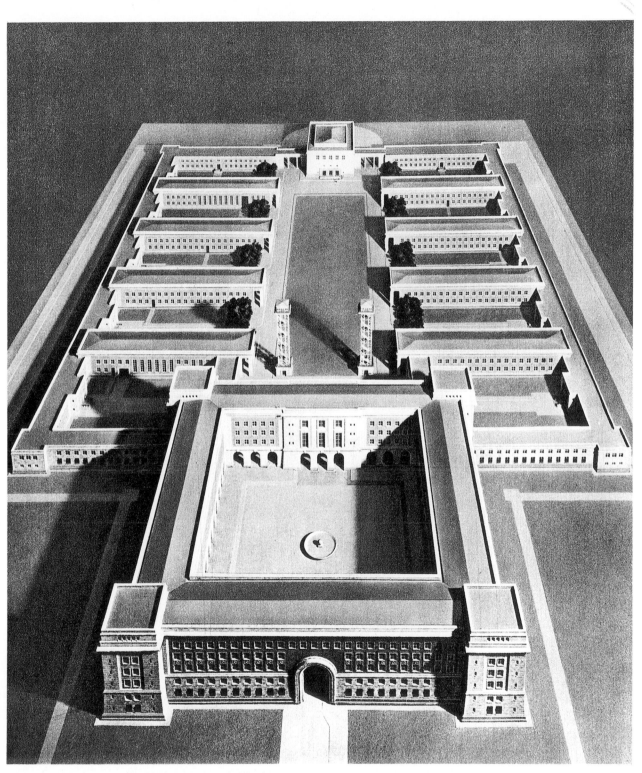

Model for the Institute for War Technology, Technical University, Berlin. Architect: Hans Malwitz

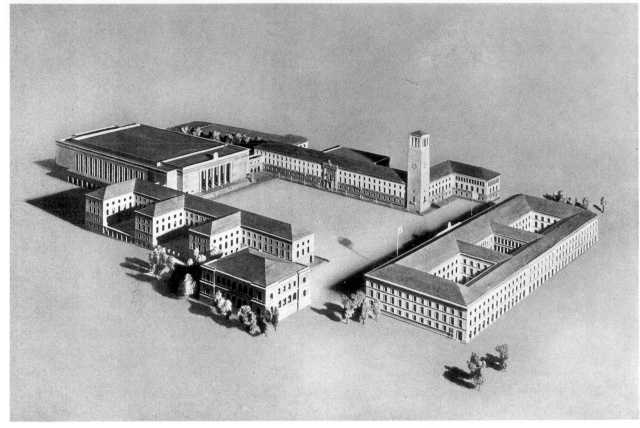

Model for Adolf Hitler Square, Weimar. Architect: Hermann Giesler

were given new attributes: Munich, "the Capital of the Nazi Movement"; Hamburg, "the City of Foreign Trade"; Nuremberg, "the City of the Party Rallies"; and so on.

In order to safeguard architectural unity, Hitler worked with only a handful of architects responsible for entire cities. Giesler looked after Weimar and Augsburg. Linz was entrusted to Roderich Fick. In Dresden, Wilhelm Kreis (1873–1953) worked. "The whole of Germany from the noblest building of faith to the humblest farmhouse will grow together in an orderly unit. A true image of a people united in their ideology and their will to work and to create."[39]

The plans for the new towns were rigidly worked out and could easily be applied to towns of any size. Most were based on the grid system of a cross, with the Party buildings on a central axis. A Party monument, the administration building of the NSDAP, and an assembly square became obligatory for all towns with more than 20,000 inhabitants. This central square was to be open, like a sports arena, not enclosed by houses as in the old towns. The National Socialists fa-

vored large open spaces for their rallies. It is notable that the plans did not include the building of new churches.

National Socialist architecture involved much more than a revival of monumental buildings to celebrate the powerful state. It meant total control of people's lives through architectural structure. Even concentration camps followed a similar architectural scheme, thus giving a Fascist order to cities, villages, and places of terror.

Salzgitter and Wolfsburg were only two of the cities built according to these new architectural principles. They were meant to be prototypes of the new cityscape and to look into the future; they did not have to disguise their economic importance behind quaint vernacular facades.

All over Germany buildings became more and more menacing. The disguised air raid shelters by Friedrich Tamms planned for Berlin in 1942 are only one of the many frightening examples. The Academy of the NSDAP at Chiemsee in Bavaria was never built, but it gives an idea of the architecture to come. Gerdy Troost

wrote, "The Führer forms with these buildings the image of the noblest characteristics of the German community. Architecture becomes the education of the new people." This rigid monumental building was planned by Hermann Giesler. When the model was exhibited in Munich, the papers spoke of "yet another gigantic work of the National Socialist movement. According to the will of the Führer, the exterior of this building will be unique. Its style will reflect its role. Here National Socialist philosophy will be constantly formed and reexamined. This building will guarantee the formation of a new type of German for all times."[40] The vast complex, over 1,600 feet long and over nearly 5,000 feet deep, was supposed to be erected along the banks of a beautiful Bavarian lake. Above a socle would rise four floors with living quarters. A tower 360 feet in diameter and 394 feet in height was to contain the huge communal hall and the reception rooms for the Führer. The building was to have its own radio station and an observatory. The brutality of this architecture has seldom been matched. It inspired fear and fascination at the same time.

The schemes meant to set examples for all major cities of the Reich remained cardboard and wood models, like so many of Hitler's dreams. The general public knew little of these grandiose plans. Just enough was leaked out to kindle the optimism of a people increasingly demoralized by the destruction that surrounded them daily. After Stalingrad, Hitler made few speeches. Gone were the large displays of power. He withdrew into the past. He spent days and nights making plans for Linz. Even before the war he had spoken about his dream of withdrawing from political life and retiring to Linz, the town of his youth. Sometimes he would sketch a large fortified tower in Linz that he wanted to have rebuilt as a youth hostel in memory of his "favorite playground as a poor pupil."

The idea of making Linz the capital of Austria, in an act of revenge against Vienna, had long been a dream of Hitler's. With the annexation of Austria the dream could become reality. If Berlin was to be the capital of the world, Linz was to be his own private capital, the place he wanted to retire to. Linz would become a cultural mecca, an ongoing festival of the arts. Hitler later played down his antagonism toward Vienna, but Linz as the cultural center became his favorite subject. He devised plans for the construction of a large theater, a concert hall devoted to Anton Bruckner, who was, after Wagner, his favorite composer. There would also be a special operetta theater, an opera house with 2,000 seats, and a large Führer Museum—all placed along a grand boulevard. Most of the buildings were to be based on his own sketches.

At a dinner in Berlin on April 28, 1942, in the presence of Speer and Martin Bormann, Hitler spoke about his plans to outshine Budapest and to make Linz the most beautiful town on the Danube. The river was to be built up in "a magnificent fashion," with grandiose buildings and a triumphal arch. On one side there was to be an eighteen-floor hotel, with 2,500 beds reserved for the Strength Through Joy organization. Plans for another "Führer Hotel," in Italian Renaissance style, had been worked out between Hitler and Roderich Fick, down to the minutest detail. Municipal buildings and an Adolf Hitler School in Baroque style were to be built by Hermann Giesler. Guesthouses for the Party and a new town hall with a facade resembling the Vienna Opera House were also planned, as well as a Party house by Fick. On the other side of the river, linked by a suspension bridge, was to be an observatory with a vast cupola, by Wilhelm Kreis, "as a counter to the pseudo-science of the Catholic Church." In it would be represented the three great cosmological conceptions of history—those of Ptolemy, of Copernicus, and of the Austrian engineer Hans Hörbiger. The interior of this edifice was to commemorate the ideas of Troost. There were plans for a district government center, a place of assembly for 100,000 visitors, and a festival hall to hold a mere 35,000. Hitler continued to sketch ad hoc plans for more and more buildings, often switching between architects. Speer and Bieber were asked to submit plans. "Linz cost an awful lot of money," noted Goebbels in his diary May 17, 1941, "but it is so important to the Führer."

Linz was also to have the largest art gallery in the world, the Führer Museum, a pendant to the Uffizi Gallery in Florence. Fick designed the building with a facade by Giesler. A library for it by Leonhard Gall was planned. Originally Hitler had wanted to make this a museum of the nineteenth century. As early as 1925 he had drawn up plans for a gallery with sixty rooms, each filled with the masters of his beloved period. His list included: Anselm Feuerbach, Wilhelm Leibl, and Hans von Marées. Adolph Menzel was to have five rooms for himself, and Arnold Böcklin and Moritz von Schwind three each. An inventory of 1940 lists 334 works of the nineteenth century, all earmarked for Linz. But Hitler changed his mind. In 1939 he had appointed Dr. Hans Posse, who perversely had been

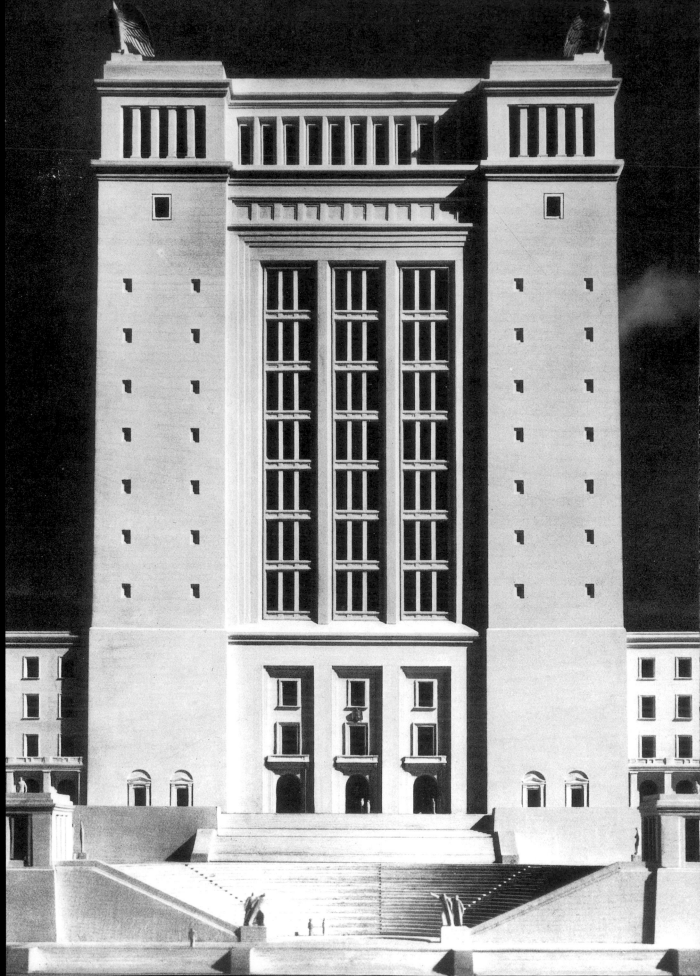

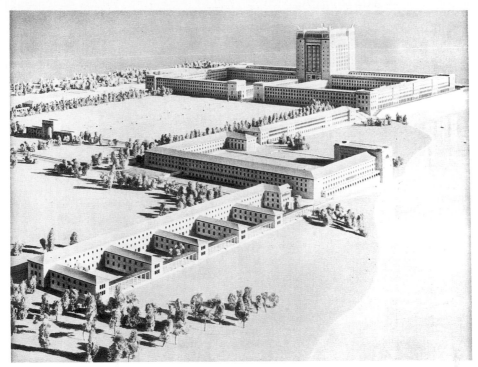

Opposite:
Model for the entrance tower of
the NSDAP Academy, Lake
Chiemsee, Bavaria. Architect:
Hermann Giesler

Above:
Model for the campus of the
NSDAP Academy, Lake
Chiemsee, Bavaria

sacked in 1933 from his post as director of the gallery in Dresden, to look after the contents of the new museum. Posse's task was to buy masterworks of earlier periods in Belgium, Italy, and the Netherlands. Rosenberg in the meantime plundered museums and churches elsewhere in the occupied territories and confiscated artworks from Jewish families, while Himmler's Storm Troopers did the same in churches and monasteries in the East. Entire collections were taken from Jewish families in Austria, Holland, and France—not only paintings but also furniture and silver. Most of it was destined for Linz, some went to other museums or was earmarked for Rosenberg's fantasy: an NSDAP University for Aryan Art.

This is not the place to deal with one of the great art plunders of all time. A few figures suffice. In 1944 Robert Scholz, responsible for the special Rosenberg requisition force, drew up the balance sheet of the acquisitions: from March 1941 to July 1944, twenty-nine transports had brought 137 wagons filled with art into the Reich. This was comprised of 4,174 crates containing 21,903 works. Altogether, 100,000 works of art were taken; 30,000 were rescued by the Allied forces in 1945, but much of it was destroyed.

Art theft on such a scale and sanctioned by Adolf Hitler made a mockery of the motto he had planned to put above the Linz Museum: "To the German people, that which belongs to it."[41]

Dr. Hermann Voss, who had taken over from Posse, continued to buy. Hitler reserved for himself the right to buy from this group and also largely determined the prices. He thus purchased valuable paintings, among them works by Rembrandt, Cranach, Tintoretto, Watteau, van Dyck, Brueghel, and Leonardo da Vinci. In 1943, 881 masterworks were acquired, among them 395 Flemish paintings.

Nearly 7,000 pictures destined for Linz were hidden in the salt mines of Alt Aussee to await the new museum building.

There were other plans for Linz. A new bridge was built across the Danube and finished in 1941; it was to have special bridgeheads by Fritz Tamms.

Hitler's plan had been to transform the town into an international metropolis, with a crypt in which he would be buried.[42] Like plans for the other monuments in Linz, Hitler's plans for this great burial place did not materialize either. His final resting place was among the rubble of the bunker in a hastily dug hole in the ground.

THE ORDER OF THE COMMUNITIES, IN MEDIEVAL TIMES, WAS DETERMINED BY THE NATURAL ORDER OF SOCIETY. TODAY TOO, OUR COMMUNITY DEMANDS A HEALTHY AND ORDERLY ORGANIZATION FOR OUR HOMES. THE NEWLY FOUNDED UNITY IN COMMUNAL LIFE AND COMMUNAL SPACE REFLECTS THE NATIONAL SOCIALIST REVOLUTION. THIS IS THE BASE FOR NEW HOMES AND NOT, AS SO MANY ARCHITECTS STILL BELIEVE, A VARIETY OF AESTHETIC IDEAS. . . . THE GERMAN LAND BELONGS TO THE COMMUNITY. THIS CALLS FOR THE PROTECTION OF THE HEIMAT [HOMELAND]. THE NATIONAL SOCIALIST PHILOSOPHY DEMANDS URBAN PLANNING ALONG THE LINES OF POLITICAL-GEOGRAPHICAL CONSIDERATIONS, AND WITH A FEELING FOR THE LANDSCAPE.

—Der Deutsche Baumeister (The German Master Builder), 1939[1]

CHAPTER 12 THE VERNAC

ULAR STYLE

If monumentalism was the style of official buildings, vernacular was usually used for housing, and for the Party's youth hostels. The folksy, country village style fitted in with the preconceptions about landscape and a feeling for tradition. It also blended with the volkish idea.

The National Socialists had turned against the big cities with their asphalt culture and urban decadence. Big cities were international, sophisticated, open to the world; the places where modern art was made and enjoyed, a disorganized mix of heterogeneous nationalities and races. "Decadent" and "nigger-loving" were Hitler's favorite words to describe Berlin in the twenties. Salvation from the "sinful city" lay in the country with its farmers, its tradition, and its handicrafts. As in paintings, architecture too had to reflect this philosophy. Words like "home," "faith," "nation," and "family" took on magic mystical tones.

Of course the animosity toward towns and the longing for country living were not solely a German phenomenon. Hitler's attack on the big cities echoed

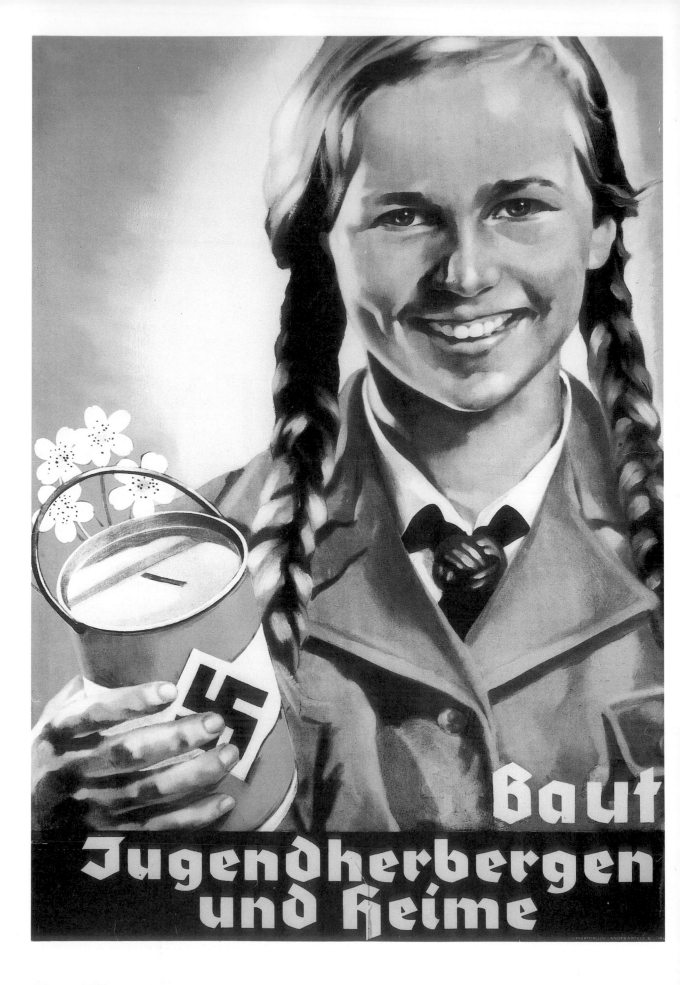

Baut Jugendherbergen und Heime

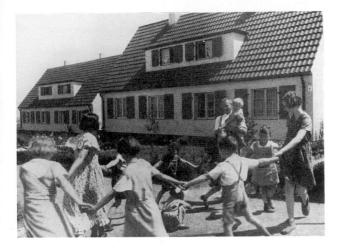

feelings that were widespread in the nineteenth century. The National Socialists ardently promoted the many German writers who previously had celebrated the landscape and country life, including Annette von Droste-Hülshoff, Conrad Ferdinand Meyer, Hermann Löns, and Adalbert Stifter. Their themes were usually a call to return to nature and a rejection of the Industrial Revolution and the spread of urban developments. The National Socialists distorted these feelings into a racially determined theory. The racially pure *Heimat* was celebrated in the Blubo (*Blut und Boden*—blood and soil) literature of R. Marlitt, Hedwig Courths-Mahler, and Kuni Tremel-Eggert. Their veneration of country life was played out against the background of German villages and farmhouses.

Top and center:
Vernacular-style housing developments

Opposite:
"Build Youth Hostels and Camps." Poster

Below:
Camp for Hitler Youth, Melle. Architect: Hanns Dunstmann

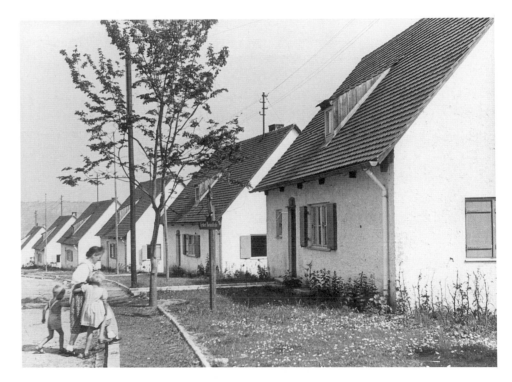

Das Vollbad und das Brausebad

so ist es richtig. Für eine gesunde Lebensführung in modernen Wohnungen müssen beide Badegelegen-

"Bath and shower—yes. Both are a must for a healthy life style in a modern apartment." Advertisement for Junkers's gas water heaters

Housing became a political weapon. Like the other arts, it had to follow a prescribed style. The National Socialists developed the concept of community architecture, an architecture that gave the feeling of belonging. Youth hostels, special training schools, and general housing projects were all to be built in a style promoting the feeling of naturalness and health. One of the leading architects of the new "healthy" settlements was Julius Schulte-Frohlinde. Convinced of the Germans' unerring sense of a healthy, clear German style, he pleaded for the "expansion and preservation of a unified architecture, corresponding to National Socialist ideology."[2] The small house, in particular, was "the seed core for the *Volk*."[3] Special attention was given to old farmhouses. They had to be mirrors of the German character.

Robert Ley, together with the Labor Front and the German Heimatbund (Association of the Native Land), formed the Heimat und Haus (Native Land and Home) Society. It distributed books recommending approved rural styles for villages and houses. Books like *Kraft durch Freude gestaltet das schöne Dorf* (Strength Through Joy Creates the Beautiful Village), by Franz Gutsmiedl, demanded that villages be orderly and beautiful and follow a given pattern. There was to be the village square for meetings and a people's hall instead of the church as the spiritual center. Building new houses in the countryside for the poor, who lived in dingy city courtyards, became a potent propaganda weapon. Propaganda films never ceased to proclaim the new dream world of fields, meadows, and gardens for the working man, "homes for the working man as they had never existed before, with generous and centralized planning everywhere."[4] The new housing developments were mostly an expression of the Reich's hostility to the city, their small homes reflecting a cozy wholesome world. "The German Workers' Front fulfills a building program in line with the will of the Führer. We create homes which are in harmony with the landscape and which are traditional."[5]

Ramersdorf, a *Hitlerdorf* (Hitler village), was opened in 1934 in Bavaria as a model for the new vernacular architecture. It consisted of one hundred fifty single-family houses of unbelievable monotony. Yet the press did not tire of praising this achievement of blood and soil architecture. One hundred fifty villages were built of similar size and layout. The individual home with its little garden was also seen as an invitation to create families and to encourage people to have children. The uniform pattern of this kind of home also helped to

Adolf Reich. All Their
Worldly Goods. *1940*

HOFFART · ZORN · NEID · GEIZ · TRÄGHEIT · UNMÄSSIGKEIT · UNKEUSCHHEIT

Franz Weiss. The Seven
Deadly Sins

Franz Weiss. The Seven Deadly
Sins. *Detail:* Gluttony, *depicting
British Prime Minister Neville
Chamberlain (standing) and
Winston Churchill*

Living room, Führer Building,
Munich. Designers: Leonhard
Gall and Gerdy Troost.

Over the fireplace: The Four
Elements *by Adolf Ziegler*

overcome class differences, and to generate a life in peaceful preindustrial surroundings which would forge people into one loving and faithful family loyal to their Fatherland. Apartments in large residential blocks in the city could not bring that about. Here too the National Socialists found it easy to implement their ideas. Their rejection of the city and love for small towns cashed in on popular attitudes and played on the desire of many to live in their own little house. The detached small home with its own garden was held up as the norm to which most people were encouraged to aspire. In this field, as in so many others, National Socialist ideology revealed itself to be strewn with contradictions. While apparently giving people this independence, it regimented their lives even more intensely.

The Weimar Republic too had had a wide-ranging housing policy. Many settlements, the *Siedlungen*, were financed by the state to alleviate the housing shortage. They often employed famous architects, some of them defenders of the modern movement. The most famous ones were those designed by Le Corbusier in Stuttgart and Bruno Taut in Berlin. Gropius and Mies van der Rohe were also involved in mass housing. They offered the poor and unemployed decent places to live, often in small units, with a small plot of land.

The National Socialists did not reject out of hand all the work that had been done by these pioneers of modern architecture. In 1942 Hitler boasted that as soon as the war was over he would build a million dwellings a year. Standardization of techniques should make it possible to build a house in three months. He was interested in block buildings with a communal garden inside to protect the children from the road. Every house was to have a garage. Hitler was especially interested in standardization of design. In conversation with Bormann he furiously attacked the varieties of electrical currents and the many different designs for washbasins as wasteful: they should be interchangeable, like spare parts for a car. Despite this modern outlook, the findings of the modernists were replaced everywhere by a cult of folksy buildings with thatched roofs, oak beams, and wooden balconies. It was a style borrowed from the vernacular architecture of southern Germany, a revamped and comforting pastiche of the past—a style that appealed to the taste of many of the leaders.

The use of local craftsmanship helped to save on more costly materials such as steel and concrete, which were needed for building motorways. Natural materials were also seen as effective camouflage during air raids. A gabled roof and a home crafted along the lines of the old handicraft traditions gave people a sense of security. Organizations like the Kampfbund für Deutsche Kultur had exploited these feelings years before Hitler came to power. Under the National Socialists the pitched roof and shutters became powerful symbols and were used for their specialized propaganda value.[6]

The houses in this *Heimatschutzstil* (literally, the style for the preservation of the homeland) were praised as "functional and beautiful."[7] "Functional," "simple," "beautiful" became the key words for the style of public buildings forever repeated and elaborated. "Here, too, the principle of honesty has won the battle . . . this distinguishes new houses from those of the turn of the century and from the 'Sachlichkeit' of the postwar years. They are, in their architectural laws, the expression of our feelings for life."[8]

The mass media continually depicted the whole of Germany as a huge building site. Actually, from 1935 onward Hitler lost almost all interest in mass housing, leaving it increasingly to private enterprise, while he concentrated on the construction of his monumental schemes. The result was a rapid decline in the number of dwellings built, fewer than under the Weimar Republic. Hitler's plan for standardized dwellings with large kitchens and bathrooms remained on the drawing board. The war stopped all plans for building domestic housing. Even Goebbels began to express doubts about the money spent to realize Hitler's monumental sites for Berlin and the lack of apartments for the working classes in that city.

The many Hitler youth hostels were also built in the same traditional style, many with thatched roofs. The manual for the Hitler Youth proclaimed:

The gable is a natural, practical, and important element of German architecture. It gives the feeling of homeyness especially in the country. . . . For the Hitler Youth Hostels the following guidelines should be observed: If the groundplan is simple and clear, the roof should be the same. . . . A Hitler Youth Hostel must not show off with an artificial and extravagant roof. We want harmony with the landscape. If the village has long simple roofs, the Hitler Youth Hostel must not stick out like a horrible café; it must blend. . . . The flat roof is necessary in only very few cases, for instance, in very large buildings for festive assemblies. But in our villages Hitler Youth Hostels must not be built with flat roofs in order to attract attention or to appear modern.[9]

They were not just places for shelter for the hiking youth; they were places to teach the new political

Model dining room. "First International Crafts Exhibition," Berlin, 1938

thoughts and to educate the young people in the new mental hygiene. It was planned to build at least three hostels in all cities with more than twenty thousand inhabitants. In layout and decoration they had to be "clear, simple, and solid." The message was obvious. They too had to reflect German values.

There were special holiday homes and Strength Through Beauty ships for the working population. The "Beauty of Work" office was also busy in this area. Under the headline "Healthy Life, Happy Working," they created community halls and friendship houses for the workers to meet in after work. Factories were ordered to build special leisure centers for the work force. The aim was not only to create places of relaxation and leisure, but also to indoctrinate the workers and fuse them together into a willing group of compatriots. Individual holidays were not encouraged. The structures made use of traditional building materials and evoked traditional styles. It was all part of the total reshaping of people's lives.

Along with the rejection of modern architecture came a rejection of the corresponding furniture. John Ruskin's and William Morris's calls for natural material, which was eagerly taken up by the Deutsche Werkbund and the Wiener Werkstätte at the turn of the century, were also taken up by the National Socialists and ex-

aggerated. Designs for the interiors were also meant to blend with the vernacular style. Country furniture was copied. Medieval and Renaissance motifs flourished. Wood replaced the more streamlined chrome and steel. For the private home the regime recommended simple functional designs in good solid wood like pine or oak—preferably German. Wrought-iron for lamps and doors continued the handicraft tradition. There was no room for the ornaments of the nineteenth century. Things had to be timeless, not dictated by a fleeting fashion.

The act of making things was seen as an act of cleansing the material world. The same words that were hurled against creators of modern art were now used to attack modern design. It was "playful, decadent, against natural material. It had torn the threads that linked us with the mysterious and alive world of raw material," wrote Dr. Wilhelm Rüdiger on the opening of the "Second German Architecture and Craft Exhibition." Now every spoon, chair, or table had to reflect "the newly cleansed feeling for life, free of junk." The new German craft had to be linked to the German race, not associated with foreign or Jewish blood.

The common word for applied art was *Kunstgewerbe*, *Gewerbe* meaning craft as well as commerce. This was

now replaced by the word *Kunsthandwerk*, a combination of the word for art with the word for handicraft. "In the word *Gewerbe* rings the selling of art and the desire to make money with it. In the word *Handwerk* rings the making of things, the pious reflection during the process of working and creating."

This was a direct attack on the functionalism of the "Oriental" Bauhaus modernists, with their love for steel and modern man-made materials. Le Corbusier's idea of the house as a *"machine à habiter"* was anathema to the apostles of the rustic style. The making of things, like the act of creation, took on mystical overtones. The working process with materials that were "given by nature" and "grown in nature" was more important than the actual object. The made object became "a piece of nature, a bridge to the elementary world of creation itself."[10]

Everything, even the most modern tools and pieces of furniture, had to be "transformed nature." The making of things was seen as a mission. The transformation of nature meant conquest. The very act

of making a chair or a table preserved nature and made it visible, gave it a voice. The act of creation gave the prime materials—iron, clay, wood—a "soul."

The decor of official buildings was very different from that of the simple rusticity preached for youth hostels and workers' homes. Much of the so-called representative furniture was based on Hitler's own designs. But most of all it was the influence of Troost's widow, Gerdy, and his partner, Leonhard Gall, that determined the interiors of the official buildings. Massive oak furniture, huge sofas, paneled ceilings and walls mirrored again the feudal tendencies of the rising clique. It was the look of hotel lobby design, with the emphasis on comfort.

The desire for opulence and a regal effect found its culmination in the jewel-studded trophies and cases for the Nazi insignia.

Love for the country style was not confined to the populace; the leadership too built themselves country houses in the popular and rustic style of southern Germany. Hitler had acquired a small country house in the

Rendering of furniture for the Chancellery, Berlin

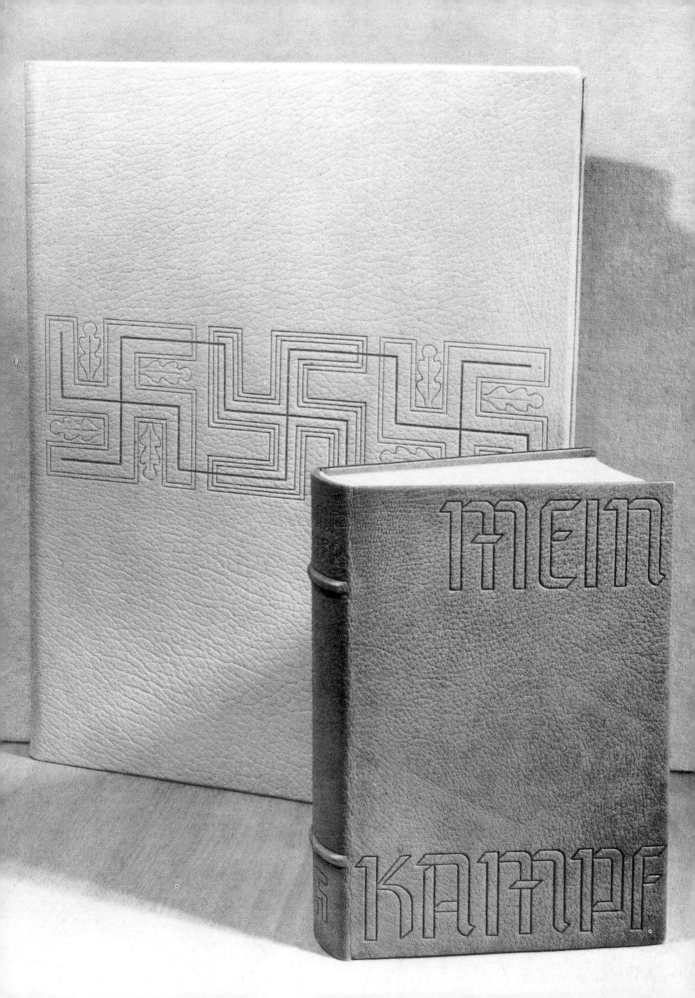

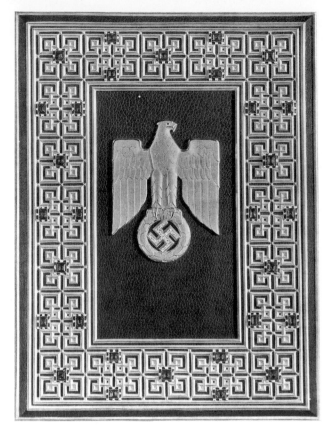

Case for citation of military
decoration. Blue pigskin with
topazes and diamonds, set in gold

Trophy for the Kiel Regatta, 1935.
Designer: Richard Klein

Pigskin book binding with gold and
brass ornamentation. Designer:
Otto Dorfner

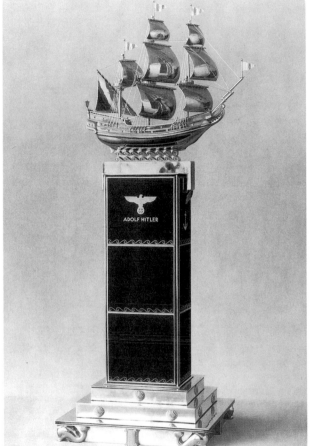

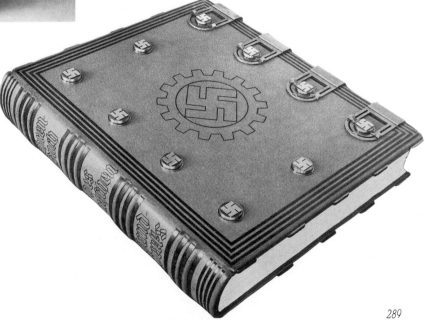

Pigskin binding for Hitler's Mein
Kampf *and a document folder*

Bavarian mountains, of which he was extremely fond. Here he would retire and be seen walking in leather shorts. Hitler's link with the Obersalzberg dated from the early time of the National Socialists' struggle for power. It was the journalist Dietrich Eckart who had then introduced Hitler to this area. Many of his projects were conceived here, many plans ripened here. It became Hitler's favorite place. He had become enchanted with the landscape. So it came as no surprise when he decided to build a house here for himself and his closest friends and allies. In Berchtesgaden, a small town on the German-Austrian border, a huge piece of land was reserved for the country houses of the Party leadership. The Obersalzberg was really the idea of Martin Bormann, Hitler's secretary and confidant. Despite the protest of the local residents, he had pulled down several old farmhouses and chapels to create a private enclave. The architect Roderich Fick designed most of the buildings in this Bavarian mountain resort. Bormann, Speer, and Göring also had country houses here. Most of them were linked by underground tunnels. A private road, several miles long, was cut into the mountain, guaranteeing privacy and protection in case of an attack.

Besides the four country houses there were barracks, a hotel for Hitler's guests, and a large housing complex for the employees. Thousands of workers toiled day and night on floodlit sites. The cost was tremendous,

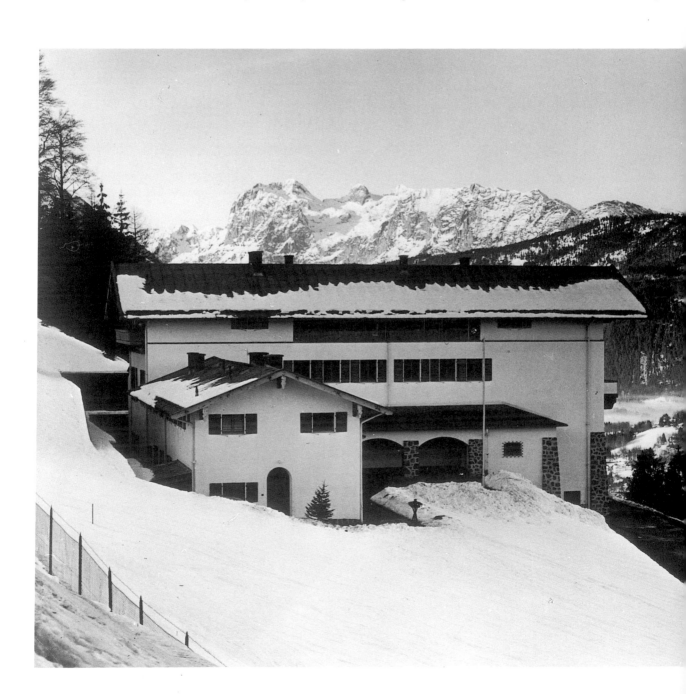

especially for the large road leading to Hitler's mountain. The road was open only to a few privileged people. In 1935 he decided to enlarge his modest house into a more impressive dwelling. Borrowing a drawing board and some architectural tools from Speer, he began to design his own home. The Berghof, as it was called, became his country residence, where he lived with Eva Braun and entertained his close friends. A luxurious chalet, it could be the setting for the reception of a few foreign dignitaries on a more intimate scale than was possible in the Berlin Chancellery. The result was not, as he hoped, a stroke of genius, but a rather clumsy blown-up version of his small cottage. Hitler's pride was another display of quaint giganticism: the largest window in the world, capable of being raised and lowered like a portcullis, from which he looked at "his mountains."

Speer described the interior thus: "The furniture was bogus old-German peasant style and gave the house a comfortable petit-bourgeois look. A brass canary cage, a cactus, and a rubber plant intensified this impression. There were swastikas on knickknacks and pillows embroidered by admiring women, combined with, say, a rising sun or a vow of 'eternal loyalty.'"[11]

It was the embodiment of much of their architecture, pompous, *spiessig* (petit bourgeois), and pretentious. Speer went on: "The Troost studio had furnished the salon sparsely, but with oversize furniture: a sideboard

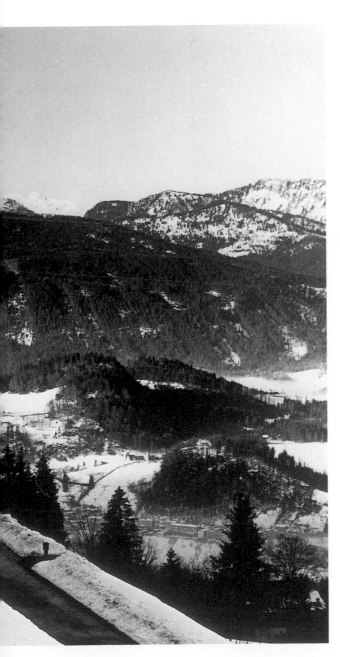

Berghof, Obersalzberg. Photograph Heinrich Hoffmann

over ten feet high and eighteen feet long which housed phonograph records along with various certificates of honorary citizenship awarded to Hitler; a monumental classicist china closet; a massive clock crowned by a fierce bronze eagle. In front of the large picture window stood a table twenty feet long. . . . There were two sitting areas: one a sunken nook . . . with the red upholstered chairs grouped around a fireplace; the other, near the window, dominated by a round table whose fine veneer was protected by a glass top. . . . Beyond this sitting area was the movie projection cabinet, its opening concealed by a tapes-

all aped the style and manners of the upper-middle-class bourgeoisie of the turn of the century. Mercedes-Benz cars and home movies completed the trappings of the parvenu ambience.

On the summit of Kehlstein, the peak which dominated the area, Hitler built himself a teahouse at a height of 6,500 feet. Nicknamed "the Eagle's Nest," it was a private retreat. This remains today, a low fortress-like building of massive stone. To reach the Eagle's Nest, the visitor had to walk through an arched tunnel built into the mountain. At its end was a domed rock hall. A gleaming polished elevator, of mir-

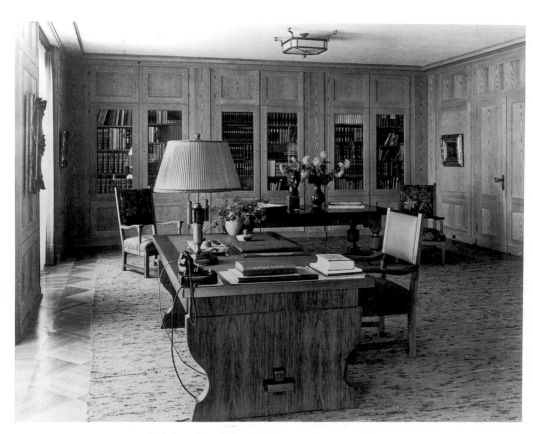

Hitler's study in the Berghof. Photograph Heinrich Hoffmann

try. Along the opposite wall stood a massive chest . . . adorned by a large bronze bust of Richard Wagner by Arno Breker. Above this hung another tapestry which concealed the movie screen."[12]

In the richly refurbished interior hung some of Hitler's favorite paintings of the Viennese school, Anselm Feuerbach's *Nana*; a Carl Spitzweg, *On the Road*, with a label: "A present from the Hitler Youth," purchased by Baldur von Schirach; an altar painting by Edward Steinle, a reclining nude by Titian, and a nude by Paris Bordone. The old German oak furniture, the heavy oriental carpets, the tapestries, the paintings—

ror and brass, whose luxury stood in total contrast to the rustic architecture, transported the visitor almost 500 feet up onto the edge of the mountain. Here he would have had the feeling of coming into the presence of the leader of the world, a man above the rest.

By 1937 Hitler had begun his descent into isolation. He avoided personal contacts. The public image of the man—embracing children, talking to young people in a friendly and relaxed way—did not correspond to the reality. In this mountain retreat Hitler wrote his major speeches, often withdrawing for several weeks while doing so. The home movies of Eva Braun show him re-

laxing with a small coterie of Party friends and their wives. From time to time he allowed thousands of adoring visitors to see him, but most of the time he remained there with a few friends. The routine of the day was always the same; the friends hardly varied.

Albert Speer described a typical day, an account that sheds much light on the quality of life of a group of people who had set themselves up as the arbiters of a new culture, taste, and art:

Hitler usually appeared in the lower rooms late in the morning, around eleven o'clock. He then went through the press summaries, received several reports from Bormann, and made his

less monologues. The subjects were mostly familiar to the company, who therefore listened absently, though pretending attention. Occasionally Hitler himself fell asleep over one of his monologues. . . . Later the company met again for supper, with repetition of the afternoon ritual. Afterward, Hitler went into the salon, again followed by the still unchanged company.[13]

There they usually saw a film, usually a standard work of German light entertainment, often a love story. Hitler was particularly fond of operettas. Later the film shows were replaced by sessions of listening to records. But here too the choice was rather limited. Never Baroque or chamber music, or any symphonic

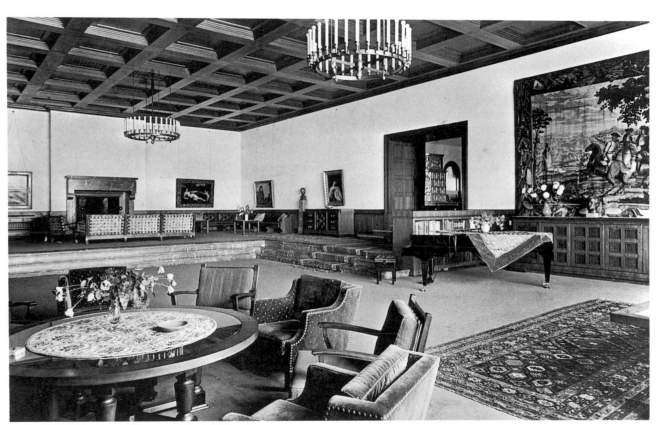

View into the great hall in the Berghof. Photograph Heinrich Hoffmann

first decisions. The day actually began with a prolonged afternoon dinner. The guests assembled in the anteroom. Hitler chose the lady he would take in to dinner, while Bormann, from about 1938 on, had the privilege of escorting Eva Braun to the table; she usually sat on Hitler's left. . . . The china was a simple white; the silver bore Hitler's monogram. . . . The food was simple and substantial: soup, a meat course, dessert, with either Fachinger mineral water or wine. The waiters, in white vests and black trousers, were members of the SS bodyguard. Some twenty persons sat at the long table. . . . Hitler sat in the middle, facing the window. He talked with the person opposite him, who was different every day, or with the ladies to either side of him. Shortly after dinner the walk to the teahouse began. . . . Here, at the coffee table, Hitler was particularly fond of drifting into end-

works. Hitler was interested only in bravura selections from the operas of Richard Wagner.

In reading descriptions of these barren evenings within the top circles and Hitler's published lunch and dinner conversations, one begins to understand the narrow and philistine attitude of the leadership to the arts. Like the master, Hitler's entourage was without any international or cosmopolitan experience. Most of them were provincial. Few had ever crossed the German borders, except to conquer. They had very little higher education. Among the fifty or so Party leaders, only ten had been to college.

Göring's residence, Karinhall

The great hall, Karinhall.
Photograph Heinrich Hoffmann

Göring also had a luxurious hunting lodge, Karinhall in Prussia, fifty miles from the capital, Berlin. It was a suitable retreat for the commander of the Luftwaffe and minister of Hunting and Forestry. Karinhall (named after Göring's wife) was also used as a private guest house for the National Socialist elite. It too was built in the quaint rustic style.

The architect Werner March has been commissioned to build a hunting lodge for . . . Hermann Göring. A complex task. The pure wooden building reflects the client's link with the Nordic landscape. Everywhere signs of beautiful and healthy handicraft. Indigenous pine wood. Bamboo and the color of the landscapes are in the traditional way of building. Local craftsmen made the furniture, using their own ideas and skill. The result is a harmonious ensemble with the forest, the lake, and a universally understood language of material. The humane way to build. . . . Inside is a large German hall with a fireplace as the focal point. Also a dining room, a library, two guestrooms, and the servants' rooms. They form the simple arrangement. . . . The building reflects the austere landscape, a test for the value of this indigenous architecture.[14]

*Interior court, Karinhall.
Photograph Heinrich Hoffmann*

It is ironical that Göring kept his art loot in this quaint decor. Karinhall housed the work of many so-called degenerate artists—among them, Marc, Gauguin, Munch—which Göring had confiscated. During the invasion of Poland, he amassed antique furniture and carpets. From Poland he brought back thirty Dürer drawings as a present for his Führer. In France, he personally combed the Louvre for suitable works of art. He loved art so much that in 1945 he offered to blow up Karinhall in order to prevent it falling into the hands of the Allied troops. The collection was worth an estimated 500 million Reichsmarks.

With its overhanging thatched roofs and solid walls, timber pillars, and wrought-iron fixtures, Karinhall was the foremost example of a rustic "Volkish style," which flourished in the many youth hostels and special training schools.

The most exotic flowering of National Socialist thought expressed through architecture were the Thing places and the Ordensburgen. Hitler's Ordensburgen (Order Castles) were a strange mixture of styles echoing medieval fortresses and Tudor castles. Built in a remote area on a hill overlooking the landscape, they dominate the land like the castles of medieval knights. The Order Castles became the homes of the Adolf Hitler Schools, elite institutions for the racially pure. A selected group of young men were to be educated there in the virtues of obedience, loyalty, honesty, strength, and fearlessness. There was no reference to a specific moral cause. It was Nietzsche's idea of the "blond beast." In the name of virtue it prepared young men for a mission which ended with them walking over corpses.

Originally planned to turn out a technically and ideologically trained elite, the schools fostered a closely knit community life. "The Party forms the human being, leads him back to its true nature. . . . A celebration of the NSDAP or a visit of the Führer to one of the Ordensburgen is such a gigantic and overwhelming event that architecture must try to be the worthy framework for such occasions of the declaration of faith."[15] The architecture reflected the schools' crusade-like mission.

Hermann Giesler was commissioned to build Ordensburg Sonthofen in Bavaria. In his opening speech to the 1938 meeting of the architects' chamber, as reported by the press, Giesler underlined that

architecture has to be based on the [prevailing] philosophy of life. He compared buildings based on the egocentric, Christian philosophy with those of the Renaissance, with its idea of humanism. . . . Only the artists who belong to that community, e.g., National Socialist artists, can fulfill the Führer's ideas. The totality

of the style has won the day. . . . The main task of the new architecture does not lie in the building of facades but in the ground plan. It is here that gigantic problems of a philosophical nature are to be solved. . . . The pledge is for a monumentalism to which the Führer leads us.[16]

Sonthofen is a mixture of vernacular style and monumentalism, a reflection of the two ideas that Hitler wanted to instill, especially in the youth—power and love of nature. The architecture of these political training schools, like their inhabitants, was earthy, serious, masculine, expressive of stately power through massive construction that stressed horizontal lines with long wings and colonnades. A massive stone tower had no other function than to symbolize power. Everything became imitation in this rigid and imposing

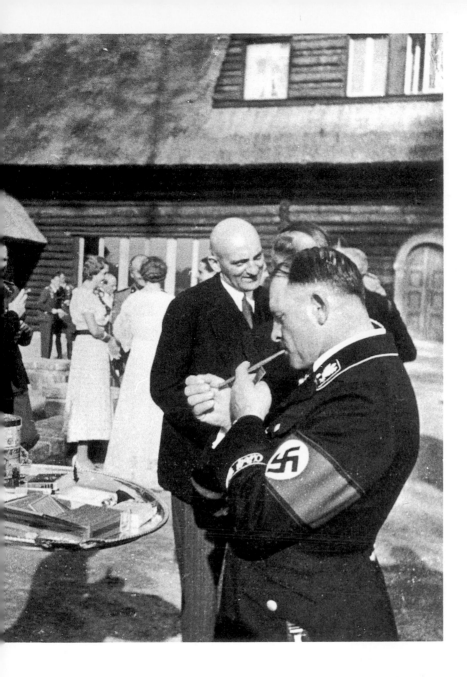

architecture, aping past centuries, pretending to be eternal fortresses against time and attack. Gigantic in proportion, brutal in their materials, these buildings showed off the ideology of the Reich. Its military style was the self-assertion of the *Volk.*

The Ordensburgen, like most youth hostels, had vast assembly rooms adorned with the insignia of the Party. The head of the office of Visual Art in the Propaganda Office of the Party declared:

Painting and sculpture belong to our idea of a festive assembly room. . . . There better than anywhere else they can speak about our present life, there they fulfill their greatest service. From celebration to celebration a unified community watches with heightened senses these pictorial representations of our philosophy. Never before has painting had such a great task and

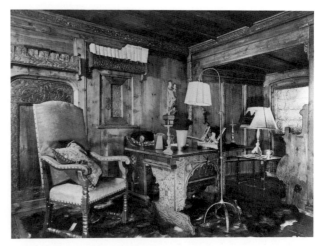

Gothic study, Karinhall. Photograph
Heinrich Hoffmann

Ordensburg Sonthofen, Bavaria.
Architect: Hermann Giesler

*responsibility in the political life of a people. . . . The clarity of
the architecture of those assembly rooms demands pictures of ec-
static liveliness and the monumentality of healthy bodies. . . . On
these walls a new ideal of beauty can take shape. Only those art-
ists who recognize and master the human body, those who have
exercised it, are able to create healthy bodies. A pale imbecile is
incapable of creating symbols of radiant beauty and magnificent
strength. Only those who live between the light sunrise and the
dusky evening, whose hands have been steeled in hard work,
whose heads are clear, whose eyes are deep from the nights of
waking, have a right to create for these assembly rooms.[17]*

The German decor with echoes of the past, the ritual
of the events, all helped to forge a feeling of commu-
nity and to extinguish any feeling of the individual
who might doubt, question, or even rebel. The Party
looked after you.

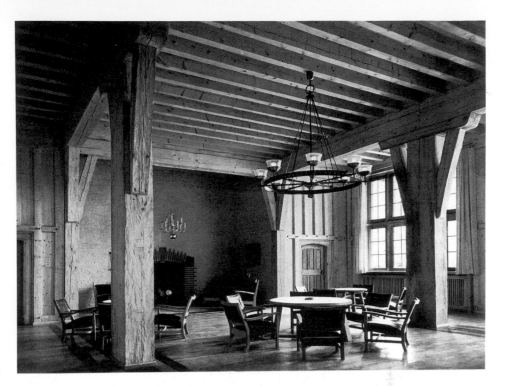

Assembly hall,
Ordensburg Sonthofen

Two other Ordensburgen were built in Vogelsang, in the Eifel, and in Crössinsee, in Pomerania, the eastern part of Germany.

The Ordensburg Vogelsang was designed by Clemens Klotz. A solitary tower rises above a long four-story-high stone building. An inscription reads: "You are the nation's torchbearers, you are the light of the spirit— forward into battle." There was a ceremonial hall, a hall of honor, and a community building. The parade ground, called "the Place of Solstice," was decorated with Karl Albiker's giant nudes. In the Eagle's Court-yard stood a large stone eagle by Willy Meller. Some of the extensive buildings were never finished.

The Ordensburg in Crössinsee was a complex of rustic stone buildings with thatched roofs. And there were all the other paraphernalia of Nazi symbolism— the braziers, the carved eagles.

Few Germans ever saw the Ordensburgen but they were widely featured in photographs and literature. Sonthofen, Vogelsang, and the Falkenburg in

Parlor, Ordensburg Sonthofen

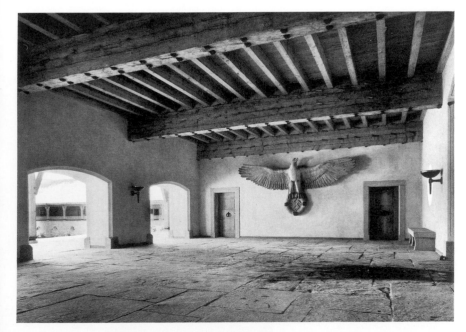

Willy Meller. Torch Bearer.
Ordensburg Vogelsang

IHR SEID DIE
FACKELTRÄGER
DER NATION
IHR TRAGT DAS
LICHT DES GEISTES
VORAN IM KAMPFE
FÜR ADOLF HITLER

Eagle Court, Ordensburg
Vogelsang, Eifel. Architect:
Clemens Klotz

Crössinsee were only the beginning of a program of many elite schools to come. Hitler asked Robert Ley to continue to build fortresses in which he could form a hard group of fearless young men, brought up in the chilling system of what he called an elite education:

When these boys have joined the organization at the age of ten, they will experience—for the first time—a breath of fresh air (e.g., authority and obedience). Afterward, four years later, they will join the Hitler Youth movement. We will keep them there for a further four years. Then we will not hand them back to those who produced the old class system, we take them immediately into the Party, into the Labor Front, the SA, or the SS. And after two years there they will be put into the Reich Workers' Service, for a six- to twelve-month stint under the symbol of the "German spade." Then the army will drill them for two years. And when they return we take them immediately again into the SA, the SS, etc.[18]

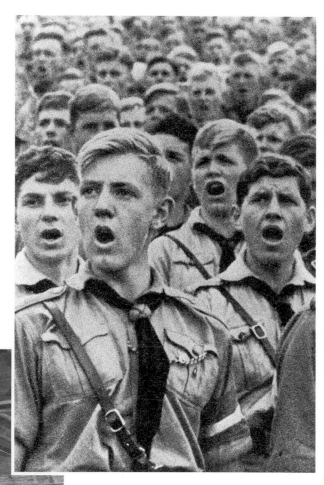

Hitler Youth

Dining room,
Ordensburg Crössinsee.
Architect: Hermann Giesler

CHAPTER 13 THE FALSE DAWN OF A NEW ART

The National Socialist movement and its philosophy did not set off a revolution that started at a given moment. It was the bitter consequence of a cultural and sociological development that began long before Hitler came to power, and nowhere is this more evident than in the arts. We cannot isolate the twelve years of National Socialist rule from the history of our century; in the same way we cannot treat the art created between 1933 and 1945 in isolation. Most of the ideas expressed in National Socialist cultural politics had established roots long before 1933. Despite the narrowing of minds that followed the elimination of the avant-garde, Hitler's election did not represent a new departure.

It is widely assumed that the National Socialists invented a style and an art unmistakably their own. But they did not. They borrowed freely from all possible sources. Very little was produced as a result of personal discovery. Most of it was hijacked from a carefully restricted store of art history, and it brought illusion to millions who enjoyed the deliberate stage management of so much evil.

Hitler never tired of proclaiming that Germany was at the threshold of a new Renaissance. Yet the Nazis did not break new ground except in their cruelty and disregard for everything human. There was no "powerful beginning." As in the other arts—literature, theater, film, music—most paintings, sculpture, and architecture the Third Reich produced was of pitiful mediocrity. Hitler had turned the clocks back. The cultural motivation of the masses did not produce new talent. Every utterance, every article, every catalogue tells the same story. It was a period in which, with very few exceptions, only the second- and third-rate flowered.

How are we to judge this art? The eye of the art historian is not enough. Our emotional response to the art produced under Hitler is overshadowed by history; this makes it impossible to divorce aesthetics from their political context. Today, with all the knowledge we have of the horror of the Third Reich, it is impossible to look at these pictures without remembering

their actual function. Which is ironically what the Nazis intended. Our suspicion that a wicked regime produces only inferior art is legitimate and widespread. There is evidence for this when faced with the overwhelming mediocrity of the artwork which was exhibited.

The corruption of the artists had much to do with the publicness of their art. The official support system did remove the artist from the necessary abrasiveness, the rough and tumble. As a result the creative impulse was sadly lacking. What was missing was a driving force, the energy which could only come from conflict, and from a burning desire to break with old habits. There was no artist who was encouraged to stir up "minds and hearts," as Goebbels and Hitler had vowed to do. Artists were called upon to celebrate something which did not exist: a thousand-year Reich.

There was no development during these twelve years either, just endless repetitive displays so that in the end the boredom became palpable. The emphasis on technical proficiency and the minute execution of detail was meant to guarantee eternal value and authenticity, but it led in most cases to monotonous routine. Out of the bombastic proclamations, German artists made works which supported a megalomaniac ordinariness. With the exception of the writers Ernst Junger and Gottfried Benn, there were no figures who retained an international stature.

The people who left were the people of ideas. Although not all were brilliant practitioners of the arts, they were exceptional in what they stood for. Real art was made outside of Germany by those Germans who bravely had turned their backs on a regime which betrayed humanity and civilization.

In this climate the choice between traditional or modern art became a political one. On a political level the controversy between realism and abstraction lasted well into the postwar years. However, the idea that abstract art stood for progress and representational art for conservatism is as misleading as the idea that the artist's preference for one or the other implied an act of political allegiance. The polarization of these two categories of artistic debate is too simplistic and can-

not be used to explain Fascist art. The dictum of the art historian Will Grohmann, who said that "after Auschwitz the painting of the human body is no longer possible," is a moving declaration of faith, but wrong because it questions the moral attitude of the figurative painter.

The advent of postmodernism has led several people to give some credibility to the architecture of the Third Reich and assign it some merit. While the construction of the motorways and some buildings does demand a certain respect, architecture in general betrays the same lack of creative invention as the other arts. The buildings represented absolute authority. They were meant to secure Hitler's power for all time. As a vehicle for self-assertion, National Socialist architecture was mostly an instrument of self-glorification. By denying any real pluralism and censoring any real exploration, the leaders ensured that everything would conform to old-fashioned ideas. Very little built during the Hitler years had any feeling of joy or spontaneity. As in the visual arts, there was no humor, no irony. Most of the architecture was blank and orderly, standing like obedient soldiers whose role was to impress and to intimidate. It expressed the permanence of power over people. Man was crushed by its monumentality and reduced to an insignificant prop.

Many people have tried to define what is specifically Fascistic about Hitler's buildings. Does not the same question arise about the Capitol in Washington or some similar Neoclassic buildings? Is the Reich Chancellery more authoritative than the Capitol? Is one monumental and the other merely colossal? Here too, as in the other arts, aesthetic questions are not enough. It cannot be seen simply as a more brutal or larger variation of Neoclassicism. The question of what is Fascistic about the architecture of the Third Reich can be answered only by looking at the political philosophy which brought it about.

What is frightening about all these works of art is not so much what was Fascist about them, but what was normal, a normality which pleased so many. Looking at the mediocre and undemanding art on offer, one

can but wonder if the popularity of the regime was based on the fact that it provided a mass art which corresponded to what most people liked, a pleasant, reassuring art free of anything esoteric or disturbing, art which gave answers and did not ask questions. Art as the affirmation of a better world has always had its supporters. New art always meant uncertainty, a questioning of the status quo. There is no doubt that the masses and the National Socialist leadership had the same taste. The Führer and his people liked the same art. Many saw in this the justification of the Party's cultural politics. It led to a collective regression. National Socialist paintings, sculptures, and architecture were popular because they seemed to express what most people expected from art. "They were," as the critic Adolf Dresen stated in 1938, "pictures which came nearest to a 'weltanschauliche Sehnsucht,'" a metaphysical longing.

The aversion to modern art and architecture felt by many people was, and still is, a universal phenomenon. The petit-bourgeois world saw beauty and truth as a protection or a shield behind which they could shelter. It was this attitude which favored a strong authoritarian state instead of a liberal one, an attitude which defended traditional values and set moral and aesthetic standards. A world for the philistine who rejected any radical change. And it produced an art at the service of popular opinions, an art that was morally clean and sensible, something for the man in the street. It is this self-satisfied attitude, this sheltering from reality, that paved the way for Fascism and made it possible. "We don't want in art anything which does not exist in life," Goebbels had claimed. But when he said "life," he meant only what the National Socialists considered to be "life." There was no room for real life, only the manipulated and fabricated lie which they considered life—a life of healthy bodies. It was this lack of imagination, and unwillingness to acknowledge the evil and destructiveness that exist in life, which lay at the root of what was to follow.

More than just cities have been destroyed—a whole intellectual era and many concepts, like conservatism and idealized Fatherland and military honor, have been destroyed as well and changed forever, and with it a whole intellectual tradition.

Was National Socialism a typical German phenomenon growing out of a special German mentality prone to love authority and arrogantly seeing itself above the rest of the civilized world? For fifty years people have been trying to answer this question. Certainly Fascism was more radical in Germany than in other countries, and more absolute. Italy and Spain did not persecute their artists the way Germany did. But no rational explanation is possible for the fall of an entire nation. Economic crisis, inflation, the Versailles Treaty, middle-class fear—nothing suffices to explain why so many succumbed to the fascination of Fascism in Germany. Even less so can human beings grasp or explain or understand Auschwitz. Golo Mann spoke about "the raging water which engulfed everything," as if National Socialism was a kind of natural catastrophe. Theodor Adorno's studies on the authoritarian society, Marcuse's essays on culture and society and *Eros and Civilization*, as well as Wilhelm Reich's *The Mass Psychology of Fascism* have all tried to explain the Hitler phenomenon. The question still remains: How was Auschwitz possible?

It is not a question of who was a member of the Party or who knew what. It has been proved that most people did not know anything about the atrocities of the camps, a damning fact which is made up of lies, political blindness, and human indifference. Even if the phenomenon of National Socialism cannot be fully grasped, the civilized world must never cease to ask what kind of people and what kind of society made the horrors possible. We must never forget that the people who went along with this kind of middle-of-the-road art at the same time went along with the *Weltanschauung* which—known or unknown to them—led to mass murder. As the ultimate verdict stands the irrefutable fact that the philosophy of one man, and the willingness of almost an entire people to follow him, led to the death of fifty-five million human beings of many races, colors, and nations.

APPENDIXES

CHRONOLOGY OF ADOLF HITLER'S LIFE BEFORE THE CHANCELLORSHIP

April 20, 1889	Hitler is born in Braunau, Austria
1900	He enters high school in Linz, Austria
1909	He goes to Vienna
1913	He goes to Munich
1914	He joins the German Army
1918	He returns to Munich
1919	He joins the German Workers' Party
1920	Hitler becomes propaganda chief of the Party and makes his first major public speech in the Hofbräuhaus in Munich
February 1920	The National Socialist German Workers' Party (NSDAP) is founded Hitler designs the National Socialist flag with a swastika Party acquires a failing anti-Semitic newspaper, the *Völkischer Beobachter*
1921	Rudolf Hess and Hermann Göring join the Party The German Workers' Party becomes the National Socialist Workers' Party
November 1923	The abortive NSDAP putsch takes place in Munich
February 1924	Hitler is convicted of treason and sentenced to 5 years' imprisonment in the fortress of Landsberg National Socialist Workers' Party and newspaper banned Hitler writes *Mein Kampf* (first volume published 1925)
December 1924	Hitler is released from prison
1925	Joseph Goebbels joins the Party The *Völkischer Beobachter* resumes publication with an editorial by Hitler: "A New Beginning" By year's end the Party has 27,000 members Hitler renounces his Austrian citizenship
1926-29	Hitler organizes the Hitler Youth Group, forms the SA and SS, and establishes special groups for women and artists within the Party Party headquarters are set up in the Braunes Haus in Munich Hitler's royalties from *Mein Kampf* enable him to buy a villa at Obersalzburg Party membership now 49,000
1927	Hitler writes the second volume of *Mein Kampf* in Berchtesgaden He is permitted to speak in public again Party membership now 72,000 The first Party rally is held in Nuremberg
1928	Party membership now 108,000
1929	Party Membership now 178,000
1930	Party membership now 810,000 107 delegates elected to the Reichstag
1931	President von Hindenburg receives Hitler for the first time
1932	Hitler runs for president: 11 million vote for him; 18.5 million for Hindenburg 230 National Socialists are elected to Reichstag; opposition to Hitler is divided: conservatives and Social Democrats fight each other
January 30, 1933	Hindenburg appoints Hitler Reich Chancellor

THE CULTURAL CHAMBERS

The Chamber for the Visual Arts includes the following areas of activities:

1. The creation of culture: architects, landscape architects, painters, designers, sculptors, graphic artists, decorative arts craftsmen, decorators
2. Reproduction, preservation, and care of culture: copiers and restorers
3. Spiritual and technical dissemination of culture: art and antique dealers, art publishers (books and printing), advertising, art associations, decorative arts associations, the Lutheran Association for Christian Art, the Catholic Association for Christian Art
4. Art education: academies

In Dr. Gerhard Menz, Der Aufbau des Kulturstandes *(The Structure of the Cultural Profession), Munich/Berlin, 1938, p. 30.*

QUESTIONNAIRE

First and last names:
Date and place of birth:
Marital status:
First and maiden name of the wife:
Is the wife of Aryan origin?
Are you a member of the NSDAP?
Since when and membership number?
Which part of the NSDAP do you belong to?
Since when and number?
Which political parties did you belong to?
And during what period?
Were you a member of the Black Red Gold Veterans' Organization?
 If yes, when?
Were you a member of the Republic Civil Servants' Association?
 If yes, when?

Did you belong to the League for Human Rights?
 If yes, when?
Did you belong to the Bible Association?
 If yes, when?
Do you belong to an Order (Lodge) or a similar organization?
 If yes, which one, and when? (The Order of the Druids and Schlaraffia are covered here.)
Which rank did you hold?
Did you have a leading role?
 If yes, which one?
Have you ever been sentenced for
 a) Political reasons?
 b) Others?

In Dr. Gerhard Menz, Der Aufbau des Kulturstandes *(The Structure of the Cultural Profession), Munich/Berlin, 1938, p. 30.*

THE LITTLE PROOF OF RACIAL PURITY

The little proof of racial purity, which members have to bring, must include birthplace and birth date of the four grandparents. . . . We recommend that all members purchase a forefathers' pass, which can be found in all bookshops.

Mitteilungsblatt Der RKdbK, *February 1937, p. 3.*

ABBREVIATIONS

BdM (Bund deutscher Mädchen): Association of German Girls
The girls' section of the HJ (see below)

DAF (Deutsche Arbeitsfront): German Labor Front
An organization formed by Robert Ley, head of the government's labor department, to replace the banned workers' unions

GDK (Grosse deutsche Kunstausstellung): "Great German Art Exhibition"

HJ (Hitler Jugend): Hitler Youth
Founded in 1936 by Baldur von Schirach

KdF (Kraft durch Freude): Strength Through Joy
A section of the DAF whose task was to organize the holidays and leisure time of the working classes

KiDR (*Die Kunst im Dritten Reich*): Art in the Third Reich
A monthly art magazine. After 1939, the title was changed to *Die Kunst im Deutschen Reich* (Art in the German Reich)

NSDAP (National Sozialistische Deutsche Arbeiter Partei): National Socialist German Workers' Party (Until February 24, 1920, the DAP [German Workers' Party])

RKdbK (Reichskammer der bildenden Künste): Reich Chamber for the Visual Arts

RKK (Reichskulturkammer): Reich Culture Chamber

SA (Sturmabteilung): Storm Troopers
A paramilitary troop of the NSDAP, founded in 1921

SS (Schützstaffel): Internal Security Force—blackshirts
Arm of the NSDAP founded in 1925, and from 1929 the responsibility of Heinrich Himmler. An important and ruthless security system to control the "final solution"

The term Third Reich was coined not by a National Socialist but by a conservative revolutionary, Arthur Moeller van den Bruck, a vehement anti-Nazi who committed suicide in 1925. He wanted a third Reich to follow the first Reich (up to 1806, The Holy German Reich of German Nationality) and the Wilhelminic Kaisers' Reich, the second Reich.

NOTES

ABBREVIATIONS

DAZ (*Deutsche Allgemeine Zeitung*)
KiDR (*Die Kunst im Dritten Reich/Die Kunst im Deutschen Reich*)
RKdbK (*Reichskammer der bildenden Künste*)
VB (*Völkischer Beobachter*)

INTRODUCTION

1. "Kunst und Künstler im Dritten Reich," *Weltkunst*, April 3, 1938.
2. Ludwig Eberlein, "Der kulturelle Auftrag," *Das Reich*, January 31, 1943.
3. Hitler, Party Day speech, Nuremberg, September 2, 1933.
4. Hitler at Nuremberg, September 11, 1935, in *DAZ*, September 13, 1935.
5. See *DAZ*, September 13, 1935; *VB*, September 9, 1937; and *Frankfurter Zeitung*, September 8, 1938.
6. Hitler's speeches at the openings of the House of German Art in 1937, 1938, and 1939, in *VB*, July 19, 1937; *Frankfurter Zeitung*, July 11, 1938; and *VB*, July 17, 1939.
7. Hitler, *Mein Kampf*, translated by Helmut Ripperger. New York, 1939, pp. 416–17.
8. Hitler at Nuremberg, September 11, 1935. In *DAZ*, September 13, 1935.
9. Hitler, Party Day speech, Nuremberg, 1938. In *Reden des Führers am Parteitag Grossdeutschlands*, Munich, 1938, p. 31.
10. *Mein Kampf*, p. 397.
11. Ibid., pp. 579–81.
12. Ibid., p. 631.
13. Ibid., p. 359.
14. Ibid., p. 579.
15. Hitler at Nuremberg, September 11, 1935. In *DAZ*, September 13, 1935.
16. Dr. Reinhold Krause, in *Rassische Erziehung als Unterrichtsgrundsatz der Fachgebiete*, edited by Dr. Rudolf Benze. Frankfurt, 1937, p. 198.
17. Hitler at Munich, July 18, 1937. Translation in Norman H. Baynes, *The Speeches of Adolf Hitler April 1922–August 1939*, New York, 1969, pp. 590–91. Henceforth referred to as Baynes.
18. Hitler, Party Day speech, Nuremberg, September 11, 1935. In Baynes, p. 576.
19. Dr. Otto Dietrich, *Revolution des Denkens*, Dortmund/Leipzig, 1939, p. 9.
20. Hitler, Party Day speech, Nuremberg, September 11, 1935. In Baynes, p. 572.
21. Robert Böttcher, *Kunst und Kunsterziehung im neuen Reich*, Breslau, 1933, p. 61.
22. Hitler at Munich, July 18, 1937. In Baynes, pp. 590–91.
23. *Mein Kampf*, p. 468.
24. Ibid., p. 852.

CHAPTER 1

THE NORDIC MYTH: NATIONAL SOCIALIST IDEOLOGY

1. *SS-Mann und Blutfrage*, published by the SS training office, n.d.
2. Hitler, 1938, at the Kulturtag, in *Frankfurter Zeitung*, September 8, 1938.
3. Karl Grosshans, "Romain Rolland und der germanische Geist," Ph.D. dissertation, Friedrich-Wilhelm University, Berlin, February 17, 1937, p. 13.
4. Hitler, July 18, 1937, in *VB*, July 19, 1937.
5. Alfred Rosenberg, *Der Mythos des 20. Jahrhunderts*, Munich, 1933, pp. 290 and 299.
6. Paul Schultze-Naumburg, *Kunst und Rasse*, Munich, 1928, p. 84.
7. Paul Schultze-Naumburg, *Die Kunst der Deutschen*, Stuttgart/Berlin, 1934, p. 111.
8. Robert Böttcher, *Kunst und Kunsterziehung im neuen Reich*, Breslau, 1933, p. 61.
9. Rosenberg, *Der Mythos des 20. Jahrhunderts*, pp. 290 and 299.
10. Hitler at Nuremberg, September 11, 1935, in *DAZ*, September 13, 1935.
11. Hanns Bastanier, "Jedem das Seine," *Kunst und Wirtschaft*, 1935, p. 65.
12. Julius Schulte-Frohlinde, "Baukultur im Dritten Reich," *Bauten der Bewegung*, 1939, vol. 1, p. iv.

CHAPTER 2

THE RING MASTERS

1. From *Sieben Reden von Burte*, Strasbourg, 1943,
 pp. 19–21, 27–32. Translation in George L.
 Mosse, ed., *Nazi Culture: Intellectual, Cultural, and
 Social Life in the Third Reich*, New York, 1966,
 pp. 142–44. Henceforth referred to as Mosse.
2. See Billy F. Price, *Adolf Hitler: The Unknown Artist*,
 Houston, 1984.
3. Dr. Hermann Nasse, *Die neue Literatur*, 1936,
 p. 736. Nasse was a professor at the Academy
 of Fine Arts in Munich.
4. *Ufa Ton Woche*, no. 406.

CHAPTER 3

THE PRACTICE OF NATIONAL
SOCIALIST IDEOLOGY

1. *Mein Kampf*, pp. 467–70.
2. Hitler at the "Great German Art Exhibition
 1939," Munich.
3. In *Germania*, November 16, 1933.
4. Dr. Joseph Goebbels at the Annual Congress of
 the Reich Culture Chambers and the Strength
 Through Joy organization, Berlin, November 26,
 1937. In *Von der Grossmacht zur Weltmacht*, 1937,
 edited by Hans Volz. Berlin, 1938, pp. 416–26.
 Translation in Mosse, pp. 153–54.
5. Ibid.
6. Hitler at Nuremberg, in *VB*, September 9, 1937.
7. Winfried Wendland, *Kunst und Nation*, Berlin,
 1934, p. 19.
8. Goebbels, in *Germania*, November 16, 1933.
9. Gottfried Benn, *Gesammelte Werke*, vol. 4, p. 245.
 Cited in Joachim Fest, *Hitler. Eine Biographie*.
 Frankfurt, 1976, p. 635.
10. Goebbels, June 6, 1934, in *Weltkunst*, June 10,
 1934.
11. Arnold Waldschmidt, in *Blätter der Kameradschaft
 deutscher Künstler*, special edition for Hitler's

birthday, April 20, 1933, p. 32.
12. Hitler, September 1, 1933.
13. *Die Tagebücher von Joseph Goebbels: Sämtliche Frag-
 mente. Part 1: Aufzeichnungen 1924–1941*. Edited
 by Elke Fröhlich. 4 vols. Munich, 1987. April 28,
 1934, vol. 2, p. 406.
14. Alfred Rosenberg, in *VB*, July 7, 1933.

CHAPTER 4

THE TURNING POINT

1. Professor Hans Adolf Bühler, "Zum Geleit," *Das
 Bild*, 1934, p. 1.
2. Fritz Beyer, in *Deutsche Kultur-Wacht*, vol. 12, p. 2.
3. Max Liebermann, in *Centralvereins-Zeitung*, May
 11, 1933.
4. *Tägliche Rundschau*, May 11, 1933.
5. Ursula von Kardorff, *Chronik unserer schwersten
 Jahre—Berliner Aufzeichnungen 1942-1945*, Munich,
 1962.
6. All letters in the archive of the Akademie der
 Bildenden Künste, Berlin.
7. Letter from Kraus and Schumann, November 3,
 1933. In *Musik im Dritten Reich. Eine Dokumenta-
 tion*, edited by Joseph Wulf, Gütersloh, 1963.
8. Robert Scholz, in *Deutsche Kultur-Wacht*, 1933, no.
 10, p. 5.
9. Kurt Karl Eberlein, *Was ist deutsch in der deut-
 schen Kunst*, Berlin, 1933, p. 17.
10. Otto Klein, "Das Deutsche Volksmuseum," *Deut-
 sches Volkstum*, 1934, p. 942.
11. Rudolf Ramlow, "Der deutsche Stil des 20. Jahr-
 hunderts," *Bausteine zum deutschen National-
 theater*, 1935, vol. 4, p. 98.
12. *VB*, November 27, 1936.
13. Hitler at the opening of the House of German
 Art, July 18, 1937, in *VB*, July 19, 1937.
14. Goebbels at Berlin, November 26, 1937. Trans-
 lation in Mosse, p. 154.
15. Hitler at Munich, July 18, 1937, in *VB*, July 19,
 1937.

CHAPTER 5

THE ART OF SEDUCTION
1. Professor Max Kutschmann, in *Deutsche Kultur-Wacht*, no. 1, p. 6, 1933.
2. Hitler at Nuremberg, September 11, 1935, in *DAZ*, September 13, 1937.
3. Burte, translation in Mosse, pp. 142-43.
4. Hitler at Munich, in *Frankfurter Zeitung*, July 11, 1938.
5. Werner Hager, "Bauwerke im Dritten Reich," *Das innere Reich*, 1937, vol. 1, p. 7.
6. Cited in R. R. Taylor, *The Word in Stone*, Berkeley and London, 1974, p. 33, n. 79.
7. Professor Hubert Schrade, "Der Sinn der künstlerischen Aufgabe und politischen Architektur," *Nationalsozialistische Monatshefte*, 1934, p. 306.

CHAPTER 6

THE "GREAT GERMAN ART EXHIBITIONS"
1. Hitler at the Day of German Art, in *Mitteilungsblatt der RKdbK*, August 1, 1939.
2. *Hakenkreuzbanner*, June 10, 1938.
3. Hugo Landgraf, "Die Museen im neuen Reich," *Nationalsozialistische Monatshefte*, July 1934, p. 52.
4. Eberlein, *Was ist deutsch in der deutschen Kunst*, p. 17.
5. Werner Rittich, in *Kunst und Volk*, vol. 5, no. 8, August 8, 1937.
6. Bruno E. Werner, "Erster Gang durch die Kunstausstellung," *DAZ*, July 20, 1937.
7. Dr. Hans Kiener, in *KiDR*, July/August 1937, p. 19.
8. Dr. Wilhelm Spael, "Grosse Deutsche Kunstausstellung 1937," *Kölnische Volkszeitung*, July 22, 1937.
9. Walter Horn, "Vorbild und Verpflichtung: Die grosse Deutsche Kunstausstellung 1939 in München," *Nationalsozialistische Monatshefte*, September 1939, p. 830.
10. Professor Winfried Wendland, "Nationalsozialistische Kulturpolitik," *Deutsche Kultur-Wacht*, 1933, no. 24, p. 2.
11. Paul Schultze-Naumburg, "Hermann Urban, the Master of the Heroic Landscape," *KiDR*, July 1941.
12. F. A. Kauffmann, cited in Berthold Hinz, *Art in the Third Reich*, translated by Robert and Rita Kimber. New York and Oxford, 1979, pp. 77–78.
13. Dr. Adolf Feulner, *Kunst und Geschichte*, Leipzig, 1942, p. 37.
14. Goebbels at the Day of German Art, July 9, 1938, in *Mitteilungsblatt der RKdbK*, August 1, 1938.
15. Hans-Walter Betz, "Freiheit des Künstlers," *Der Film*, July 9, 1938.
16. Hitler at Nuremberg, September 11, 1935, in *DAZ*, September 13, 1935.
17. Dr. Hans Kiener, in *Kunstbetrachtungen*, Munich, 1937, p. 334.
18. Ibid.
19. Letter from Kraus and Schumann, November 3, 1933. Archives Akademie der Künste, Berlin.
20. Goebbels, November 26, 1937, in *Von der Grossmacht zur Weltmacht*. Translation in Mosse, pp. 152–54.
21. Hitler, in *KiDR*, August/September 1938.
22. Ibid.
23. Goebbels, November 26, 1937, in *Von der Grossmacht zur Weltmacht*. Translation in Mosse, p. 155.
24. Ibid.

CHAPTER 7

THE EXHIBITION OF "DEGENERATE ART"
For additional information on the subject dealt with in this chapter, see *"Degenerate Art": The Fate of the Avant-Garde in Nazi Germany*, Los Angeles, 1990, ex-

hibition catalogue of the Los Angeles County
Museum of Art.

1. Hitler, *Mein Kampf*, p. 354.
2. Hitler at Nuremberg, September 11, 1935, in *DAZ*, September 13, 1935.
3. From *Der SA-Mann*, September 18, 1937. Translation in Mosse, p. 48.
4. Professor Bruno Goldschmitt, in *Das Bild*, 1935, p. 32.
5. Goebbels, November 26, 1937, in *Von der Grossmacht zur Weltmacht*. Translation in Mosse, pp. 152–53.
6. Ziegler, July 19, 1937, *Mitteilungsblatt der RKdbK*, August 1, 1937.
7. Dr. Walter Hansen, *Judenkunst in Deutschland*, Berlin, 1942, p. 197.
8. Goebbels, November 26, 1937, in *Von der Grossmacht zur Weltmacht*. Translation in Mosse, pp. 156–57.
9. Letter from P. D. Colnaghi, October 19, 1938, cited in Reinhard Mueller-Mehlis, *Die Kunst im Dritten Reich*, Munich, 1976, p. 164.

CHAPTER 8

THE VISUALIZATION OF NATIONAL
SOCIALIST IDEOLOGY

1. Hitler, Party Day speech, Nuremberg, September 11, 1935, in *DAZ*, September 13, 1935.
2. Eberlein, *Was ist deutsch in der deutschen Kunst*, p. 17.
3. Wilhelm Westecker, in *KiDR*, March 1938, p. 86.
4. Walter Horn, in *KiDR*, April 1939, p. 123.
5. Scholz, in *KiDR*, August 1938.
6. Horn, in *KiDR*, April 1939, p. 122.
7. Ibid.
8. R. Walther Darré. Translation in Mosse, pp. 148–49.
9. Ibid., p. 148.
10. Review of exhibition, in *Das Bild*, 1935, p. 370.
11. Paul Hermann, *Deutsche Rassenhygiene*, pp. 17–21. Translation in Mosse, pp. 36–37.
12. Eberlein, *Was ist deutsch in der deutschen Kunst*, p. 18.
13. Ibid., pp. 56–59.
14. Baldur von Schirach, in B. Kroll, *Deutsche Maler der Gegenwart*, Berlin, 1937, pp. 140ff.
15. Hermann, *Deutsche Rassenhygiene*, pp. 17–21. Translation in Mosse, p. 36.
16. Hitler, cited in *VB*, September 15, 1935.
17. *Michael: Ein Deutsches Schicksal*, Munich, 1929, p. 41.
18. Reichsminister Rudolf Hess, at a meeting of the Women's Association, in *VB*, May 27, 1936.
19. *Frankfurter Zeitung*, August 11, 1933. Translation in Mosse, p. 45.
20. *Frankfurter Zeitung*, June 1, 1937. Translation in Mosse, p. 43.
21. *Der SA-Mann*, September 18, 1937. Translation in Mosse, pp. 48–49.
22. *VB*, February 2, 1936.
23. Fritz Zadow, "Kulturbewusstsein und nationale Wirklichkeit," in *Kant-Studien*, edited by Hans Heyse, 1936, vol. 41, p. 14.
24. Professor Dr. Otto Kuemmel, in *KiDR*, March 1940, p. 76.
25. Scholz, in *KiDR*, September 1940, p. 236.
26. Horn, in *KiDR*, December 1940, p. 374.
27. Scholz, "Zukunftsbewusste deutsche Kunst," *VB*, July 4, 1942.
28. Robert Volz, in *KiDR*, November 1938.
29. Heinrich Garbe, "Rassische Kunsterziehung," *Nationalsozialistisches Bildungswesen*, 1938, p. 664.
30. Rittich, "Zum Tode von Prof. Elk Eber," *VB*, August 15, 1941.
31. Horn, in *KiDR*, November 1942, p. 282.
32. Karl-Horst Behrendt, "Deutsche Künstler und die SS," *VB*, June 18, 1944.
33. Horn, in *KiDR*, February 1942.
34. *Das schwarze Korps*, June 19, 1935, p. 12.

CHAPTER 9

SCULPTURE

1. Horn, "Vorbild und Verpflichtung," *Nationalsozialistische Monatshefte*, September 1939, p. 832.
2. Hitler at Munich, July 18, 1937, in *VB*, July 19, 1937.

3. Werner, "Erster Gang durch die Kunstausstellung," *DAZ*, July 20, 1937.

4. Hitler, Party Day speech, Nuremberg, in *Berliner Lokal-Anzeiger*, September 2, 1933.

5. *Olympische Rundschau*, April 1939.

6. *KiDR*, April 1941.

7. Commentary from the film *Josef Thorak*, Bundesarchiv Koblenz.

8. Commentary from the film *Arno Breker*, Bundesarchiv Koblenz.

9. Werner Rittich, in *KiDR*, January 1942.

10. Bertrand Dorléac, *Histoire de l'Art*, Paris, 1940–44, p. 83.

11. Scholz, in *KiDR*, July 1942.

12. Bouchard, in *Illustration*, February 7, 1942.

13. See Magdalena Bushart, "Überraschende Begegnung mit alten Bekannten," *50 Jahre danach*, edited by Berthold Hinz, Marburg, 1989.

14. *Deutsche Wochenschau*, no. 518. Bundesarchiv Koblenz.

15. Wilhelm Westecker, in *KiDR*, October 1938.

CHAPTER 10

HITLER AND THE ARCHITECTS

1. "Die Begabung des Einzelnen—Fundament für alle," *Hakenkreuzbanner*, June 10, 1938.

2. Heinrich Hoffmann, *Hitler Was My Friend*, translated by R. H. Stevens, London, 1955, p. 184.

3. Franz Moraller, cited in *Mitteilungsblatt der RKdbK*, August 1, 1937, p. 12.

4. Hitler at Munich, January 22, 1938, in *VB*, November 24, 1938.

5. Hitler at Nuremberg, in *VB*, September 9, 1937.

6. Hitler at Berlin, November 27, 1937, in *Frankfurter Zeitung*, November 29, 1937.

7. "Nationalsozialistische Baukunst," in *Mitteilungsblatt der RKdbK*, September 1, 1939, p. 1.

8. Hitler at Nuremberg, September 11, 1935, in *DAZ*, September 13, 1935.

9. *Moderne Bauformen*, vol. 35, 1936.

10. Bettina Feistel-Rohmeder, "Was die Deutschen Künstler von der neuen Regierung erwarten,"

1933, in *Im Terror des Kunstbolschewismus*, Karlsruhe, 1938.

11. From a newsreel in the Bundesarchiv Koblenz.

12. Commentary from the film *Beim Bau der Autobahn*, Bundesarchiv Koblenz.

13. Ibid.

14. Moraller, cited in *Mitteilungsblatt der RKdbK*, August 1, 1937, p. 12.

15. Hitler at Nuremberg, in *VB*, September 9, 1937.

CHAPTER 11

HITLER'S BUILDING SITES

1. Hitler at Munich, January 22, 1938, in *VB*, November 24, 1938.

2. Goebbels, cited in Klaus Backes, *Hitler und die bildenden Künste*, Cologne, 1988.

3. Dr. Adolf Dresler, *Das Braune Haus und das Verwaltungsgebäude der Reichsleitung der NSDAP in München*, Munich, 1937, p. 9.

4. Rolf Badenhausen, "Betrachtungen zum Bauwillen des Dritten Reiches," *Zeitschrift für Deutschkunde*, 1937, p. 222.

5. *Bauten der Gegenwart*, p. 32.

6. Hans Sebastian Schmid, *Kunst und Stilunterscheidung für Laien, Kunstfreunde und Gewerbetreibende und für den kunstgeschichtlichen und stilkundlichen Unterricht*, Leipzig, 1938, p. 67.

7. Goebbels, cited in Backes, *Hitler und die bildenden Künste*.

8. Ibid.

9. Alex Heilmeyer, *KiDR*, October 1938, p. 296.

10. Gerdy Troost, ed., *Das Bauen im neuen Reich*, Bayreuth, 1943, I, p. 20.

11. Georg Weise, in *Zeitschrift für Deutschkunde*, 1935, p. 407.

12. Goebbels, cited in Backes, *Hitler und die bildenden Künste*.

13. *Bauten der Gegenwart*, pp. 53–54.

14. Albert Speer, *Inside the Third Reich: Memoirs*, translated by Richard and Clara Winston. New York, 1970, p. 59.

15. Neville Henderson, *Failure of a Mission*, New York, 1940, p. 72.

16. Wilhelm Lotz, "Das Reichsparteitagsgelände in Nürnberg," *KiDR*, 1938, p. 264.

17. Ibid.

18. Johannes Eilemann, *Deutsche Seele, deutscher Mensch, deutsche Kultur und Nationalsozialismus*, Leipzig, 1933, p. 14.

19. Lotz, "Das Reichsparteitagsgelände in Nürnberg," *KiDR*, 1938, p. 264.

20. Speer, *Inside the Third Reich: Memoirs*, p. 81.

21. Cited in *KiDR*, August 1939, p. x.

22. Speer, *Inside the Third Reich: Memoirs*, p. 112.

23. Goebbels, cited in Backes, *Hitler und die bildenden Künste*.

24. Ibid.

25. Hitler, "Bauen im dritten Reich," in *KiDR*, September 1939.

26. Speer, *Inside the Third Reich: Memoirs*, p. 102.

27. Ibid., p. 114.

28. Giesler, in "Bauen im dritten Reich," in *KiDR*, September 1939.

29. Rudolf Wolters, "Werk und Schöpfer," *KiDR*, August 1939.

30. Ibid.

31. Speer, *Inside the Third Reich: Memoirs*, p. 103.

32. Wilhelm Lotz, "Die Innerräume der neuen Reichskanzlei," *KiDR*, 1939.

33. Ibid.

34. For more information see Wolfgang Schäche, "Fremde Botschaften," *Transit*, Berlin, 1987.

35. Commentary from a newsreel in Bundesarchiv Koblenz.

36. Arno Breker, "Im Strahlungsfeld der Ereignisse 1925-1965," *Preussisch Oldendorf*, 1972, p. 95.

37. Goebbels, cited in Backes, *Hitler und die bildenden Künste*.

38. Ibid.

39. Troost, ed., *Das Bauen im neuen Reich*, I, p. 20.

40. Alfred Rosenberg, *KiDR*, January 1939, p. 17.

41. For more information, see also *Kunst auf Befehl*, Munich, 1990.

42. For Linz plans see also Ingo Sarlay, "Hitropolis," in *Kunst auf Befehl*, Munich, 1990.

CHAPTER 12

THE VERNACULAR STYLE

1. Karl Neupert, "Die Gemeinschaft formt das Bild der deutschen Städte," *Heimatpflege-Heimatgestaltung*, appendix to *Der Deutsche Baumeister*, 1939, no. 6, p. 64.

2. Julius Schulte-Frohlinde, *Die landschaftlichen Grundlagen*, p. 9.

3. Wendland, *Kunst und Nation*, p. 19.

4. Commentary from the film *Deutsche Heimstätten*, Bundesarchiv Koblenz.

5. Ibid.

6. *Werkhefte für den Heimbau der Hitler-Jugend*, Leipzig, 1937, p. 42.

7. Commentary from the film *Neue Heimstätten*, Bundesarchiv Koblenz.

8. *Bauten der Gegenwart*.

9. *Werkhefte für den Heimbau der Hitler-Jugend*, p. 42.

10. Dr. Wilhelm Rüdiger, in *KiDR*, January 1939.

11. Speer, *Inside the Third Reich: Memoirs*, p. 46.

12. Ibid., p. 90.

13. Ibid., pp. 88-90.

14. Richard Pfeiffer, *Die völkische Kunst*, 1935, p. 19.

15. Rudolf Rogier, in *KiDR*, March 1938, p. 68.

16. Giesler, in *Mitteilungsblatt der RKdbK*, August 1, 1938.

17. Heinrich Hartmann, "Der Feierraum," *Musik in Jugend und Volk*, 1937-38, p. 456.

18. Hitler, 1942, cited in Henry Pickerts, *Hitlers Tischgespräche im Führerhauptquartier*, Stuttgart, 1976, p. 481.

BIBLIOGRAPHY

Regrettably, it has not been possible to obtain complete publishing data for all the texts cited in this book. For further study of writings related to the arts in the Third Reich, the author commends to the reader the works of Joseph Wulf.

BOOKS AND ARTICLES

Backes, Klaus. *Hitler und die bildenden Künste: Kulturverständnis und Kunstpolitik im Dritten Reich.* Cologne, 1988.

Barron, Stephanie, et al. *Degenerate Art: The Fate of the Avant-Garde in Nazi Germany.* Los Angeles and New York, 1991.

Bartetzko, Dieter. *Zwischen Zucht und Ekstase—Zur Theatralik von NS-Architektur.* Berlin, 1985.

Baynes, Norman H. *The Speeches of Adolf Hitler April 1922–August 1939.* 2 vols. New York, 1969.

Behne, Adolf. *Entartete Kunst.* Berlin, 1947.

Benjamin, Walter. "The Work of Art in the Age of Mechanical Reproduction," in *Illuminations*, edited and with an introduction by Hannah Arendt. Translated by Harry Zohn. New York, 1968.

Benn, Gottfried. *Kunst und Macht.* Stuttgart and Berlin, 1934.

Bleuel, H. P. *Das saubere Reich—Eros und Sexualität im Dritten Reich.* Bergisch-Gladbach, 1979.

Böttcher, Robert. *Kunst und Kunsterziehung im neuen Reich.* Breslau, 1933.

Breker, Arno. *Bildnisse unserer Epoche.* Dorheim, n.d.

———. *Im Strahlungsfeld der Ereignisse.* Preussisch Oldendorf, 1972.

———. *Paris, Hitler et moi.* Paris, 1970.

Brenner, Hildegard. "Die Kunst im politischen Machtkampf der Jahre 1933/34." *Vierteljahreshefte für Zeitgeschichte* 10:1 (1962).

———. *Die Kunstpolitik des Nationalsozialismus.* Hamburg, 1963.

———. *Ende einer bürgerlichen Kunstinstitution.* Stuttgart, 1972.

Bullock, Alan. *Hitler—A Study in Tyranny.* New York, 1946.

Busch, Günter. *Entartete Kunst. Geschichte und Moral.* Frankfurt, 1969.

Bushart, M., B. Nicolai, and W. Schuster, eds. *Entmachtung der Kunst. Architektur, Bildhauerei und ihre Institutionalisierung 1920–1960.* Berlin, 1985.

Büttemann, M. *Architektur für das Dritte Reich. Die Akademie für Deutsche Jugendführung in Braunschweig.* Berlin, 1986.

Claus, Jürgen, ed. *Entartete Kunst. Bildersturm vor 25 Jahren.* Munich, 1962.

Corino, Karl, ed. *Intellektuelle im Bann des Nationalsozialismus.* Hamburg, 1980.

Czichan, E. *Wer verhalf Hitler zur Macht? Zum Anteil der deutschen Industrie an der Zerstörung der Weimarer Republik.* Cologne, 1967.

Damus, Martin. *Sozialistischer Realismus und Kunst im Nationalsozialismus.* Frankfurt, 1981.

Diel, Alex. *Die Kunsterziehung im Dritten Reich. Geschichte und Analyse.* Munich, 1969.

Doucet, Friedrich W. *Im Banne des Mythos—Die Psychologie des Dritten Reiches.* Esslingen, 1979.

Dresler, Adolf. *Das Braune Haus und die Verwaltungsgebäude der Reichsleitung der NSDAP.* Munich, 1939.

———, ed. *Deutsche Kunst und entartete "Kunst." Kunstwerk und Zerrbild als Spiegel der Weltanschauung.* Munich, 1938.

Dreyer, Ernst A., ed. *Deutsche Kultur im Neuen Reich. Wesen, Aufgaben und Ziele der Reichskulturkammer.* Berlin, 1934.

Engelbert, K. *Deutsche Kunst im totalen Staat.* Lahr (Baden), 1933.

Farner, K. *Kunst als Engagement—Zehn ausgewählte Essays.* Darmstadt and Neuwied, 1973.

Feder, G. *Die neue Stadt.* Berlin, 1939.

Feistel-Rohmeder, Bettina, ed. *Im Terror des Kunstbolschewismus. Urkundensammlung des "Deutschen Kunstberichtes" aus den Jahren 1927–33.* Karlsruhe, 1938.

Fest, Joachim. *Das Gesicht des Dritten Reiches. Profil einer totalitären Herrschaft.* Munich and Zurich, 1977.

———. *Hitler. Eine Biographie.* 2 vols. Frankfurt, West Berlin, and Vienna, 1976.

Fischer, H. W. *Menschenschönheit—Gestalt und Antlitz des Menschen in Leben und Kunst.* Berlin, 1935.

Fischer, J. *Maler und Zeichner schauen den Krieg (Maler als Soldaten).* Berlin, n.d.

Focke, H., and V. Reimer. *Alltag unterm Hakenkreuz— Wie die Nazis das Leben der Deutschen veränderten.* Frankfurt, 1979.

Frank, G., and W. Hempfing. *Die Neugestaltung deutscher Städte—Kommentar zum Gesetz vom 4. Oktober 1937.* Berlin and Munich, 1939.

Frommhold, Erhard, ed. *Kunst im Widerstand.* Dresden, 1968.

Gamm, H. J. *Der braune Kult—Das Dritte Reich und seine Ersatzreligion—Ein Beitrag zur politischen Bildung.* Hamburg, 1962.

Giesler, Hermann. *Ein anderer Hitler—Bericht eines Architekten.* Leoni, 1978.

Goebbels, Joseph. *The Goebbels Diaries, 1939-1941.* Edited and translated by Fred Taylor. London, 1982.

———. *The Goebbels Diaries, 1942-1943.* Edited and translated by Louis Lochner. Garden City, N.Y., 1948.

———. *Die Tagebücher von Joseph Goebbels: Sämtliche Fragmente.* Part 1: *Aufzeichnungen 1924-1941.* Edited by Elke Fröhlich. 4 vols. Munich, 1987.

———. *Signale der neuen Zeit—25 ausgewählte Reden von Dr. Joseph Goebbels.* Munich, 1938.

Grosshans, Henry. *Hitler and the Artists.* New York, 1983.

Grunberger, Richard. *Das zwölfjährige Reich. Der deutsche Alltag unter Hitler.* Vienna, Munich, and Zurich, 1972.

Günther, S. *Innenräume des "Dritten Reiches." Interieurs aus den Vereinigten Werkstätten für Kunst im Handwerk für Repräsentanten des "Dritten Reiches."* West Berlin, 1978.

Guthmann, H. *Zweierlei Kunst in Deutschland?* Berlin, 1935.

Harlander, T., and G. Fehl, eds. *Hitlers Sozialer Wohnungsbau 1940–1945. Wohnungspolitik, Baugestaltung und Siedlungsplanung.* (Stadt Planung Geschichte 6). Hamburg, 1986.

Haug, W. F. *Der hilflose Antifaschismus.* Frankfurt, 1970.

Heer, Friedrich. *Der Glaube des Adolf Hitler. Anatomie einer politischen Religiosität.* Munich and Esslingen, 1968.

Heigert, Hans. *Deutschlands falsche Träume—oder: Die verführte Nation.* Hamburg, 1968.

Held, J. *Kunst und Kulturpolitik in Deutschland 1945–49. Kulturaufbau in Deutschland nach dem 2. Weltkrieg.* West Berlin, 1981.

Henning, E. *Bürgerliche Gesellschaft und Faschismus in Deutschland—Ein Forschungsbericht.* Frankfurt, 1977.

Hentzen, Alfred. *Die Berliner Nationalgalerie im Bildersturm.* Cologne and Berlin, 1971.

Herding, Klaus, and Hans-Ernst Mittig. *Kunst und Alltag im NS-System. Albert Speers Berliner Strassenlaternen.* Giessen, 1975.

Hiepe, Richard. *Gewissen und Gestaltung—Deutsche Kunst im Widerstand.* Frankfurt, 1960.

Hildebrand, Klaus. *Das Dritte Reich.* Munich and Vienna, 1979.

Hinkel, Hans, ed. *Handbuch der Reichskulturkammer.* Berlin, 1937.

Hinkel, Hermann. *Zur Funktion des Bildes im deutschen Faschismus—Bildbeispiele, Analysen, didaktische Vorschläge.* Giessen, 1975.

Hinz, Berthold. *Art in the Third Reich.* Translated by Robert and Rita Kimber. New York and Oxford, 1979.

———. *"Zur Dialektik des bürgerlichen Autonomiebegriffs."* In *Autonomie der Kunst—Zur Genese und Kritik einer bürgerlichen Kategorie.* Frankfurt, 1972.

———, et al., eds. *Die Dekoration der Gewalt. Kunst*

und Medien im Faschismus. Giessen, 1979.

Hitler, Adolf. *Die Reden Hitlers am Parteitag der Ehre 1936.* Munich, 1936.

———. *Die Reden Hitlers am Parteitag der Freiheit 1935.* Munich, 1935.

———. *Mein Kampf.* Translated by Helmut Ripperger. New York, 1939.

Hofer, W. *Der Nationalsozialismus—Dokumente 1933–1945.* Frankfurt, 1957.

Hoffmann, H. *Tag der Deutschen Kunst.* Diessen, 1937.

Hofmann, W. *Grundlagen der modernen Kunst—Eine Einführung in ihre symbolischen Formen.* Stuttgart, 1966.

Huss, Hermann, and Andreas Schröder, eds. *Antisemitismus. Zur Pathologie der bürgerlichen Gesellschaft.* Frankfurt, 1966.

Jäckel, Eberhard. *Hitlers Weltanschauung. Entwurf einer Herrschaft.* Stuttgart, 1981.

Justin, Harald. *"Tanz mir den Hitler." Kunstgeschichte und (faschistische) Herrschaft.* Münster, 1982.

Kater, Michael H. *Das "Ahnenerbe" der SS 1935–1945. Ein Beitrag zur Kulturpolitik des Dritten Reiches.* Stuttgart, 1974.

Kauffmann, F. A. *Die neue deutsche Malerei. Das Deutschland der Gegenwart,* no. 11. Berlin, 1941.

Keller, Bernhard. *Das Handwerk im faschistischen Deutschland. Zum Problem der Massenbasis.* Cologne, 1980.

Köhler, Gerhard. *Kunstanschauung und Kunstkritik in der nationalsozialistischen Presse—Die Kritik im Feuilleton des "Völkischen Beobachters" 1920–1932.* Munich, 1937.

Kracauer, Siegfried. *Das Ornament der Masse.* Frankfurt, 1963.

Kraus, Wolfgang. *Kultur und Macht. Die Verwandlung der Wünsche.* Vienna, 1975.

Krier, Leon. *Albert Speer, Architecture 1932–1942.* Brussels, 1985.

Kühnl, R. *Der deutsche Faschismus in Quellen und Dokumenten.* Cologne, 1975.

Kunst, H. J. "Architektur und Macht, Überlegungen zur NS-Architektur." In *Mitteilungen, Kommentare, Berichte der Philipps-Universität Marburg* 3 (1971).

———. "Die Vollendung der romantischen Gotik im Expressionismus. Die Vollendung des Klassizismus im Funktionalismus." In *Kritische Berichte 1/1979 Bemerkungen zu Schinkels Entwürfen für die Friedrich-Werdersche Kirche in Berlin.* In *Marburger Jahrbuch* 19 (1974).

Lane, Barbara Miller. *Architecture and Politics in Germany 1918–1945.* Cambridge, Mass., 1968.

Langbehn, Julius. *Rembrandt als Erzieher—Von einem Deutschen.* 47th ed. Leipzig, 1909.

———, and Momme Nissen. *Dürer als Führer. Vom Rembrandtdeutschen und seinem Gehilfen.* Munich, 1928.

Lärmer, K. *Autobahnbau in Deutschland 1933 bis 1945—Zu den Hintergründen.* Berlin, 1975.

Larsson, L. O. *Die Neugestaltung der Reichshaupstadt. Albert Speers Generalbebauungsplan für Berlin.* Stuttgart, 1978.

Lehmann-Haupt, Helmut. *Art Under a Dictatorship.* New York, 1954.

Lepper, Barbara. *Verboten, verfolgt: Kunstdiktatur im Dritten Reich.* Duisburg, 1983.

Liska, P. *Nationalsozialistische Kunstpolitik.* Berlin, [1974].

Lukács, Georg. *Die Zerstörung der Vernunft.* 3 vols. Darmstadt and Neuwied. Vol. 1: *Irrationalismus zwischen den Revolutionen.* 1979. Vol. 2: *Irrationalismus und Imperialismus.* 1974. Vol. 3: *Irrationalismus und Soziologie.* 1981.

Maser, Werner. *Adolf Hitler. Legende—Mythos—Wirklichkeit.* Munich, 1974.

———. *Hitlers "Mein Kampf."* Munich, 1966.

Mattausch, R. *Siedlungsbau und Stadtneugründungen im deutschen Faschismus.* Frankfurt, 1981.

Merker, Paul. *Deutschland—Sein oder Nichtsein.* 2 vols. Frankfurt. Vol. 1: *Von Weimar zu Hitler.* 1973. Vol. 2: *Das Dritte Reich und sein Ende.* 1972.

Merker, Reinhard. *Die bildende Künste im Nationalsozialismus, Kulturideologie, Kulturpolitik, Kultur-*

produktion. Cologne, 1983.

Metken, Günter, ed. *Realismus. Zwischen Revolution und Reaktion 1919-1939.* Munich, 1981.

Mitscherlich, A. and M. *Die Unfähigkeit zu trauern. Grundlagen kollektiven Verhaltens.* Munich, 1967.

Mittig, H. E. "Die Reklame als Wegbereiterin der nationalsozialistischen Kunst." In *Die Dekoration der Gewalt—Kunst und Medien im Faschismus.* Giessen, 1979.

Moeller van den Bruck, Arthur. *Das Dritte Reich.* Hamburg, 1931.

Mosse, George L. *Die Nationalisierung der Massen: Von den Befreiungskriegen bis zum Dritten Reich.* Berlin, 1976.

—————, ed. *Nazi Culture: Intellectual, Cultural, and Social Life in the Third Reich.* New York, 1966.

Müller-Mehlis, Reinhard. *Die Kunst im Dritten Reich.* Munich, 1976.

Neumann, Franz. *Behemoth. Struktur und Praxis des Nationalsozialismus 1933-1944.* Cologne and Frankfurt, 1977.

Nolte, Ernst, ed. *Der Faschismus in seiner Epoche. Die Action française. Der italienische Faschismus. Der Nationalsozialismus.* Munich and Zurich, 1979.

—————. *Der Nationalsozialismus.* Frankfurt, West Berlin, and Vienna, 1970.

—————. *Theorien über den Faschismus.* Cologne and Berlin, 1967.

Peltz-Dreckmann, U. *Nationalsozialistischer Siedlungsbau.* Munich, 1978.

Petsch, Joachim. *Architektur und Gesellschaft—Zur Geschichte der deutschen Architektur im 19. und 20. Jahrhundert.* Cologne, 1973.

—————. *Baukunst und Stadtplanung im Dritten Reich— Herleitung / Bestandsaufnahme / Entwicklung Nachfolge.* Munich and Vienna, 1976.

Peukert, D., and J. Reulecke, eds. *Die Reihen fest geschlossen. Beiträge zur Geschichte des Alltags unterm Nationalsozialismus.* Wuppertal, 1981.

Picker, H. *Hitlers Tischgespräche im Führerhauptquartier 1941–1942.* Bonn, 1951.

Price, Billy F. *Adolf Hitler: The Unknown Artist.* Houston, 1984.

Probst, V. G. *Der Bildhauer Arno Breker.* Bonn and Paris, 1978.

Rave, Paul O. *Kunstdiktatur im Dritten Reich.* Hamburg, 1949.

Recker, M.-L. *Die Grossstadt als Wohn- und Lebensbereich im Nationalsozialismus. Zur Gründung der "Stadt des KdF-Wagens."* Frankfurt and New York, 1981.

Reich, W. *Massenpsychologie des Faschismus.* Copenhagen, Prague, and Zurich, 1933. Reprinted, Frankfurt, 1972.

Reichardt, H. J., and W. Schäche. *Von Berlin nach Germania. Über die Zerstörung der Reichshauptstadt durch Albert Speers Neugestaltungsplanungen.* Berlin, 1985.

Reif, Adelbert, ed. *Albert Speer: Technik und Macht.* Esslingen, 1979.

Reimann, Viktor. *Dr. Joseph Goebbels.* Vienna and Munich, 1976.

Richard, Lionel. *Deutscher Faschismus und Kultur. Aus der Sicht eines Franzosen.* Munich, 1982.

Rischbieter, H. *Gründgens—Schauspieler, Regisseur, Theaterleiter.* Hanover, 1963.

Rittich, Werner. *Architektur und Bauplastik der Gegenwart.* Berlin, 1938.

—————. "Deutsches Kunsthandwerk. Zur ersten Deutschen Kunsthandswerksausstellung München 1938." In *Die Kunst im Dritten Reich* 2 (1938).

Rosenberg, Alfred. *Der Mythos des 20. Jahrhunderts— Eine Wertung der seelisch-geistigen Gestaltenkämpfe unserer Zeit.* Munich, 1930.

Roxan, David, and Kenneth Wanstall. *The Jackdaw of Linz.* Munich, 1966.

Sarlay, Ingo. "Hitropolis." In *Kunst auf Befehl.* Munich, 1990.

Schäfer, Hans D. *Das gespaltene Bewusstsein. Über deutsche Kultur und Lebenswirklichkeit 1933–1945.* Munich and Vienna, 1981.

Schirach, Baldur von. *Zwei Reden zur deutschen Kunst.* Munich, 1941.

Schirmbeck, P. *Adel der Arbeit. Der Arbeiter in der Kunst der NS-Zeit.* Marburg, 1984.

Schmeer, K. *Regie des öffentlichen Lebens im Dritten Reich.* Munich, 1956.

Schmitt, H.-J., ed. *Die Expressionismusdebatte— Materialien zu einer marxistischen Realismuskonzeption.* Frankfurt, 1973.

Schmitthenner, P. *Baukunst im neuen Reich.* Munich, 1934.

Schneede, Uwe M. *Die zwanziger Jahre. Manifeste und Dokumente deutscher Künstler.* Cologne, 1979.

Schneider, C. *Städtegründungen im Dritten Reich. Wolfsburg und Salzgitter. Ideologie Ressortpolitik Repräsentation.* Munich, 1979.

Schnell, Ralf *Kunst und Kultur im deutschen Faschismus.* Stuttgart, 1978.

Schoenbaum, David. *Die braune Revolution—Eine Sozialgeschichte des Dritten Reiches.* Cologne and West Berlin, 1968.

Scholz, Robert. *Architektur und bildende Kunst 1933– 1945.* Preussisch Oldendorf, 1977.

Schönberger, A. *Die Neue Reichskanzlei von Albert Speer—Zum Zusammenhang von nationalsozialistischer Ideologie und Architektur.* Berlin, 1981.

Schultze-Naumburg, Paul. *Kampf um die Kunst.* Munich, 1932.

———. *Kunst aus Blut und Boden.* Leipzig, 1934.

———. *Kunst und Rasse.* Munich, 1928.

———. "Zeitgebundene und blutgebundene Kunst." *Das Bild,* 4:8 (1934).

Schuster, Peter-Klaus, ed. *Nationalsozialismus und "entartete Kunst": die "Kunststadt" München 1937.* Munich, 1988.

Schweitzer, A. *Big Business in the Third Reich.* Bloomington, Ind., 1964.

Selle, G. *Die Geschichte des Design in Deutschland von 1870 bis heute. Entwicklung der industriellen Produktkultur.* Cologne, 1978.

———. *Kultur der Sinne und ästhetische Erziehung. Alltag, Sozialisation, Kunstunterricht in Deutschland vom Kaiserreich zur Bundesrepublik.* Cologne, 1981.

Shirer, William L. *The Rise and Fall of the Third Reich.* New York, 1960.

Silva, Umberto. *Ideologia e arte del fascismo.* Milan, 1973.

Speer, Albert. *Architektur, Arbeiten 1933–1942.* Frankfurt, Berlin, and Vienna, 1978.

———. *Inside the Third Reich: Memoirs.* Translated by Richard and Clara Winston. New York, 1970.

———. *Spandauer Tagebücher.* Berlin, Frankfurt, and Vienna, 1975.

Steinberg, Rolf, ed. *Nazi-Kitsch.* Darmstadt, 1975.

Steingräber, Erich, ed. *Deutsche Kunst der 20er und 30er Jahre.* Munich, 1979.

Stern, Fritz. *The Politics of Cultural Despair—A Study in the Rise of the Germanic Ideology.* Berkeley, 1961.

Stern, J. P. *Hitler, der Führer und das Volk.* Munich, 1978.

Stommer, R., and C. G. Philipp, eds. *Reichsautobahn. Pyramiden des Dritten Reiches.* Marburg, 1982.

Tank, Kurt Lothar. *Deutsche Plastik unserer Zeit.* Munich, 1942.

Taylor, Robert R. *The Word in Stone—The Role of Architecture in the National Socialist Ideology.* Berkeley and Los Angeles, 1975.

Teut, Anna. *Architektur im Dritten Reich 1933–1945.* Berlin, Frankfurt, and Vienna, 1967.

Theweleit, Klaus. *Männerphantasien.* 2 vols. Frankfurt, 1977.

Thies, Joachen. *Architekt der Weltherrschaft. Die "Endziele" Hitlers.* Königstein/Taunus and Düsseldorf, 1980.

Thomae, Otto. *Die Propaganda-Maschinerie. Bildende Kunst und Öffentlichkeitsarbeit im Dritten Reich.* Berlin, 1978.

Treue, Wilhelm. *Kunstraub. Über das Schicksal von Kunstwerken in Krieg, Revolution und Frieden.* Düsseldorf, 1957.

———, ed. *Zum nationalsozialistischen Kunstraub in Frankreich. Der "Bargatzky-Bericht."* Stuttgart, 1965.

Troost, Gerdy, ed. *Das Bauen im Neuen Reich.* 2 vols. Bayreuth, 1938.

Valland, Rose. *Le front de l'art*. Paris, 1961.

Vinnen, Carl. *Protest deutscher Künstler*. Jena, 1911.

Vollbehr, E. *Arbeitsschlacht—Fünf Jahre Malfahrten auf den Bauplätzen der "Strassen Adolf Hitlers."* Berlin, 1938.

Vondung, Klaus. *Magie und Manipulation. Ideologischer Kult und politische Religion des Nationalsozialismus*. Göttingen, 1971.

Walz, M. *Wohnungsbau- und Industrieansiedlungspolitik in Deutschland 1933–1939*. Frankfurt, 1979.

Warnke, Martin, ed. *Bildersturm. Die Zerstörung des Kunstwerks*. Munich, 1973.

Wernert, E. *L'Art dans le IIIe Reich—Une tentative d'esthétique dirigée*. Paris, 1936.

Wilke, H. *Dein "Ja" zum Leibe*. Berlin, 1939.

Wolbert, Klaus. *Die Nackten und die Toten des "Dritten Reiches"—Folgen einer politischen Geschichte des Körpers in der Plastik des deutschen Faschismus*. Giessen, 1982.

Wolters, R. *Albert Speer*. Oldenburg, 1942.

———. *Neue Deutsche Baukunst*. Berlin, 1940.

Wulf, Joseph. *Literatur und Dichtung im Dritten Reich. Eine Dokumentation*. Reinbek and Hamburg, 1966.

———. *Theater und Film im Dritten Reich. Eine Dokumentation*. Gütersloh, 1964.

———, ed. *Die bildenden Künste im Dritten Reich. Eine Dokumentation*. Gütersloh, 1963.

Zentner, Christian. *Adolf Hitlers "Mein Kampf." Eine kommentierte Auswahl*. Munich, 1974.

CATALOGUES

Berlin, Akademie der Künste: *Skulptur und Macht: Figurative Plastik im Deutschland der 30er und 40er Jahre*, 1983.

Berlin, Nationalgalerie, Akademie der Künste, and Schloss Charlottenburg: *Tendenzen der Zwanziger Jahre*, 1977.

Berlin: *Zwischen Krieg und Frieden. Gegenständliche und realistische Tendenzen in der Kunst nach 1945*, edited by Frankfurter Kunstverein, 1980.

Berlin, Akademie der Künste: Barbara Volkmann, ed. *Zwischen Widerstand und Anpassung. Kunst in Deutschland 1933–1945*, 1978.

Darmstadt: *Ordnung in Stein—Architektur des Nationalsozialismus*, 1975.

Frankfurt: *Kunst im 3. Reich—Dokumente der Unterwerfung*, 1974.

Hamburg, Kunsthalle: *Verfolgt und Verführt: Kunst unterm Hakenkreuz in Hamburg 1933–1945*, 1983.

Munich: Jürgen, Claus. *Entartete Kunst: Bildersturm vor 25 Jahren*, 1962.

Munich: *Weltkulturen und moderne Kunst*, 1972.

ACKNOWLEDGMENTS

This book grew out of two television programs which I made for the BBC in 1988, "Art in the Third Reich 1: The Stage Management of Power," and "2: The Propaganda Machine." They belong, together with "Richard Strauss Remembered," to a group of programs which tried to show how art was used to legitimize a barbaric ideology and to camouflage the evils of a totalitarian system.

Unlike the writing of a book, the production of a television series is a collaborative affair. Many are involved and help to realize the programs. In the making of the films I drew on the knowledge and experience of a large number of people whose thoughts have also filtered into this book. I would like to thank most of all Robert McNab and Lutz Becker, who were closely involved in the research and the writing of the film scripts. My thanks also go to Judy Shears, who with loving and professional care saw the programs through the many erratic and complex stages, and to my film editor, Julian Miller. Without these four colleagues and friends the television series would not exist and would not have won the ultimate accolade: a British Academy of Film and Television Arts Award for the Best Arts Documentary of the Year.

I spoke with and interviewed a number of personalities in the arts, many with firsthand knowledge of the Third Reich. I would like to thank Dr. Ernst Aichner, Theo Baltz, Gräfin Marion Dönhoff, Dr. Dagmar Fambach, Professor Berthold Hinz, Professor Dieter Hönisch, Professor Wolf-Dieter Dube, Dr. Michael Krüger, Edmund Luft, Reinhard Müller-Mehlis, Professor Julius Posener, Dr. Wolfgang Schäche, Dr. Christoph Stötzel, Dr. Peter-Klaus Schuster, Wolfgang Weiss, Andreas Wilkens, and Professor Matthias Winner.

I would also like to thank my colleague Julia Matheson, who helped me to change from an old typewriter to a modern word processor and who was at hand at all erratic and panicky moments.

As for the book, my thanks go to my publishers, Paul Gottlieb and Andreas Landshoff, for their continuous encouragement and counsel, and to my editor, Phyllis Freeman, who worked tirelessly to iron out the many imperfections of my manuscript and whose enthusiasm never flagged, and María Teresa Vicens, her meticulous assistant. I would also like to thank my translator (and sister) Renate Winner for her many suggestions for this book. And last but not least, my thanks to Uta Hofmann, who with rare dedication helped and advised in the photograph research.

INDEX *Page numbers in italics indicate illustrations.*

PHOTOGRAPH CREDITS